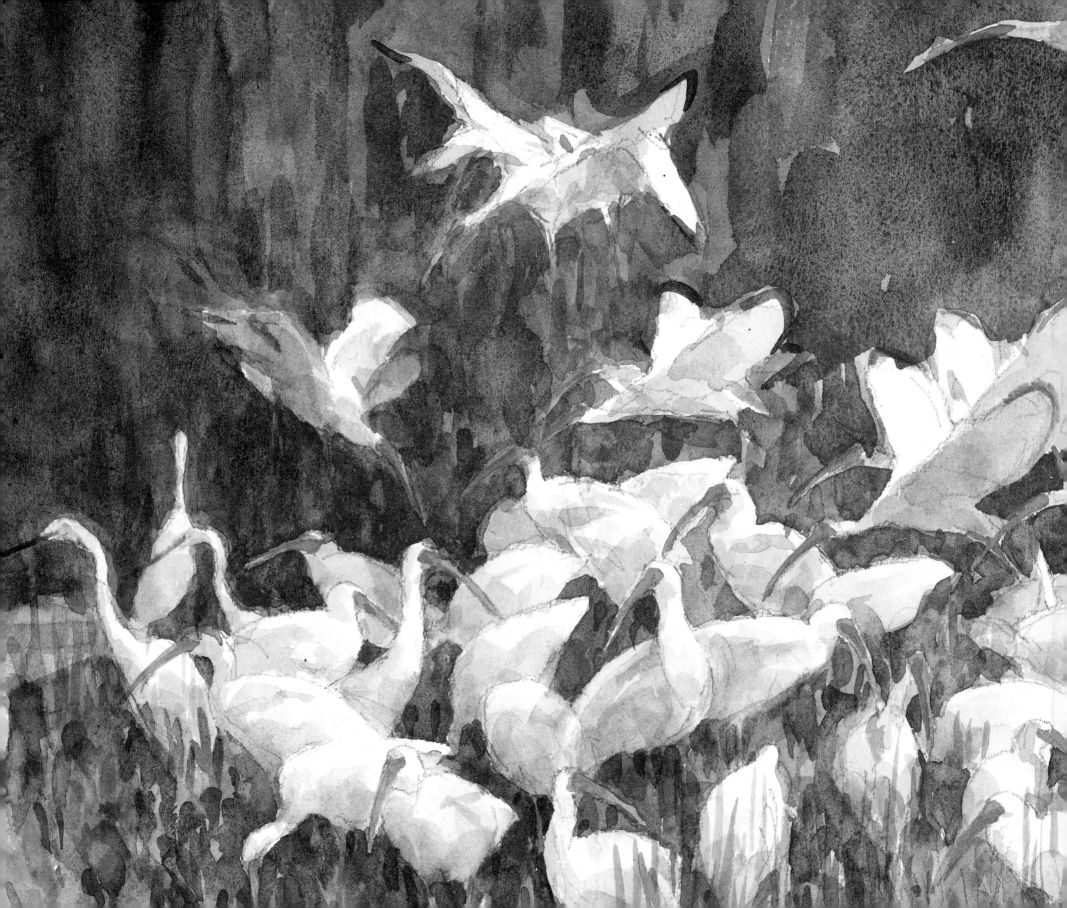

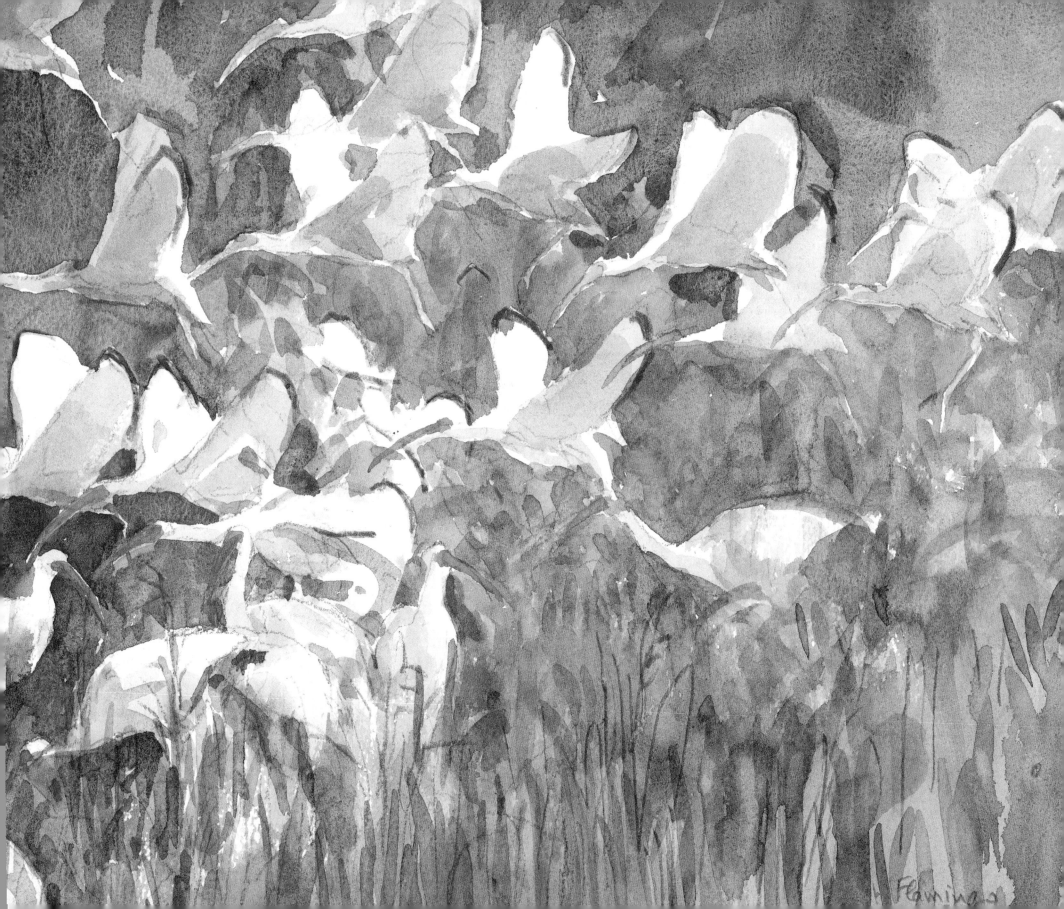
Flamingo

Published by Princeton University Press
41 William Street, Princeton, New Jersey 08540
99 Banbury Road, Oxford OX2 6JX

press.princeton.edu

All Rights Reserved

Library of Congress Cataloging-in-Publication Data

Names: Clavreul, Denis, 1955- author.
Title: In the footsteps of Audubon / Denis Clavreul.
Description: Princeton : Princeton University Press, [2022] | Includes
 bibliographical references and index.
Identifiers: LCCN 2022000623 (print) | LCCN 2022000624 (ebook) |
 ISBN 9780691237688 (hardback) | ISBN 9780691241555 (ebook)
Subjects: LCSH: Audubon, John James, 1785-1851. | Ornithologists--United
 States--Biography. | Naturalists--United States--Biography. | Animal
 painters--United States--Biography. | BISAC: NATURE / Animals / Birds |
 TRAVEL / United States / General
Classification: LCC QL31.A9 C53 2022 (print) | LCC QL31.A9 (ebook) |
 DDC 598/.092 [B]--dc23/eng/20220125
LC record available at https://lccn.loc.gov/2022000623
LC ebook record available at https://lccn.loc.gov/2022000624

British Library Cataloging-in-Publication Data is available

Editorial: Robert Kirk and Megan Mendonca
Production Editorial: Ellen Foos
Text and Jacket Design: Wanda España
Production: Steven Sears
Publicity: Matthew Taylor and Caitlyn Robinson
Copyeditor: Eva Silverfine

Designed by D & N Publishing, Wiltshire, UK

This book has been composed in Basco Std and Futura PT

Printed on acid-free paper. ∞

Printed in Italy

10 9 8 7 6 5 4 3 2 1

FRONT COVER, LEFT TO RIGHT:
(L) Arctic Tern, Labrador, 1833 (detail). John James Audubon.
(REF 1863.17.250) COLLECTION OF THE NEW YORK HISTORICAL SOCIETY.
DIGITAL IMAGE CREATED BY OPPENHEIMER EDITIONS.
(R) Arctic Tern, Paquet Island, Magdalen Islands, Quebec, July 4, 2003 (detail). Denis Clavreul.

BACK COVER:
Tree Swallows, Cedar Beach, Long Island, New York, September 21, 2017. Denis Clavreul.

PREVIOUS PAGES:
pp. ii–iii Black Skimmers, Jamaica Bay, New York City, September 20, 1991.
PENCIL AND WATERCOLOR, 9.84 × 25.19 IN (25 × 64 CM).

pp. iv–v White Ibis, Snowy Egrets, Flamingo Visitor Center, Everglades
National Park, Florida, February 4, 2003.
PENCIL AND WATERCOLOR, 9.05 × 20.87 IN (23 × 53 CM).

OPPOSITE PAGE:
Brown-headed Cowbirds, near Ripley, Tennessee, April 14, 2003.
PENCIL AND WATERCOLOR, 3.94 × 7.09 IN (10 × 18 CM).

In the Footsteps of Audubon

DENIS CLAVREUL

With a Foreword by
DAVID ALLEN SIBLEY

Translated from French by
MARTHA LE CARS

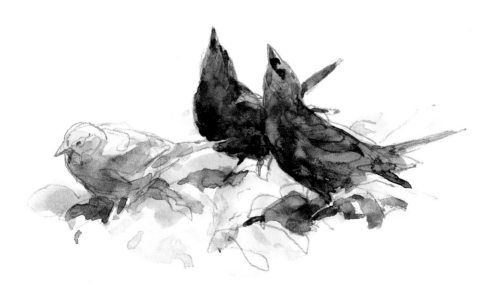

Princeton University Press

Princeton and Oxford

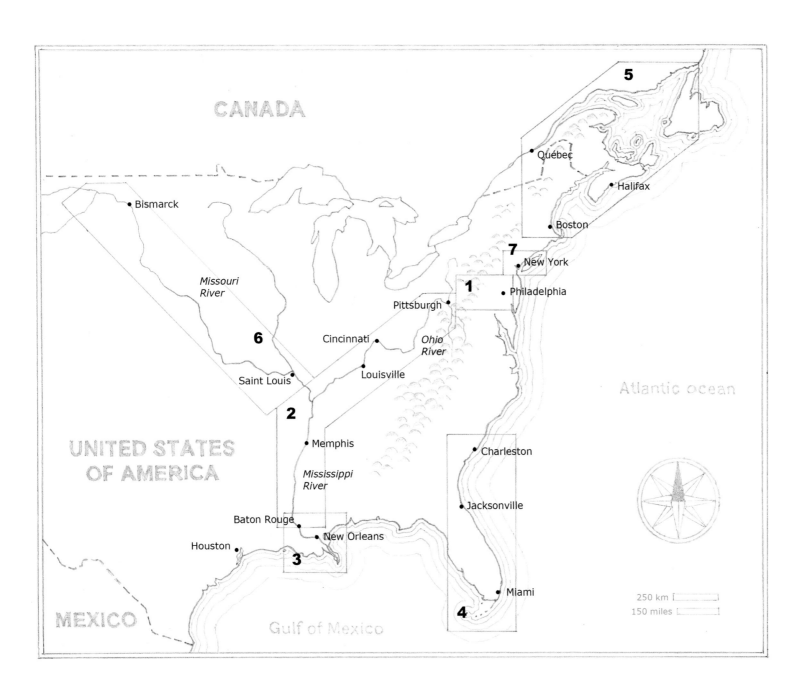

CANADA

5

Québec

Halifax

Boston

7

New York

1

Philadelphia

Pittsburgh

Bismarck

Missouri River

Cincinnati

Ohio River

6

Louisville

Saint Louis

2

UNITED STATES
OF AMERICA

Memphis

Mississippi River

Atlantic ocean

Charleston

Baton Rouge

New Orleans

Houston

3

Jacksonville

MEXICO

Gulf of Mexico

Miami

4

250 km
150 miles

Map of Audubon's travels
in the United States and
Canada with corresponding
chapter number. Asterisks on
subsequent maps indicate sites
mentioned in text and captions.

CONTENTS

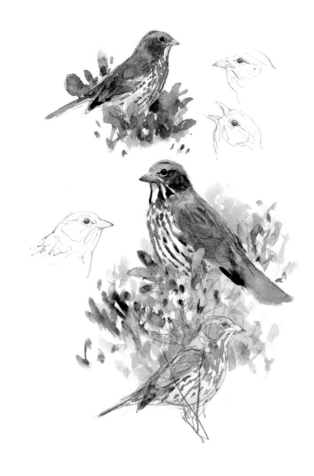

**Fox Sparrow, Harrington Harbour,
Quebec, July, 12, 2003.**

PENCIL AND WATERCOLOR,
11.02 × 7.09 IN (28 × 18 CM).

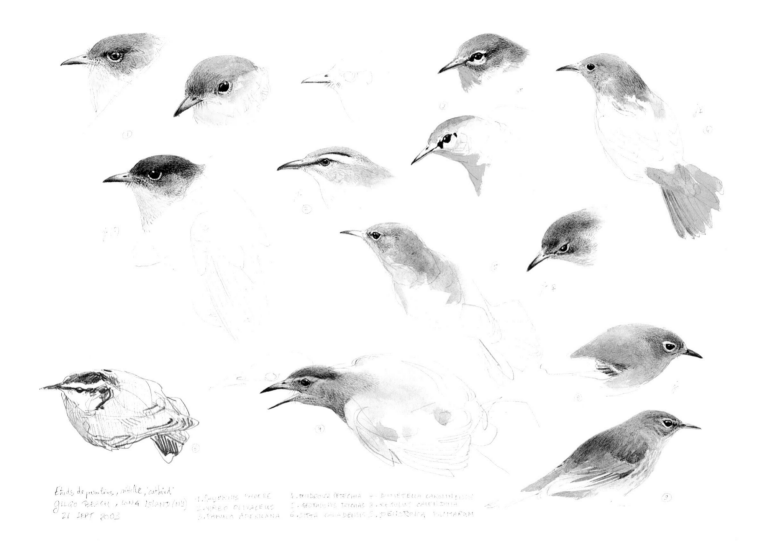

Eastern Phoebe (1), Red-eyed Vireo (2), Northern Parula (3), young female Yellow Warbler (4), young female Common Yellowthroat (5), Red-breasted Nuthatch (6), Gray Catbird (7), young Ruby-crowned Kinglet (8), and Palm Warbler (9). Gilgo Beach, Long Island, New York, September 21, 2003.

PENCIL AND WATERCOLOR, 11.81 × 16.14 IN (30 × 41 CM). COURTESY OF THE NATURAL HISTORY MUSEUM OF NANTES.

These birds, captured in mist nets in order to have a numbered band placed on a leg in a study of bird migration, were rapidly sketched before being released unharmed.

FOREWORD

I FIRST MET Denis Clavreul and learned about this project when he visited me in Massachusetts on a warm spring day in 2006. I was immediately enthralled by his watercolors and by his idea of revisiting and painting the places that were important to Audubon. Now, more than fifteen years later, it is an honor to be able to introduce the finished product.

Audubon's biography is well-known and has been documented in some excellent and very thorough books. This book is a more selective meditation on Audubon and history.

Denis's watercolors are extraordinary, atmospheric and immediate, eliciting emotion and recognition with deceptively simple patterns of color. I think of paintings like these as the visual equivalent of poetry. A few carefully chosen lines and colors capture the essential features, just enough to suggest a place, a mood, a slant of light, and we are transported to the scene.

These paintings are fundamentally different from Audubon's, not just in style but also in their function. If Denis's paintings are analogous to poems, Audubon's are like short stories, painstakingly detailed, artificially posed and lit, portraying some drama in the lives of these individual birds and leaving little to the imagination.

In contrast, Denis's paintings work because they leave a lot of room for imagination. We are invited, even required, to fill in the story, and in the process to make connections between our own experiences and Audubon's world of two hundred years ago.

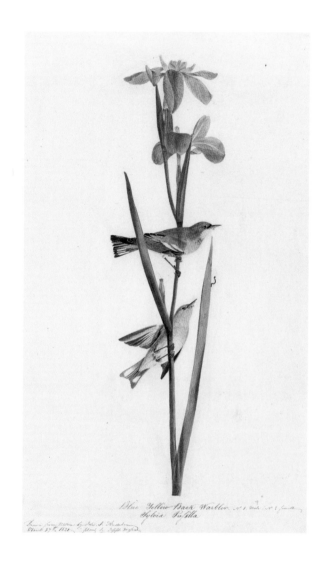

Northern Parula, New Orleans, Louisiana, March 27, 1821.

John James Audubon.

WATERCOLOR, PASTEL, BLACK INK, GRAPHITE AND GOUACHE WITH SELECTIVE GLAZING ON PAPER, 18.5 × 11.5 IN (47 × 29.5 CM).

(REF 1863.17.015)
COLLECTION OF THE NEW YORK HISTORICAL SOCIETY.
DIGITAL IMAGE CREATED BY OPPENHEIMER EDITIONS.

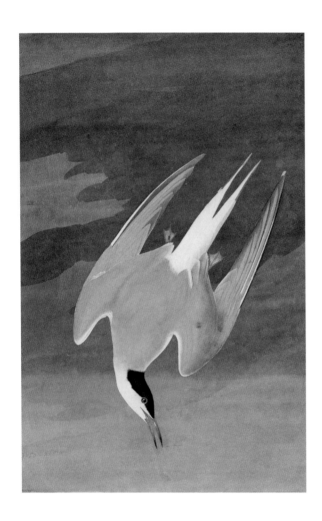

Arctic Tern, Labrador, 1833.

John James Audubon.

To understand Audubon's accomplishments, it's important to put them in the context of his time. When he arrived in the young United States in 1803 the population of the entire country was only five million people and Ohio was on the frontier, just admitted as the 17th state. There were no paved roads, no automobiles, no electric lights, no color printing, no binoculars or cameras. And no widely available books about birds.

In a world with no photographs and very little color printing, Audubon was painting to introduce the birds to people who had never even seen pictures of them. The images needed to tell a fully detailed story. Audubon's paintings, showing the birds in action, in full color, were like nothing the world had ever seen.

We view these paintings now in a very different context. We are bombarded every day with full color images, even moving pictures, showing so much detail and action that we become numb to it. Still, art has the power to transport us, and to bridge the gap between Audubon's time and ours.

My own connection to Audubon was confirmed by one passage in his writing in which he talks about developing the ability to distinguish the species of birds by sight:

...that, in fact, every family had some mark by which it could be known; and, after having collected many ideas and much material of this kind, I fairly began, in greater earnest than ever, the very collection of Birds of America, which is now being published.[1]

He is telling us that the identification and classification of birds was the inspiration for his art. Singularly passionate about birds, he wanted to discover everything that he could about them, to "capture" their distinctive character on paper, and to share his excitement with the world.

His passion for and tireless dedication to his work was certainly among his most admirable qualities. In 1839, just after the completion of *The Birds of America*, a Boston newspaper presciently wrote that it *will remain an enduring monument to American enterprise and science.*

As we celebrate Audubon's accomplishments, we need to recognize that he lived in a society in which only upper-class white men were allowed to be exceptional.

Audubon was not a superhero, he was a real person, amazing in some ways and flawed in others. He owned slaves while much of the world was recognizing the immorality of slavery. He expressed concern about the wanton destruction of birds and other animals for sport and market hunting, and then at other times participated in that wanton destruction. It seems likely that he would be an ardent supporter of today's bird conservation efforts in his name. But we can never really know, and it hardly matters.

Audubon's enduring legacy is not just his art, which decorates millions of homes, offices, and public spaces, but also his name, which has been shortened to a single word that represents an idea—a vague concept combining art, nature, and conservation.

1. Audubon, Maria R., and Elliot Coues, eds. *Audubon and His Journals*, in *My Style of Drawing Birds*, 2 vols, New York: Charles Scribner's Sons, 1897.

It is now more than 200 years since Audubon arrived in the United States, and technology has transformed our lives, but Denis Clavreul's journey in Audubon's footsteps shows that there are still very real threads that connect us to that time. There are the birds themselves—the scenes that Audubon painted can still be witnessed. Bald Eagles still eat fish, Canada Geese still aggressively defend their young. The Eastern Phoebes at Mill Grove in Pennsylvania now are probably direct descendants (through more than 200 intervening generations) of the ones that Audubon watched and sketched. There are countless people, like the ones introduced in these pages (and Denis himself), with the same dedication and passion for nature and art, devoting much of their work to conservation.

This book is not so much about Audubon the person as it is about his influence on the current world. Audubon the concept. One passionate and talented artist/naturalist of today reflecting on connections to an equally passionate and talented artist/naturalist of 200 years ago.

The sense that I take away from this book is subtle and abstract—there is beauty all around us. The things that inspired Audubon still inspire people today. It is a celebration of the persistence of nature after two centuries of human progress. A celebration of things we take for granted. Denis finds beauty in art, beauty in nature, and beauty in the passionate pursuit of a dream.

—**David Allen Sibley**

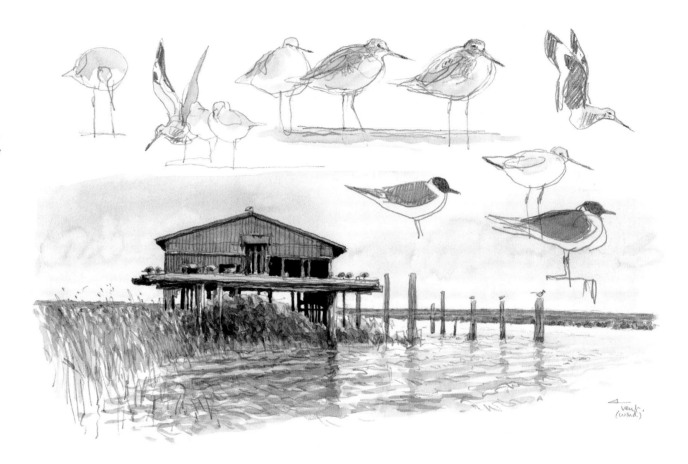

Willets and Laughing Gulls, Lake Raccourci, Mississippi Delta, April 19, 2005.
PENCIL AND WATERCOLOR,
10.24 × 16.14 in (26 × 41 cm).

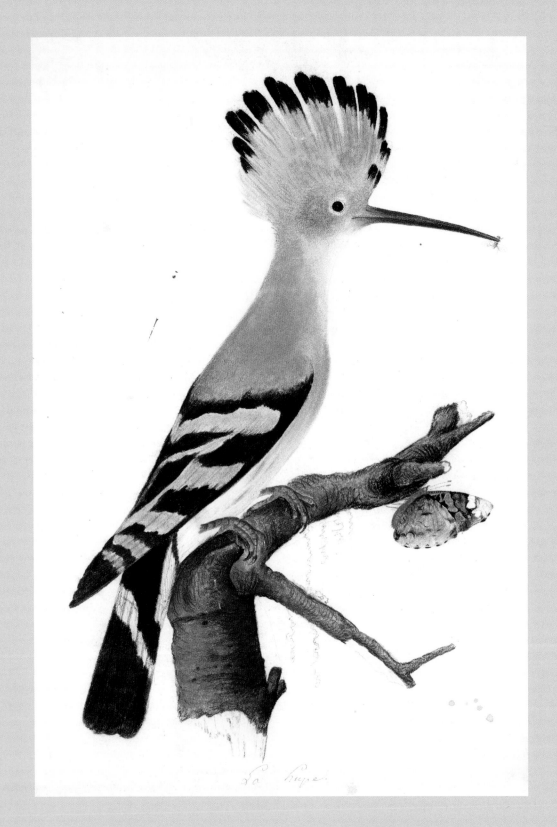

Eurasian Hoopoe, before February 1806.

John James Audubon.

PASTEL AND GRAPHITE ON PAPER, 11.81 × 7.87 IN (30 ×20 CM).

ARCHIVES DE LA SOCIÉTÉ DES SCIENCES NATURELLES DE LA CHARENTE-MARITIME, BIBLIOTHÈQUE SCIENTIFIQUE DU MUSEUM DE LA ROCHELLE−L3I.

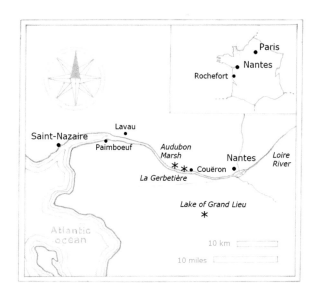

PROLOGUE

A CHILDHOOD IN FRANCE

Hoopoe taking a dust bath, Audubon Marsh, Couëron, August 9, 1991.

GRAPHITE PENCIL ON PAPER, 2.75 × 8.66 IN (7 × 22 CM).

IT ALL STARTED along the Loire a few miles from Nantes on a beautiful summer day in 1991. Near the village of Couëron I had taken a shaded path that wound its way to the marsh. To my right the hedges were dense and the hillside still pastureland whereas to the left, behind a more sparse vegetation, appeared the first rows of willows and ash trees and the first floodable meadows. The river, very close, was hidden by the trees.

That day I had come upon and sketched a Eurasian Hoopoe taking a dust bath and, returning to Couëron still under the charm of this observation, I wanted to see La Gerbetière again, the old Audubon family property where the famous painter of American birds lived the best years of his childhood. He spent numerous summers there until the age of eighteen, and, like most of the children at that time, nature was his principal source of entertainment and discovery. But unlike others, he developed an uncommon curiosity to the point of wanting to sketch one day the things that fascinated him.

The house was closed to the public. I tried to imagine the room of the young man and the stairs that he climbed when returning from his walks, his pockets filled with his finds. The garden was surrounded by an old stone wall, covered in many places by lichens, moss, and ferns. While examining these plants, already present two centuries ago when the laughter of children could be heard on the other side of the wall, I decided that I would go to America one day to discover the landscapes, trees, and birds that enchanted the life of John James Audubon.

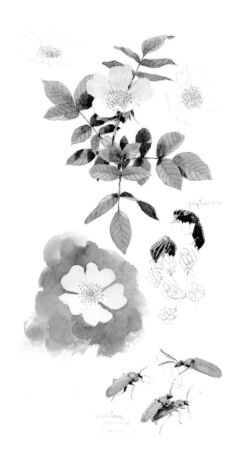

Dog Rose, Striped Shieldbugs, and Black-headed Cardinal Beetles, Couëron, May 24, 2010.

PENCIL AND WATERCOLOR ON PAPER, 11.42 × 13.78 IN (29 × 35 CM).

More than ten years passed before I began my first visits to America "in the footsteps" of this man. My initial project, essentially motivated by the discovery of regions and birds unknown to me, had evolved over the course of years. To it I had added the desire to meet and sketch people who live each day in contact with nature: biologists, farmers, foresters, fishers, and sailors navigating on the rivers. I was hoping that these people would talk to me about their relationship with nature, their delights, their fears about environmental degradation, but also their hopes. I wanted to witness in my own way their daily life and their commitments.

This book is the culmination of a personal project spread over more than fifteen years. Over the course of a dozen trips to the United States organized between 2003 and 2018, and also in France and in Canada, I have produced hundreds of sketches and watercolors in landscapes as varied as the Florida Everglades, the islands of Labrador, and the immense plains of the Dakotas.

Each chapter covers one of the regions where Audubon lived and traveled. The book follows the chronology of his life and his expeditions with the exception of the last chapter, dedicated to New York, the city where he landed for the first time in 1804 and where he lived his last days nearly fifty years later.

All of the watercolors and sketches were made in the field, without the help of photographs. This choice caused many frustrations, considering the multitude of possible subjects, but it allowed me to live more intensely in the moment, to resist the temptation to "take everything." Furthermore, in my mind nothing was more valuable than to recreate directly the varied effects of the light and the subtle colors that I saw in nature.

John James Audubon was born in 1785 in Saint Domingue on a plantation that had recently come into the possession of his father, who was a sailor, captain, soldier, and businessman. John James arrived in Nantes in 1788, at the age of four, three years before Rose, his half sister. We know very little about the daily life of the Audubon family when they left their residence in Nantes and went to stay in the country during nice weather. It is certain, however, that Jean Audubon gave his son works on natural history, among them Buffon's elaborately illustrated works. The young man drew upon his inspiration there, copying numerous drawings of common species—wagtails, goldfinches, tree sparrows, tits—most of the time in profile and in frozen stances conforming with representations at the time. Many years later he will write about his first drawings:

When, as a little lad, I first began my attempts at representing birds on paper, I was far from possessing much knowledge of their nature, and like hundreds of others, when I had laid the effort aside, I was under the impression that it was a finished picture of a bird because it possessed some sort of head and tail, and two sticks in lieu of legs; I never troubled myself with the thought that abutments were requisite to prevent it from

falling either backward or forward, and oh! what bills and claws I did draw, to say nothing of a perfectly straight line for a back, and a tail stuck in anyhow, like an unshipped rudder.[1]

The young artist, who criticized Buffon's plates for lacking life, often saw in despair that the bird he had just drawn was unrecognizable.

He used the technique of "three pencils," classic in the seventeenth and eighteenth centuries, combining black stone and red and white chalk. For his preparatory drawings, however, or to obtain softer gray tones, he was already using a new medium, graphite, or pencil lead. He soon added watercolor to his range of techniques.

Lucid and ambitious, the young Audubon never satisfied himself with the very appreciative comments of family friends. His father's attitude, more frank and constructive, was much more valuable to him:

My father, however, spoke very differently to me; he constantly impressed upon me that nothing in the world possessing life and animation was easy to imitate, and that as I grew older he hoped I would become more and more alive to this. He was so kind to me, and so deeply interested in my improvement that to have listened carelessly to his serious words would have been highly ungrateful.[2]

Like all passionate children, the young Audubon got through the difficult period of these first lessons.

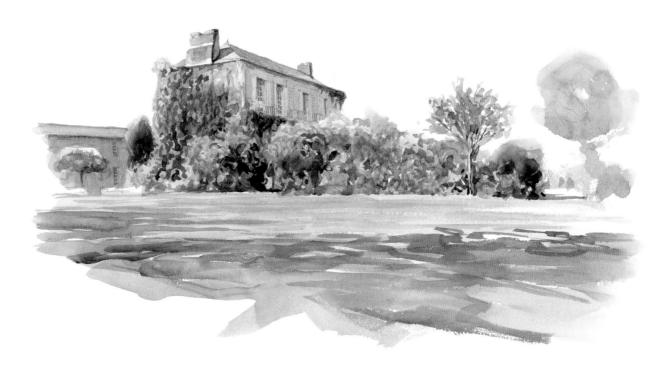

La Gerbetière, Couëron, July 23, 2004.
PENCIL AND WATERCOLOR, 7.87 × 16.53 in (20 × 42 cm).

The Couëron marshes, which now extend very near to the family home at La Gerbetière, don't look like those that we often imagine, wetlands dotted with water lilies, surrounded by reed beds and impenetrable willow groves like those of the Lake of Grand-Lieu situated a few miles south of the Loire River. This vast space is in reality covered with floodable meadows, pastures in nice weather. Water is everywhere, but in the form of a network of ditches and canals. The long rows of trees trimmed into rounded shapes, as well as the hedges and copses, more dense around the edge, give the landscapes their various tones. The majority of this land has been taken over by the river that in Audubon's time was wider and dotted with small islands and sand banks.

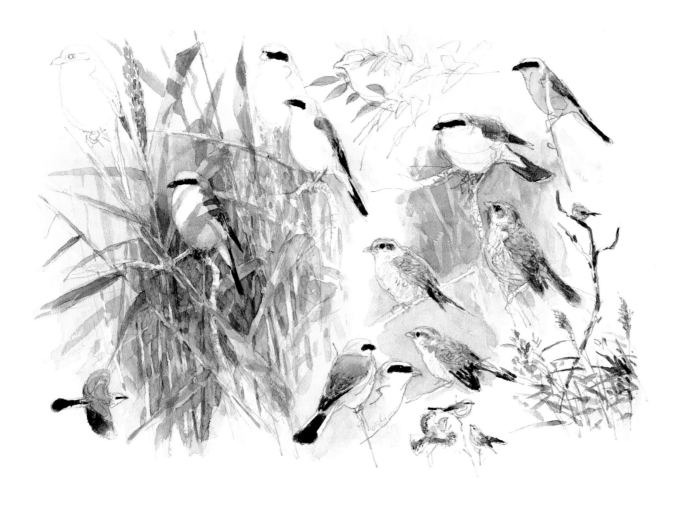

Male Red-backed Shrike, near Lavau, July 29, 2011.

PENCIL AND WATERCOLOR, 10.63 × 15.35 IN (27 × 39 CM).

A few locks allow the quantity of water retained in the marsh to be regulated. I am partial to one of them. It is a beautiful work lost in the middle of the fields, flanked by a lock keeper's house that I painted more than twenty years ago before it fell into ruin. I have a vivid memory of this place. One day some Grass Snakes slid around me on the granite slabs of the lock while overhead in a uniform blue sky a flock of gulls chased invisible insects in silence. Beyond the locks the start of the sea can just be felt. The water of the marsh flows toward the Loire River along the canals, these strange channels sculpted in the mud by the coming and going of the tides. One can hear the soft cries of the Common Teals as they feed, slowly following the rising current.

In June 2006 I joined some ornithologists of the Ligue pour la Protection des Oiseaux (the French representative of BirdLife International) in order to put a tracking device on a young White Stork, a way to track the migration of this bird all the way to Africa. These naturalists promoted the nesting of this species by building artificial platforms; today around fifty pairs reproduce in the vicinity of the estuary.

I also met with Jean-Louis Lavigne, a descendant of Rose, the half sister of John James. He proudly spoke to me about the association "Audubon Couëron Atlantique," which he created with his friend Jean-Yves Noblet, and of their efforts with other associations to prevent the dumping of mud dredged from the river on the marshes near

Couëron, in this way preserving these spaces so rich in biodiversity.

But the mobilization of naturalists isn't always enough. Corncrakes no longer nest here, and their numbers have been constantly diminishing in Western Europe for more than a century. Without a doubt the young Audubon could have heard the grating call of this migratory bird, which for a long time was a discrete and very characteristic guest of the marsh.

Between Couëron and Nantes the landscapes are still composed of a beautiful mosaic of fields surrounded by hedges, woods, and humid valleys. Country lanes skirt the farms, cross some hamlets, and the big city—even though it is close—seems far away.

In the past Nantes was called "Venice of the West" because it was crossed by several arms of the Loire River and by the Erdre River, which joins the Loire in the heart of the city. The port was flourishing, the docks ceaselessly active.

During the long absences of Captain Audubon, his son frequently missed school as a result of the kindness of Anne Moynet, his stepmother.

Thus almost every day, instead of going to school when I ought to have gone, I usually made for the fields, where I spent the day; my little basket went with me, filled with good eatables, and when I returned home, during either winter or summer, it was replenished with what I called curiosities, such as birds' nests, birds' eggs, curious lichens, flowers of all sorts, and even pebbles gathered along the shore of some rivulet.[3]

In addition, Anne Moynet wanted to make him a man of the world, in the style of the Old Regime. For a while the young Audubon attended an academy of drawing and painting, followed by classes of dance and music, and, in fact, his good manners, his knowledge of the field of art, and his numerous other talents permitted him, many years later, to create useful relationships easily among the American and English well-to-do social class. In view of the very tense political context in France at the time of the French Revolution, the tenderness and care that his parents gave him certainly made more bearable the winters spent in a city often agitated, sometimes in a very violent manner.

His first years of adolescence were less happy. He passed more than three years at the Naval Academy at Rochefort, where Jean Audubon had registered him during the summer of 1796, considering that a maritime training program would assure him an "honest and profitable" livelihood. The young man was very bored, like a bird in a cage. His father, who fifteen years earlier had taken part in the American Revolutionary War, certainly spoke to him of the Marquis de Lafayette, who embarked near Rochefort on the frigate *Hermione* to lend a hand to the young America and to participate in the victory at Yorktown against the Royal Navy.

In 1799, when the Natural History Museum of Nantes opened to the public for the first time, Audubon was fourteen years old and his parents lived in a street close by. A letter recently found

Tagging a young White Stork with a tracking device, Audubon Marsh, June 3, 2006.
BLACK LEAD, 9.45 × 14.57 IN (24 × 37 CM).

Snake's Head Fritillary, Audubon Marsh, March 21, 2003.
WATERCOLOR, 3.94 × 10.63 IN (10 × 27 CM).

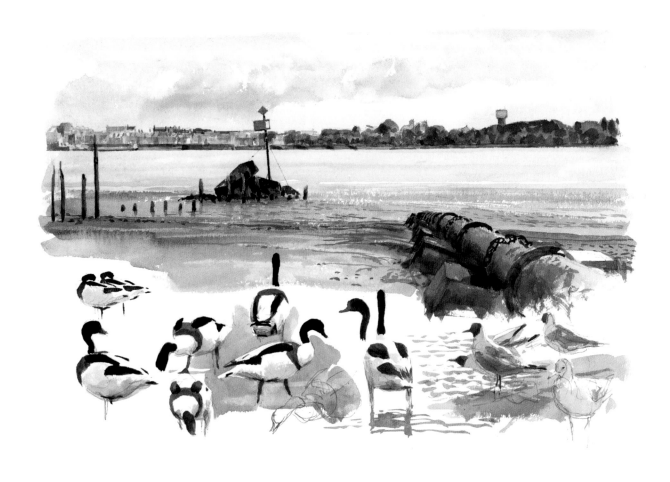

Common Shelducks and Black-headed Gulls, along the Loire Estuary, facing the village of Paimboeuf, June 18, 2006.

PENCIL AND WATERCOLOR, 12.60 × 16.53 IN (32 × 42 CM).

indicates that he frequented this place and that the director, François René Dubuisson, introduced him to ornithology.

The slave revolt in Saint Domingue put an end to his father's activities in the Caribbean. Released from his naval career in 1801, Jean Audubon wished to develop his business in America and thus joined with some businessmen of Nantes already involved in French commerce located in New York, Philadelphia, along the Ohio River, and as far west as Saint Louis. He decided to send his son to his property at Mill Grove near Philadelphia, which he had purchased around fifteen years earlier and on which there seemed to be a very promising vein of lead. Thus the young Audubon abandoned his naval training. He left for New York in the summer of 1803 and then went to Pennsylvania before returning to France one year later.

During his return trip he created numerous sketches around Couëron and enriched his knowledge through his contact with Charles Marie d'Orbigny, who was a great naturalist and a friend of his father. Jean Audubon took some measures so that his son could leave for America less in order to avoid his being drafted into Napoléon's army than to involve him permanently in his overseas commercial projects.

Thus the young man boarded a ship a second time on April 12, 1806, this time in the company of Ferdinand Rozier, the son of a business associate of his father in Nantes. Destination: New York, Philadelphia, and then Mill Grove. He never

expected that with the publication of his *The Birds of America*, the work unique in the world that he would finish thirty-five years later, he would become one of the most notable naturalist figures in the history of the United States.

1. Audubon and Coues, *My Style of Drawing Birds* in *Audubon and His Journals.*

2. Audubon and Coues, *My Style of Drawing Birds* in *Audubon and His Journals.*

3. Audubon and Coues, *Myself* in *Audubon and His Journals.*

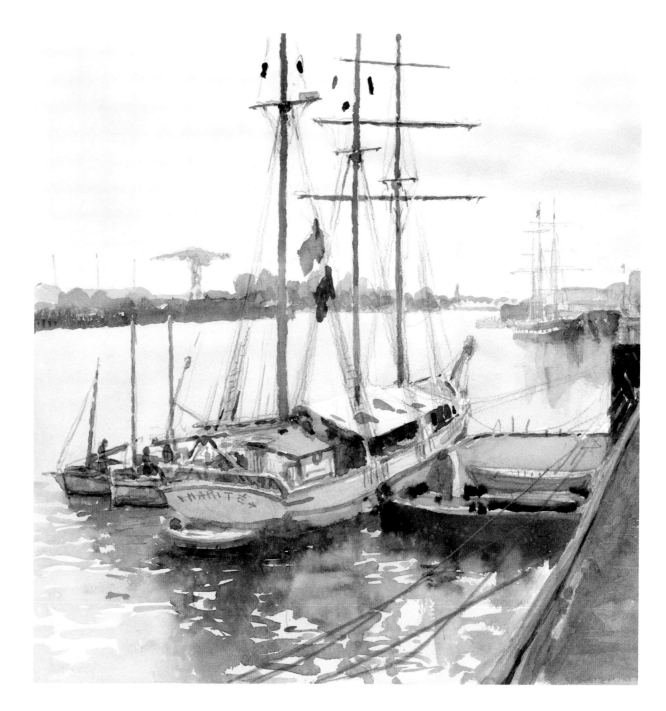

The *Marité* and the *Belem* docked, Port of Nantes, November 17, 2004.

PENCIL AND WATERCOLOR ON PAPER, 10.24 × 10.24 IN (26 × 26 CM).

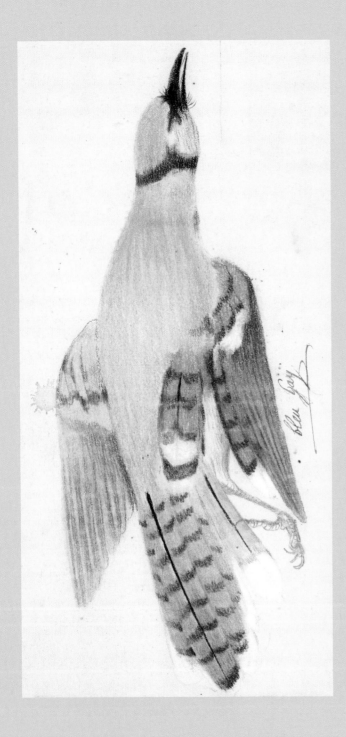

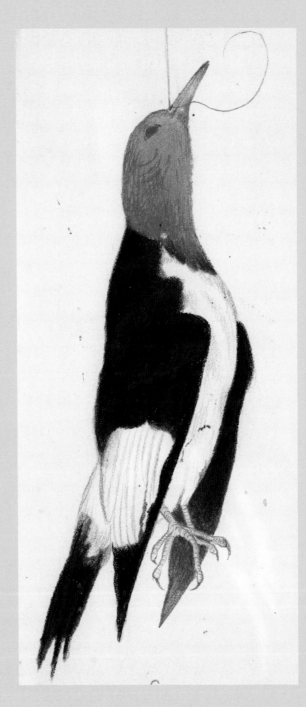

Before I sailed to France I have begun a series of drawings of the birds of America, and had also begun a study of their habits. I at first drew my subjects dead, by witch[1] I mean to say that, after procuring a specimen, I hung it up either by the head, wing, or foot, and copied it as closely as I possibly could.

Audubon, Maria R. and Elliot Coues, eds.
Myself in *Audubon and His Journals*,

2 VOLS. NEW YORK, CHARLES SCRIBNERS'S SONS, 1897.

FAR LEFT: **Blue Jay, *Cyanocitta cristata*.
Mill Grove, October 1804–March 1805.**

John James Audubon

PASTEL AND GRAPHITE ON PAPER, 30 X 15 CM.

SOCIÉTÉ DES SCIENCES NATURELLES DE LA CHARENTE-MARITIME, MUSÉUM D'HISTOIRE NATURELLE DE LA ROCHELLE–L3I.

FAR LEFT: **Redheaded Woodpecker,
Melanerpes erythrocephalus. Mill Grove, October 1804–March 1805.**

John James Audubon

GRAPHITE AND PASTEL ON PAPER, 25 X 11 CM.

SOCIÉTÉ DES SCIENCES NATURELLES DE LA CHARENTE-MARITIME, MUSÉUM D'HISTOIRE NATURELLE DE LA ROCHELLE–L3I.

PENNSYLVANIA

THE ENCHANTED COUNTRY

ON A FINE September morning I discover the property of Mill Grove where the young John James Audubon, as he himself wrote in his autobiography, "Myself," experienced some of the best times of his life.

Mill Grove was ever to me a blessed spot; in my daily walks I thought I perceived the traces left by my father as I looked on the even fences round the fields, or on the regular manner with which avenues of trees, as well as the orchards, had been planted by his hand.[2]

Under the golden canopy of the first trees a Northern Cardinal suddenly slips away between two shadows: a burst of red as a sign of welcome. The landscape opens, and I notice a meadow on my right. The air is very luminous. Everything

seems at once calm and expectant, like that moment of suspense in the theater when the curtains are raised and the scene first becomes visible. I am there … at last! No one in sight, just a single car in the parking lot. The main drive takes me along some rows of fruit trees and then a barn before reaching the principal dwelling, still well preserved after two centuries.

Alan Gehret, the director of the John James Audubon Center, welcomes me and invites me to visit the house. Friendly eyes and, behind the mustache, a smile. I feel an immediate connection between us, in this place so far away from Nantes. Immediately as I step into the hallway the house feels inhabited. The only thing lacking is the crackle of a fire and the ticking of a clock. Engravings, documents, furniture, and period

Blue Jay, John James Audubon Center, Mill Grove, Audubon, Pennsylvania, May 16, 2006.
PENCIL AND WATERCOLOR ON PAPER, 3.94 × 3.54 IN (10 × 9 CM).

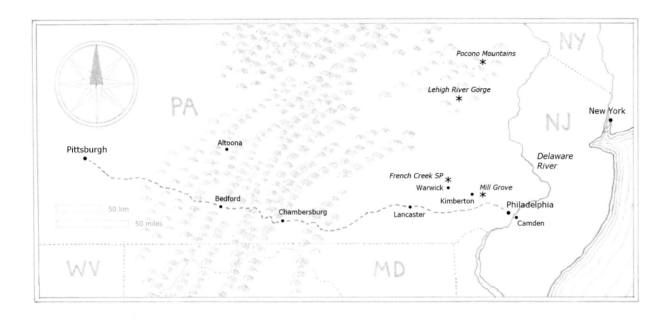

Eastern Bluebird, Mill Grove, May 16, 2006.

PENCIL AND WATERCOLOR,
6.30 × 5.90 IN (16 × 15 CM).

stocked with material used by the center's educators: stuffed birds, shells, stacked cardboard boxes, canvasses against the wall. This place looks like the studio of a contemporary painter and naturalist. It reminds me of the description given by William Gifford Bakewell, brother of Lucy, the neighbor's daughter and Audubon's future wife, after the young Frenchman had invited Bakewell to his home:

On entering his room, I was astonished and delighted to find that it was turned into a museum. The walls were festooned with all kinds of birds' eggs, carefully blown out and strung on a thread. The chimney-piece was covered with stuffed squirrels, raccoons, and opossums; and the shelves around were likewise crowded with specimens, among which were fishes, frogs, snakes, lizards, and other reptiles.[3]

I go out next to explore the banks of the river, an enchanted place that Audubon remembered all his life:

While young I had a plantation that lay on the sloping declivities of a creek, the name of which I have already given, but as it will ever be dear to my recollection you will, I hope, allow me to repeat it—the Perkiomen. I was extremely fond of rambling along its rocky banks, for it would have been difficult to do so either without meeting with a sweet flower spreading open its beauties to the sun or observing the watchful Kingfisher perched on some projecting stone over the clear water of the stream.[4]

objects garnish the first rooms. I am hoping to be able to see some of Audubon's drawings and watercolors, but Alan tells me that the majority of the originals are in New York and at Harvard University.

The second floor offers a reconstruction of Audubon's studio. For a long moment I stand near the window and steep myself in the view he would have appreciated as the seasons passed: the sloping meadow, the woods, and Perkiomen Creek. It was here that one day he had the idea for drawing from dead birds by attaching them with wire to boards in positions that corresponded to his observations of them in nature. This way of proceeding could be shocking today, but without modern optics like binoculars, scopes, and cameras, killing birds was the only way to study birds in Audubon era.

The happiest surprise awaits me a little further when a door ajar, under the roof, reveals a room

The old mill has disappeared and is replaced by a pumping station, but the dam still resembles the one painted by Thomas Birch in the 1820s and displayed at the New York Historical Society. I install myself on a bench at the foot of the hill and attempt a watercolor. No success ... the light changes too quickly at the end of this afternoon.

Leaving these places rich with memories, I head north and spend the next two days discovering the Lehigh River Gorge and the Pocono Mountains. At the end of the summer of 1829, Audubon painted some fine studies there, notably that of the Magnolia Warbler, having observed on several occasions its gracious and lively behavior and heard its short and high-pitched song.

It rains a lot, and the river runs along powerfully. The narrow valley and the humid atmosphere create a scene of wilderness. These valley slopes would have been even more beautiful and impressive while still covered with primeval forest and inhabited by bear, wolf, and elk, before the massive logging operations described by Audubon in this way:

Whilst I was in the Great Pine Swamp, I frequently visited one of the principal places for the launching of logs. To see them tumbling from such a height, touching here and there the rough angle of a projecting rock, bouncing from it with the elasticity of a foot-ball, and at last falling with an awful crash into the river, forms a sight interesting in the highest degree, but impossible for me to describe. Shall I tell you that I have seen masses of these logs heaped above each other to the number of five thousand?

Followed by a premonition:

And in calm nights, the greedy mills told the sad tale that in a century the noble forest around should exist no more.[5]

At dawn the following day I find a road that climbs into the Pocono Mountains. Clouds engulf the valley floor while the blue peaks streaked by mist lie in succession all the way to the horizon.

I return to Mill Grove in May 2006. Jean Bochnowski, the new director of the Audubon Center, has invited me to present the watercolors I have produced since beginning my project, "In the footsteps of Audubon." The show's opening celebration coincides with the official kick-off of the restoration of the barn, the future visitors' center. My exhibition "Chasing Audubon" is opened in the presence of John Flicker, president of the National Audubon Society, local politicians, and American friends. It is the first time an artist has shown his work in this house since Audubon left in 1808, and, as one can imagine, I feel both honored and happy.

It is splendid weather, and the birds are very active. My European ear has trouble identifying the species, but in spite of that I notice the diversity of bird calls and bird songs.

Near the orchard a Blue Jay prospects the meadow, bounding like a small kangaroo. I watch it intently, and now and then I draw some of its postures from memory. As always, the first sketches are rough and unfinished, but after I spend several minutes observing and drawing,

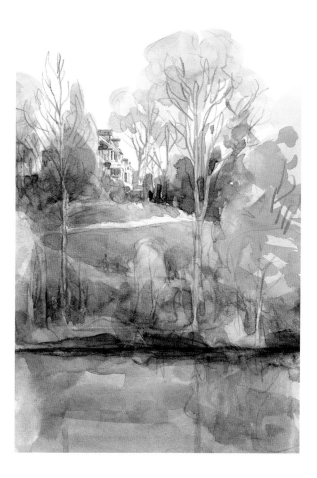

Mill Grove and Perkiomen Creek, November 5, 2005.

PENCIL AND WATERCOLOR, 10.63 × 6.69 IN (27 × 17 CM).

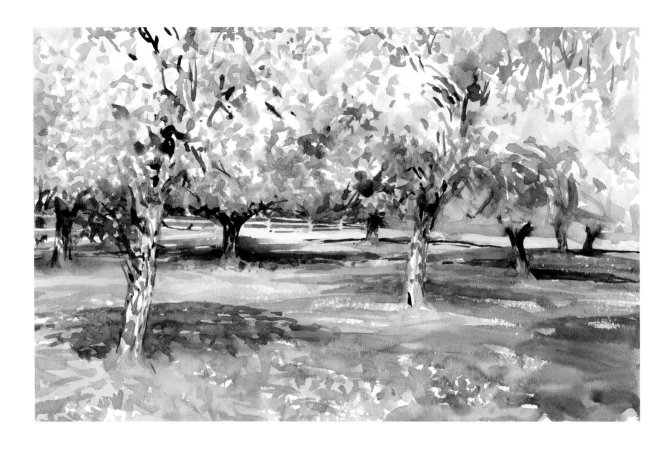

The orchard, Mill Grove, May 17, 2006.

WATERCOLOR, 10.24 × 16.14 IN (26 × 41 CM).

they become more accurate and begin to enliven the page. A woodchuck feeds happily on flowers, holding the stems with its agile fingers. All along the barn nest Barn Swallows, and a wren pair flies back and forth without respite to feed their chicks. Their nest, hidden inside a metal fence post, has me wondering how the chicks can survive encased in the stifling heat!

A little farther, at the edge of a field, I perceive the aerial ballet of a bird that reminds me of the European Flycatcher. It is the Eastern Phoebe, one of Audubon's favorite species while he was living here and which he named "Peewee" because of its simple and easily recognizable song. The bird perches; with quick, agile movements it scans the

sky, chooses its prey. Three, five times a minute it rises, pirouettes, and returns to its point of departure.

It is then that Toni, one of the teachers at the center, brings me a nest that has fallen to the ground and tells me that a pair of Eastern Phoebes sometimes nest under a nearby bridge. Curious, I follow the trail down through the forest toward the river. I have put away my pencils because I want to memorize this place without thinking of drawing. The small cave where the peewees nested no longer exists, but along the riverbank a charming site becomes visible, a kind of small backwater, where the light penetrates through the leaves. Hard not to attempt a watercolor. …

I imagine the young Audubon, engulfed by the scent of spring, developing a clever hunch, the idea that migrating peewees could be returning year after year to the place of their birth to nest. One day watching for their return, he noticed on one of them the silver thread that he had tied to one of its legs the previous year, when the chick was still in its nest.

At the beginning of the nineteenth century the surrounding countryside was still heavily wooded, rich in game, and Audubon crossed it often on foot or on horseback, accompanied by his dog, Zephyr, and his gun on his shoulder. I suppose the landscape here resembled the west of France. The local Quaker families practiced a kind of agriculture that was generally respectful of nature. In the spirit of their approach, I wish

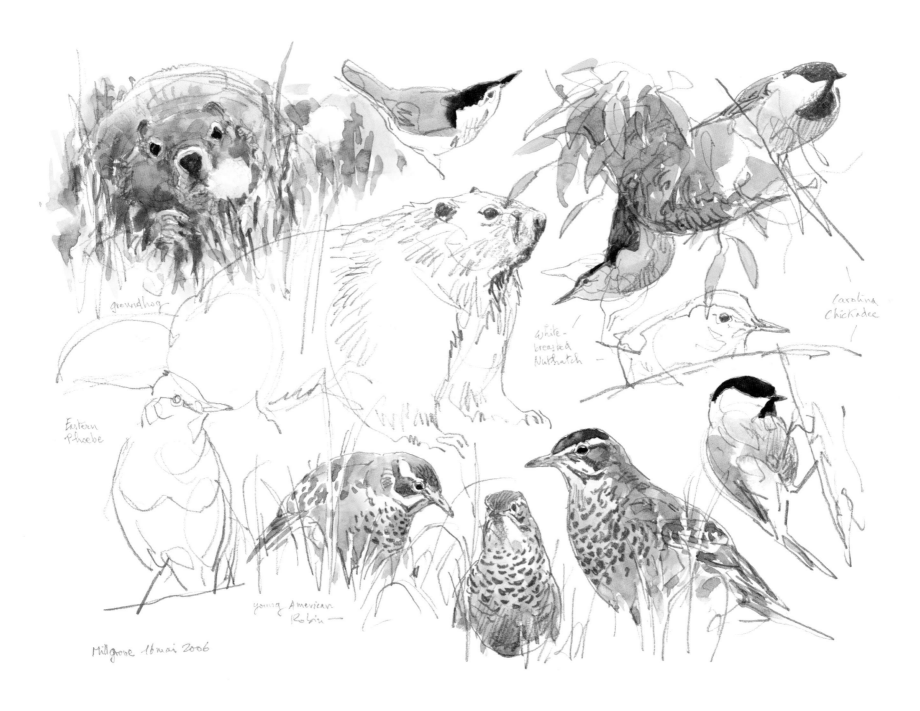

groundhog

Eastern
Phoebe

White-
breasted
Nuthatch

Carolina
Chickadee

young American
Robin

Millgrove 16 mai 2006

**Groundhog, White-breasted Nuthatch, Carolina Chickadee, Eastern Phoebe,
and American Robin, John James Audubon Center at Mill Grove, May 16, 2007.**

PENCIL AND WATERCOLOR, 11.81 × 16.14 in (30 × 41 cm).

Edie Griffith, Seven Stars Farm, Kimberton, March 9, 2007.

GRAPHITE ON PAPER,
7.87 × 7.87 IN (20 × 20 CM).

to meet current farmers who engage in organic agriculture, to get to know their daily work and their projects. I am told that not too far from Mill Grove, in Kimberton, David and Edie Griffith keep Jersey cattle and produce excellent organic yogurt. Like many Americans, they know about the work of Audubon and agree to let me visit as long as I want. I spend the following morning in their stables, then go to paint the orchard and the brook beyond it. At the end of the afternoon, I am back in the barn for milking time, and I sketch Edie working.

David explains that during the 1990s American agricultural policies supported smaller farms but that nowadays there is overwhelming support for intensive farming of corn and soybeans for the production of ethanol. In his opinion the politicians in charge aim at making the country energy independent, whatever the cost. The farming systems of the West and Midwest are more than ever focused on intensive production based on genetic crop manipulation, whereas farming in the eastern states is more diversified as the production is intended for urban dwellers who are more and more concerned about the quality of what they consume. My hosts remain highly motivated in spite of difficulties, such as the prohibition of using their own seed crop. The emergence of a new generation of farmers who are more aware of the environment nourishes their optimism.

Leaving Kimberton I head to Warwick, where I have a rendezvous with James Thorpe

of The Nature Conservancy. Not far from French Creek State Park I sketch him while he scythes a marsh, removing invasive European reeds. The goal of this effort is to facilitate the movement of Bog Turtles by restoring an ecological corridor imperative for their survival in the region. This small species lives in rare and fragile acidic wetlands such as bogs and needs very specific ecological conditions to complete its life cycle: thick moss and deep layers of mud, which provide protection from predators, and short clumps of vegetation that let in plenty of sunlight for incubating eggs and basking, to name but two. If any of these conditions change, the Bog Turtle population can decline and may disappear.

James tells me about his first job in a university laboratory and his choice to leave it to concentrate on fieldwork, and we discover that the subjects of our ecology studies were similar.

Among my essential stops in Pennsylvania was Philadelphia and its famous Academy of Natural Sciences, founded by the entomologist Thomas Say in 1812. I had seen the city a few years before from Camden, New Jersey, on the banks of the Delaware. On that occasion the skyline dissolved in the lemony light of a fine September evening.

I let myself be enveloped by the night and the smells of the river. Then, for a long time, I studied the dark mass of Philadelphia, a city buzzing with life and whose economic activity and intellectual dynamism had contributed so

much to the history of the United States in the nineteenth century.

Although Audubon rarely traveled to this city during his years at Mill Grove, he must have visited the museum created by Charles Willson Peale. This museum was situated on the top floors of the building that would later be named Independence Hall because it was there during the summer of 1787 that the Constitution of the United States was established.

Peale was a renowned portrait painter but also a naturalist and paleontologist. His bird collection was exceptional for the day. Many of his birds had been mounted in natural positions and arranged in front of painted landscapes depicting their natural habitat. While Audubon stayed with the Bakewells at Fatland Ford during the autumn of 1811, he rode on horseback to Philadelphia. At Peale's museum he encountered Alexander Wilson, his artistic rival, whom he had met the year before on the banks of the Ohio. Wilson was then drawing a Bald Eagle holding a fish in its talons. Ten years later Audubon would use the same mounted specimen as a model for his own plate dedicated to the species.

Audubon returned once more to Philadelphia during the spring of 1824, seeking approval of his work from the best naturalists of his time and also searching, in vain, for an engraver interested in publishing his watercolors.

Perhaps daunted by John James Audubon's disappointments at the Academy of Natural Sciences, I feared it might be difficult to approach

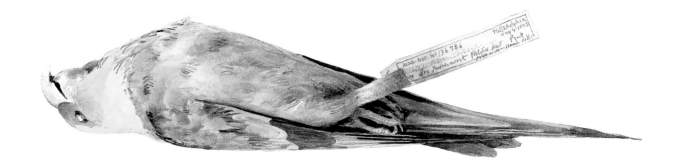

this great institution. By chance, in the spring of 2006, an artist friend of mine, Sherrie York, arranged an introduction to Robert McCracken Peck. Robert is a well-known naturalist, author of several publications and the academy's curator of collections.

During our visit Robert gives us a few hours of unimaginable joy. In a specially adapted room, he opens the cabinets where dozens of drawings and paintings by the greatest American naturalist artists are arranged: Louis Agassiz Fuertes, Francis Lee Jaques, and others. Next, we pass through the research laboratories, visit the public galleries and then the educational rooms, and finally arrive at the immense library. All around us are portraits of great American scientists. Some of them very quickly recognized Audubon's talent and offered him their loyal support while others chose the side of his rival, Alexander Wilson. Audubon's detractors were led by George Ord, vice president of the academy, and these

Carolina Parakeet. Specimen collected by J. J. Audubon, Philadelphia, March 7, 2007. Collection Academy of Natural Sciences of Philadelphia.

PENCIL AND WATERCOLOR,
2.75 × 12.40 IN (7 × 31.5 CM).

**Dame's Rocket, Mill Grove,
May 17, 2006.**

PENCIL AND WATERCOLOR,
9.84 × 5.51 IN (25 × 14 CM).

opponents successfully thwarted his inclusion in their circle. This hurt Audubon considerably, so much had he hoped for official recognition from the institution that concentrated all scientific and naturalist knowledge in America at the time.

Leaving the library Robert leads us next into a room where a modest cabinet holds a small treasure. In each drawer are arranged the birds collected and prepared by John James Audubon himself ... and I have the privilege of painting some of them.

Early in spring of the following year I return to Pennsylvania, now in the grip of a cold snap and with snow on the ground. At Mill Grove the shadows of trees delicately delineate the frozen surface of the Perkiomen River. Observing the thin layer of river ice, I think of an evening when Audubon, returned from a day's shooting, narrowly escaped death while skating with some friends on the river. The shocking event he recorded thus:

Unconsciously I happened to draw so very near a large air-hole that to check my headway became quite impossible, and down it I went, and soon felt the power of a most chilling bath. ... I must have glided with the stream some thirty or forty yards, when, as God would have it, up I popped at another air-hole, and here I did, in some way or another, manage to crawl out.[6]

This time at the Academy of Natural Sciences I meet the taxidermist, Nate Rice, working on some specimens that have come in that morning, notably a colorful woodpecker that he is showing to a young trainee. I am here for a high point of this journey: thanks to Robert Peck, one of the great figures of American research, Ruth Patrick, a world expert on river ecology and diatoms, has agreed to meet with me. In the 1930s Ruth shed light on the effect of pollution on these microscopic algae, an observation that secured her place as one of the founders of the concept of biological indicators. She will reach the age of one hundred in a few months but still comes to work at the academy every week.

Ruth Patrick welcomes me in her office and, with her soft, even voice, recounts her childhood years. She speaks in a touching way of her father, a lawyer, who was a science and nature enthusiast and had acquired a microscope early on. She recalls that day when she was allowed to sit in his lap, after having insistently tried to clamber up, and her unchecked wonder at the microscope's revelation of the beauty of the tiniest life forms.

If Pennsylvania had for a long time held a place dear to Audubon as a result of his happy times in Mill Grove, his first crossings of the Appalachians to reach the Ohio River brought back less pleasant memories. When he went for the first time to Louisville, Kentucky, at the end of summer 1807 with his young French associate, Ferdinand Rozier, in order to investigate opening a business there, the trip passed without any problems until Lancaster. But the condition of the road worsened, and they had to add two more horses to the team. A little after Chambersburg, the landscape became hillier and the trip became

very difficult. They found themselves on a path so obstructed by stumps and rocks that the two men decided to cross the remaining passes on foot. A few months later, in April 1808, the coach taking the young Audubon couple to Kentucky, where they had decided to live, tipped over not far from the Tuscarora summit. The panicked horses continued to pull the coach, now tipped on its side, while Lucy, pregnant, was still inside.

Driving west to Pittsburgh, I think of the young couple confident in their future, ready to overcome the difficulties of an adventurous and less comfortable life. Following Route 30, I stop near Bedford to draw the old covered bridge of Claycomb before continuing my journey. The successive ridges here are so characteristic of the Appalachian mountain chain. The fickle weather sometimes shifts within minutes from glaring sunshine to a coal-gray sky. On this little road dampened by rain, between the summits covered with mist, the Alleghenies seems rugged and wild, almost deserted, so rare are lighted windows after dark. The next day I move a little farther north near Altoona to see the remains of the Allegheny Portage Railroad, an astonishing train track built at the beginning of the 1830s to link two important canals across the pass. Considered as a technological marvel at the time, for twenty years this project played a key role in the development of the interior of the United States.

I walk in the rain in a silent forest just before the last pass. I sketch a few trees, touch a few rocks, fragments of one of the oldest mountains

in the world. The end of the trip is near. I know that in less than two hours I am going to reach the outskirts of Pittsburgh, but I want to smell once more the fresh scents of moss and dead leaves.

Allegheny Mountains, between Bedford and Ligonier, November 8, 2005.

PENCIL AND WATERCOLOR,
2.75 × 9.45 IN (7 × 24 CM).

1. The spelling errors that appear in this book in some of Audubon's quotes are consistent with Audubon's original texts.

2. Audubon and Coues, *Myself* in *Audubon and His Journals*.

3. Herrick, *Audubon the Naturalist*.

4. Audubon, *The Pewee Flycatcher* in *Ornithological Biography*, vol. 2, 1834.

5. Audubon and Coues, *The Great Pine Swamp* in *Audubon and His Journals*.

6. Audubon and Coues, *Myself* in *Audubon and His Journals*.

**Farm between Oaks and Phoenixville,
Pennsylvania, September 6, 2003.**

PENCIL AND WATERCOLOR, 11.42 × 16.14 IN (29 × 41 CM).

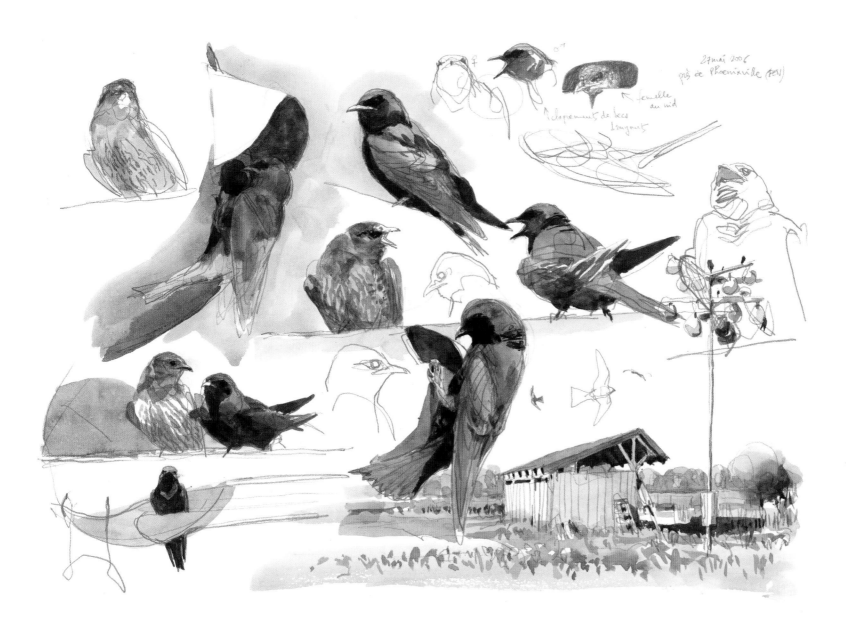

Purple Martins, Phoenixville, near Kimberton, May 27, 2006.

PENCIL AND WATERCOLOR, 11.81 × 16.14 IN (30 × 41 CM).

The birds interspersed their singing with a curious rattle made by rapidly clicking their bills together.

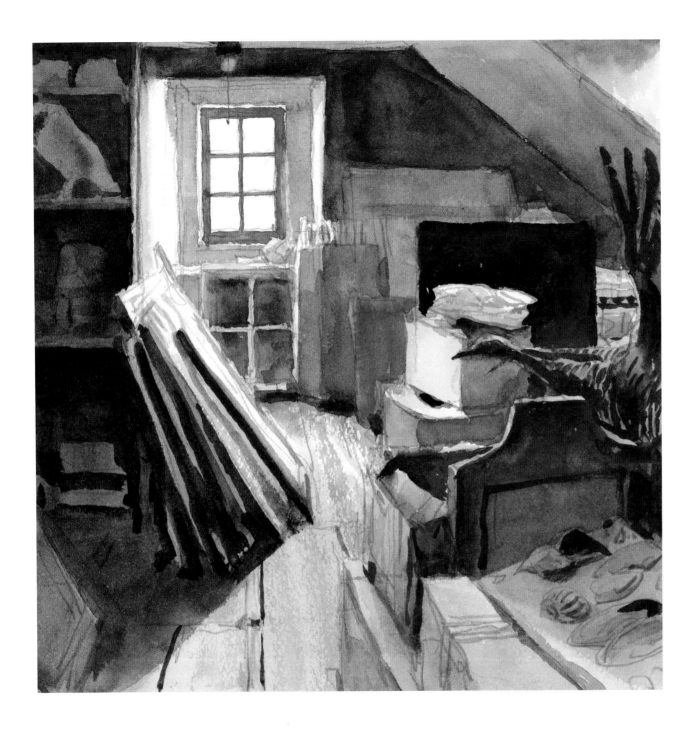

Under the roof, John James Audubon Center at Mill Grove, June 2, 2006.

PENCIL AND WATERCOLOR, 10.24 × 10.24 IN (26 × 26 CM).

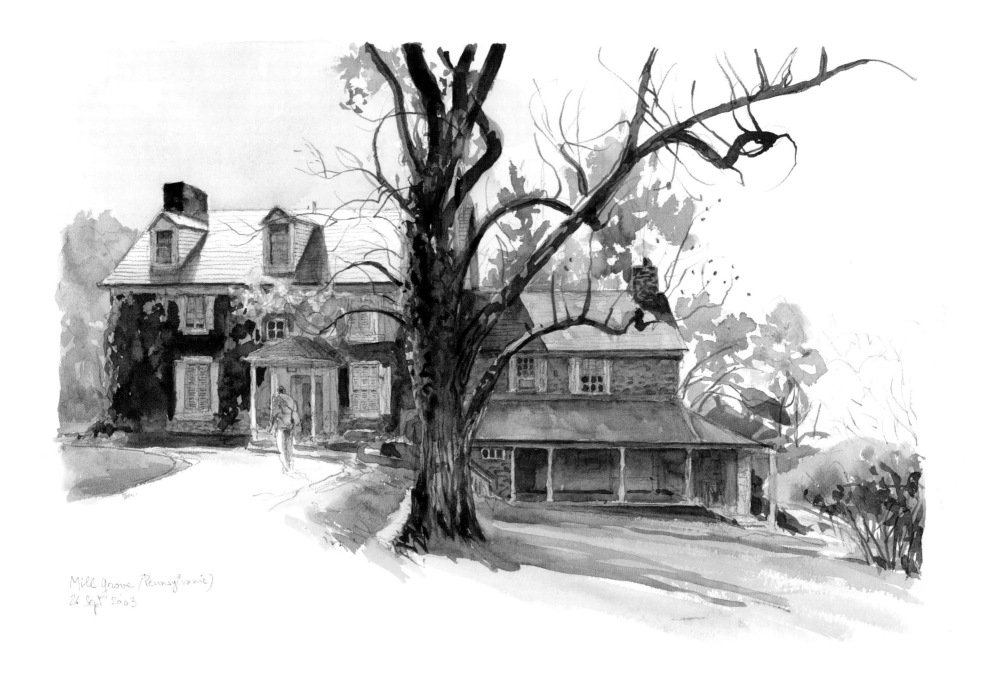

Mill Grove (Pennsylvanie)
26 Sept 2003

John James Audubon Center at Mill Grove, September 26, 2003.

PENCIL AND WATERCOLOR, 10.63 × 16.14 IN (27 × 41 CM).

COURTESY OF THE NATURAL HISTORY MUSEUM OF NANTES.

Only the left part of the building was there when Audubon lived here.

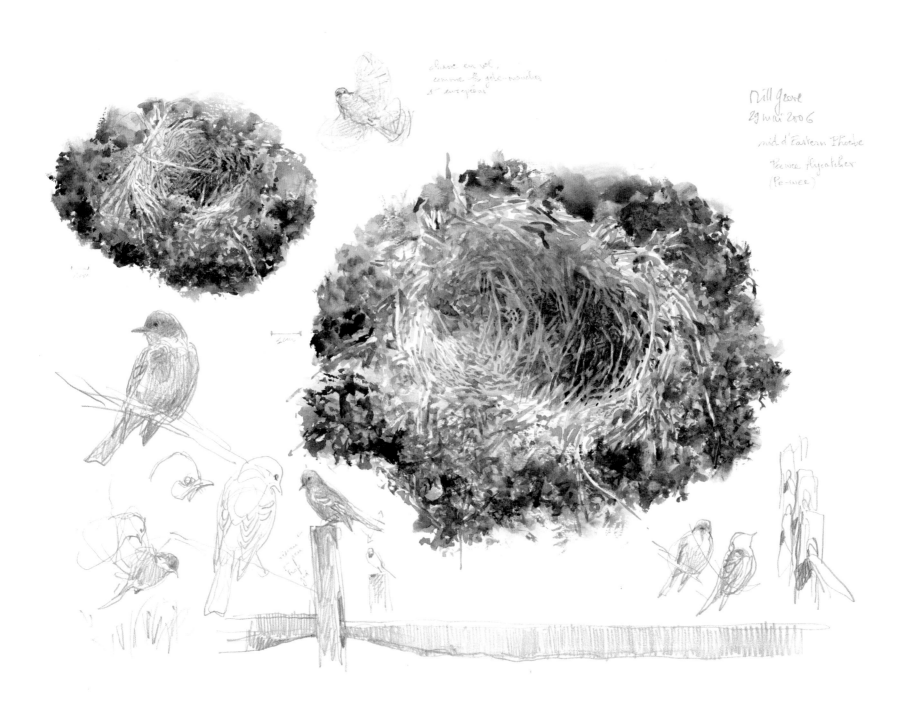

Eastern Phoebe, study of a nest, John James
Audubon Center at Mill Grove, May 29, 2006.

PENCIL AND WATERCOLOR, 11.42 × 15.35 in (29 × 39 cm).

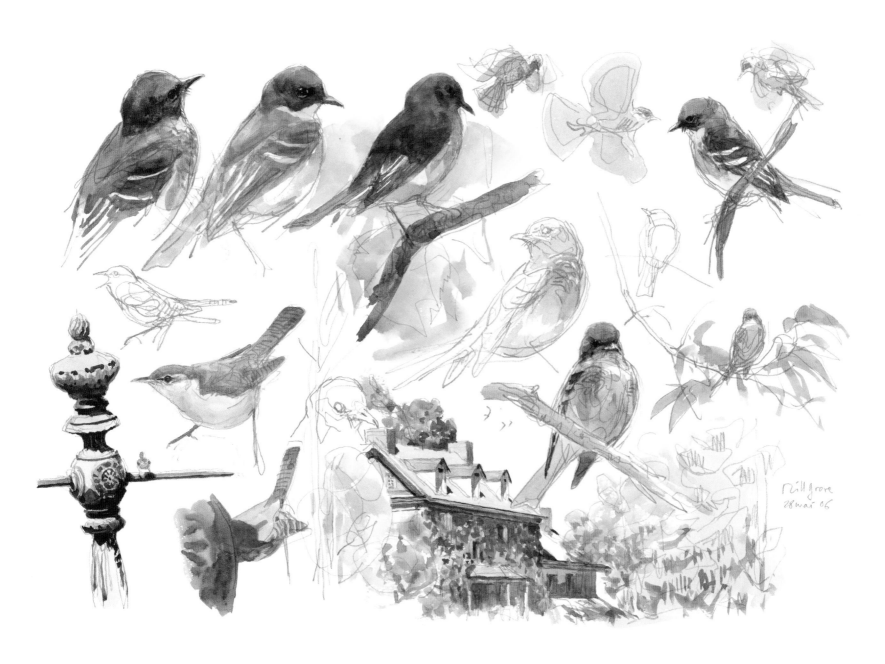

Eastern Phoebe and House Wren, John James
Audubon Center at Mill Grove, May 28, 2006.

PENCIL AND WATERCOLOR, 11.42 × 16.14 IN (29 × 41 CM).

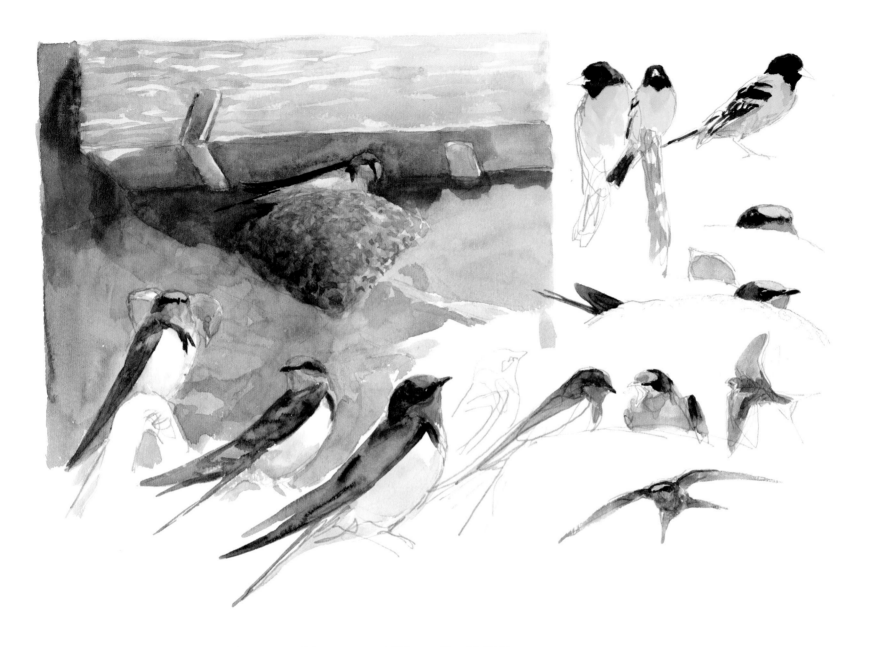

Barn Swallows and Baltimore Oriole, John James Audubon Center at Mill Grove, May 28, 2006.

PENCIL AND WATERCOLOR, 11.02 × 15.75 IN (28 × 40 CM).

Observe the passing Swallow, how swiftly she glides around us, how frequently she comes and goes, how graceful her flight, how pleasant her musical twitterings, how happy she seems to be! ... There a female sits on her eggs, and is receiving a store of insects from the mouth of her mate. Having fed her, he solaces her with a soft chaterring voice, and away he goes in search if more food.

— Audubon, *The Chimney Swallow* in *Ornithological Biography*, vol. 2.

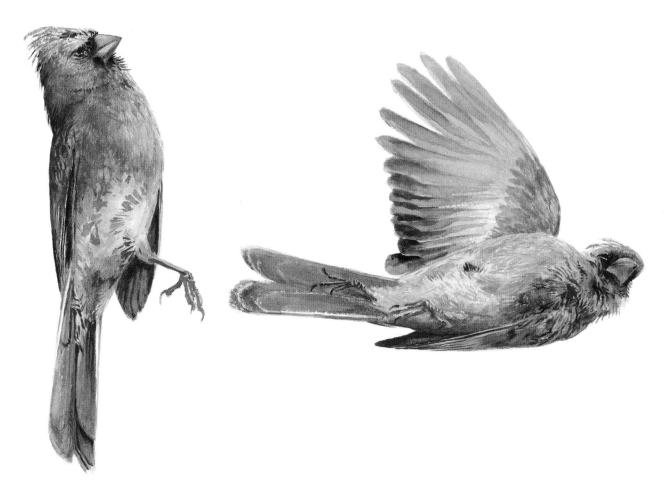

femelle de Northern Cardinal (trouvée morte)
Mill grove 21 mai 2006

Study of a female of Northern Cardinal, John James Audubon Center at Mill Grove, May 31, 2006.

PENCIL AND WATERCOLOR, 9.05 × 11.81 IN (23 × 30 CM).

Toni, one of the teachers of the center, brought me this bird that she found dead at the edge of a path.

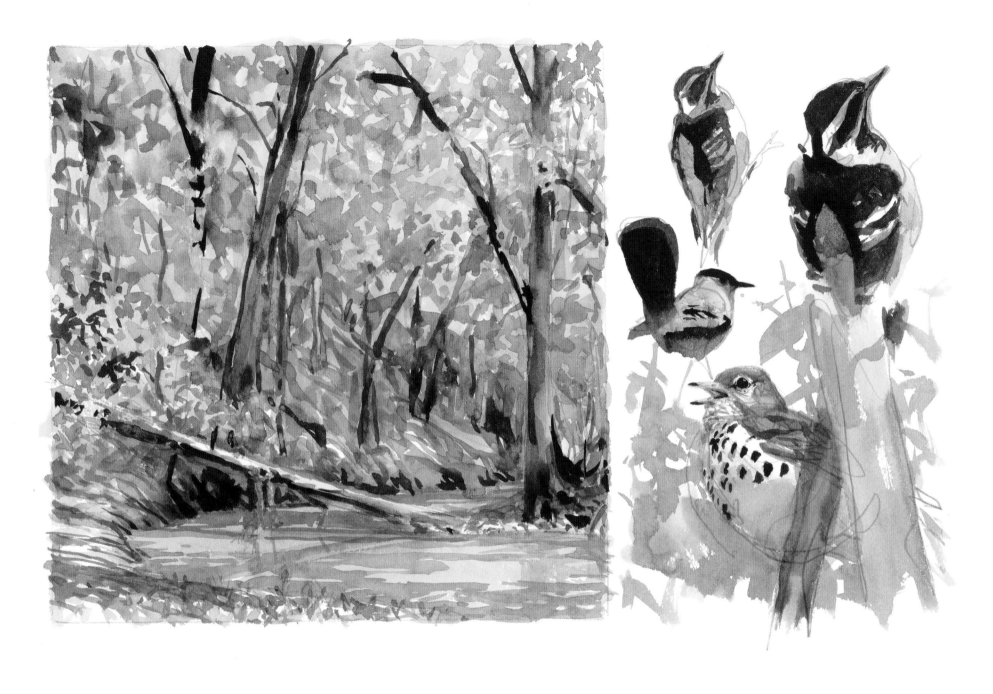

Along the wooded bank of the Perkiomen River, Hairy Woodpecker, Gray Catbird, and Hermit Thrush, John James Audubon Center at Mill Grove, May 16, 2006.

PENCIL AND WATERCOLOR, 10.24 × 15.75 IN (26 × 40 CM).

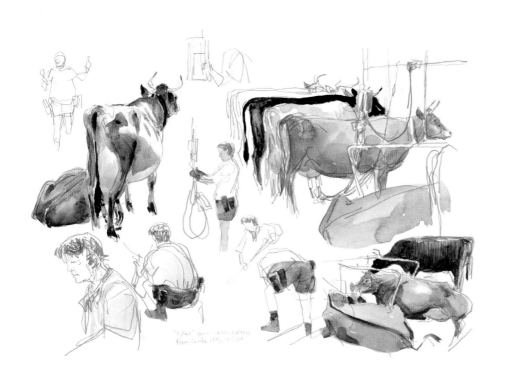

Edie Griffith milking her Jersey cows, Seven
Stars Farm, Kimberton, May 28, 2006.

PENCIL AND WATERCOLOR, 11.42 × 15.75 IN (29 × 40 CM).

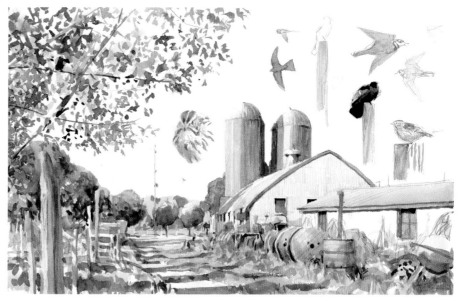

Purple Martins, Killdeer, Red-winged Blackbird, and Song
Sparrow, Seven Stars Farm, Kimberton, March 27, 2006.

PENCIL AND WATERCOLOR, 10.24 × 16.14 IN (26 × 41 CM).

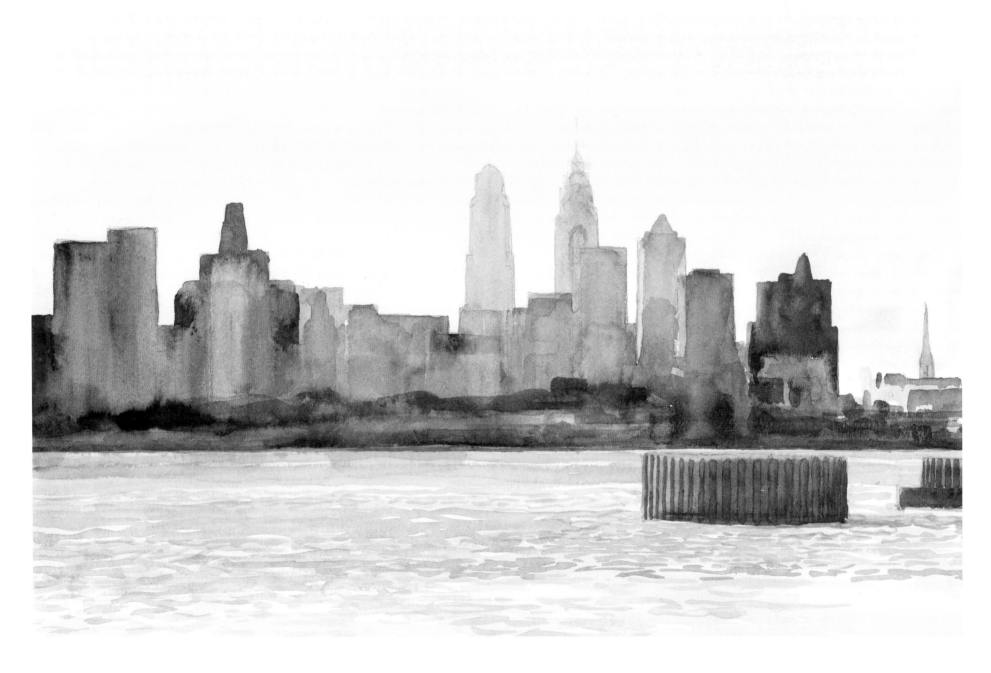

**Philadelphia seen from Camden, New Jersey,
September 24, 2003, in the evening.**

PENCIL AND WATERCOLOR, 11.02 × 16.14 IN (28 × 41 CM).

ACADEMY OF NAT.-SCIENCES
PHILADELPHIE 6.03.2007

Study of Western Meadowlark and Eastern Meadowlark made at the Academy of Natural Sciences of Philadelphia, March 6, 2007. Collection of the Leigh Yawkey Woodson Art Museum, Wausau, Wisconsin.

PENCIL AND WATERCOLOR, 7.87 × 11.81 IN (28 × 30 CM).

These birds were collected by John James Audubon during his expedition along the Missouri River in 1843.

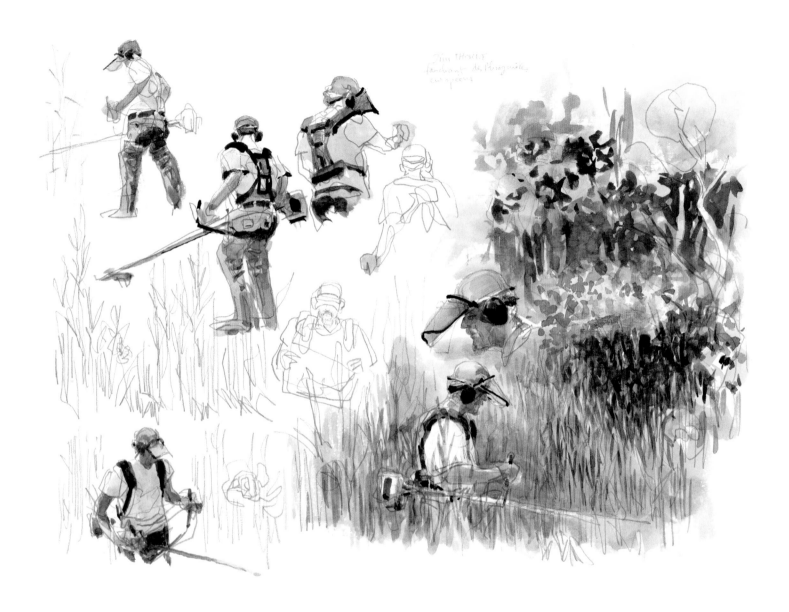

Jim Thorpe mowing a species of reed originating from Europe that upsets the ecological balance of a very large number of marshes across the country, near Warwick, May 31, 2006.

PENCIL AND WATERCOLOR, 11.42 × 15.75 IN (29 × 40 CM).

After leaving Jim, I joined Sean Quinn, a young volunteer who was pulling Asiatic Tearthumb shoots along Pine Creek, an invasive plant from Asia, which is nicknamed "mile a minute."

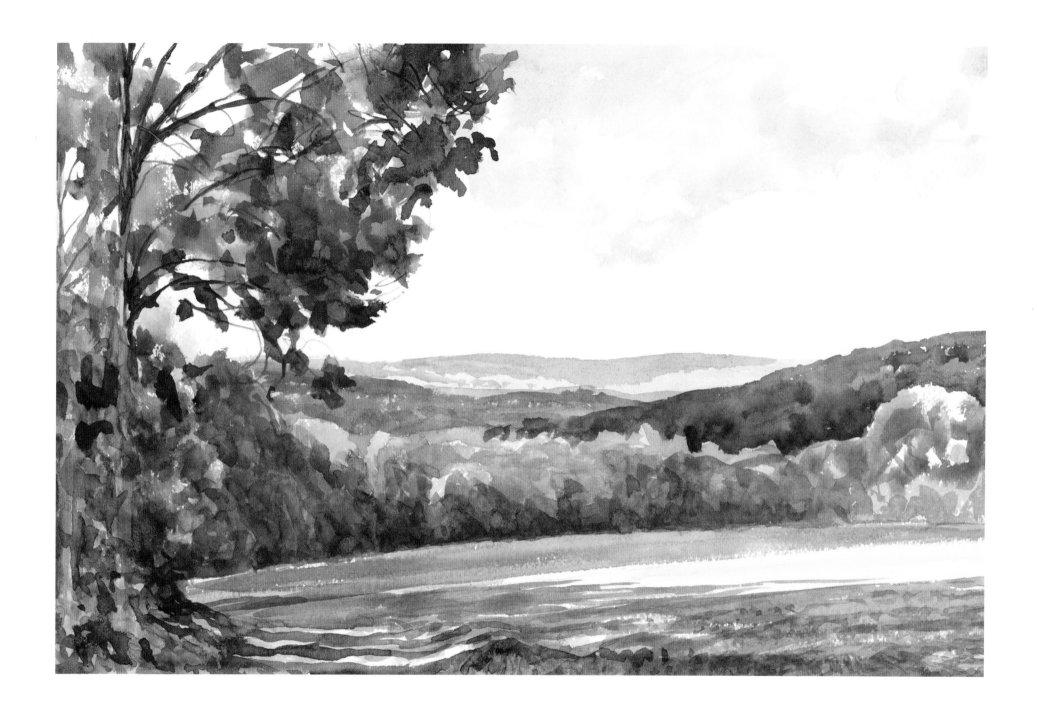

Wooded hills in the French Creek State Park, May 30, 2006.

PENCIL AND WATERCOLOR, 10.24 × 15.75 IN (26 × 40 CM).

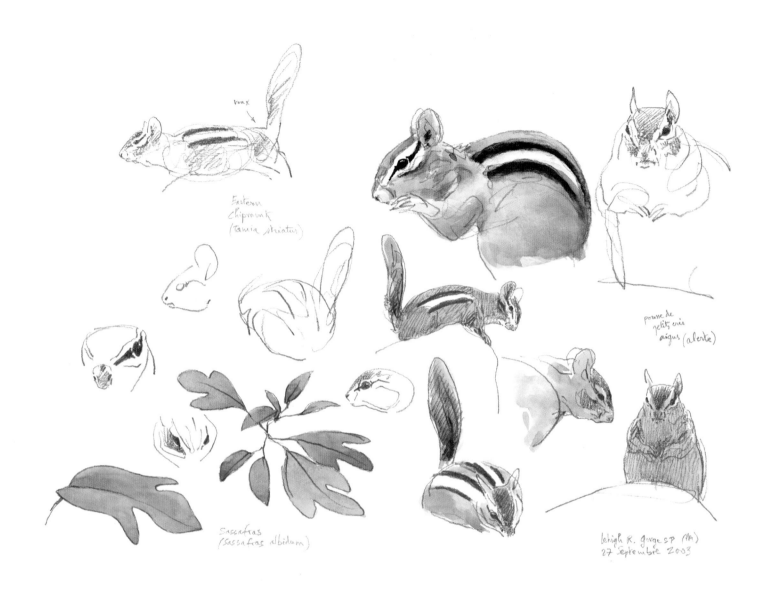

Eastern Chipmunk, Lehigh River Gorge State Park, September 27, 2003.

PENCIL AND WATERCOLOR, 11.81 × 16.14 IN (30 × 41 CM).

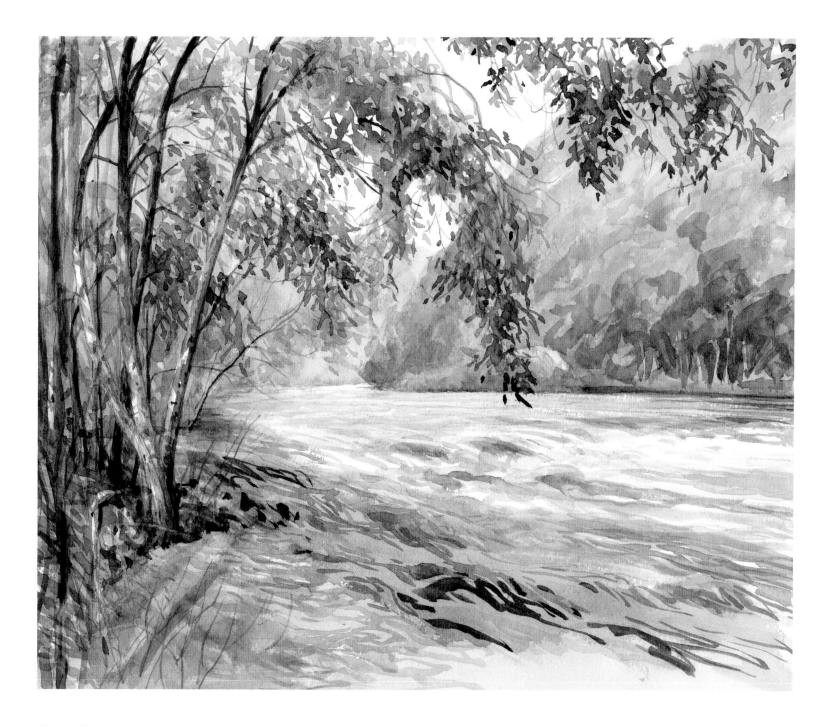

The Lehigh River, near Rockport, September 27, 2003.

PENCIL AND WATERCOLOR, 11.02 × 13.38 IN (28 × 34 CM).

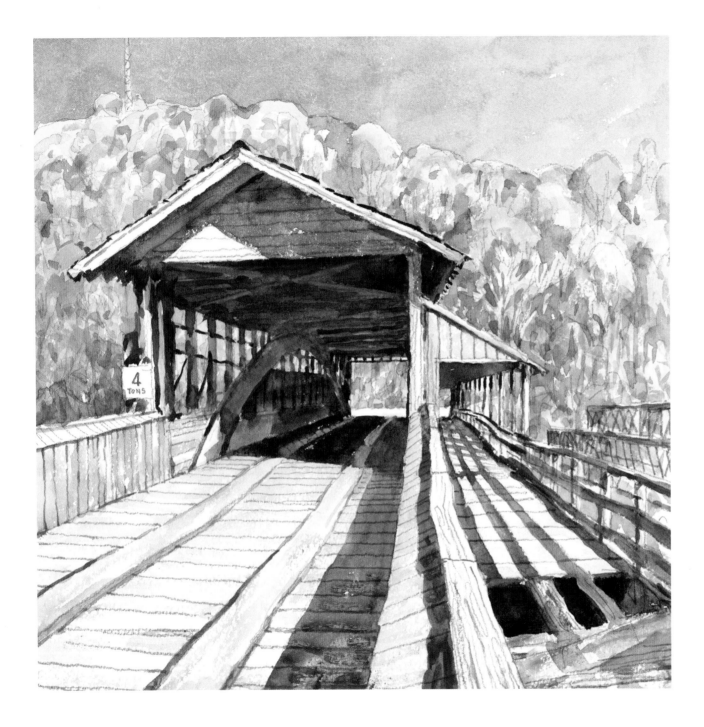

Covered bridge along Route 30, Bedford, November 7, 2005.

PENCIL AND WATERCOLOR, 10.24 × 10.24 IN (26 × 26 CM).

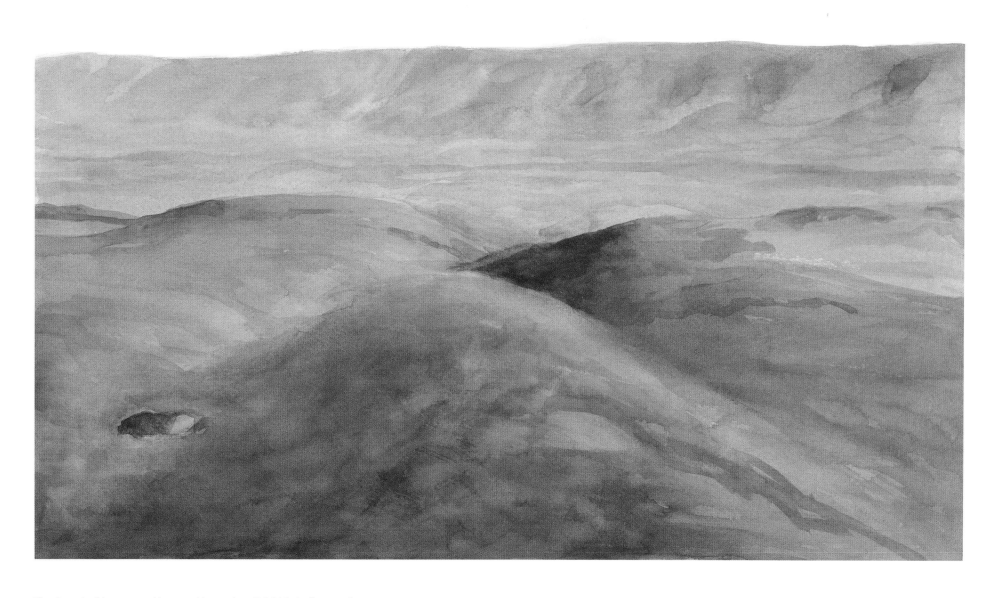

The Appalachians near Altoona, November 7, 2005, in the evening.

WATERCOLOR, 10.24 × 15.35 IN (26 × 39 CM).

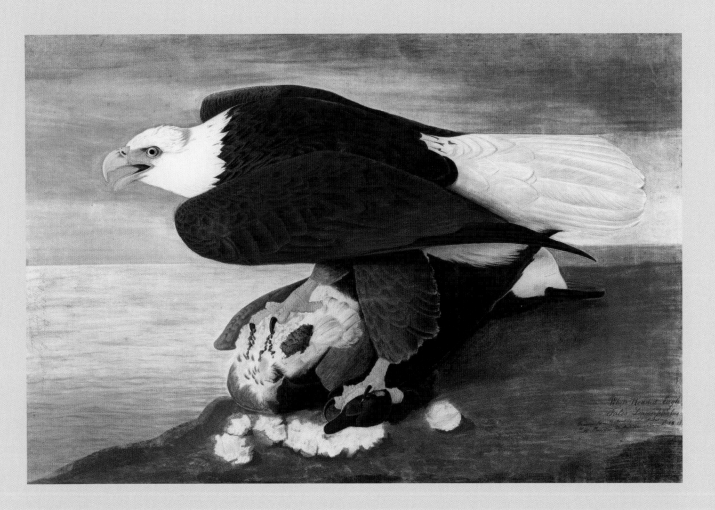

Bald Eagle holding its prey, a Canada Goose, Little Prairie, Mississippi River, November 1820.

John James Audubon

PASTEL, BLACK CHALK, WATERCOLOR, GRAPHITE PENCIL, BLACK INK AND GOUACHE ON PAPER, 37.5 × 25.6 IN (95 × 65 CM).

(REF 1863.18.40)
COLLECTION OF THE NEW YORK HISTORICAL SOCIETY. DIGITAL IMAGE CREATED BY OPPENHEIMER EDITIONS.

In another watercolor, created eight years later in London and which was engraved in *Birds of America*, Audubon replaced the Canada Goose with a catfish.

OHIO–MISSISSIPPI

ALONG THE RIVERS FROM PITTSBURGH TO BATON ROUGE

Bald eagle spitting out a pellet, near Henderson, Kentucky, April 12, 2003.

GRAPHITE PENCIL ON PAPER,
3.94 × 4.72 IN (10 × 12 CM).

WHEN AUDUBON ARRIVED for the first time in Pittsburgh in 1807, the rapidly expanding city already had several thousand inhabitants. It was one of the gateways to the West, a revolving door between the Atlantic coast and the new territory to the west, down to New Orleans. The Ohio and Mississippi Rivers were already important transportation routes. The diversity of watercraft aligned along the banks was surprising; locally built, most of them flat bottomed and sometimes equipped with a mast, they were conceived for a single voyage, downstream, pushed by the current. Entire families embarked on the biggest ones, with luggage, stocks of food, sacks of seed, carts, horses, and cows.

The Ohio River at that time, the "Beautiful River" as it was named by the first French settlers, was very different than the river of today whose natural flow is now interrupted by a series of dams. At the beginning of the nineteenth century, rocks, sandbars, boat wrecks, and grounded tree trunks made navigation perilous. Certain rapids could not be crossed except during periods of higher water; the rest of the year it was necessary to portage the watercraft.

The life of Audubon is inseparable from the great American rivers on which he so often traveled in search of work, to support his endeavors or to discover new birds. So I too wanted to navigate the rivers in order to experience this particular universe in a different way than from the bridges or the rarely accessible river banks. I wanted to meet the barge workers of today and to paint them while working. This is the idea I had in mind when I traveled along these rivers in 2003 and 2005.

Discovering Pittsburgh from the Mount Washington neighborhood, I can see the place where the Allegheny and Monongahela Rivers join and, in the space of a few nearly undetectable eddies, become the Ohio. It is raining, but this doesn't affect my enthusiasm because I have recently found out that I will soon embark on a towboat. By sheer good luck I have met the director of the Port of Pittsburgh, who kindly set up a meeting on the quays of Clairton, Pennsylvania, about twenty-five miles south of the city.

The next day, comfortably situated on the stern of the *Jacob G* going upstream on the Monongahela River, pushing five empty barges destined for the coal terminals, I draw and paint relentlessly for

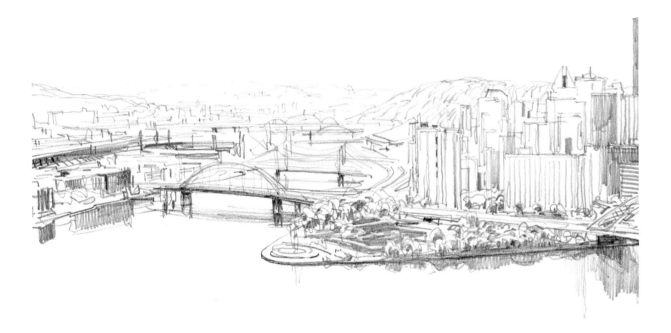

The Allegheny and Monongahela Rivers join to form the Ohio River, Pittsburgh, Pennsylvania, November 9, 2005.

GRAPHITE PENCIL ON PAPER,
7.48 × 14.96 IN (19 × 38 CM).

several hours, stimulated by the landscape that passes and disappears at each new meander. The sun approaches the horizon, magnificent blue shadows burst here and there, projecting their somber mass on the blazing river basin. I don't see anyone on this part of the boat but the hum of the motors and metallic sounds clearly indicate the presence of men working. While we draw alongside to moor or detach a barge, the quickness of the stops suggests a team perfectly practiced in their maneuvers.

In the evening, I install myself in the kitchen, draw and chat with the crew who are preparing

their dinner or doing chores. Mark Fetty has worked on this boat for four years. His features pinched, he peruses the newspaper before going to his berth. Rick Lowe, the captain, stops by for a few moments. I show him the drawings made that afternoon. I touch upon the light, so beautiful that afternoon, and ask him which season he prefers. He talks to me of winter, the frozen river, and the convoys that pass each other in the crashing noise of broken ice.

Magic vision at dawn: we glide on a layer of luminous fog. Several Canada Geese pass, honking, and land a bit farther on the invisible water. Looking to these birds, how not to think at this precise moment of the evocative words of Audubon:

[Thus] on some of the great sand-bars of the Ohio, the Mississippi, and other large streams, congregated flocks, often amounting to a thousand individuals, may be seen at the approach of night, which they spend there, lying on the sand within a few feet of each other, every flock having his own sentinel. In the dawn of next morning they rise on their feet, arrange and clean their feathers, perhaps walk to the water to drink, and then depart for their feeding-grounds.[1]

Since this trip I have learned about the disastrous effects of the polluted and radioactive wastewater created by the extraction of natural gas and petroleum by hydraulic fracturing. In 2008, a flood on this river caused pollution so troubling that the authorities recommended local inhabitants to drink only bottled water.

Back to Pittsburgh for a crew change, I undertake the descent of the Ohio by car, searching for viewpoints to paint or draw. I stop near Wheeling, West Virginia, where the river carves vast meanders between the hills. The next day I pass through Ashland, Kentucky, then take the small roads that follow the river at the foot of the hills. The weather is nice and the cruise is peaceful.

I stop in Augusta, Kentucky. The Ohio is wide and difficult to paint here; I look for a good angle, the perspective that will allow me to represent a wide river rather than a lake. Seeing the ferry *Jerry Ann* slowly cross this landscape, I imagine one spring day in 1808 the silent passing of a flat-bottom boat, children's voices, the groaning of a rudder … and the young Audubon couple stretched out in the middle of their luggage. Their voyage between Pittsburgh and Louisville, Kentucky, took ten days in rather good conditions, and Lucy touched upon them in a letter addressed to her English cousin, Euphemia Gifford:

The seven hundred miles by water was performed without much fatigue though not without some disagreeables. Our conveyance was a large square or rather oblong boat; but perfectly flat on all sides; and just high enough to admit a person walking upright. There are no sails made use of owing to the many turns on the river which brings the wind from every quarter in the course of an hour or two. The boat is carried along by the current, and in general without the least motion, but one day we had a high a wind as to make some of us feel a little seasick.

Bread, beer and hams we bought at Pittsburgh, but poultry, eggs and milk can always be had from the farmhouses on the banks.[2]

Setting off again, I discover a bit farther the Meldahl Locks and Dam. A few anglers are perched along the bank below, dwarfed by this immense construction. What can they be catching? Have the Asian carps introduced in the Mississippi in the 1970s already spread this far upstream, disrupting the ecosystem of the river as they have elsewhere? Scientific studies on the biology and movements of these fish along the Wabash River—one of the main Ohio River tributaries—confirm their remarkable ecological flexibility. Today the urgent need is to avoid contaminating the Great Lakes.

I pass through Louisville at night. In 1808, at the age of twenty-three, Audubon opened a business here with his friend Ferdinand Rozier. He drew often, whenever possible: orioles, Indigo Buntings, tanagers, kingfishers, and many other species. His portfolios already contained more than two hundred drawings, and his technique improved with more frequent use of watercolor. To push himself to improve, he burned some of his first works that didn't meet his standards. However, he was very happy many years later to find some drawings that he had sent to one of Lucy's cousins who had carefully kept them. Audubon was starting to create compositions putting several birds in one scene. One day he was able to locate within a couple of miles from

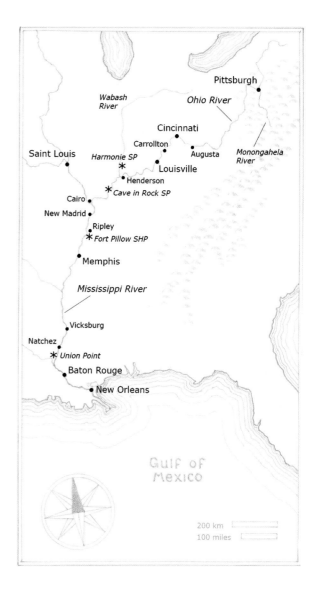

Florida Dogwood in bloom, Harmonie State Park, Indiana, April 9, 2003.

PENCIL AND WATERCOLOR ON PAPER,
9.45 × 11.02 IN (24 × 28 CM).

Louisville a hollow sycamore trunk in which swarms of swifts assembled each evening. Audubon often went to the foot of this tree at dusk to watch this performance. He estimated their number at nine thousand individuals in peak season and several times collected some birds in order to discern the number of males, immatures, and females.

It was also in Louisville that he met Alexander Wilson, the Scottish ornithologist and artist whose engravings of American birds were already well recognized in the scientific community. Wilson was surprised by the talent of the young Audubon and undoubtedly perceived in him a rival. As vain as one another, alternately admiring and distrusting each other, accomplices in their passion for birds, ready to share some of their discoveries but refusing a real collaboration, the two men did not manage to seal a real friendship during these few days spent on the Ohio River.

Facing the Ohio River in Henderson, Kentucky, I sit on a wall whose stones served as the foundation of a sawmill that Audubon built at this site. I spend a long time observing the imperceptible movement of the river, majestic in the soft spring light. A woman is walking at the edge of the water and collecting small objects, maybe shells. She seems happy, someplace else, like a child searching for treasure, while her husband is waiting impatiently on the top of the bank.

John James and Lucy lived in Henderson for nearly ten years. They shared periods of happiness there thanks to a comfortable income from the store and from some profitable investments in land. This financial ease permitted them to own slaves, an inhuman practice, inadmissible today but widespread at the time, including in the French colonies. Moreover, ownership of slaves permitted them to affirm their social rank in this little frontier city. They also faced difficult years marked by bankruptcy, physical violence, poverty, and the death of their first daughter at the age of one year.[3]

Barely settled in, on June 1, 1810, Audubon made a beautiful portrait of a Red-winged Blackbird. This was followed by many observations and remarkable drawings. Like many of his contemporaries, he hunted often in the forests and marshes of the area to feed his family or to collect specimens, often killing more than was really necessary. However, it is here that he realized the madness of humankind and the possible disappearance of certain species that were overhunted. The best-known example is that of the Passenger Pigeon, whose flocks could number more than a billion birds at their peak.

At Henderson, I am warmly welcomed by Don Boarman, custodian of the John James Audubon State Park. The dogwoods and Eastern Redbuds are in bloom. For two days I draw all sorts of birds: chickadees, Northern Cardinals, American Goldfinches, doves, woodpeckers. Don's assistant suggests that I go observe a Bald Eagle's nest. We drive for several miles before taking a small trail along an immense floodplain. I see the eyrie, a small dark shape in the distance, midheight in a bald cypress, then install my telescope. The eaglet

is there, alone, waiting for food. As often in this type of situation, I start a detailed drawing of the nest on one part of the page, reserving the free space for rapid sketches of the eaglet. One of the parents lands with prey and feeds the eaglet with amazingly delicate movements.

On the route back, we surprise some snipe. A bit farther, in the middle of a clearing, a male turkey is parading in the sun among a small group of females. Having seen these large birds only on the farms of my childhood, I am surprised to see them in the wild. Audubon observed many during his voyage between Cincinnati and New Orleans in the fall of 1820:

Tuesday October 17th ... The Turkeys, extremely plenty and Crossing the River hourly from the North Side, great number destroyed falling in the Stream from want of Strength. ... Saw a Great Number of Chimney Swallows going South-west; these Birds travells much More advantageously than Most all others being able to feed without halting.

Then two days later, this surprise meeting after a hunting party:

While absent the boats having put too to Make Sweeps a flock of Turkeys came amongst them and in tring to Kill some with Aumacks' pistols One was bursted and the other Wounded Joseph's Scull pretty severely.[4]

Farther to the west, not far from Marion, Kentucky, I cross the Ohio River to see what the picturesque site, Cave in Rock, Illinois, looks like, a natural curiosity already well known to travelers at the beginning of the nineteenth century. I am finishing a sketch before preparing to spend the night in the car when two large, yellow headlights appear, then pull up against the back of my car, illuminating the interior. I slowly lower my window, barely making out the suspicious face of the person who approached. I attempt to explain to this man what I am doing there at that hour, down below his farm, with no other response than the sound of his engine. I am not sure that I have been understood when the headlights move away. I go the next day to paint the cave. It is a Sunday, and the weather is very nice. While waiting for the ferry near a group of motorcyclists out for a ride, I see a Red-headed Woodpecker climbing on a tree; a nuthatch appears, much smaller than the woodpecker, and boldly chases the woodpecker away.

Leaving the Ohio valley, I head southwest to rejoin the Mississippi just after Dyersburg, Tennessee. I take small roads that wind through the river plain. The "Father of Waters" is difficult to see there, always hidden by the riparian forest, but its presence is palpable. It is the river that has created these vast horizontal landscapes sprinkled with rare dwellings, sometimes abandoned, most of them constructed on stilts to protect them from floods. I paint one of them while thinking of the floods that Audubon mentioned in his journal.

Pileated Woodpecker, John James Audubon State Park, Henderson, Kentucky, April 12, 2003.

PENCIL AND WATERCOLOR ON PAPER, 3.15 × 2.75 IN (8 × 7 CM).

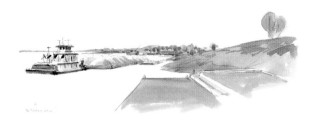

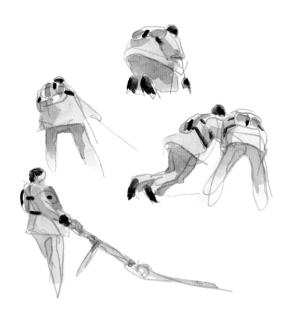

So sudden is the calamity that every individual, whether man or beast, has to exert his utmost ingenuity to enable him to escape from the dreaded element. The Indian quickly removes to the hills of the interior, the cattle and game swim to the different strips of land that remain uncovered in the midst of the flood, or attempt to force their way through the waters until they perish from fatigue.[5]

I start along a logging trail then leave my car to walk for several hundred yards before sitting down to contemplate, smell, and listen. The air is hot and humid at this hour of the afternoon. The woods are astonishingly silent. Swarms of tiny insects buzz in the rays of light, and a small butterfly with white-spotted black wings comes to pose its golden yellow legs on the corner of my drawing paper.

Next stop is Fort Pillow State Park, Tennessee, located on a bluff, one of the rare places where one looks out over the valley. These are the Chickasaw Bluffs that Audubon described in his journal. One of the park rangers tells me about the force of the Mississippi that can collapse entire swaths of hills or create new meanders during very high floods.

When Audubon crossed this region for the first time, each day of river travel was for him a delight. A vast number of migratory birds flew over the river and populated the nearby swamp forest: ducks, swans, raptors, shorebirds, passerines of all sorts, not to mention caribou, bear, puma, and wolves. ... This list is all the more impressive in that it includes species that were common at the time but are now extinct, such as the Carolina Parakeet and the Ivory-billed Woodpecker.

Following the river downstream, I spend a rainy day near Memphis, Tennessee, with Larry W. Agee, who pilots the towboat *Margaret J* of the company Fullen Dock and Warehouse. Every day Larry moves enormous barges to prepare the convoys or to dock the cargo boats for unloading. I watch the precise and exhausting work of the two workers who bustle about on the bridge, a dangerous job because the barges are often filled to the brim. The water is never far, and the currents are strong. During the strongest rain showers the workers become invisible, almost like ghosts. In the middle of the day, we dock alongside a big towboat equipped with a kitchen; the crew welcomes us to join them for lunch. The men exchange several words, but I quickly understand that the meal will be short; everyone eats rapidly—sausages, eggs, and beans—then gets back to work. Later, taking advantage of a break, Larry shares a bit of his life with me. Originally from a small town in Arkansas, he chose his career simply by following in his brother's footsteps. I get the impression that he misses the days when he traveled far on the rivers.

Several months earlier to the south of Natchez, Mississippi, I had met Kenny Ribbeck and Duck Locascio at the Red River State Wildlife Management Area, managed by the Louisiana Department of Wildlife and Fisheries. They led a

restoration program of the flood zones and surrounding forests in order to limit the effects of floods. In the evening while we were talking, seated on top of the levee, an Eastern Kingbird chased some insects near us with elegance and dexterity. I had observed for the first time a couple of Orchard Orioles, perched on the bushes down below. A little farther stood a group of trees cut at very different heights by beavers, showing just how much the level of the river is changing. Duck had promised to install some banding nets in anticipation of my visit. Thus the next morning I could sketch the migrating passerines that we had captured.

My descent along the rivers reaches its end. The space opens up as I approach Baton Rouge, Louisiana. I see to the west vast expanses of water sprinkled with bald cypress. It is the start of the delta. At the beginning of the nineteenth century, travelers saw other metamorphoses: the forests and banks marked by sparse huts gave way to sugar cane and cotton plantations, protected by dikes. The modernization of boats, more rapid and comfortable, also accelerated the passing of the landscapes, and Audubon himself could appreciate these changes. When in 1830 he went up the Mississippi and the Ohio all the way to Pittsburgh with Lucy, lodged in deluxe cabins, their voyage took less than two weeks, while twenty years earlier most of the keel boats or barges equipped with a mast and a sail took three months or more to cover the same distance, often putting the lives of the crew in peril.

Baton Rouge, last stop before reaching New Orleans. This community, which in 1821 Audubon qualified as a "prosperous village," less than thirty years later became the capital of Louisiana! Its strange name comes from the large colored posts that the Native Americans erected along the river to display heads of bear and fish offered in sacrifice.

I paint the city from Port Allen, Louisiana, on the opposite bank. The buildings of the business quarter struggle to rival the dimensions of the river. The air is luminous. The slowness and imposing mass of the Mississippi contrasts with the lightness of the swallows that skim the surface of the water.

1. Audubon, *The Canada Goose in Ornithological Biography*, vol. 3, 1835.

2. Rhodes, Letter from Lucy Audubon to Euphemia Gifford, Louisville, Kentucky, May 27, 1808, in *The Audubon Reader*. Reproduced by permission of Everyman's Library, an imprint of Alfred A. Knopf.

3. DeLatte, *Lucy Audubon*.

4. Corning, *Journal of John James Audubon*. Courtesy of Club of Odd Volumes.

5. Audubon and Coues, *A Flood in Audubon and His Journals*.

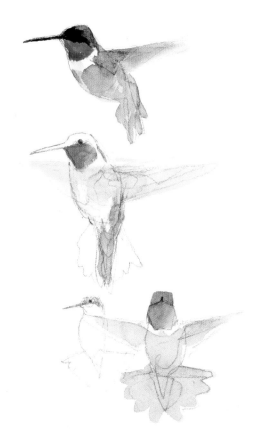

Ruby-throated Hummingbirds, Red River Wildlife Management Area Headquarters, Louisiana, April 15, 2005.

PENCIL AND WATERCOLOR, 8.66 × 5.12 IN (22 × 13 CM).

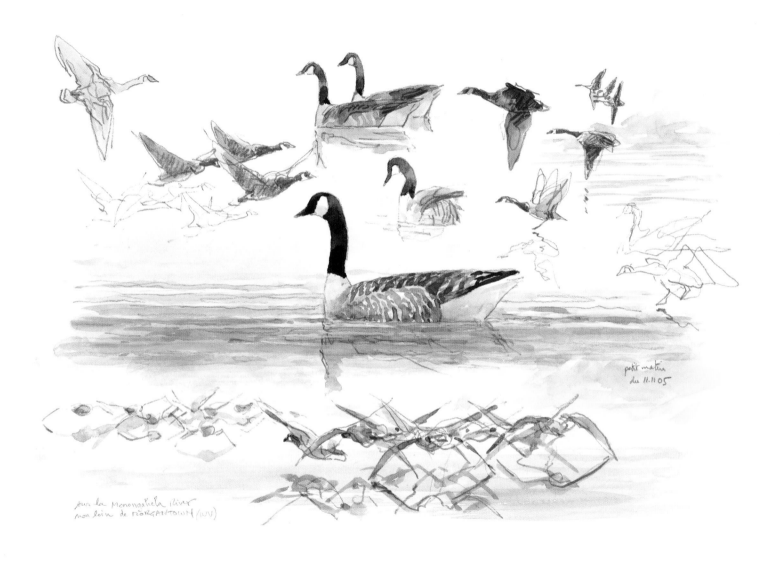

Canada Geese on the Monongahela River, near Morgantown, West Virginia, November 11, 2005.

PENCIL AND WATERCOLOR, 11.02 × 14.96 IN (28 × 38 CM).

While on the water, the Canada Goose moves with considerable grace and in its general deportment resembles the Wild Swan, to which I think it is nearly allied.
—Audubon, The Canada Goose in Ornithological Biography, vol. 3.

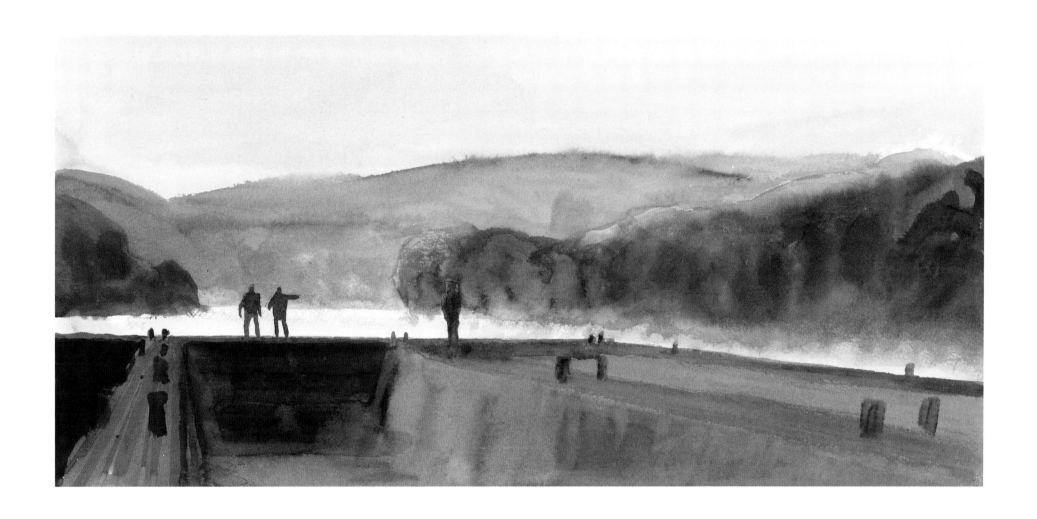

On the Monongahela River, near Morgantown,
West Virginia, morning of November 11, 2005.

WATERCOLOR ON PAPER, 7.87 × 15.75 IN (20 × 40 CM).

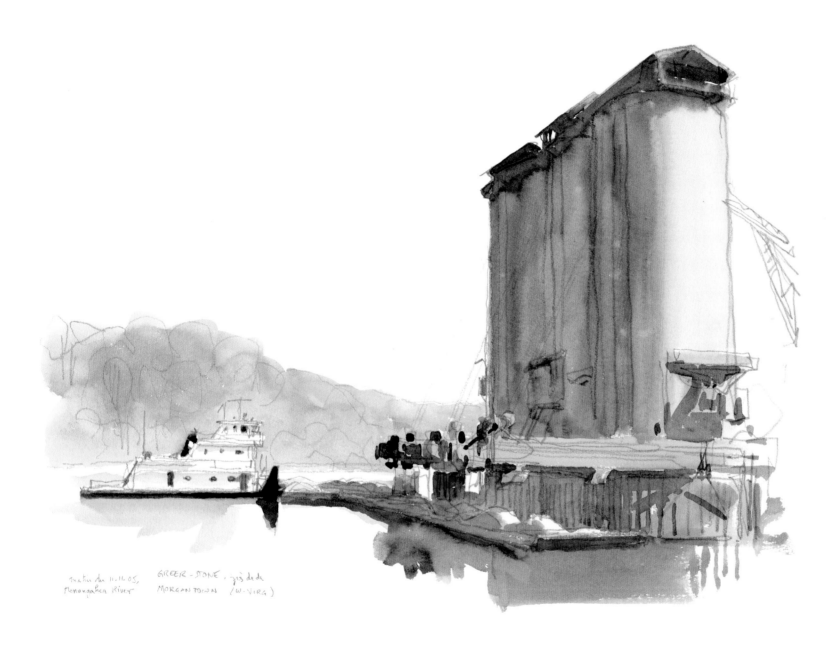

Matin du 11.11.05,
Monongahela River

GREER-STONE, près de de
MORGANTOWN (W-VIRG)

The *Jacob G* at Green Stone, Monongahela River, near
Morgantown, West Virginia, November 11, 2005.

PENCIL AND WATERCOLOR, 11.81 × 16.14 IN (30 × 41 CM).

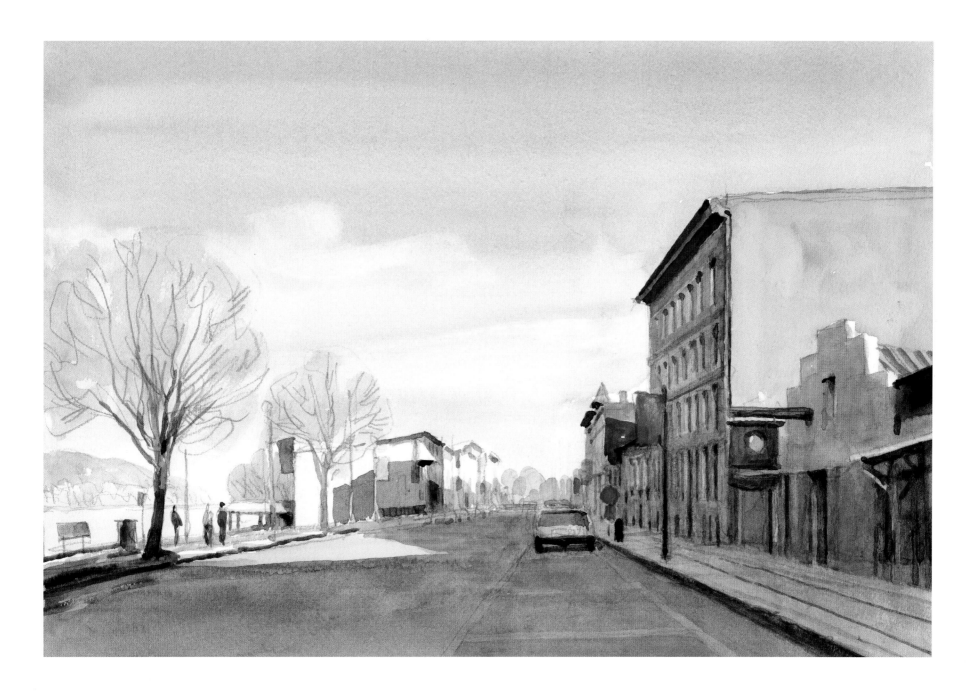

Carrollton, upstream of Louisville, Kentucky, evening of November 12, 2005.

PENCIL AND WATERCOLOR, 10.24 × 15.35 IN (26 × 39 CM).

Most of the cities situated along the river no longer look like what they did at the
time of Audubon, but this street still resembled a small city of the nineteenth century.

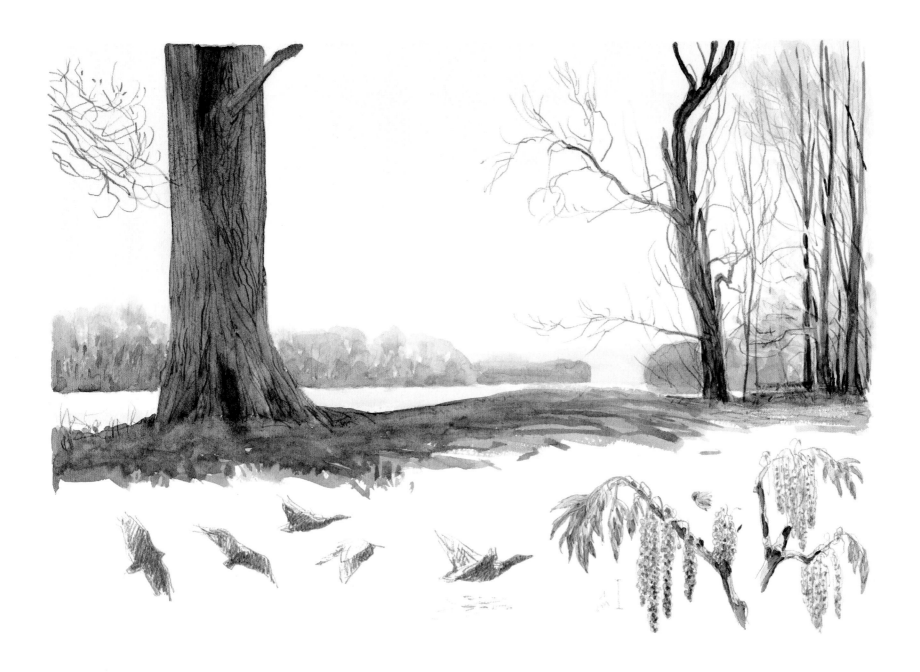

**The Wabash River, rain and melted snow,
Harmonie State Park, Indiana, April 9, 2003.**

PENCIL AND WATERCOLOR, 11.02 × 16.14 IN (28 × 41 CM).

Audubon rented a forest concession close by to supply
timber for the sawmill he had built in Henderson.

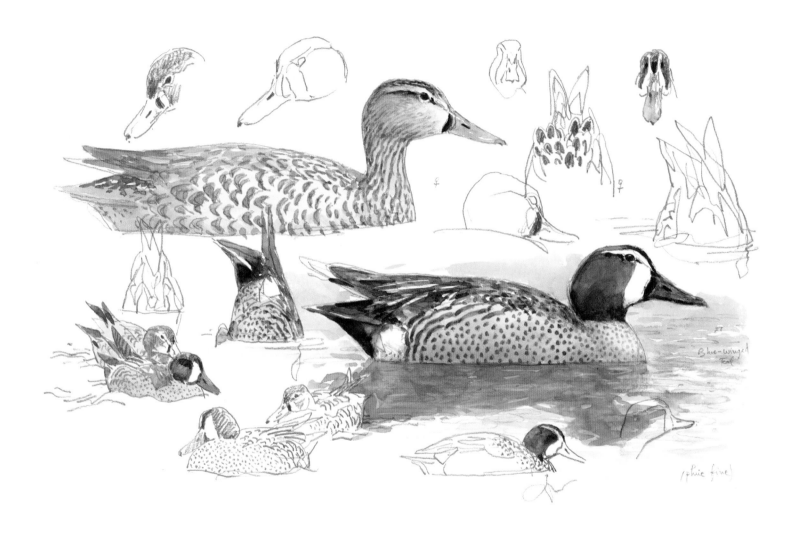

**Blue-winged Teal, near New
Harmony, Indiana, April 9, 2003.**

PENCIL AND WATERCOLOR, 10.24 × 15.75 IN (26 × 40 CM).

**The Ohio River at Henderson, Kentucky,
morning of November 13, 2005.**

GRAPHITE PENCIL, 9.84 × 15.35 IN (25 × 39 CM).

Someone told me that the stones used to build the wall around the park come from the foundation of Audubon's mill.

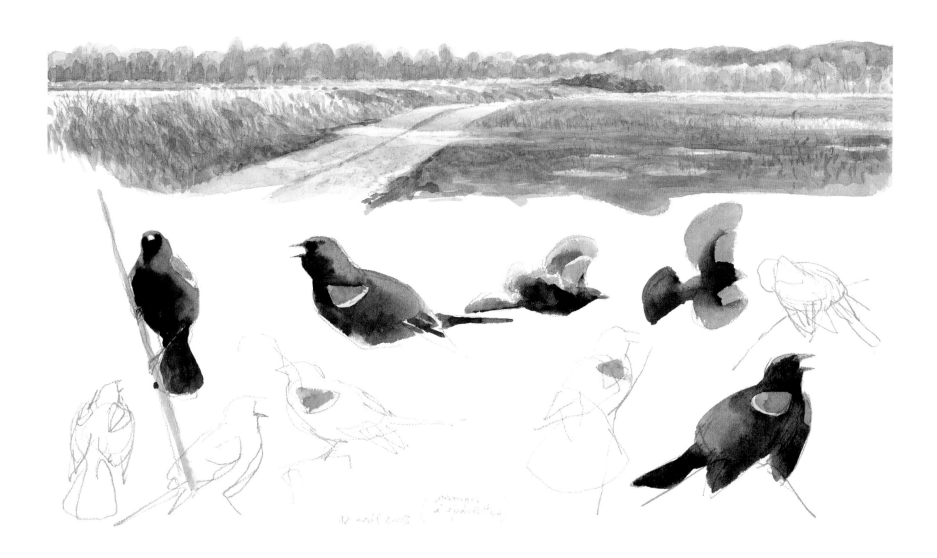

Red-winged Blackbird, near Henderson, April 12, 2003.

PENCIL AND WATERCOLOR, 11.02 × 16.14 IN (28 × 41 CM).

When Audubon was living at Henderson, vast spaces like this one, fertile and close to the river, were covered with dense stands, called "canebrakes," of a native bamboo-like vegetation. These thickets could reach twenty-six feet in height and formed a unique ecosystem that has almost entirely disappeared today.

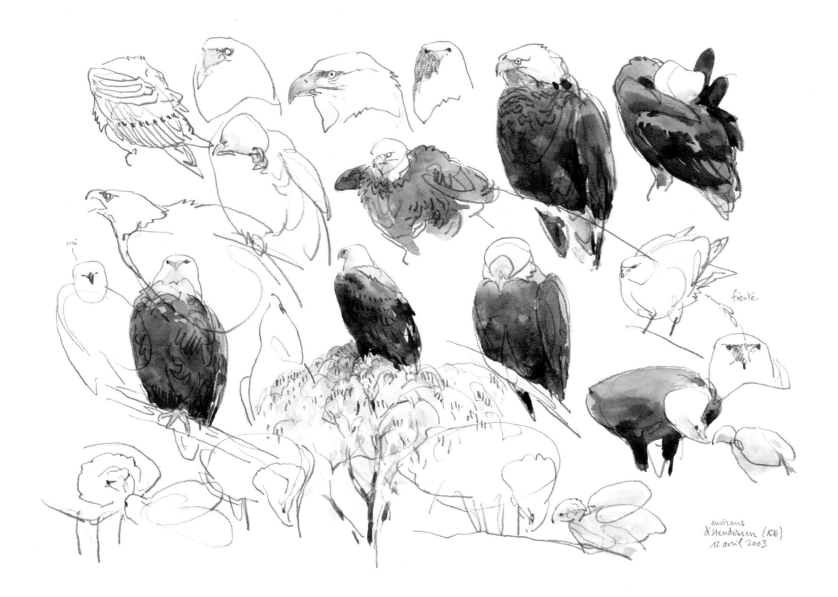

Bald Eagle resting and feeding his chick, near Henderson, April 12, 2003.

PENCIL AND WATERCOLOR ON PAPER, 11.42 × 15.75 IN (29 × 40 CM).

The attachment of the parents to the young is very great, when the latter are yet of a small size; and to ascend to the nest at that time would be dangerous. But as the young advance, and, after being able to take wing and provide for themselves, are not disposed to fly off, the old birds turn them out, and beat them away from them. They return to the nest however, to roost, or sleep on the branches immediately near it, for several weeks after. They are fed most abundantly while under the care of the parents, which procure for them ample supplies of fish, either accidentaly cast ashore, or taken from the Fish-Hawk, together with rabbits, squirrels, young lambs, pigs, oppossums or raccoons.

—Audubon, *The White-headed Eagle in Ornithological Biography*, vol. 1.

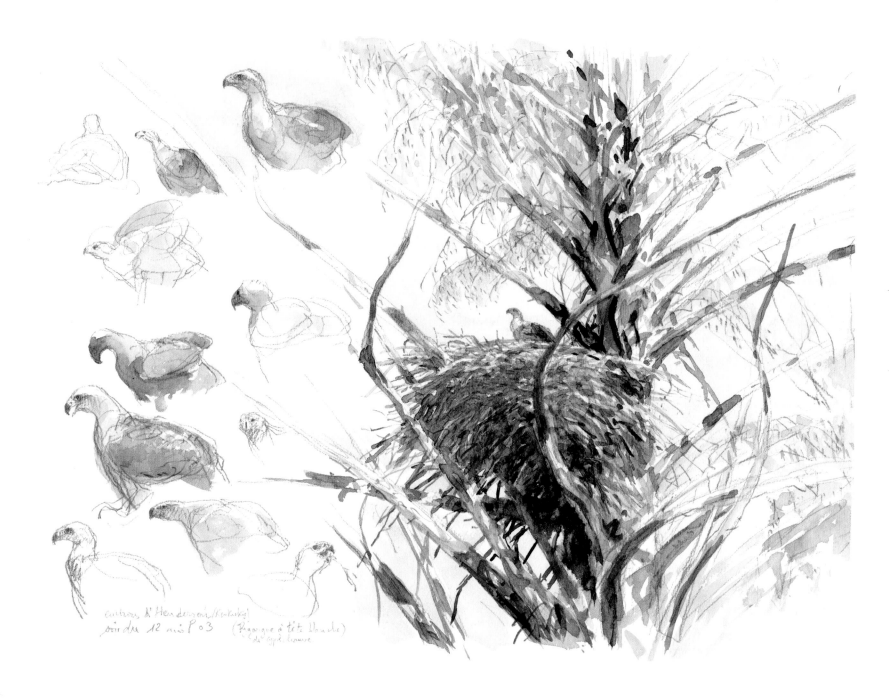

Young Bald Eagle in the nest, near Henderson, April 12, 2003.

PENCIL AND WATERCOLOR, 11.42 × 15.75 IN (29 × 40 CM).

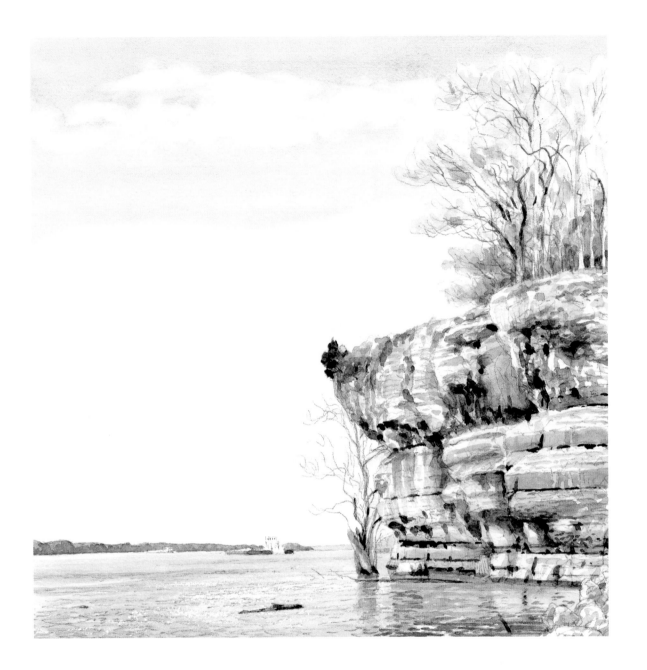

The Ohio River at Cave in Rock, Illinois, April 12, 2003.

PENCIL AND WATERCOLOR, 11.42 × 11.42 IN (29 × 29 CM).

The Ohio River, seen near the entrance of the cave. This natural curiosity is what remains of a long tunnel formerly dug by underground rivers and a multitude of floods. Facing this limestone rock, which is almost three million years old, Audubon's life suddenly seems very contemporary to me.

The Mississippi River under the full moon, New Madrid, Missouri, night of November 13, 2005.

CHARCOAL ON PAPER, 11.81 × 16.53 IN (30 × 42 CM).

The Mississippi River seems frozen under the moon. By contrast, I am thinking of the appalling series of earthquakes that occurred in this area during the winter of 1811 – 1812, killing many people and changing the course of the river here and there.

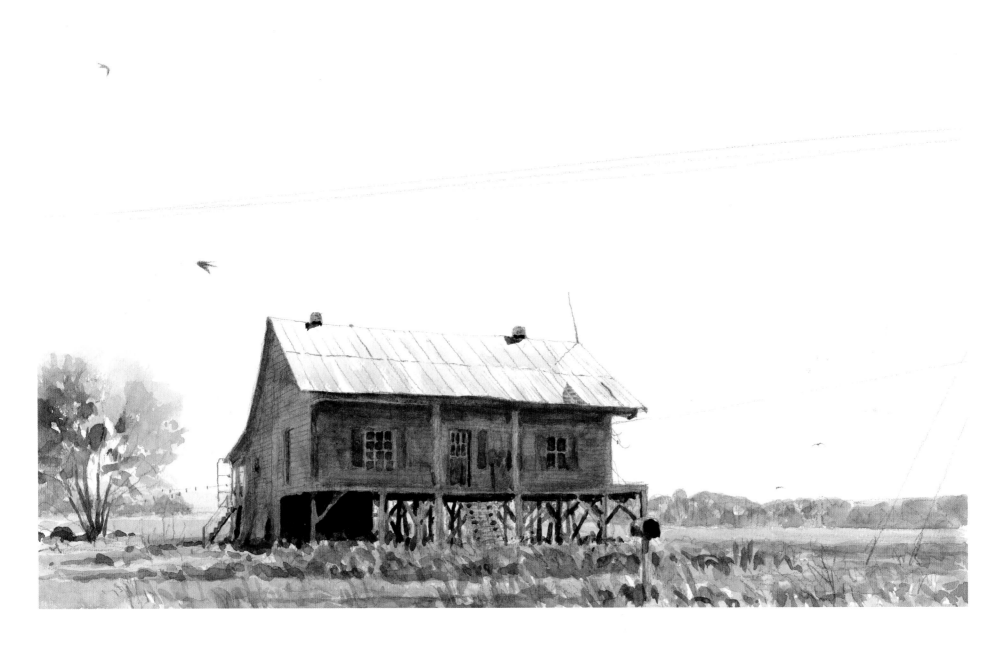

Near Ripley, Tennessee, Mississippi Valley, April 14, 2003.

PENCIL AND WATERCOLOR, 10.24 × 16.14 IN (26 × 41 CM).

How much good news and bad news have been delivered in this mailbox? I wanted to take a look inside the house, but the buzzing of a big wasp nest dissuaded me. In the field nearby, two male Cowbirds paraded around a female.

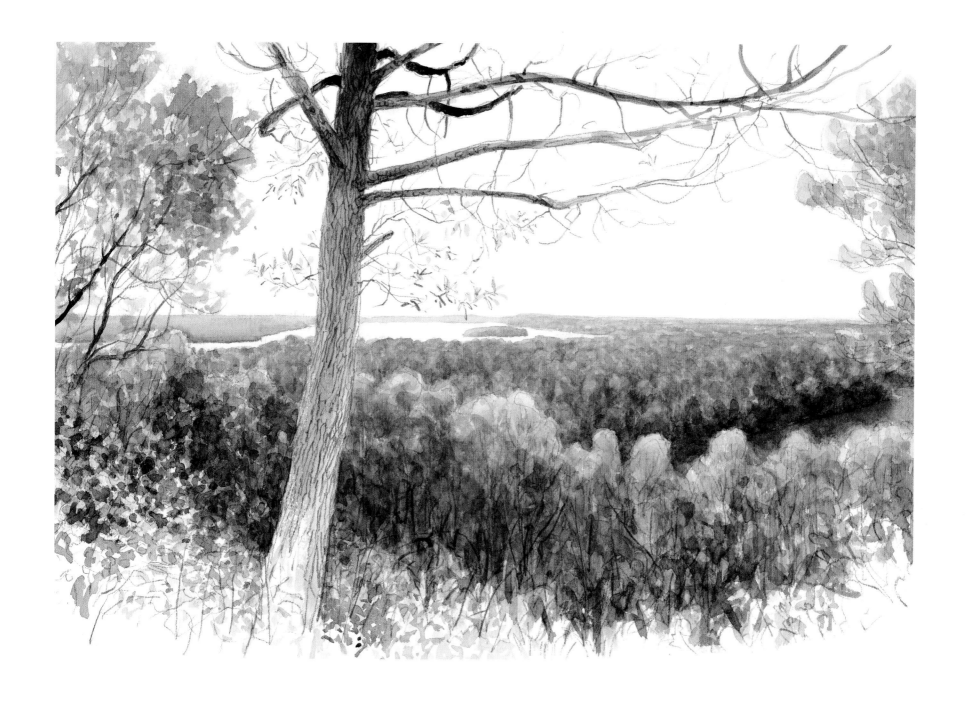

The Mississippi River viewed from Fort Pillow State Park, Tennessee, April 14, 2003.

PENCIL AND WATERCOLOR, 11.42 × 16.14 IN (29 × 41 CM).

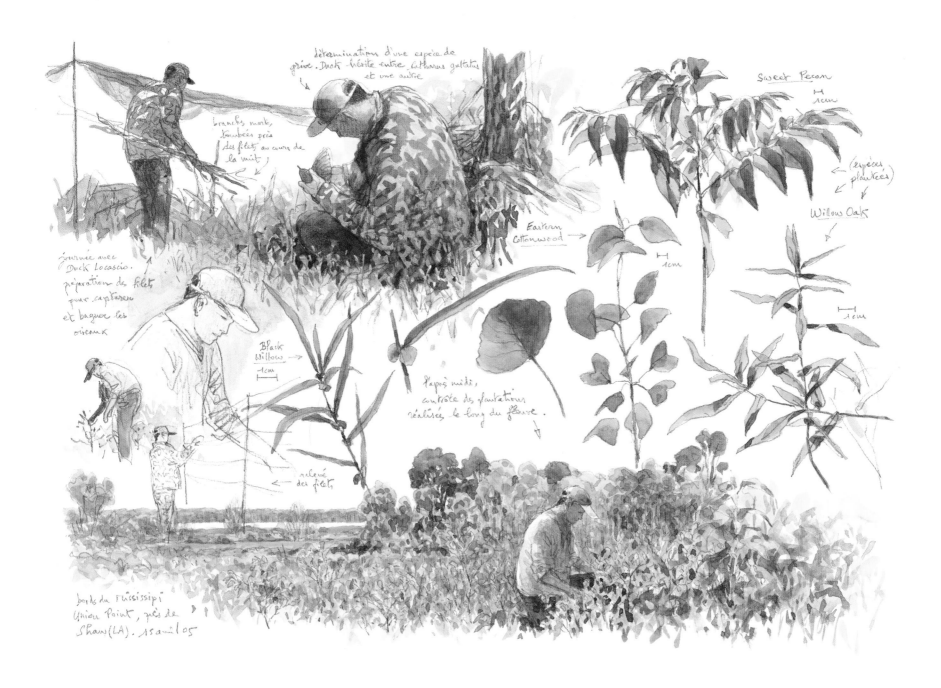

détermination d'une espèce de
prive. Duck hésite entre Catharus guttatus
et une autre

branches mork,
tombées près
des filets au cours de
la nuit

Journée avec
Duck Locascio.
préparation des filets
pour capturer
et baguer les
oiseaux

Black
Willow →
1cm

l'après midi,
contrôle des plantations
réalisées le long du fleuve.

← relevé
des filets

Eastern
Cottonwood →

Sweet Pecan
1cm

(espèces
plantées)

Willow Oak

1cm

1cm

bords du Mississipi
Union Point, près de
Shaw (LA). 15 avril 05

Near Union Point, Louisiana, banks of the Mississippi River, April 15, 2005.

PENCIL AND WATERCOLOR ON PAPER, 11.42 × 16.14 IN (29 × 41 CM).

Preparation of the banding nets and checking the saplings recently planted along the river.

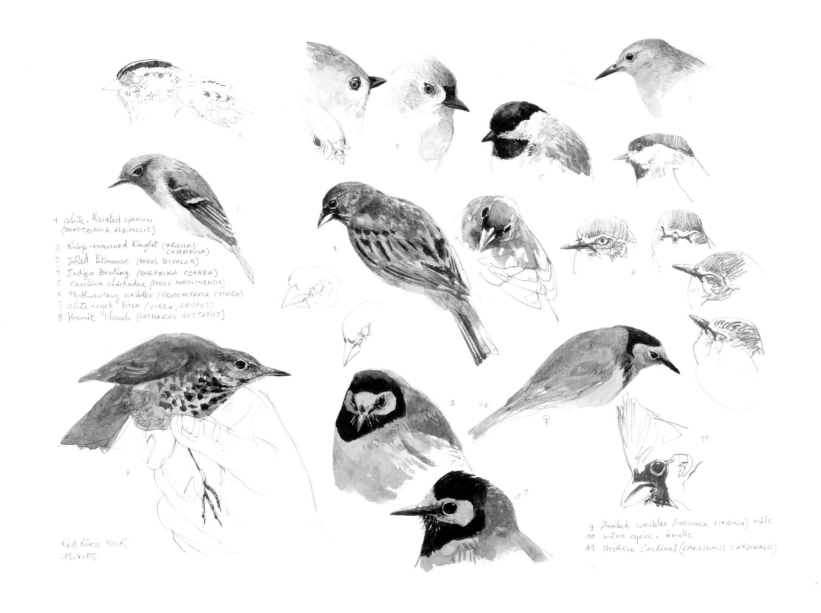

1 white-throated sparrow
(ZONOTRICHIA ALBICOLLIS)

2 Ruby-crowned Kinglet (REGULUS
CALENDULA)
3 Tufted titmouse (PARUS BICOLOR)
4 Indigo Bunting (PASSERINA CYANEA)
5 Carolina chickadee (PARUS CAROLINENSIS)
6 Prothonotary warbler (PROTONITARIA CITREA)
7 white-eyed Vireo (VIREO GRISEUS)
8 Hermit Thrush (CATHARUS GUTTATUS)

Red River NWR
15.4.05

9 Hooded warbler (WILSONIA CITRINA) mâle
10 même espèce - femelle
11 Northern Cardinal (CARDINALIS CARDINALIS)

Some birds captured with net, near Union Point, April 15, 2005.

GRAPHITE PENCIL AND WATERCOLOR ON PAPER, 10.24 × 14.96 IN (26 × 38 CM).

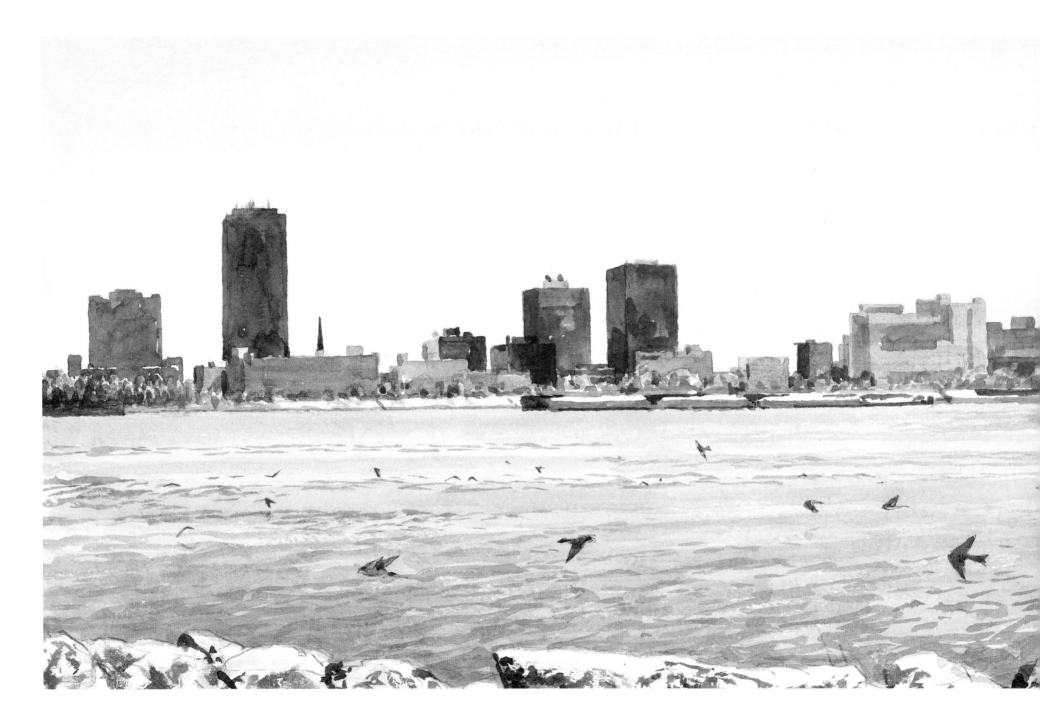

Baton Rouge seen from Port Allen, Louisiana, April 18, 2012.

GRAPHITE PENCIL AND WATERCOLOR ON PAPER, 9.84 × 25.19 IN (25 × 64 CM).

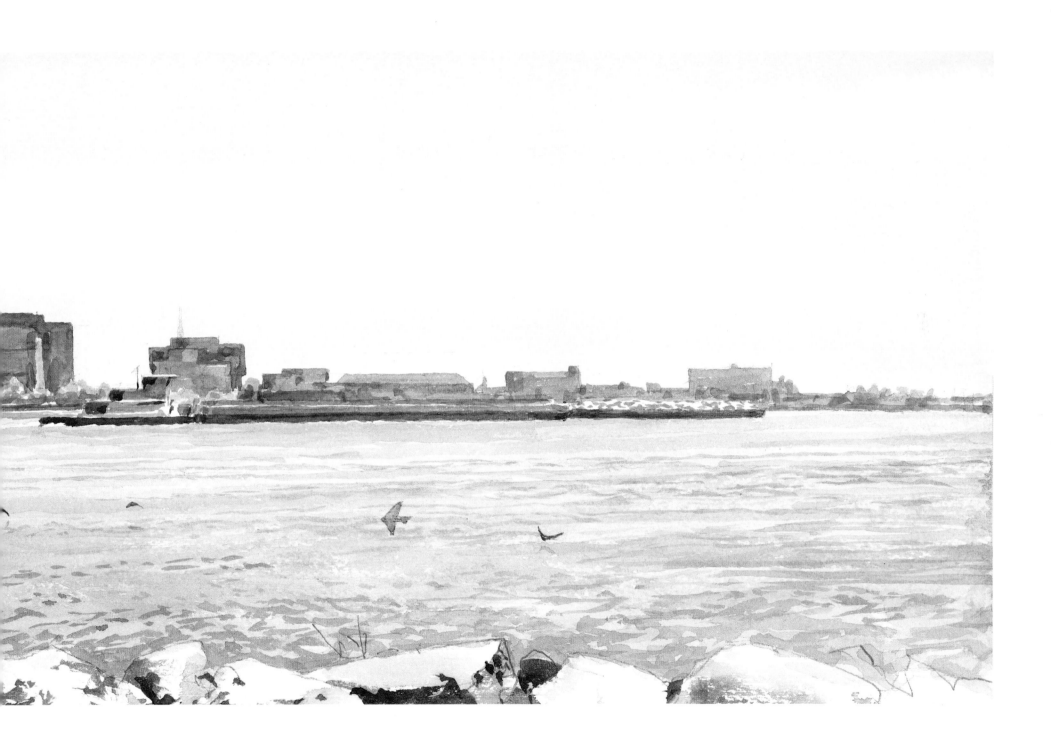

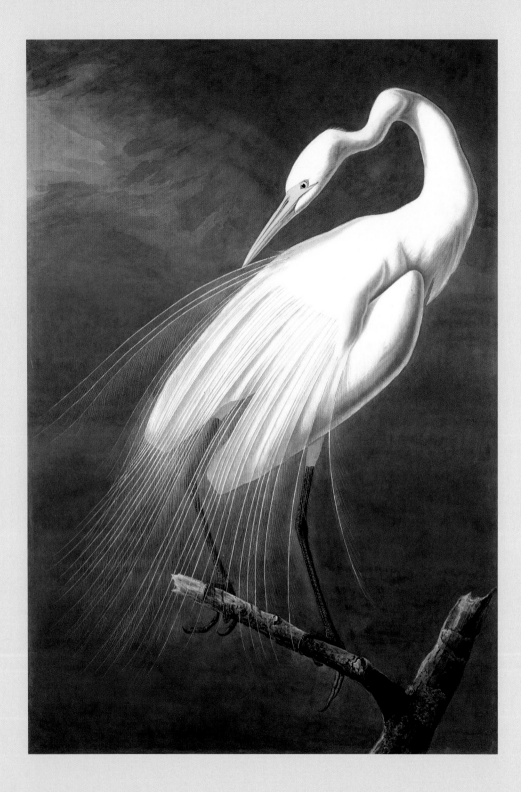

Sunday 25th March 1821. Bought a beautiful specimen of the Great White Heron in perfect order. It had been sent me by a hunter with whom I had formed acquaintance a few days ago. Worked on it the whole day and found it the most difficult to imitate of any bird I have yet undertaken.

—Audubon and Coues, *The Mississippi Journal* in *Audubon and His Journals.*

Great Egret, New Orleans, 1821.

John James Audubon.

WATERCOLOR, GRAPHITE, PASTEL, GOUACHE, WHITE LEAD PIGMENT, BLACK INK, AND BLACK CHALK ON PAPER, 37.40 × 25.60 IN (95 × 65 CM).

(REF 1863.18.30)
COLLECTION OF THE NEW YORK HISTORICAL SOCIETY.
DIGITAL IMAGE CREATED BY OPPENHEIMER EDITIONS.



x



LOUISIANA

TIME TO REACH MATURITY

Great Egret brooding, Lake Martin,
Breaux Bridge, Louisiana, April 17, 2003.

PENCIL, 11.42 × 15.75 IN (29 × 40 CM).

JACKSON SQUARE, NEW Orleans, April 17, 2012. Rainy day. People walk quickly, and their silhouettes reflect on the square in front of the Saint Louis Cathedral. This sight makes me think of Father Antoine, curate of this cathedral for forty years when John James Audubon stayed here for the first time. He was a colorful person, a defender of minorities in a Louisiana already very cosmopolitan. Audubon lived several times in this great city, but he never felt very attached to it despite the presence of close friends.

When Audubon arrived in New Orleans in January 1821, broke, he moved with his young assistant, Joseph Mason, into a small house at 706 Barracks Street, rented for ten dollars per month. It is here in this modest housing over the course of several months that he painted his

best-known watercolor paintings, such as the Snowy Egret and the Great American Egret. Taking in the most he could from his surroundings, every day he searched the sky and recorded his most noteworthy observations:

Monday 19th February 1821. The Weather beautifull. Clear and Warm, the Wind having blown hard from the Southwest for 2 days & Nights—saw this Morning three immense Flocks of Bank Swallows that past over Me with the rapidity of a Storm, going North-east. ... I was much pleased to see these arbingers of Spring but Where could they be moving So rapidly at this early Season. I am quite at a Loss to think, & yet their Passage here was about as long after the Purple Martin that Went By on the 9th Instant as is their Arrival in Kentucky a Month hence—perhaps Were they forced by the east Winds

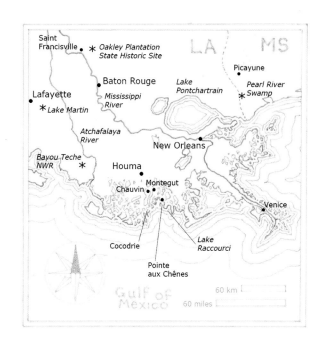

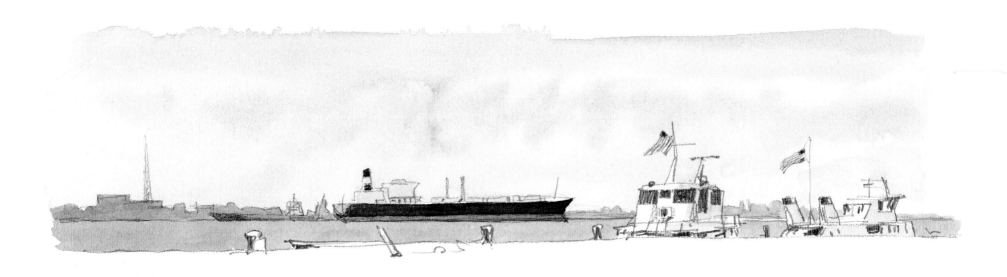

**New Orleans Harbor,
April 4, 2003.**

PENCIL AND WATERCOLOR,
4.33 × 16.14 in (11 × 41 cm).

*and now Enticed to proceed by the Mildness of the
Weather, the Thermometer being at 68.*[1]

Often homesick, far from his family in Cincinnati,
Audubon nevertheless broadened his contacts
thanks to some letters of recommendation. He
also met with some acquaintances from
Kentucky. He soon obtained his first portrait
orders and offered some drawing classes.

Today under a warm and unrelenting rain, I
have difficulty distinguishing between the
tourists and inhabitants of this neighborhood. I
am near the Old French Quarter, the picturesque
city center of New Orleans built at the end of the
eighteenth century in a Spanish style.

The ambiance was very different several years
ago during my first trip to Louisiana. Under a

sweltering sun, I had come here to draw 505
Dauphine Street, the other house that Audubon
rented in this city.

I remember the old oak trees of Washington
Square whose branches reached outside the limits
of the park, well beyond the fence, like huge
menacing tentacles. I had painted the flea market,
just next to the Mississippi River, thinking of the
one that existed in the same place at the
beginning of the nineteenth century. Many fresh
products were sold there: fish, meat, and various
tropical fruits and vegetables in abundance.
Audubon went there often to look at the stalls
filled with wild game, hoping to discover some
new species and, if possible, some specimens in
a state to be sketched. Herons, cranes, ducks,
shorebirds, and numerous passerines were found

there. Each one of his visits offered a different assortment, depending on the seasons and the migratory routes. He arranged to have professional hunters offer him the birds that they killed in the marshes or on the surrounding lakes. He paid them one dollar for each bird on condition that it be interesting specimen.

Next I had gone along the port, then took Route 23, which leads to the end of the delta, to see how this mythical river ends. Majestic magnolias punctuated the first few miles while here and there service trucks rolled along slowly on the shoulder of the road, dispersing clouds of insecticide on the nearby marshes. Just after Venice, well before the sea, the road stopped at the edge of a lagoon dotted with bald cypress trees. Large surfaces were covered with water hyacinths, their thousands of flowers composing a magnificent picture in this late afternoon. A Yellow-crowned Night-Heron watched for prey along the river bank. Some Blue Grosbeaks alighted with agility in the tall grasses moving in the wind. Night was falling as I left this enchanting end of the world. On the route back, near a group of wooden huts, smoke from some fires enveloped several African American children who were playing with a ball in the road.

Other memories come to mind, like the memorable day in the spring of 2005 noted in my notebook: "Airfield of Picayune, MS, morning of April 13. The single-engine plane is waiting at the end of the runway and ready to take off. I am in the rear of the plane, knees folded under my drawings and I am jubilant at the prospect of

flying over the forests around New Orleans. In front of me, Jennifer Coulson is seated near the pilot. Usually lively and cheerful, with each burst of laughter throwing back her blond hair, she seems impatient, serious, very concentrated on the last flight checks while the engine roars at full-throttle, shaking the cabin. This flight is important to her. For a number of years, supported by the National Audubon Society, she has carried out research on the Swallow-tailed Kite, to the point where she is now considered a leading specialist of this elegant bird of prey. Each day of research is precious to her because this migratory species is only present in the forests of this region for part of the year.[2] Wearing a headset, she hopes to locate active nest sites thanks to micro-transmitters that she previously attached to some of these birds. I draw for nearly two hours despite feeling air sick, sometimes I shiver in fright watching the pilot negotiate tight turns, apparently more interested in the nest he has just seen than in flying his plane!"

During each of my trips to Louisiana, Jennifer and Tom—her husband, just as dedicated as she is—propose that I accompany them in the vast flooded forests of the Pearl River swamp. One day after having stayed on dry land to paint the aerial ballet of some kites, I saw them return from deep in the woods, drenched up to their thighs, covered by bites and scratches but with beaming faces, profoundly happy to survey this rough and fascinating wilderness. During a canoe trip we saw a Great Horned Owl perched high in a large

Washington Square Park, New Orleans, April 4, 2005.

PENCIL AND WATERCOLOR, 10.24 × 10.24 IN (26 × 26 CM).

Evergreen Magnolia, Picayune, Mississippi, April 21, 2003.

PENCIL AND WATERCOLOR, 9.45 × 9.05 IN (24 × 23 CM).

Jennifer Coulson during an inspection flight to locate Swallow-tailed Kites nests, Pearl River Swamp, Mississippi, February 13, 2004.

PENCIL, 7.87 × 9.84 IN (20 × 25 CM).

pine tree. Jennifer explained to me that the fragmentation of the forests caused by urbanization and the creation of new roads benefits this predator … to the detriment of the kites, which it captures at night when they are roosting on their nests.

I will visit Jennifer and Tom again in 2012 in their new house located to the north of Lake Pontchartrain, far from the crowded neighborhood of New Orleans where they lived before. Seven years after Hurricane Katrina, they will tell me how they took refuge on the roof, watching helplessly while the seas swallowed up this part of the city, killed people, and drowned the Harris's Hawks that they devotedly raised in their back garden.

Two days after the acrobatic flight over the forest, I went to Saint Francisville, located 110 miles upstream from New Orleans, to see Oakley Plantation, where Audubon stayed for a few months while employed by Mr. and Mrs. Pirrie to teach drawing, music, and French to one of their daughters. This evening, the 16 of April 2005, I found myself near the pier for the ferry linking Saint Francisville to the right bank of the Mississippi. On the left, over the ancient dock, a forged iron portico still addressed to travelers a friendly "AU REVOIR."[3] Just underneath, three men were standing silently facing the immense and calm water. When one of them passed next to me he asked the name of this river!

I installed myself near the road to sketch Sara Bayou, a place that Audubon loved. The atmosphere of the marsh at dusk was mysterious and stimulating, and the mosquitoes—by chance—were bearable. I opted for a water-soluble pastel, which allowed me to suggest this landscape rapidly with brisk strokes, rubbings, and washed effects. Behind me the line of cars waiting for the next crossing was getting longer. I felt curious looks behind me. From the open car windows loud rap music was spreading into the marsh plunged in darkness.

After having visited the restored mansion at Oakley Plantation, I lingered in the garden to soak up this place so rich in history.[4] I was sure, drawing near a large oak, that Audubon had leaned back for a moment against it.

It is at Sara Bayou that Audubon landed on June 16, 1821, after having left New Orleans on board the steamboat Columbus. Without a penny in his pocket, he went on foot the next day to Oakley Plantation. Along the way he observed a Mississippi Kite and was immediately entranced by these parts unknown.

The Aspect of the Country entirely New to us distracted My Mind from those objects that are the occupation of My life—the Rich magnolia covered with its Odoriferous Blossoms, the Holy, the Beech, the Tall Yellow Poplars, the Hilly ground, even the Red Clay I Looked at with amasement.—such entire Change in so Short a time, appears, often supernatural, and surrounded Once More by thousands of Warblers & thrushes, I enjoyed Nature.[5]

He and his assistant set themselves up in a simple but cool room on the first floor of the main house. Over the course of the four following months, Audubon took maximum advantage of his free time to happily explore the still-wild nature of this part of Louisiana, well beyond the plantation's cotton fields.

He started a pad of drawings dedicated to insects and reptiles, discovered new species of birds, and accomplished a series of watercolors that is, without a doubt, the most beautiful of all his works. His work took a new turn, more mature, more careful of the details, such as the portrayal of a wasps' nest in the watercolor of the American Redstart. His collaboration with the young Joseph Mason, assigned to represent the plants and environment of the birds, was crucial, and it is well recognized today that the artistic qualities of certain plates display the talent of this young man as well as that of the master. Audubon often dissected the birds that he managed to shoot. He noted their general state and their amount of fat tissue, examined the contents of their stomachs, determined their sex, and sometimes even, in the case of females, measured the dimensions of their eggs.

The two men explored a vast wooded marsh situated along the Mississippi several miles downstream from Saint Francisville, where they saw a White Ibis, numerous warblers, and many pairs of Ivory-billed Woodpeckers.

When we left the ridges, We at once saw a different Country in Aspect, the Tall White and red Cypress being the principal Trees in Sight with their thousand Knees raising Like so Many Loafs of Sugar—Our eagerness to see the Lake engaged us to force our Way through Deep stiff mud & Watter—We came to it and saw several Large Alligator Sluggishly moving on the surface; Not in the least disturbed by our approach.[6]

This reference makes me think of Lake Martin located in Cajun country, more to the south near Breaux Bridge: my favorite place among those that I discovered in Louisiana. Continuously for two days I sketched there an incredibly profuse colony where Roseate Spoonbills, Great Egrets, Snowy Egrets, Little Blue Herons, and Black-crowned Night-Herons nested among the cypress … under the attentive watch of some alligators.

Audubon didn't discover the coast of Louisiana until during a short trip to Texas in the spring of 1837. On board the *Campbell* he stopped at Grand Terre, in the bays of Bayou Salle, Cote Blanche, and Atchafalaya, before sailing on to Galveston, Texas. Undoubtedly the birds were numerous in these immense marshes, but Audubon did not observe any new species. At this time, no one imagined that one century later this region would be the site of one of the most catastrophic ecological disasters in US history. Levees, erected at the start of the nineteenth century on both sides of the Mississippi River to protect the cities and plantations, were to blame. This containment, which had for a long time

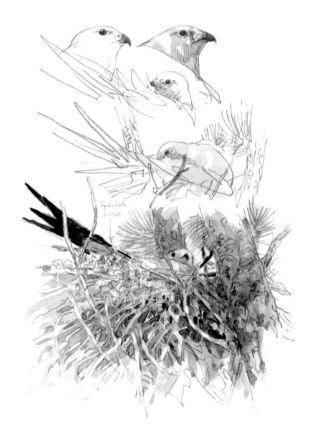

Swallow-tailed Kite on the nest, Pearl River Swamp, Mississippi, April 20, 2003.

PENCIL AND WATERCOLOR, 10.24 × 7.48 IN (26 × 19 CM).

**Summer Tanager, Pearl River
Swamp, Mississippi, April 12 2005.**

PENCIL AND WATERCOLOR, 5.90 × 5.12 IN (15 × 13 CM).

deprived the delta of the silt carried by the river, finally broke the fragile equilibrium between the action of the sea and the natural, indispensable delivery of sediments by the river. More recently the hundreds of miles of canals dug by the petroleum companies have accentuated the salinity and the undermining action of the tides. Result: with the exception of the Atchafalaya Delta, these marshes and lands situated behind have been disappearing for eighty years at the rate of the surface of one football field every hour. The rise in sea level linked to climate change will only accelerate this erosion, while the regional economy linked to coastal and marine resources is already threatened. The extent of this phenomenon is such that it can no longer be remedied within the delta alone. The objective of projects now planned is to restore only some high-priority sections, such as that of New Orleans.

In the spring of 2005 at Point aux Chênes, I met Jay Naquin, an oyster fisherman, and his cousin Richard, a crab fisherman. They are members of the Houma Nation, the Native Americans who lived on the delta when the first Europeans arrived. They speak English but express themselves more often in Cajun. I will remember for a long time these conversations in which the men were using words like "bougres" for people and "piastres" for dollars. What a pleasure to hear these people use old French so naturally.

I sketched Jay working one evening on the banks of Lake Raccourci. He was renting a plot there that allowed him to make a living, but he had no illusions; the current ecological changes were favorable for oyster growth, but that would last for only a while. The next morning at day break, I accompanied Richard to Lake Billiot to see him pull up his traps, not far from Bayou Salle where Audubon stopped for a few hours.

Pointe aux Chêne, April 2012. Two years after the British Petroleum Deepwater Horizon accident in the Gulf of Mexico, I visit again Jay and his wife. Their smiles are as welcoming as ever … but the oysters have disappeared. Behind their place, water as far as the eye could see have replaced the field where in another time the cows grazed and where I had seen their children play baseball. Their decision is made: they are leaving to live farther north, near Houma, to find work there, expecting their house to disappear. As for Richard, still a professional fisherman, he has decided to stay. I meet him in his yard, where he is clearing the mud from his pool, flooded by a recent hurricane.

As for Marceline, Richard and Jay's eighty-five-year-old grandmother who has lived all her life speaking only old French, I join her in her garden among her flowers. She has left her little house, frequently invaded by floodwaters, for another, more spacious, one perched on high pilings.

Audubon lived mostly in Louisiana between 1821 and 1826, usually with his family because Lucy had joined him with the children and found a stable job as a teacher at a big plantation. He stayed in Natchez for a while looking for work, preferring to paint in oils because he was

persuaded that this technique would sell better. In 1823, he traveled to Philadelphia where his watercolors received a mixed reception among scientists. Convinced that his work could not be published in America, he prepared his departure for Europe.

That is how in May 1826, the day before his forty-first birthday, John James Audubon embarked on the *Delos* at New Orleans, destination Liverpool, in the hope of finding in England an engraver and the subscribers that he needed to get his work published.

June 30. We have at last entered the Atlantic Ocean this morning and with a propitious breeze; the land birds have left us, and I—I leave my beloved America, my wife, my children, my friends. The purpose of this voyage is to visit not only England, but the continent of Europe, with the intention of publishing my work on the "Birds of America." If not sadly disappointed my return to these shores, these happy shores, will be the brightest day I have ever enjoyed. Oh! Wife, children, friends, America, farewell! Farewell![7]

On board the ferry, New Orleans, April 17, 2012.

PENCIL AND WATERCOLOR, 7.48 × 9.84 IN (19 × 25 CM).

1. Corning, *Journal of John James Audubon*. Courtesy of Club of Odd Volumes.

2. Swallow-tailed Kites winter far away in South America. One of the birds recently tagged with GPS-tracking technology by Jennifer was hovering the next early November south of the city of Campo Grande in the state of Mato Grosso do Sul, Brazil.

3. The ferry and portico no longer exist. A bridge was built slightly upstream, which now links the two banks.

4. The house at Oakley Plantation and the interpretive center situated just next door are dedicated in memory of John James Audubon and the life in the old plantations of this region of Louisiana.

5. Corning, *Journal of John James Audubon*.

6. Corning, *Journal of John James Audubon*.

7. Audubon and Coues, *The European Journals* in *Audubon and His Journals*.

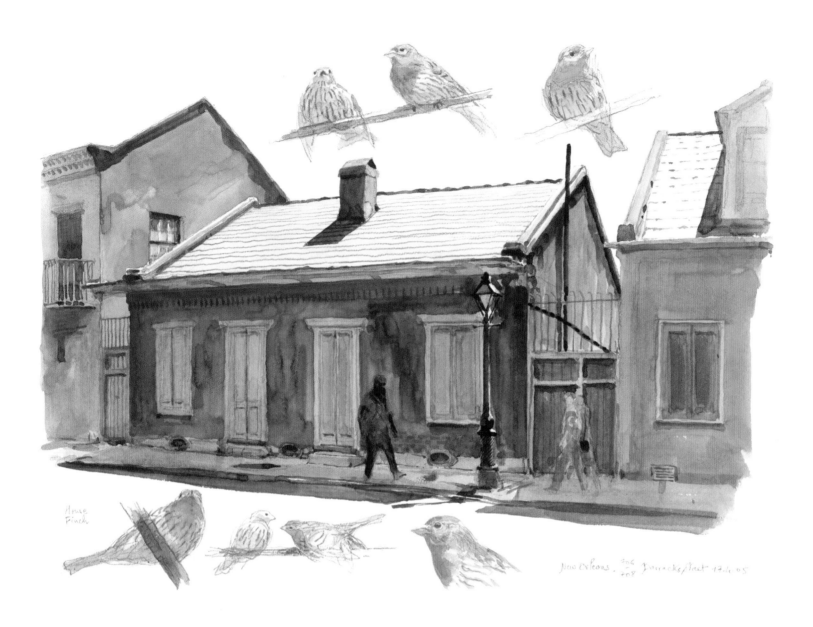

Audubon's house and House Finch, Barracks Street, New Orleans, April 17, 2003.

PENCIL AND WATERCOLOR, 11.42 × 16.14 IN (29 × 41 CM).

COURTESY OF THE NATURAL HISTORY MUSEUM OF NANTES.

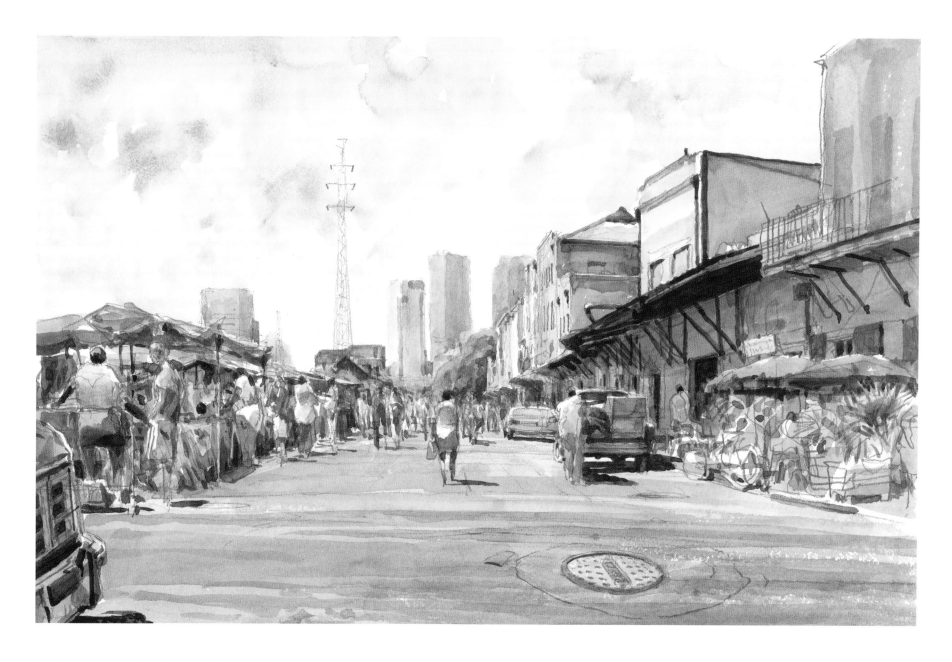

The French Market, New Orleans, April 17, 2003.

PENCIL AND WATERCOLOR, 10.63 × 15.75 IN (27 × 40 CM).

Monday, January 8th 1821. At day breake, went to the market, having received information that much and great variety of game was brought to it. We found vast many Malards, some teals, some American Widgeons, Canada Geese, Snow Geese, Mergansers, Robins, Blue Birds, Red wing Starlings, Tell Tale Godwits.

—Audubon and Coues, *The Mississippi Journal in Audubon and His Journals.*

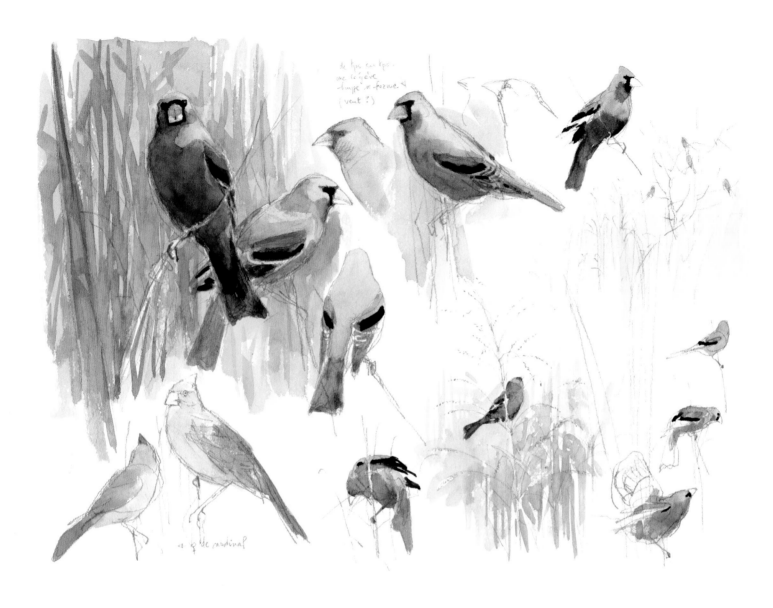

**Blue Grosbeaks and Northern Cardinal, near Venice.
Mississippi Delta, evening of April 21, 2003.**

PENCIL AND WATERCOLOR, 11.42 × 16.14 IN (29 × 41 CM).

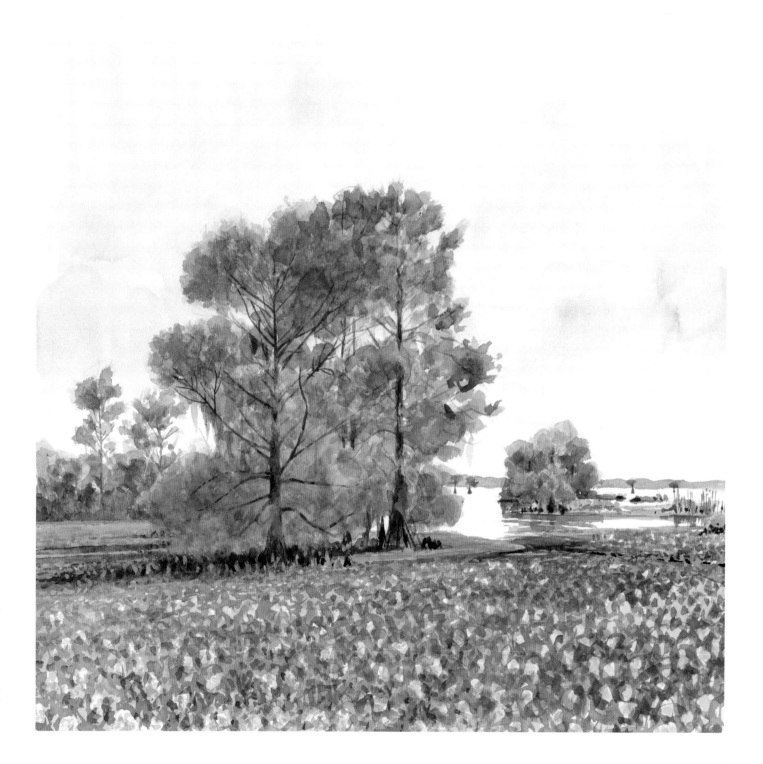

Bald Cypress and Water Hyacinths near Venice, Mississippi Delta, evening of April 21, 2003.

PENCIL AND WATERCOLOR,
15.75 × 15.75 IN (40 × 40 CM).

Water Hyacinth is an invasive plant that forms thick layers over the water and shades out other plants. In this way this species does great damage to the aquatic ecosystem.

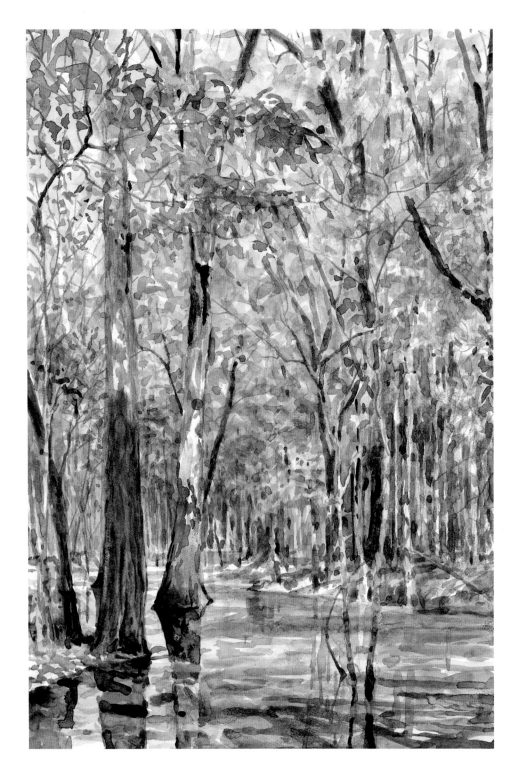

THIS PAGE:
Pearl River Swamp, Mississippi, April 12, 2005.

PENCIL AND WATERCOLOR, 15.35 × 10.24 IN (39 × 26 CM).

OPPOSITE PAGE:
Swallow-tailed Kites, Bayou Teche National Wildlife Refuge, April 12, 2012.

PENCIL AND WATERCOLOR, 11.02 × 15.75 IN (28 × 40 CM).

The Swallow-tailed Hawk pairs immediately after his arrival in the Southern States, and as its courtships take place on the wing, its motions are then more beautiful than ever.

—Audubon, *The Swallow-tailed Hawk* in *Ornithological Biography*, vol. 1.

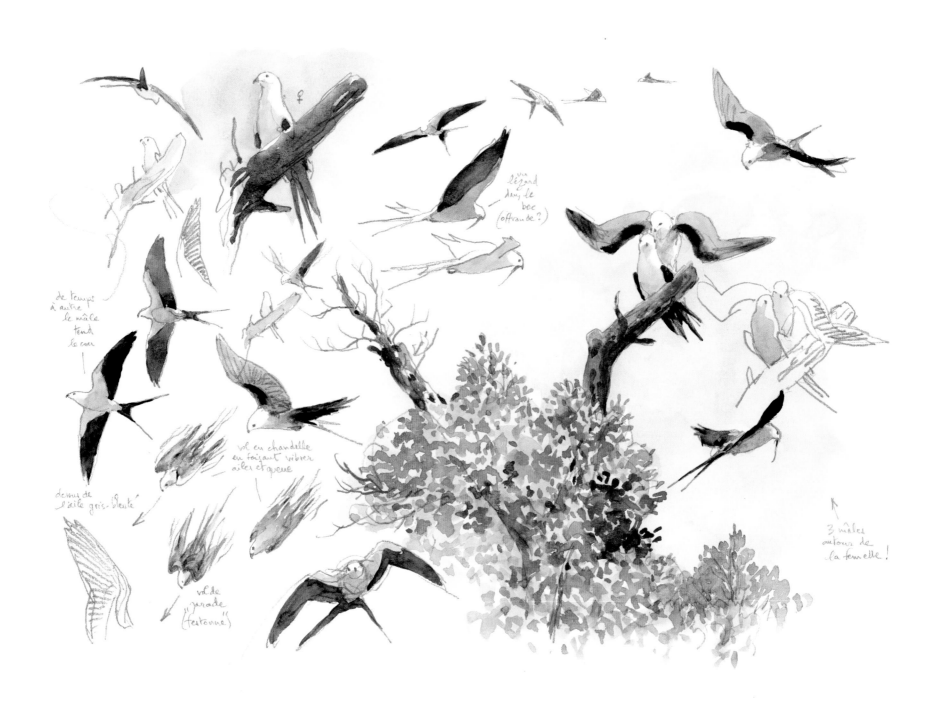

un lézard
dans le
bec
(offrande?)

de temps
à autre
le mâle
tend
le coeur

dessus de
l'aile gris-bleuté

vol en chandelle
en faisant vibrer
ailes et queue

vol de
parade
(festonné)

3 mâles
autour de
la femelle !

75

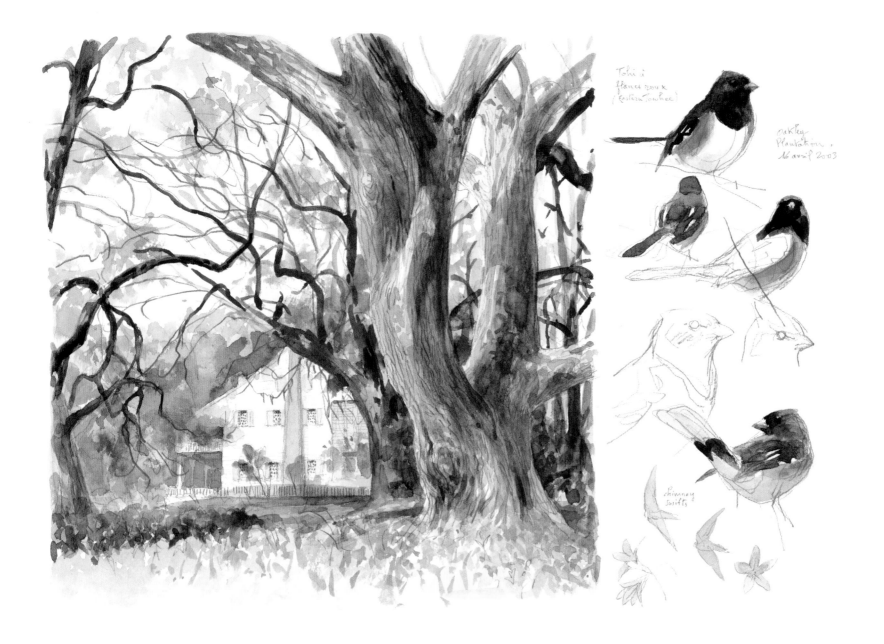

Oakley Plantation, Eastern Towhee, Audubon State Historic Site, Saint Francisville, April 16, 2003.

PENCIL AND WATERCOLOR, 11.42 × 16.14 IN (29 × 41 CM).

COURTESY OF THE NATURAL HISTORY MUSEUM OF NANTES.

It is a diligent bird, spending its days in searching for food and gravel, amongst the dried leaves and in the earth, scratching with great assiduity, and every now and then uttering the notes tow-hee, from which it has obtained its name.

—Audubon, *The Towhe Bunting in Ornithological Biography*, vol. 1.

Audubon's room, Oakley Plantation, Audubon State Historic Site, Saint Francisville, April 19, 2012.

PENCIL AND WATERCOLOR, 10.63 × 15.35 IN (27 × 39 CM).

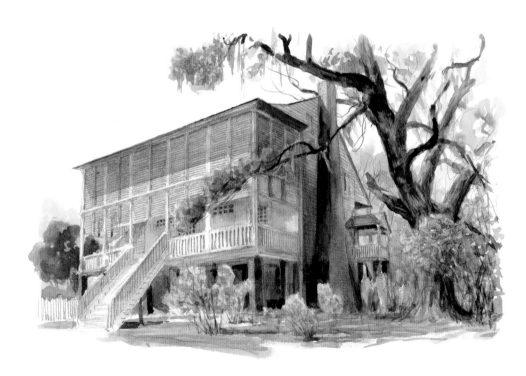

Oakley Plantation, Audubon State Historic Site, Saint Francisville, April 16, 2003.

PENCIL AND WATERCOLOR, 11.42 × 16.14 IN (29 × 41 CM).

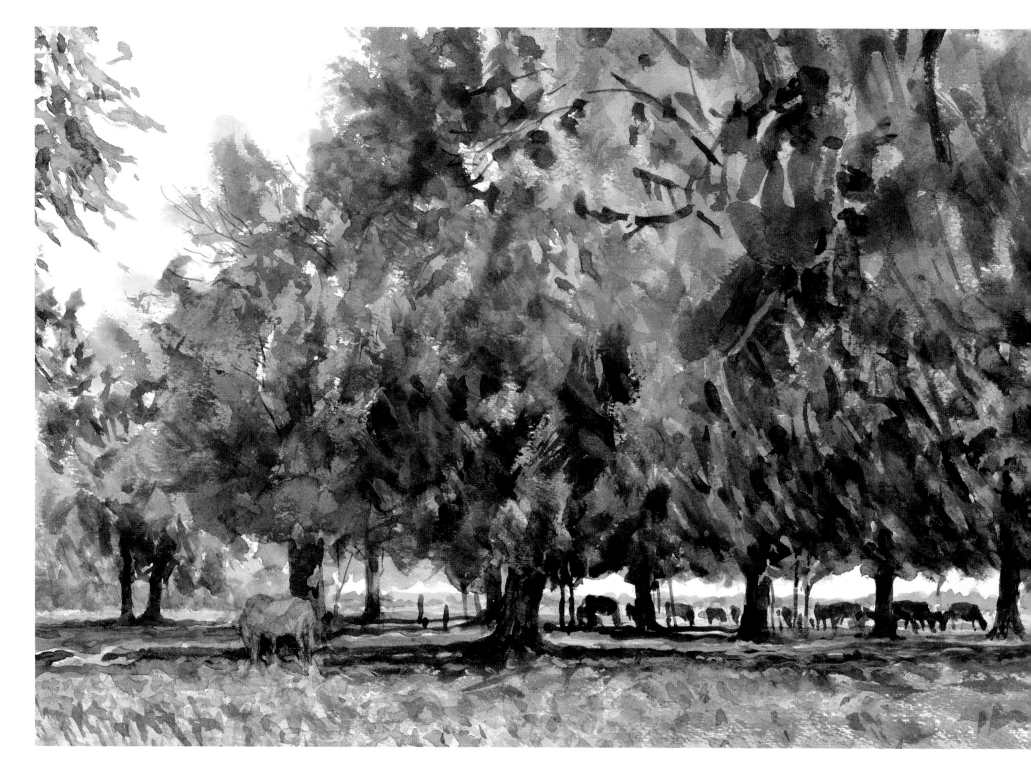

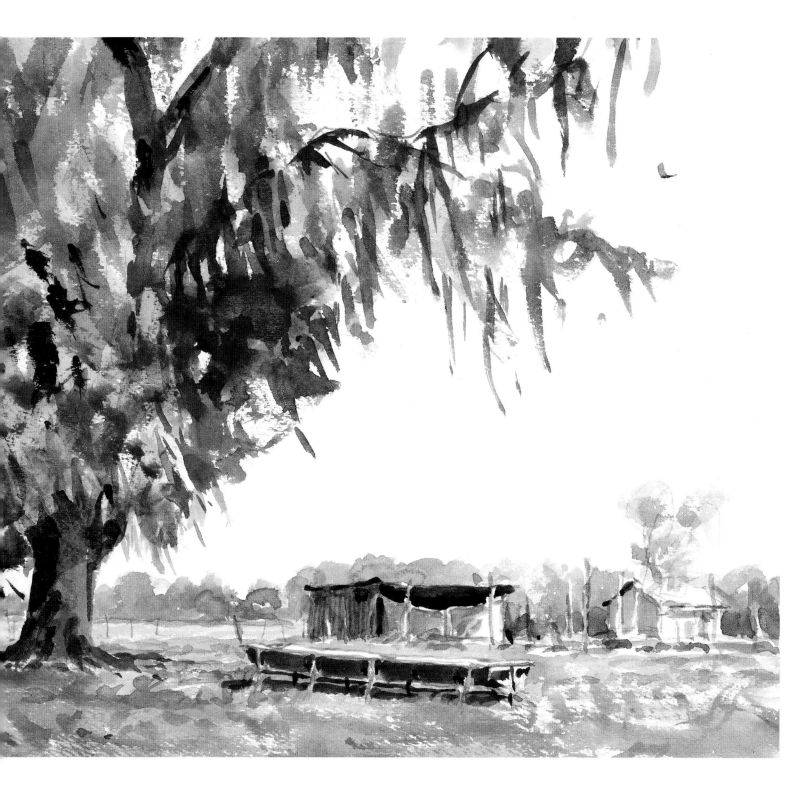

Oaks, Spanish Moss, cattle, and
Turkey Vulture, near Lake Martin,
Breaux Bridge, April 11, 2012.

PENCIL AND WATERCOLOR,
9.84 × 25.19 IN (25 × 64 CM).

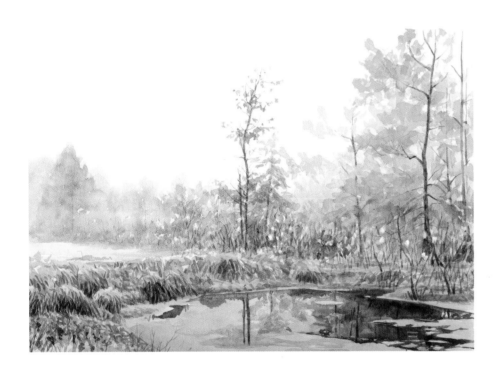

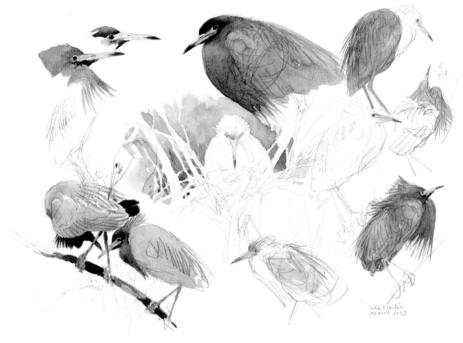

Heronry in the mist (Snowy Egrets, Cattle Egrets, Great Egrets, Little Blue Herons, and Black-crowned Night-Herons), Lake Martin, morning of April 18, 2003.

PENCIL AND WATERCOLOR, 11.42 × 15.75 IN (29 × 40 CM).

The heronries of the southern portions of the United States are often of such extraordinary size as to astonish the passing traveller. I confess that I myself might have been as sceptical on this point as some who, having been accustomed to find in all places the Heron to be a solitary bird, cannot be prevailed on to believe the contrary, had I not seen with my own eyes the vast multitudes of individuals of different species breeding together in peace in certain favourable localities.

—Audubon, *The Little Blue Heron in Ornithological Biography,* vol 4.

Little Blue Heron breeding, Lake Martin, April 18, 2003.

PENCIL AND WATERCOLOR, 11.81 × 16.53 IN (30 × 42 CM).

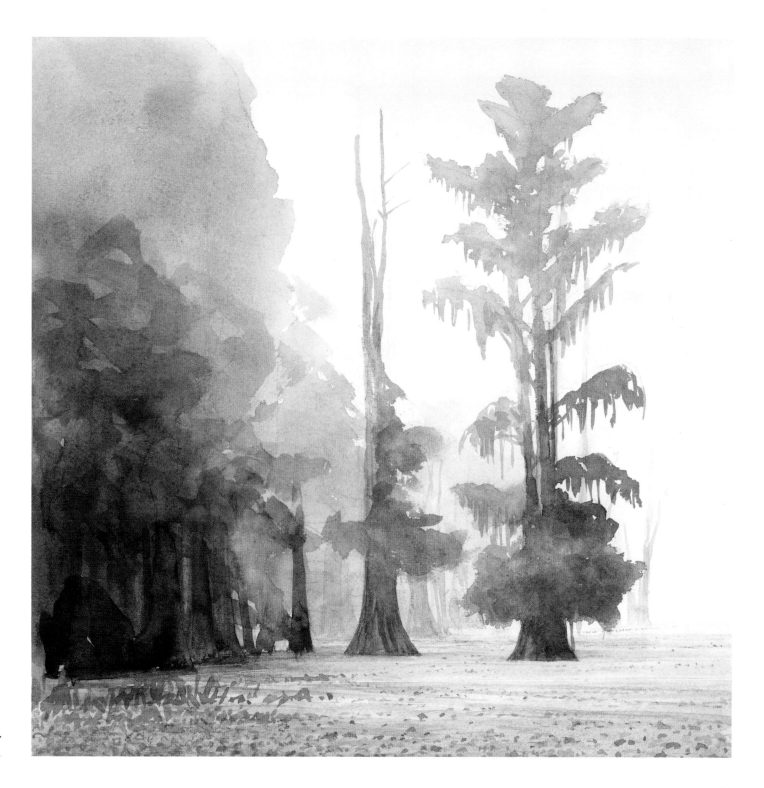

Lake Martin, morning of April 18, 2003.

WATERCOLOR, 11.42 × 11.42 IN (29 × 29 CM).

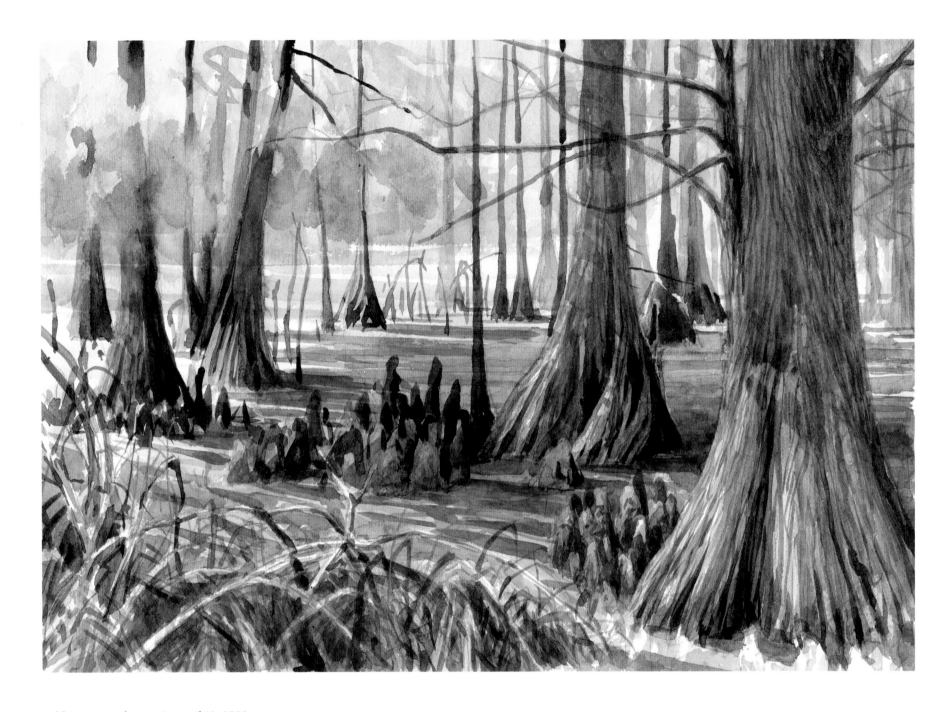

Bald Cypress, Lake Martin, April 18, 2003.

PENCIL AND WATERCOLOR, 11.42 × 16.14 IN (29 × 41 CM).

"Cypress knees," Prothonotary Warbler, small lizard,
and Roseate Spoonbill, Lake Martin, April 18, 2003.

PENCIL AND WATERCOLOR, 11.42 × 16.14 IN (29 × 41 CM).

Study of dragonflies (Green Jacket Skimmer) and White-eyed Vireo, Lake Martin, April 17, 2003.

PENCIL AND WATERCOLOR, 11.42 × 16.14 IN (29 × 41 CM).

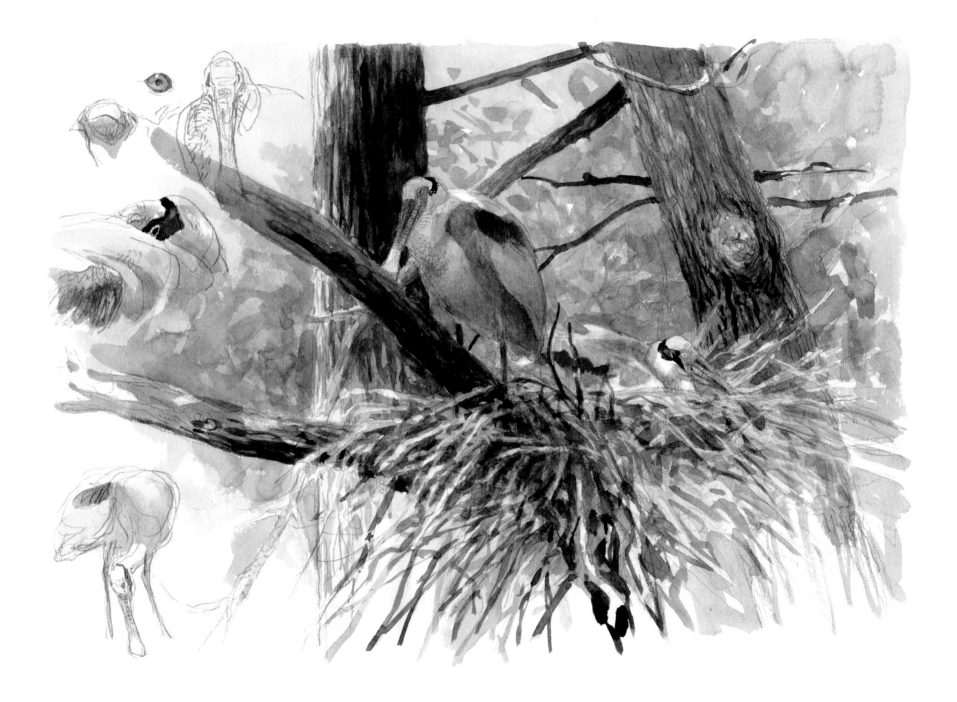

Roseate Spoonbills on the nest, Lake Martin, April 18, 2003.

PENCIL AND WATERCOLOR, 11.42 × 16.14 IN (29 × 41 CM).

Contrary to popular belief, the Roseate Spoonbill does not need to eat crustaceans to maintain its pink coloring; these birds principally eat fish and maintain a pink hue from hatching until death regardless of diet (although the color intensity may change with diet).

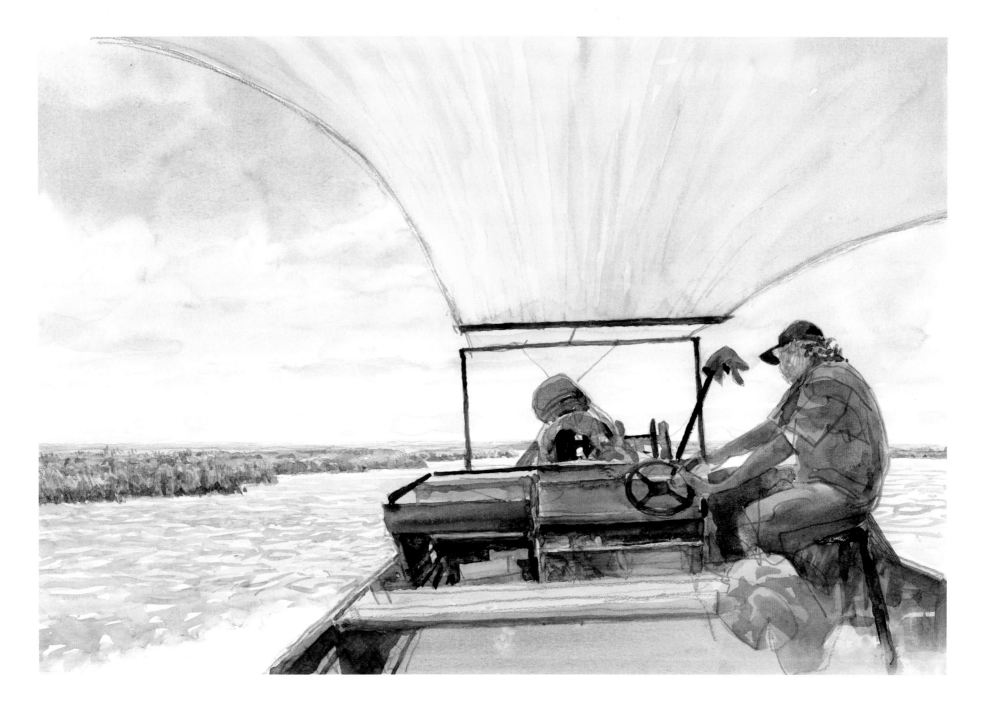

Jay Naquin, a professional oyster fisherman, on the way to his oyster beds, between
Bayou Pointe aux Chênes and Lake Billiot, Mississippi Delta, April 19, 2005.

PENCIL AND WATERCOLOR, 10.24 × 14.96 IN (26 × 38 CM).

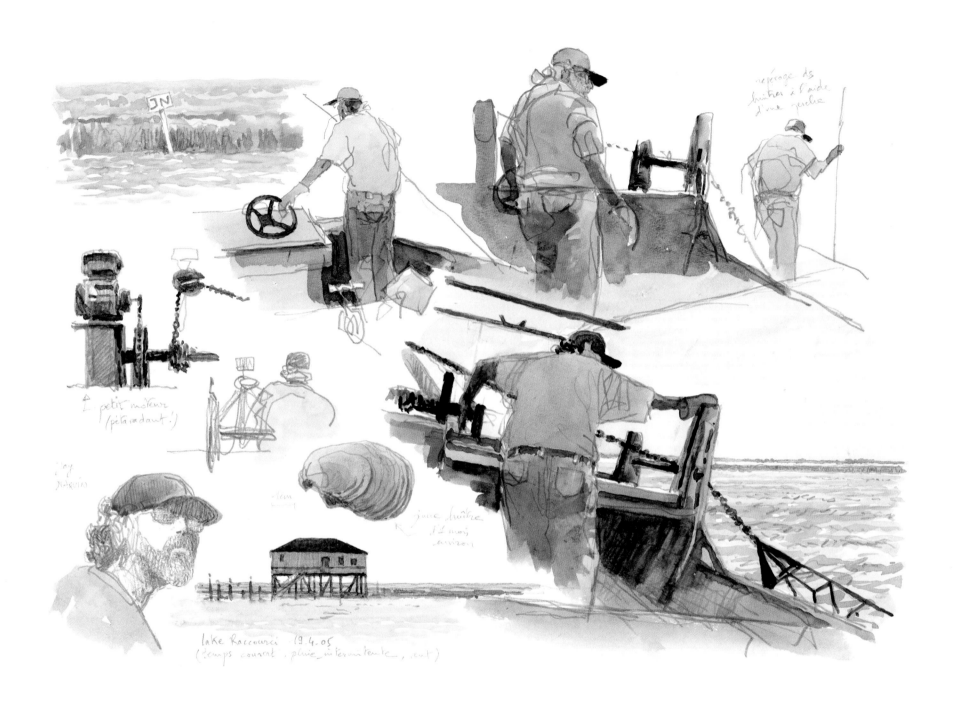

Jay Naquin at work, Lake Raccourci, Mississippi Delta, April 19, 2005.

PENCIL AND WATERCOLOR, 11.02 × 15.75 IN (28 × 40 CM).

Marceline Naquin is cooking "chevrettes" (traditional
shrimp fritters), Montegut, Mississippi Delta, April 20, 2005.

PENCIL, 11.02 × 12.60 IN (28 × 32 CM).

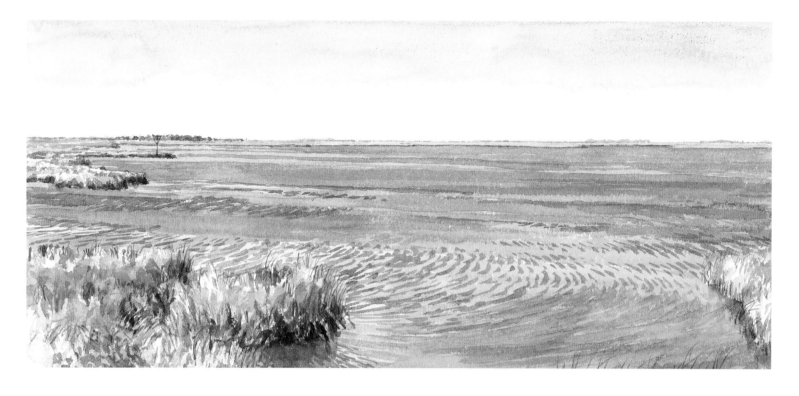

Lake Quitman, near Cocodrie, Mississippi Delta, April 14, 2012.

PENCIL AND WATERCOLOR,
7.09 × 15.35 IN (18 × 39 CM).

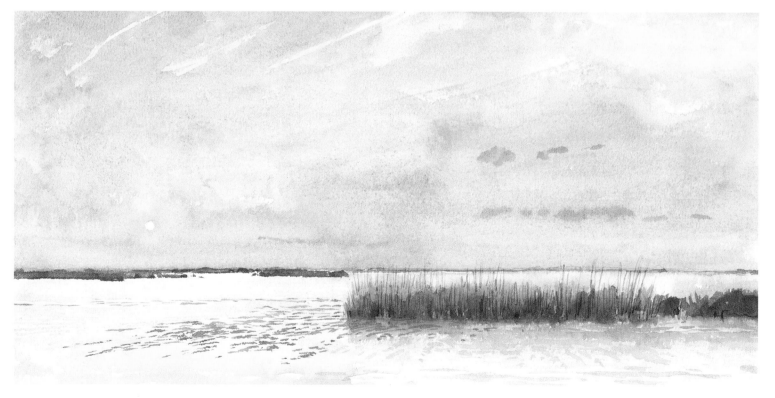

Sunset, between L'île Jean Charles and Pointe aux Chênes, April 14, 2012.

WATERCOLOR,
7.09 × 14.57 IN (18 × 37 CM).

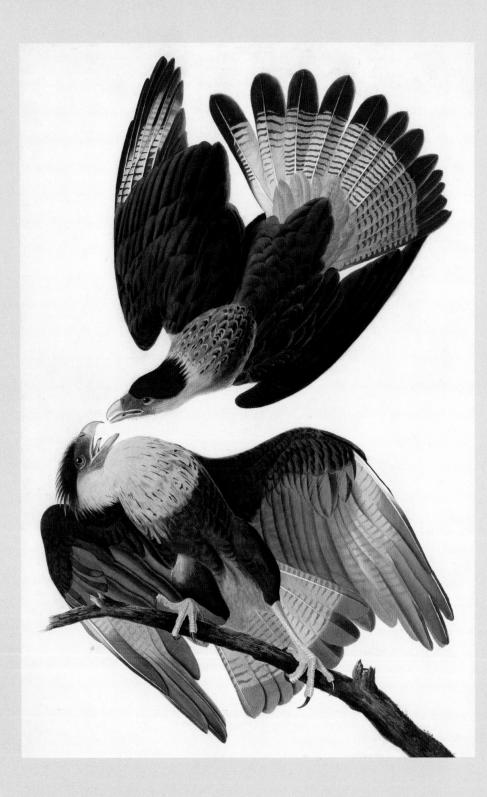

The most remarkable difference with respect to habits, between these birds and the American Vultures, is the power which they possess of carrying their prey in their talons. They often walk about, and in the water, in search of food, and now and then will seize on a frog or a very young alligator with their claws, and drag it to the shore. Like the Vultures, they frequently spread their wings toward the sun, or in the breeze, and their mode of walking also resembles that of the Turkey Buzzard.

—Audubon, *The Crested Caracara in Ornithological Biography*, vol 2.

Crested Caracara, Augustine, Florida, 1831.

John James Audubon.

WATERCOLOR, GRAPHITE, PASTEL AND BLACK INK WITH TOUCHES OF AND GLAZING ON PAPER, 38 × 25 IN (96.5 × 63.5 CM).

(REF 1863.17.161)
COLLECTION OF THE NEW YORK HISTORICAL SOCIETY.
DIGITAL IMAGE CREATED BY OPPENHEIMER EDITIONS.

"LAS FLORIDAS"

SOUTH TO PURSUE HIS DREAMS

Crested Caracara, Kissimmee Prairie Preserve
State Park, near Lorida, Florida, February 2, 2005.
PENCIL, 6.69 × 7.48 IN (17 × 19 CM).

JOHN JAMES AUDUBON visited Florida twice. The first time in the northern part, from Saint Augustine and along the Saint Johns River during the fall of 1831, and the second in the south, all the way to the Florida Keys and Florida Bay during the following spring.

When he disembarked in New York with his family at the beginning of September 1831, after a second long stay in Europe, Audubon had only one idea in mind: to discover the famous "Floridas" in order to observe and paint new species there. He had read, like many others, the famous work by William Bartram, published forty years earlier, entitled *Travels through North and South Carolina, Georgia, East & West Florida*, in which the explorer and naturalist lyrically evokes the landscapes of this paradise, the

American Indians that he met, and the beauty of the plants and animals.

Many things had changed since Audubon's departure from Louisiana. Over the course of the last five years in Europe, essentially in Scotland and England, he had met many more people and displayed his drawings dozens of times. He had been received by the greatest naturalists, among them the famous Baron Cuvier during a trip to Paris, all of whom had commended the artistic and scientific qualities of his watercolors. After having received sufficient subscriptions, he had initiated the publication of *The Birds of America*. The first attempts at printing in Edinburgh with W. H. Lizars not being satisfactory, Audubon then entrusted his works to the excellent London engraver, Robert Havell, and by the end of 1827

91

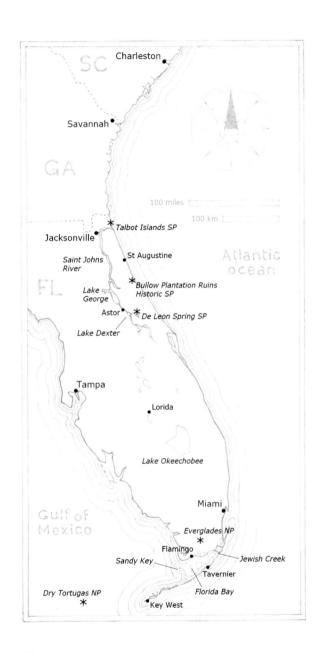

twenty-five plates in Double Elephant folio format had already been published. His growing reputation now allowed him to live reasonably well, to enlarge his subscription base, and to obtain the new letters of recommendation he needed for pursuing his explorations.

Audubon had returned from England accompanied by a young taxidermist, Henry Ward, charged with preparing the animals collected, destined for different private collectors and museums. In Philadelphia he hired George Lehman as well, a Swiss artist, who was responsible for portraying the natural environment and the landscapes around the birds sketched by the master, as Joseph Mason had done for him in Louisiana. This expedition to Florida was possible because a relative peace reigned there since 1818, the year when the first war led by the United States against the Seminoles ended.[1] But Audubon could not travel alone along the coasts of this peninsula, and even less so to the small islands farther south that were still relatively unexplored at this time. He went first to Washington in order to request the logistical support that he needed, which he obtained without difficulty from the Corps of Topographical Engineers, from the Secretary of the Navy, and from the Secretary of the Treasury. This support showed how much his fame had grown.

Audubon was not the first naturalist attracted by the South. Others, more or less known, had already explored parts of Florida. Among them was the Englishman Mark Catesby, who lived in Charleston, South Carolina, and the West Indies from 1712 to 1726. The books that he had published, illustrated by hand, such as the famous *The Natural History of Carolina, Florida and the Bahama Islands*, were basic works that had been republished many times. Also exploring Florida were John Bartram and his son, William, and the Frenchman André Michaux, named Royal Botanist by Louis XVI, who collected plants almost everywhere on the North American continent, gathering numerous specimens for the gardens of his country. Michaux came to Florida in 1789 after having created a botanical garden in Charleston three years earlier. Last, Alexander Wilson himself had already come to this region.

But the hurried man, driven by his grand project, who arrived in Charleston on October 16, 1831, had little interest in the works of most of his predecessors, his personal knowledge of science and history being, in fact, rather limited.

Audubon met John Bachman there, pastor of Saint John's Lutheran Church and, incidentally, a very good naturalist. This cultivated man had grown up in Philadelphia, spending a part of his childhood leisure time in the garden of William Bartram. Bachman, his wife Harriet, and their numerous children warmly welcomed the travelers to their large house and Audubon hastened to write to Lucy:

We removed to his house on a crack—found a room already arranged for Henry to skin our birds—another

for me and Lehman to draw and a third for thy husband to rest his bones in on an excellent bed![2]

He added in another letter, about his host: *We laugh and talk as if we had known each other for twenty years.*[3] This was the start of a deep friendship, and the two men shared for a long time, without rivalry, their passion for nature.

They explored until November of that year the areas surrounding the city, even organizing a small expedition to the coastal islands. But Audubon didn't forget Florida or his ambitious objective on which he was fixated before returning to England:

My mind was among the birds further South—towards Floridas, Red River, Arkansas, that unknown country California and the Pacific Ocean. I felt drawn to the untried scenes of those countries and it was necessary to tear myself away from the kindest friends.[4]

On this day in February 2005, I discover Charleston from Harbor View Road, just beyond James Island, and I am struck by the flatness of this city surrounded by water. The marsh vegetation undulates in soft waves under the influence of the wind. A canal forms large meanders along which a construction barge slowly advances upstream. Farther to the north, on the other side of the Ashley River, the city extends without skyscrapers, which is surprising. With the exception of the recently opened Arthur Ravenel Bridge, whose futuristic lines

soar very high in the distance, only the church steeples emerge from the roofs and over the tallest trees. Charleston doesn't seem to have changed since the meticulous representation that Lehman painted in 1831 as the landscape of Audubon's Long-billed Curlew plate. However, the different parts of his composition are far closer together than in reality. Fort Sumter is represented not far from the city when in fact it lies much farther to the east, toward the ocean, near the opening of the bay.

I drive out to one of the coastal points closest to this fortress classified as a national monument, where Union army troops suffered the first cannon shots of the Civil War thirty years after Audubon's visit. Some Oystercatchers fly by. Farther away I observe a hundred small shorebirds grouped together at low tide on a mudflat: Dunlins, Western Sandpipers, Least Sandpipers, and Semipalmated Plovers. Most of them doze on one foot, eyes half closed; some bathe or groom their feathers. While I sketch, a man approaches with curiosity. He smiles discovering what I am doing, then tells me with big gestures about the birds that he knows.

I return to Charleston in the evening under the rain. From inside my car through a half-open window, I sketch Saint John's Lutheran Church, along Clifford Street, where Bachman carried out his ministry for nearly sixty years. Two Mourning Doves peck the wet asphalt of the parking lot. The next day I roam the streets of the city center overrun with tourists. Beautiful houses line the

Talking about birds, near the Grice Marine Laboratory, Charleston, South Carolina, February 14, 2003.

CHARCOAL, 6.30 × 6.30 IN (16 × 16 CM).

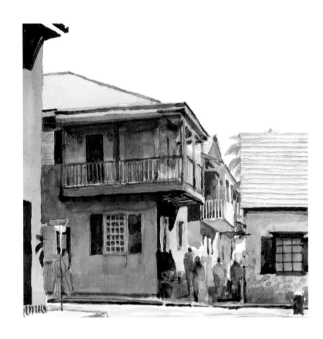

Saint Augustine, February 10, 2005.

Saint Augustine was founded on September 8, 1565, by Spanish admiral Pedro Menéndez de Avilés, the first governor. It is considered as the oldest continuously settled city in the United States.

old streets, some of which, narrow and paved with stones, look like the old neighborhoods of Nantes. I visit the Charleston Museum, the oldest in the United States, founded in 1773, where I discover, fixed along a wall, some birds collected in the eighteenth century by Mark Catesby. The names indicated are probably those used at that time: "The Red-wing'd Starling" (Red-winged Blackbird), "The Large Lark" (Eastern Meadowlark), "The Fox Coloured Thrush" (Brown Thrasher), and "The Blue Linnet" (Indigo Bunting). One of the displays presents a Bachman's Warbler's nest, a species believed extinct today that the reverend discovered in a nearby marshy forest.

Impatient, excited by his new adventure, Audubon embarked on November 15, 1831 with his two companions and his dog, Plato, aboard the coaster Agnès, which linked Charleston with Saint Augustine. *The wind was fair, and we hoisted all sails for the Floridas.*[5]

February 9, 2005, Little Talbot Island State Park, Florida. I set up at the end of a small wooden bridge overlooking the beach to paint the sea and the dunes, which extend to the north as far as the eye can see. The light wind makes me think of the taut sails of the Agnès. I imagine the boat in profile slipping slowly past offshore. Everyone aboard must have sighted the recently constructed lighthouse built to indicate the entrance to the Saint Johns River and the sandbars at its mouth.

The next day I go to Saint Augustine, Florida, with Robin Arnold, a musician friend, ornithologist in his spare time and horn player with the Jacksonville Philharmonic Orchestra. We wander in the little streets of the oldest city of the United States, established by the Spanish in 1565. It is very hot. We pass from one shadow to another under the old, restored wooden balconies. Audubon was very disappointed upon arriving here. *The poorest hole in the Creation*, he wrote to Lucy.[6] Saint Augustine reminded him of certain old villages in France. The population was composed of fishing families, mostly poor. The narrow streets, covered in sand and bordered by orange trees, were dirty, without doubt smelly, used as much by the pigs as by people. Groups of vultures were also seen there, which at the time shocked the visitors, especially those coming from Europe.

Audubon stayed three weeks in this city, exploring the surrounding areas in search of new species.

When we have nothing on hand to draw, the guns are cleaned overnight, a basket of bread and cheese, a bottle with old whiskey, and some water, is prepared. We get into a boat, and after an hour of hard rowing, we find ourselves in the middle of most extensive marshes, as far as the eye can reach. The boat is anchored, and we go wading through mud and water, amid myriads of sand-flies and mosquitoes, shooting here and there a bird, or squatting down on our hams for half an hour, to observe the ways of the beautiful beings we are in pursuit of.[7]

Audubon finally spotted an unknown bird near the small San Sebastian River, but after several days of unsuccessful searches and missed rifle shots, he abandoned the quest. Ward continued the search … and returned the next day with the famous bird! Audubon rapidly made a study sketch of it because the heat quickly altered the cadaver and colors of the feathers. It was a large-sized bird of prey, *an exotic bird, probably very common in South America, but quite unknown to me or anyone else in this place.*[8] He learned later that it was a Crested Caracara.

We return to Jacksonville at the end of the afternoon, by logging trails that Robin knows well. We drive alongside numerous wetlands before stopping near a pond where a beautiful light gives me the desire to paint. Robin turns on the sound system of his car, and the first notes of Dvořák's *New World Symphony* spread over the area. The sound—loud—bothers me. Then, with time, in a surprising way, the music becomes in tune with this place. Curiously, the very last touch of the brush coincided with the last notes of the symphony. …

February 11. Here I am at Saint Augustine again to draw the Castillo San Marcos. Some Ruddy Turnstones overwintering in the region rest at the foot of the ramparts. The sun shines but the wind has strengthened—glacial. Farther south, after having visited the ruins of John Bulow's old property—a young planter who warmly welcomed Audubon for several days— I go to the famous springs of Spring Garden,

located about thirty miles away. I try to follow the same route that Audubon took when he made this trip in one day on horseback in January 1832. I paint the dark waters of Hawk Creek, which he had a hard time crossing because it was wide and divided in some places. I stop where the little roads cross ancient American Indian trails, and I sketch in charcoal these trails that disappear under the pines and palms. Audubon was disappointed by this immense forest without birds. He went by boat the next day as far as the Saint Johns River, crossing Woodruff and Dexter Lakes, whose banks and small islands were covered with wild orange and other magnificent trees. But despite all of this beauty he felt depressed in this endless labyrinth of water, marshes, and flooded forests in the middle of these monotonous and silent stands of pine. He found that Florida resembled very little the "Garden of America" of which he had dreamed.

A few weeks later, he was able to embark on board the *Spark*, a war vessel commissioned to go up the Saint Johns River in order to take an inventory of the most interesting oak trees for naval construction. But after various technical problems arose on the boat, Audubon decided to return by his own means to Saint Augustine: more than thirty-five miles by foot, one day and one night in a violent storm. His dog Plato led the way, sniffing out the trail drawn through low vegetation, often dense and thorny. *Plato was now our guide, the white spots on his (coat) being the only objects that we could discern.*[9]

Golden Silk Spider, "Banana spider," Bulow Plantation Ruins Historic State Park, October 28, 2005.

PENCIL AND WATERCOLOR, 8.66 × 3.54 IN (22 × 9 CM).

Jacksonville, October 2005. For the twentieth anniversary of the Nantes–Jacksonville sister cities program, I exhibit a series of watercolor paintings at the Cummer Museum. This evening, the museum has organized an auction of artwork donated by artists to the association Saint Johns Riverkeeper. I responded to this request in order to support the people who work year-round to educate the local public and to preserve the river ecosystem.

My friend, Philip Petersen, professor of biology and ecology at Florida State College, suggests a canoe trip on the Saint Johns River while waiting for the auction. We paddle along one of the banks under the gently swinging Spanish Moss. He tells me about trying ten years ago to find *Franklinia alatamaha*, also called "Lost Camellia." This tree was first discovered in 1765 by John and William Bartram a little farther to the north, in Georgia, and has not been seen again in the wild since 1803. Happily, the magnificent flowers of this American tea plant still bloom in gardens thanks to the seeds that these two botanists planted in Philadelphia. Philip tells me that for three weeks he paddled, exploring every corner of the river, going upstream as far as possible toward its source … without success. Among his most fascinating memories are the astonishing ancient dirt mounds built up along the river. Several yards high, sometimes as large as a football field, these elevations are composed of debris accumulated over many centuries by the American Indians: shells of mussels, oysters,

Purple Gallinule, Anhinga Trail, Everglades National Park, February 5, 2003.

PENCIL AND WATERCOLOR, 3.15 × 3.15 IN (8 × 8 CM).

clams, and snails, turtle shells, alligator and manatee bones. *What a wonderful place to camp when the world around you is marsh and water as far as the eye can see!* exclaims Philip.

I slept peacefully many a night under the palms atop a shell midden knowing that I was high and dry, enjoying the gentle breeze off of the marsh and feeling connected with the native peoples of this fascinating land.

But where are the alligators? I don't see any of them, while the water teemed with them when Audubon was here aboard the Spark, to the point that he prevented Plato from going into the water for fear that he would be devoured. William Bartram was also surprised by their number and size. The description that he made of these reptiles, assembled by the hundreds in a narrow passage of the river at the moment of the trout migration, constitutes one of the most memorable passages of his book:

I have seen an alligator take up out of the water several great fish at a time, and just squeeze them betwixt his jaws, while the tails of the great trout flapped about his eyes and lips, ere he had swallowed them. The horrid noise of their closing jaws, their plunging amidst the broken banks of fish, and rising with their prey some feet upright above the water, the floods of water and blood rushing out of their mouths, and the clouds of vapour issuing from their wide nostrils, were truly frightful.[10]

Audubon returned to Charleston in March 1832, disappointed by this first expedition in Florida despite twenty-nine sketches, eleven complete studies of both male and female specimens, the most famous of which is that of the "snake-bird," the Anhinga, without mentioning the five hundred skins destined for both private and museum collections and the boxes filled with shells and amazing seeds. Lucy was becoming impatient in Louisville, where the winter was harsh. She was also anxious about the idea that her husband might linger in the South during "fever season." Her son John was often sick, and Victor was working as much as he could to earn a bit of money. Audubon attempted to reassure her, conscious that an important stage of his work might be playing out here in the South. By chance, and thanks to the president of the United States, Andrew Jackson himself, a second expedition south was made possible. Audubon embarked with Lehman, Ward, and Plato on the Marion, a Coast Guard vessel, on April 19, 1832, for a six-week exploratory mission among the Florida Keys and in Florida Bay.

At this time the population of the Florida archipelago was limited to a few administrative representatives, some fishing families, some wreckers, as well as some descendants of buccaneers, smugglers, and other pirates. As for the birds, there was a profusion of them. Audubon marveled at what he discovered. On the island of Indian Key, the day of his forty-seventh birthday, he drew a Double-crested Cormorant

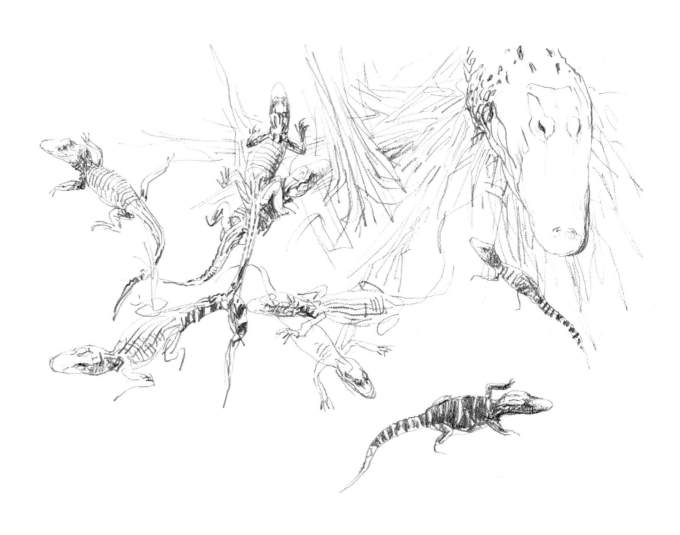

Alligator, adult and young, Anhinga Trail, Everglades National Park, February 8, 2003.

PENCIL, 9.84 × 15.35 IN (25 × 39 CM).

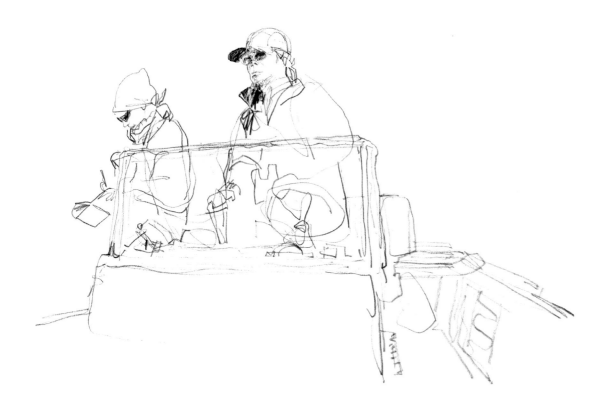

Brennan Mulrooney and Brynne Langan making an inventory of the bird species present in the lagoon, near Calusa Key, Florida Bay, February 3, 2005.

PENCIL, 9.45 × 14.57 IN (24 × 37 CM).

small boats he needed to explore from one small island to another. Strobel accompanied Audubon only once but was impressed by the energy and perseverance with which the naturalist pursued his research from daybreak to evening without letting any pond, lake, or marsh go unexplored.

May 7, Audubon was thrilled to see a flight of American Flamingos, but he wasn't able to collect a single one of them. He had to be content with a specimen in the London Museum to accomplish his plate of this species. Guided by John Egan, a wrecker who knew well the birds, the currents, and the shallows of Florida Bay, he spotted an unknown heron which he called the "Great White Heron." His companions brought him some live specimens that vigorously struggled; one of them even pecked at Plato's nose! In this way Audubon was able to draw this bird, believing that he had discovered a new species … but, in reality, it was the white form of the Great Blue Heron. As for Lehman, he represented the landscape around the heron with the small houses of Key West on the horizon.

Several times the *Marion* passed boats loaded with birds' eggs. The "eggers," looters coming most of the time from Havana, ravaged the nesting colonies. Audubon noted one day: *They had already laid in the cargo of about eight tons of the eggs of Sooty Terns and Brown Noddies.*[11]

Florida Bay, February 2005. Motor stopped, our boat slowly drifts between Crane Key and Captain Key, pushed by the sea breeze and currents. In the company of Brennan Mulrooney

among the thousands that nested there in the mangroves. He made studies of the Roseate Tern, the Brown Pelican, the Tricolored Heron, and a couple of White-crowned Pigeons over the course of the following days.

The *Marion* stopped several times at Key West, situated at the very end of the archipelago, where Audubon met Benjamin Strobel, military doctor … and the brother-in-law of Harriet Bachman. Strobel allowed him the use of personnel and the

and Brynne Langan, biologists at the Tavernier Audubon Research Center, I observe for the first time a Reddish Egret. The bird moves about with grace in the clear water. He shakes the water off himself, intrigued by our silent presence, but he doesn't take off. The wide lagoon extends all around us. A Bald Eagle soars before a large dark cloud. The changing sky and the shallow water enhance the effects of the light and create astonishingly varied minimalist landscapes where only the dark splotches of wooded islands mark the horizon. I paint while Brennan and Brynne take water samples. We berth at Calusa Key, its center occupied by a small brackish lake, nearly dry at this time of year but very interesting for ornithological surveys.

The director of the research center, Jerry Lorenz, organized a surprise for me the following day. In the company of Cara Dickman, in charge of educational programs at Everglades National Park, we take off by boat for the long bay crossing to Sandy Key to study a colony of Roseate Spoonbills, a species of which Jerry is a recognized specialist. This outing will allow me to spend several hours on the island where Audubon stopped on his return voyage from the Dry Tortugas, after having observed marine turtles laying their eggs and innumerable colonies of marine birds on this archipelago situated far offshore.

The weather is cool and unstable. Jerry pilots the boat with precision in an invisible maze of shallow water and channels. Between two showers, without taking his eye off reference points that only he knows, he tells me of his first memories of the area. As a student coming from Northern Kentucky University, he returned from one of his first days in Florida Bay, burned by the sun and covered with insect bites. At that time, the unique ecology of the Everglades and the lagoon were already profoundly affected by a lack of fresh water because a large part of the fresh water that for centuries had flowed into the porous soils of the northern regions of the state was being rerouted to canals for agricultural use and the urbanization of the coast. Certain canals led to the bay, but the water was discharged in unsuitable locations and at the wrong times of the year. Algae invaded, and the seagrass beds and micro-organisms necessary for all other forms of life—fishes, manatees, birds, dolphins, crocodiles—disappeared little by little. But over the last fifteen years the economic consequences of this environmental disturbance and the accumulated knowledge of scientists have pushed the local and federal agencies, the US Army Corps of Engineers and the South Florida Water Management District charged with the construction and maintenance of the canals, to react.

As Sandy Key appears in the distance, Jerry relates with some pride that in 2000 the US Congress approved an ambitious program, the Comprehensive Everglades Restoration Plan. *We are nowhere near achieving true restoration and the Bay still has more than its share of ecological problems but it is in better shape than it was in the 1990s.*

Reddish Egret, Florida Bay, February 3, 2005.
PENCIL AND WATERCOLOR, 5.51 × 8.26 in (14 × 21 cm).

Pa-hay-okee road
bde du 8 2 03

Southern Toad, Pa-Hay-Okee Road,
Everglades National Park, February 8, 2003.
PENCIL, 5.12 × 6.30 in (13 × 16 cm).

Raccoon looking for food along the shore near Fort Caroline, Jacksonville, October 25, 2005.

PENCIL AND WATERCOLOR, 8.66 × 16.14 IN (22 × 41 CM).

We approach the island with the help of GPS. I distinguish on the screen the channel that we have to take appearing ever narrower and more winding. Jerry drops anchor, leaving enough distance to avoid being grounded at low tide. We walk ashore holding our backpacks over our heads, the water waist high. Upon arriving here Audubon was stunned by the abundance and the diversity of birds, mostly nesting or scattered over the mudflats uncovered by the tide: thousands of godwits, egrets, herons, and ibis, not to mention frigatebirds, gallinules or moorhens, and countless others. But—and it is a part of his life that is difficult to understand today—he spent most of his time killing as many birds as he could with his companions before setting course for Key West and then returning to Charleston.

Each of us, provided with a gun, posted himself behind a bush, and no sooner had the water forced the winged creatures to approach the shore than the work of destruction commenced. When it had length ceased, the collected mass of birds of different kinds looked not unlike a small haycock.[12]

Today the cold, the wind, and the rain make it difficult to paint with watercolor, but it doesn't matter. The smell of the ocean, the trees agitated by the storm, and my being surrounded by the sound of the waves are so exciting. As for Jerry and Cara, half submerged under the branches of the mangrove, they observe, count, and take notes. I notice a group of Sanderlings that are resting on a sheltered point, a brief rest for these migrants during their long voyage between Chile and Canada. At the very end of the island, hundreds of White Pelicans resting in the shallows trace an abstract line under a leaden sky. Some of the spoonbills brood whereas others come and go in acrobatic flight between the gusts.[13]

Just before going back to the boat Jerry shows me a nest where an adorable pink spoonbill chick is nestled.

Roseate Spoonbills, near Flamingo, Everglades National Park, February 4, 2003.

WATERCOLOR, 3.94 × 6.69 IN (10.5 × 17 CM) OR 5.51 × 10.63 IN (14 × 27 CM).

1. Two more wars followed in Florida during the nineteenth century in an attempt to force the entire Seminole people to move beyond the Mississippi River, but to no avail.

2. Corning, Letters of John James Audubon. Courtesy of Club of Odd Volumes.

3. Corning, *Letters of John James Audubon*.

4. Herrick, *Audubon the Naturalist*.

5. Herrick, *Audubon the Naturalist*.

6. Herrick, *Audubon the Naturalist*.

7. Herrick, *Audubon the Naturalist*.

8. Corning, *Letters of John James Audubon*.

9. Audubon, Ornithological Biography.

10. Bartram, *The Alligators* in *Travels*.

11. Audubon, *Ornithological Biography*.

12. Audubon and Coues, *The Florida Keys II* in *Audubon and His Journals*.

13. The spoonbills no longer nest on Sandy Key, mainly because of climate change. The average sea level has increased by about 3 inches between 2000 and 2015 in Florida Bay, profoundly affecting the ecosystem and bird nesting. The spoonbills have formed new colonies on the continent, in this way adapting, more or less, to their new living conditions.

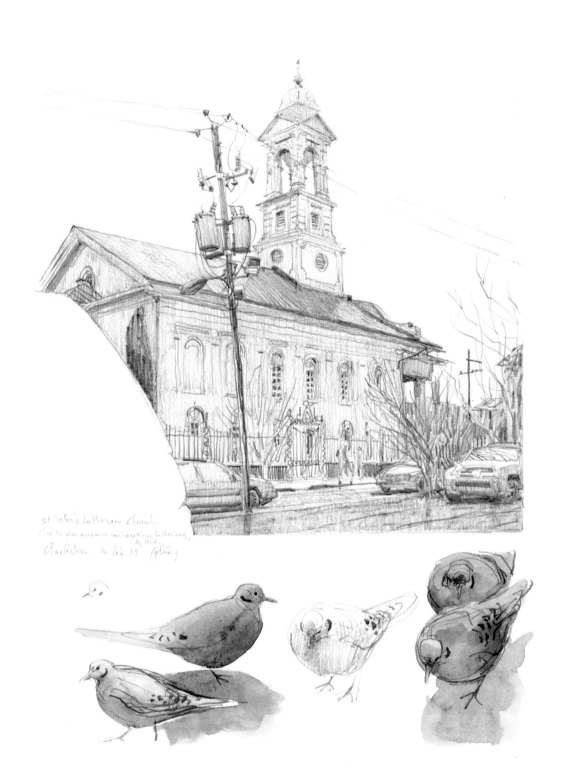

St John's Lutheran Church
Plus ancienne congrégation luthérienne,
du USA.
Charleston 14 fév. 05 (pluie)

**Saint John's Lutheran Church and Mourning Doves,
Charleston, South Carolina, February, 14, 2005.**

PENCIL AND WATERCOLOR, 14.17 × 10.24 IN (36 × 26 CM).

Reverend Dr. John Bachman was the pastor of the church,
built in 1818, and one of Audubon's best friends.

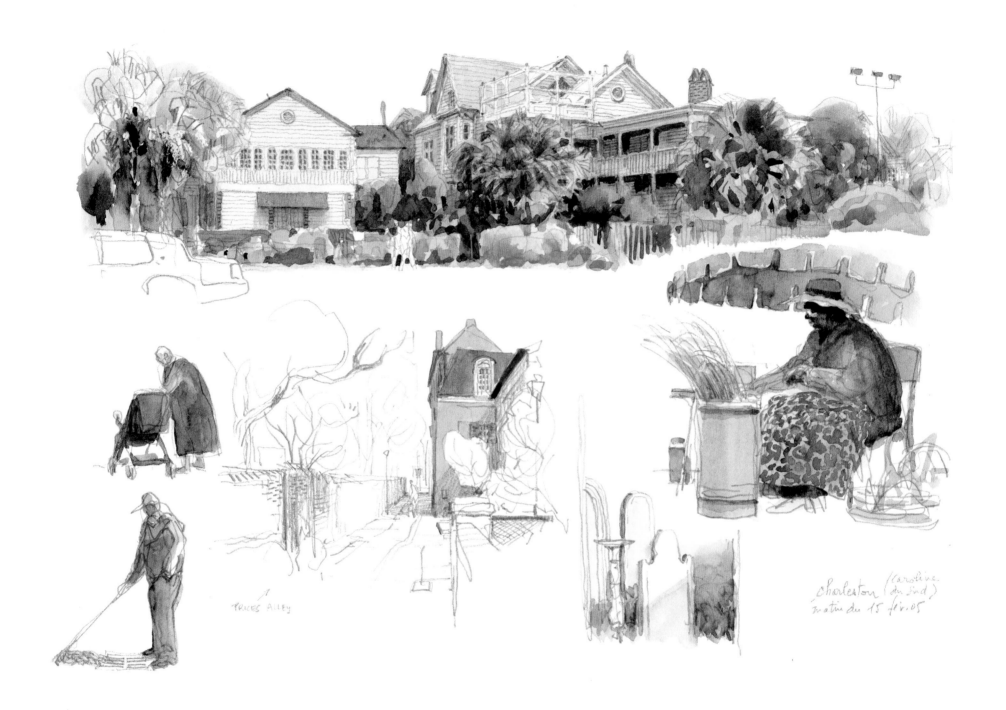

Charleston, February, 15, 2005.

PENCIL AND WATERCOLOR, 11.02 × 16.14 IN (28 × 41 CM).

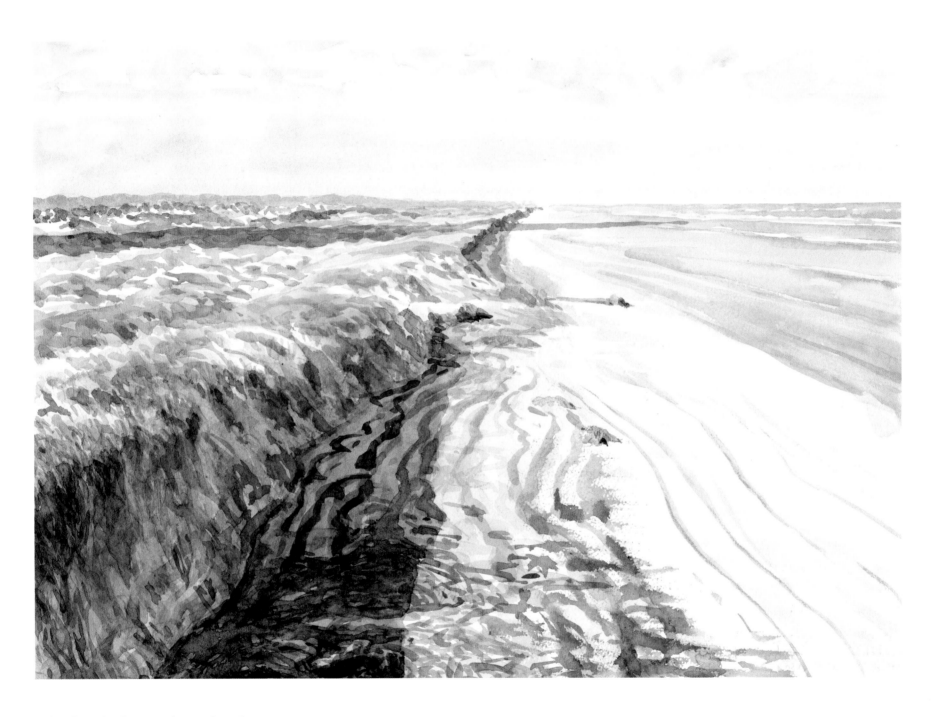

Little Talbot Island State Park, near the Saint John's River mouth, Florida, February, 9, 2005.

PENCIL AND WATERCOLOR, 11.02 × 14.96 IN (28 × 38 CM).

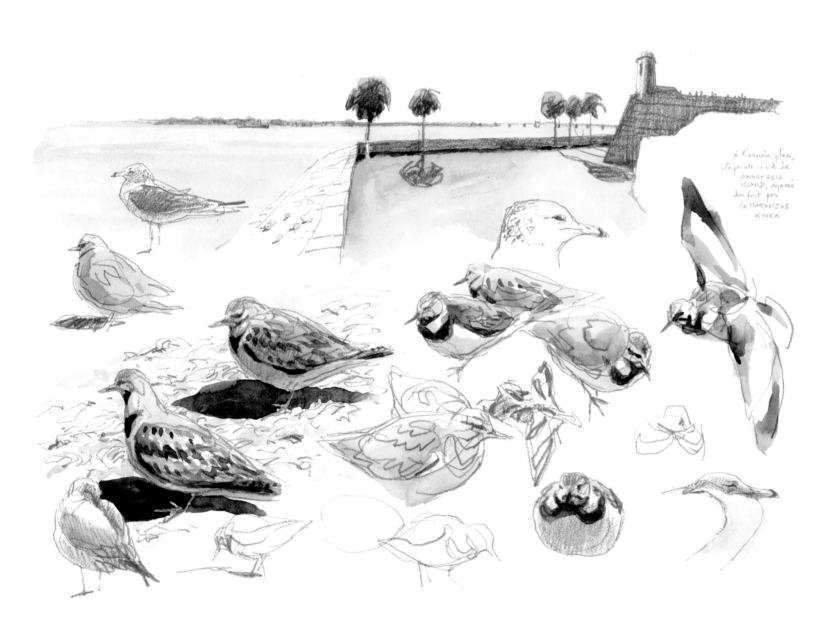

à l'arrière-plan,
la pointe nord de
ANASTASIA
ISLAND, séparée
du fort par
la MATANZAS
RIVER

**Ruddy Turnstones and Ring-billed Gulls resting on the wall of
the Castillo San Marcos, Saint Augustine, February 11, 2005.**

PENCIL AND WATERCOLOR, 10.63 × 16.14 IN (27 × 41 CM).

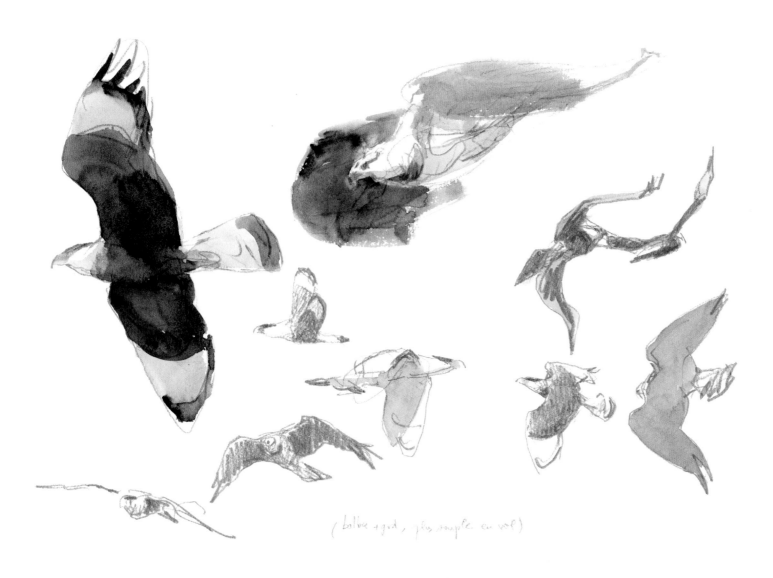

(bibe + gut, plus ample en vol)

**Crested Caracara attacked by an Osprey, Kissimmee Prairie
Preserve State Park, near Lorida, February 7, 2005.**

PENCIL AND WATERCOLOR, 9.84 × 13.78 IN (25 × 35 CM).

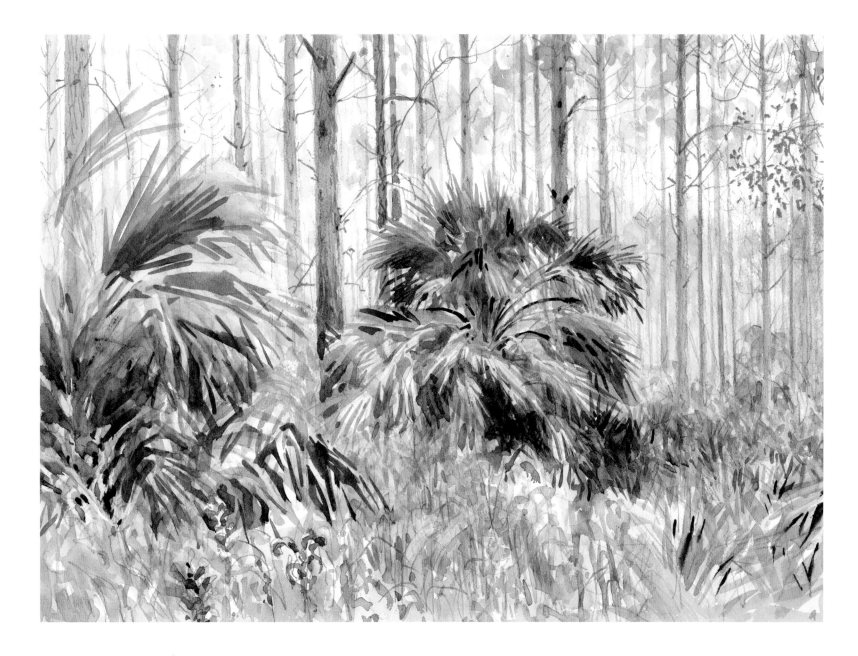

Pine forest near Astor, Lake County, February 8, 2005.

PENCIL AND WATERCOLOR, 10.63 × 15.35 IN (27 × 39 CM).

*The greater part of the forests of East Florida consist principally of what in that country are called pine barrens.
In these districts, the woods are rather thin, and the only trees that are seen in them are tall pines of indifferent
quality, beneath which is a growth of rank grass, here and there mixed with low bushes, and sword-palmettoes.*

—Audubon and Coues, *Episodes, the Live-Oakers in Audubon and His Journals.*

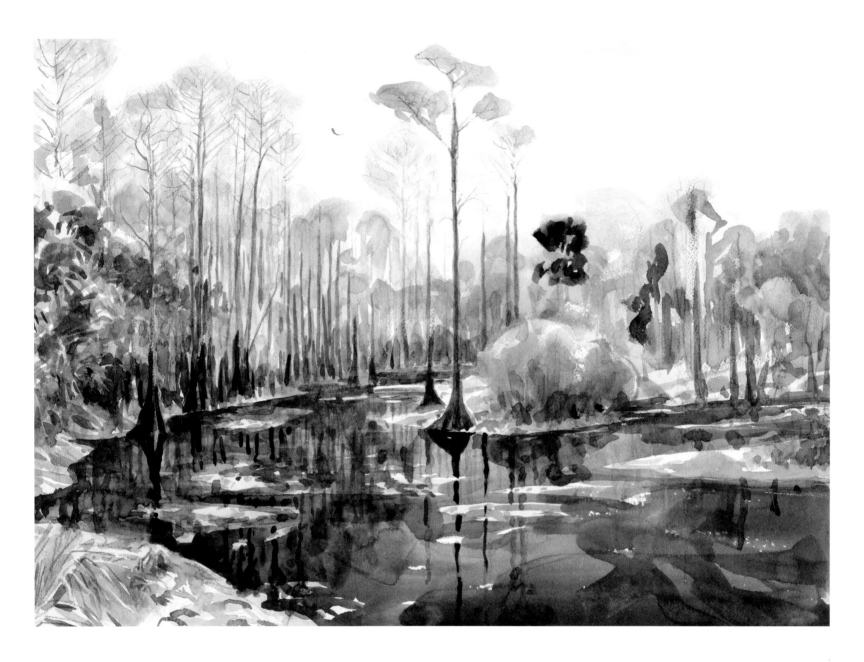

Middle Hawk Creek, between Bulow Plantation and De Léon Springs Garden, February 11, 2005.

PENCIL AND WATERCOLOR, 11.02 × 15.35 IN (28 × 39 CM).

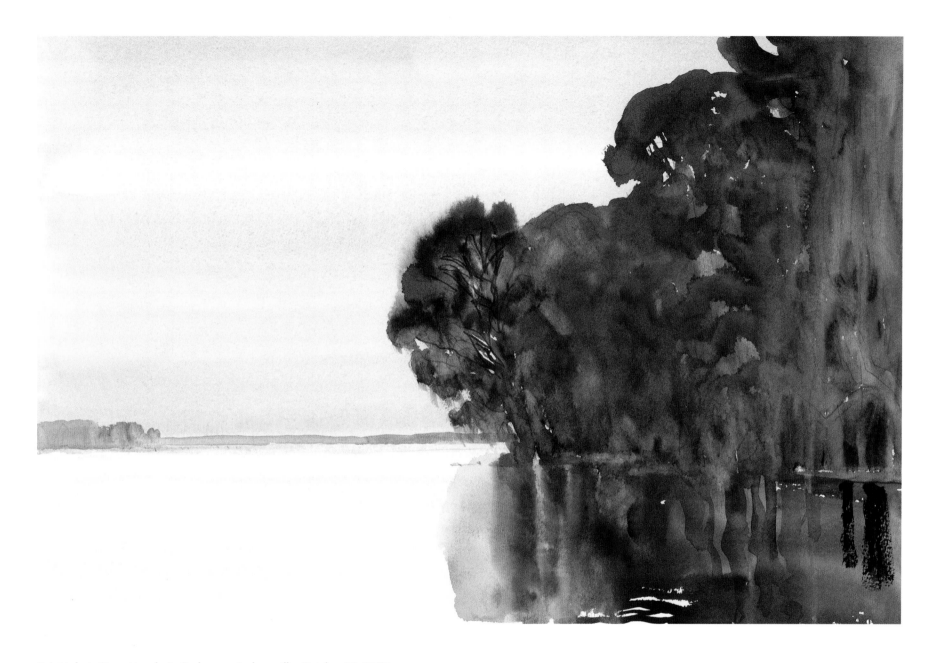

Saint John's River, Mandarin Park, near Jacksonville, October 24, 2005.

PENCIL AND WATERCOLOR, 10.63 × 15.75 IN (27 × 40 CM).

After a while the Spark again displayed her sails, and as she silently glided along, we spied a Seminole Indian approaching us in his canoe. The poor, dejected son of the woods, endowed with talents of the highest order, although rarely acknowledged by the proud usurpers of his native soil, has spent the night in fishing, and the morning in procuring the superb feathered game of the swampy thickets; and with both he comes to offer them to our acceptance.

—Audubon and Coues, *Episodes, the St. John's River in Florida in Audubon and His Journals.*

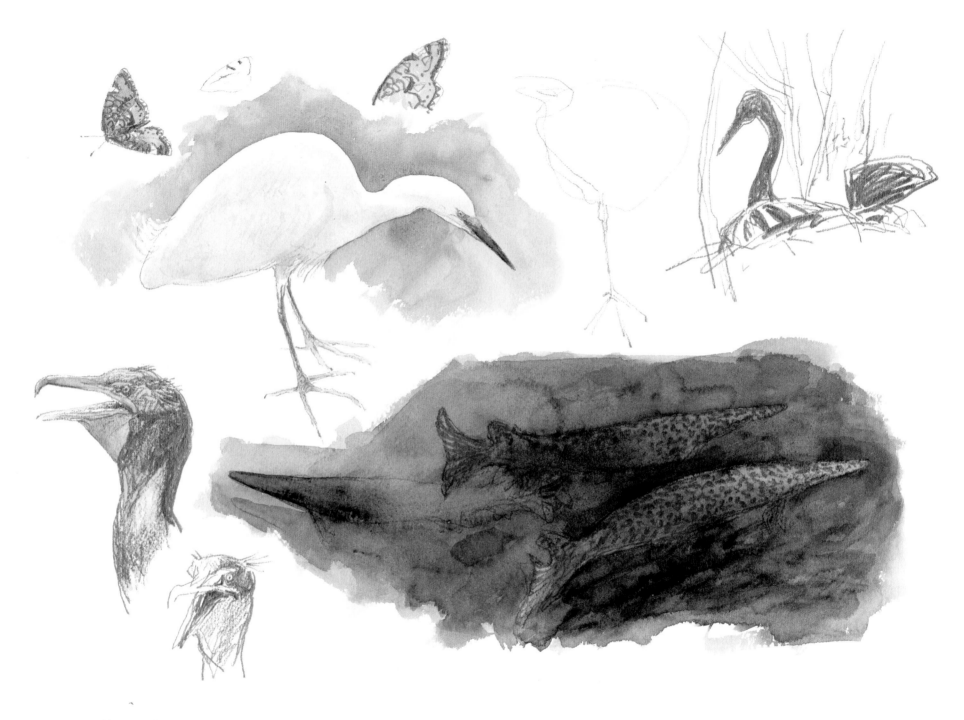

Snowy Egret, Double-crested Cormorant, Anhinga, and Florida Gars, Anhinga Trail, Everglades National Park, February 8, 2003.

PENCIL AND WATERCOLOR, 11.02 × 16.53 IN (28 × 42 CM).

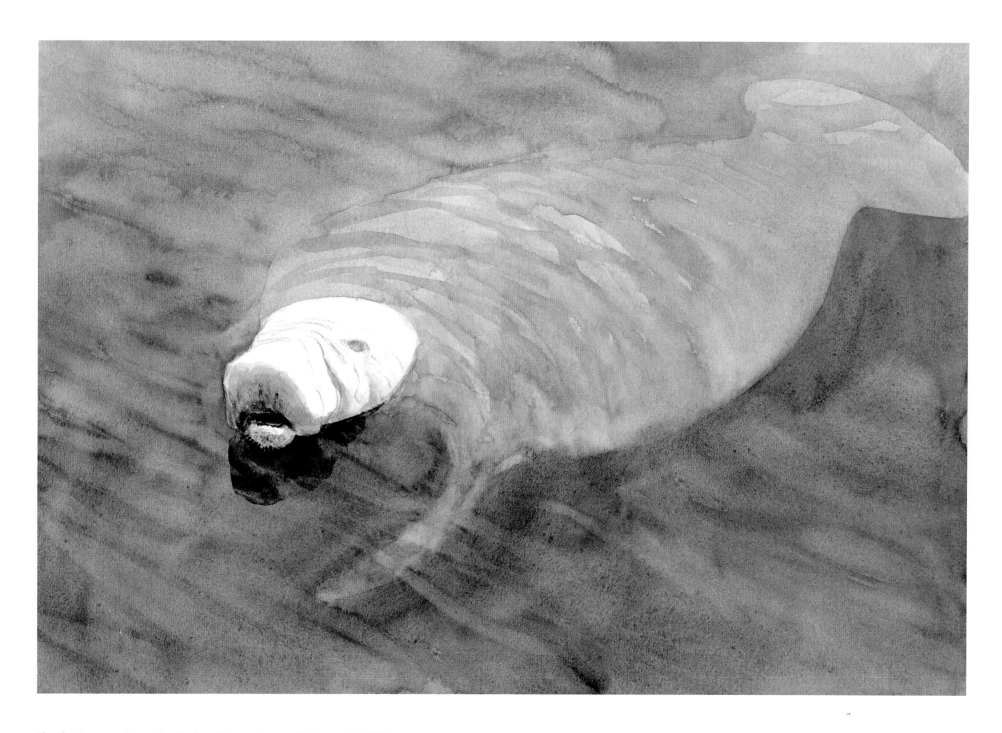

Florida Manatee, Tavernier Harbor, Monroe County, February 3, 2005.

PENCIL AND WATERCOLOR, 10.24 × 14.96 IN (26 × 38 CM).

Along Jewfish Creek, North Key Largo, February 5, 2005.

PENCIL AND WATERCOLOR, 9.84 × 25.19 IN (25 × 64 CM).

Jewfish creek. matin du 5.2.05
Keus (Sud Floride)

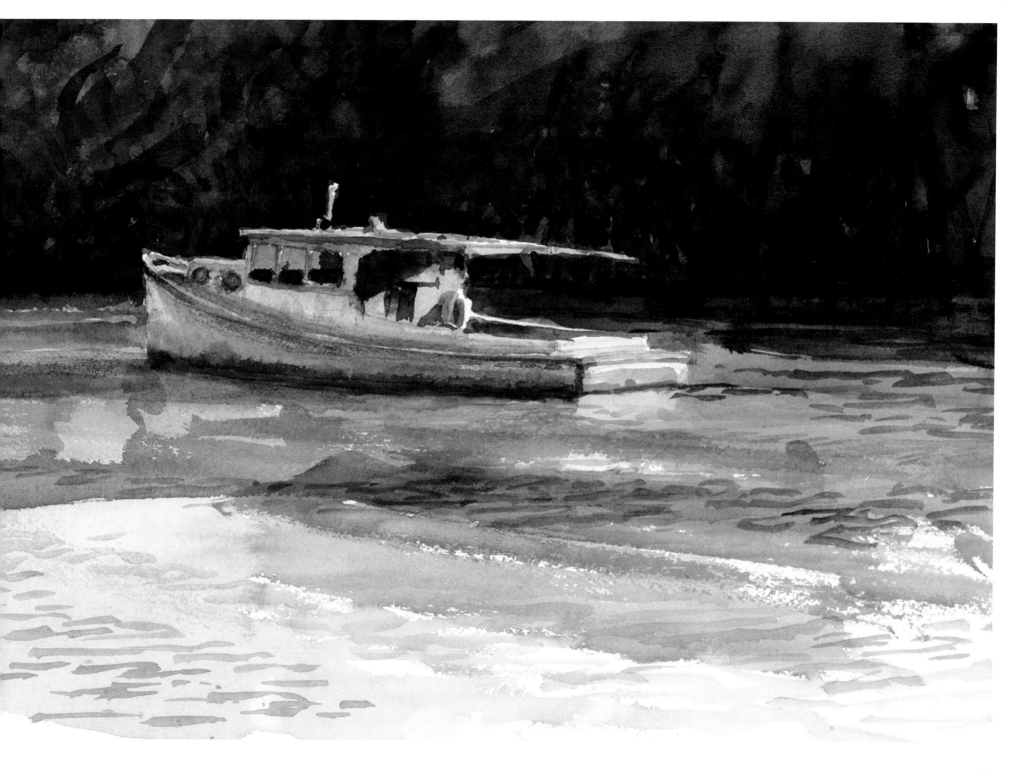

Study of Red Mangrove fruit, West Lake, Everglades National Park, February 10, 2003.

PENCIL AND WATERCOLOR, 11.02 × 13.78 IN (28 × 35 CM).

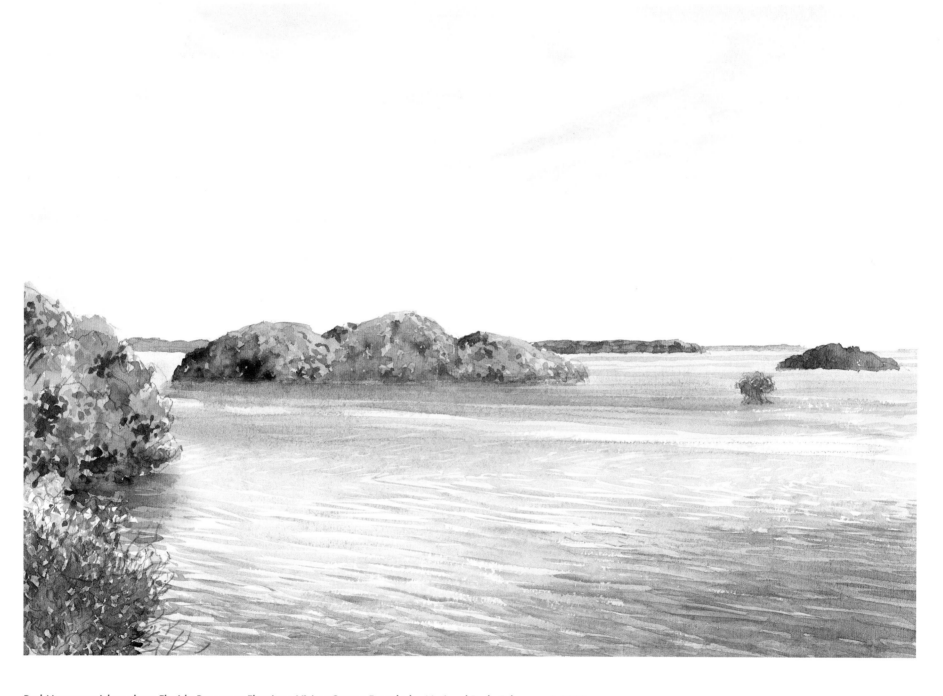

Red Mangrove islets along Florida Bay, near Flamingo Visitor Center, Everglades National Park, February 4, 2003.

PENCIL AND WATERCOLOR, 11.81 × 16.53 IN (30 × 42 CM).

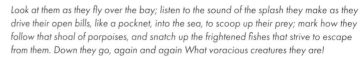

Look at them as they fly over the bay; listen to the sound of the splash they make as they drive their open bills, like a pocknet, into the sea, to scoop up their prey; mark how they follow that shoal of porpoises, and snatch up the frightened fishes that strive to escape from them. Down they go, again and again What voracious creatures they are!

—Audubon, *The Brown Pelican in Ornithological Biography*, vol. 3.

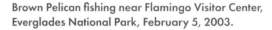

Brown Pelican fishing near Flamingo Visitor Center, Everglades National Park, February 5, 2003.

PENCIL AND WATERCOLOR,
11.42 × 16.53 IN (29 × 42 CM).

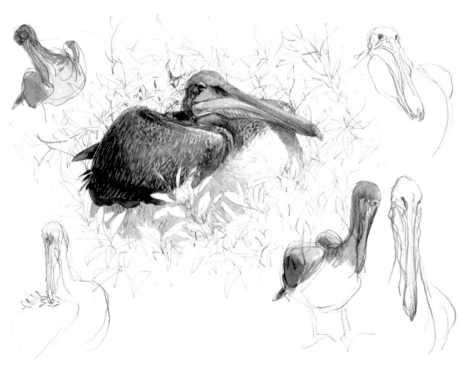

Young Brown Pelican, Flamingo Visitor Center, Everglades National Park, February 4, 2003.

PENCIL AND WATERCOLOR,
11.42 × 16.14 IN (29 × 41 CM).

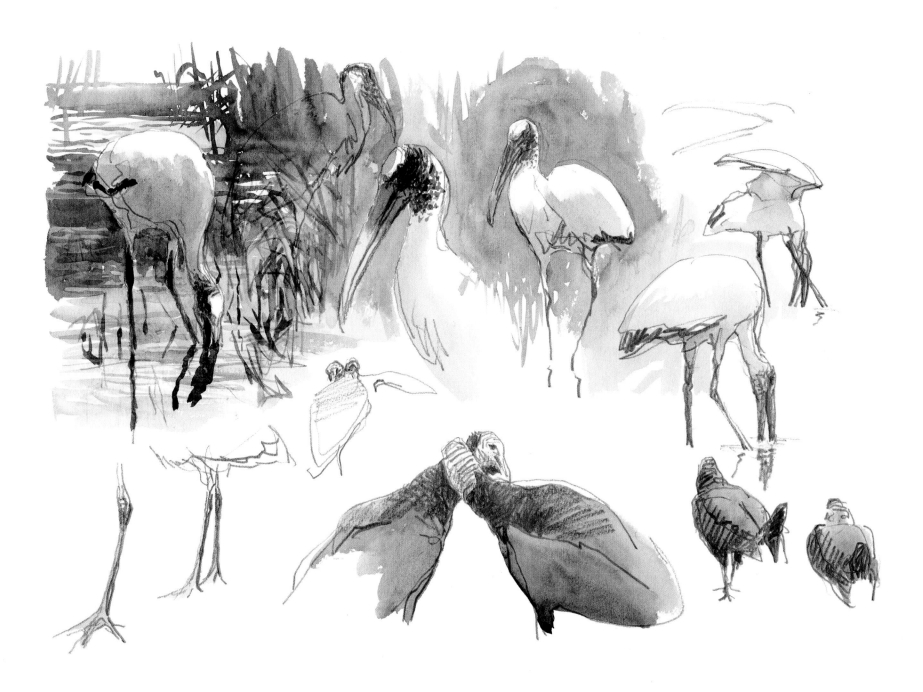

Wood Stork and Black Vultures, Anhinga Trail, Everglades National Park, February 8, 2003.
PENCIL AND WATERCOLOR, 11.81 × 16.14 IN (30 × 41 CM).

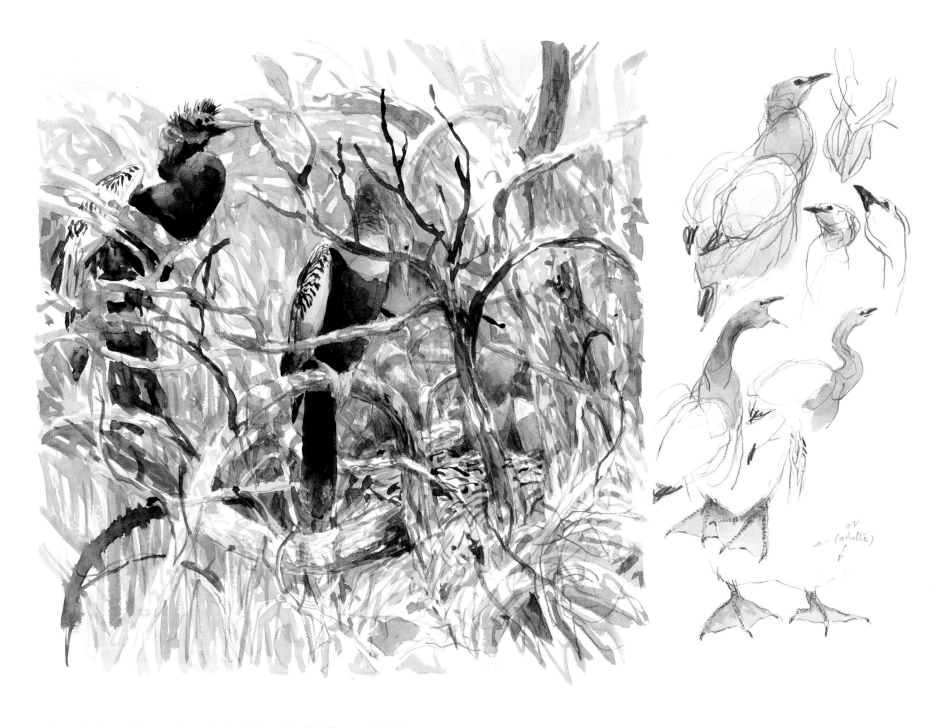

Anhinga family, Anhinga Trail, Everglades National Park, February 3, 2003.

PENCIL AND WATERCOLOR, 15.75 × 22.44 IN (40 × 57 CM).

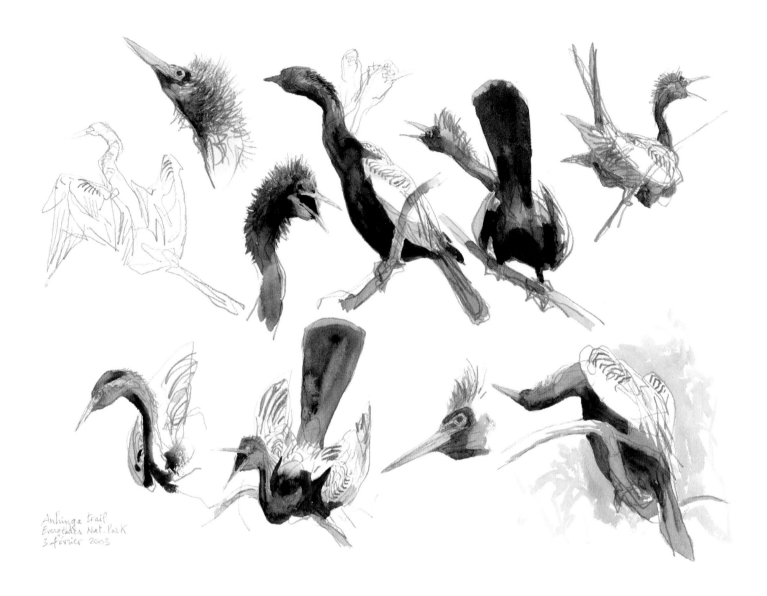

Male Anhinga displaying, Anhinga Trail, Everglades National Park, February 3, 2003.

PENCIL AND WATERCOLOR, 11.81 × 16.14 IN (30 × 41 CM).

What delightful sights and scenes these have been to me, good Readers! With what anxiety have I waded toward these birds, to watch their movements, while at the same time I cooled my overheated body, and left behind on the shores myriads of hungry sand-flies, gnats, mosquitoes, and ticks, that had annoyed me for hours! And oh! How great has been my pleasure when, after several failures, I have at last picked up the spotted bird, examined it with care, and then returned to the gloomy shore, to note my observations!

—Audubon, *Anhinga or Snake Bird in Ornithological Biography*, vol 4.

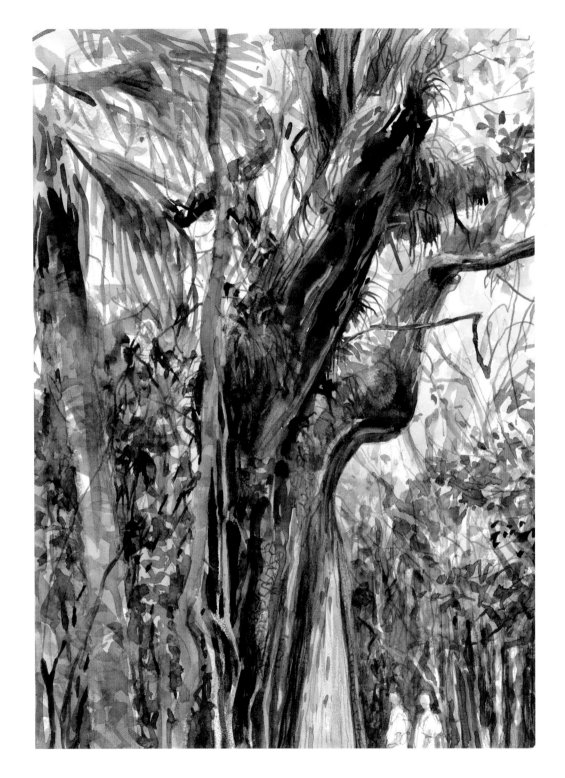

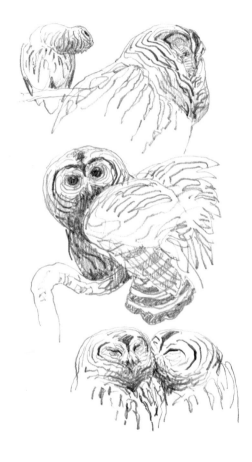

ABOVE: **Barred Owls, Mahogany Hammock, Everglades National Park, February 5, 2005.**

PENCIL, 10.63 × 5.90 IN (27 × 15 CM).

LEFT: **Old Mahogany tree, Mahogany Hammock, Everglades National Park, February 5, 2005.**

PENCIL AND WATERCOLOR,
14.96 × 11.02 IN (38 × 28 CM).

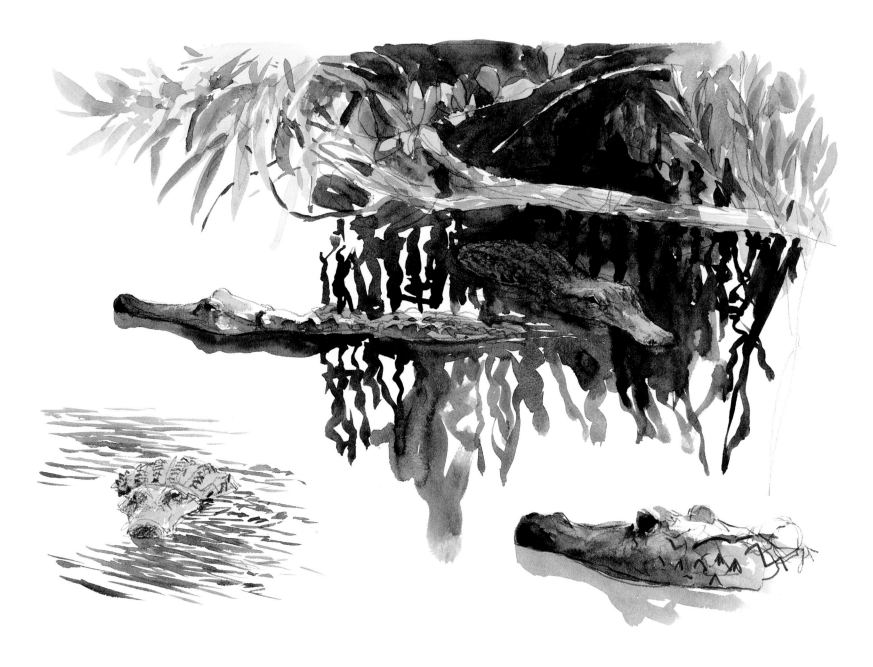

Alligators, Everglades National Park, February 5, 2003.

PENCIL AND WATERCOLOR, 11.42 × 16.14 IN (29 × 41 CM).

One day I sat for an hour on a lake shore, very close to the water to paint mangrove roots. Everything was calm around me, when I suddenly realized that a large alligator had very discreetly come just a few meters from me!

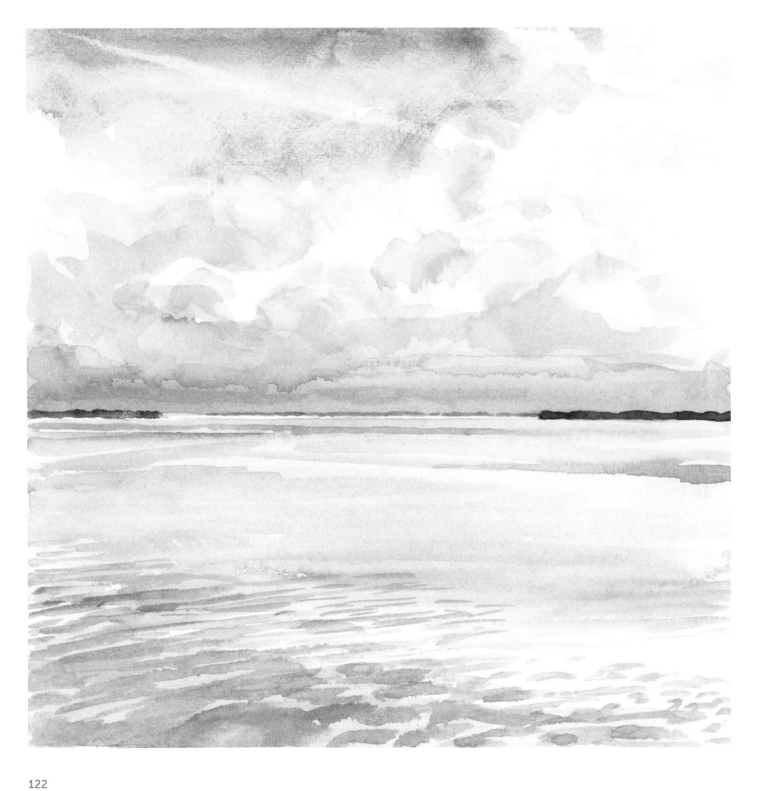

Approaching Calusa Key,
Florida Bay, February 2, 2005.
WATERCOLOR, 7.09 × 7.09 IN (18 × 18 CM).

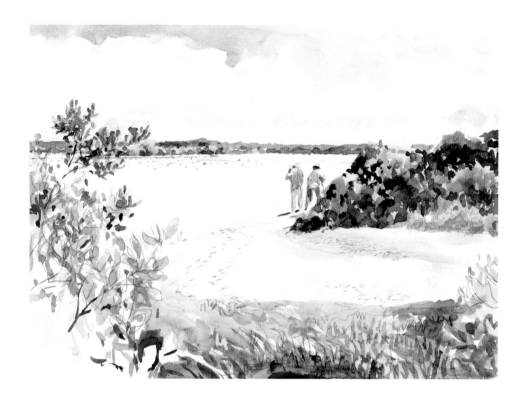

Brennan Mulrooney and Brynne Langan during a bird count, Calusa Key, Florida Bay, February 2, 2005.

WATERCOLOR, 11.02 × 15.35 in (28 × 39 cm).

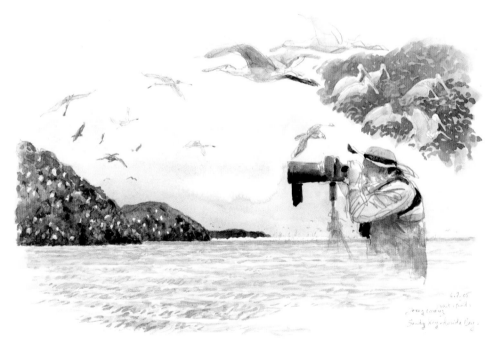

Jerry Lorenz observing Roseate Spoonbills, Sandy Island, Florida Bay, February 4, 2005.

PENCIL AND WATERCOLOR, 11.02 × 16.53 in (28 × 42 cm).

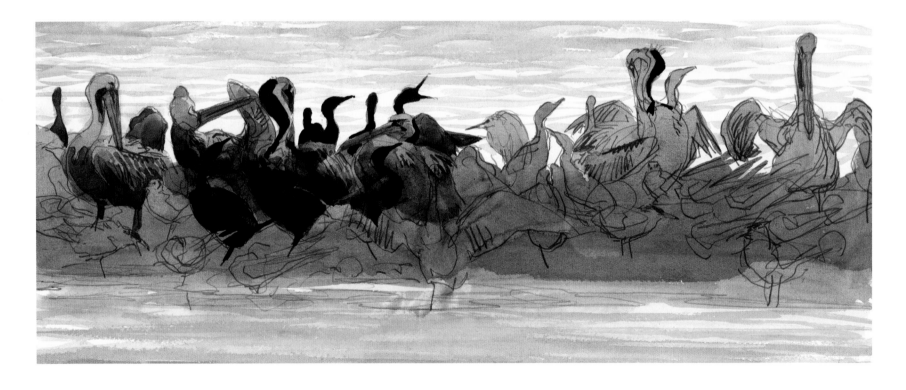

Brown Pelicans, Laughing Gulls, Royal Terns, Black Skimmers, Double-crested Cormorants, and Snowy
Egret seen from Flamingo Visitor Center, Everglades National Park, early morning, February 5, 2003.

PENCIL AND WATERCOLOR, 8.66 × 21.65 IN (22 × 55 CM).

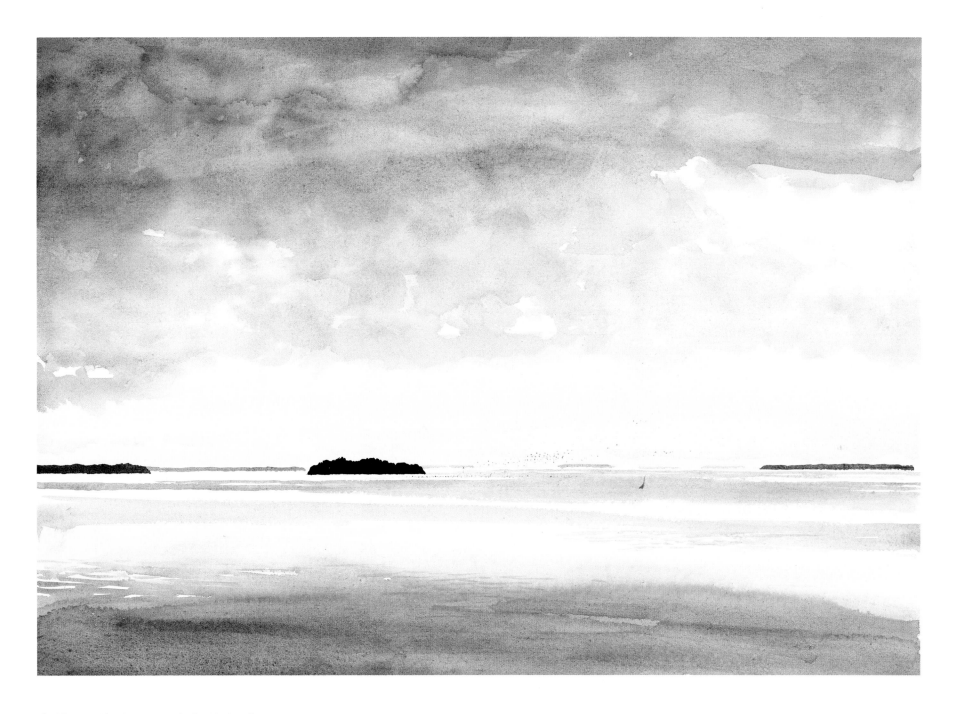

Florida Bay, Flamingo, Everglades National Park, early morning, February 5, 2003.

PENCIL AND WATERCOLOR, 15.35 × 21.65 IN (39 × 55 CM).

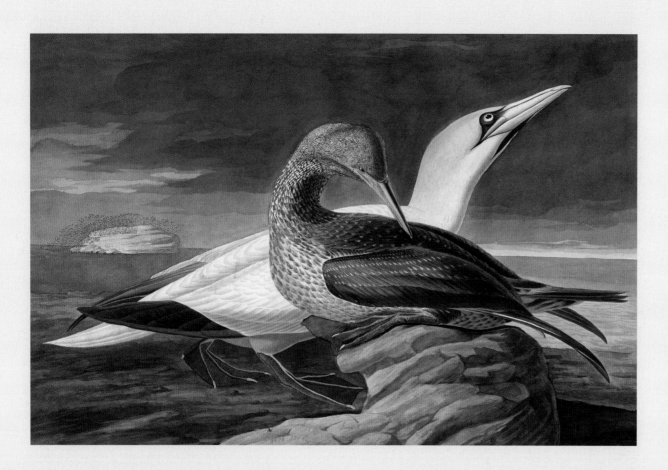

Northern Gannet, Labrador, 1833.

John James Audubon.

WATERCOLOR, GRAPHITE, PASTEL, BLACK CHALK,
BLACK INK, COLLAGE AND GOUACHE WITH
SCRATCHING OUT AND SCRAPING ON PAPER,
24.80 × 37.80 IN (63 × 96 CM).

(REF 1863.17.326)
COLLECTION OF THE NEW YORK HISTORICAL SOCIETY.
DIGITAL IMAGE CREATED BY OPPENHEIMER EDITIONS.

THE VOYAGE TO LABRADOR

FROM BOSTON TO ÎLE-DU-PETIT-MÉCATINA

LEFT NEW YORK City this morning for Boston, Massachusetts, where Audubon prepared his expedition to Labrador. I make a stop about sixty miles west of the city, near Princeton, Massachusetts, to meet Barry Van Dusen, naturalist, illustrator, and artist. Both of us have participated in projects for the Dutch organization "Artists for Nature Foundation," which motivates the public of different countries toward nature preservation.

Today, far from India or Peru where we have previously collaborated for this organization, we walk along the trails of Wachusett Meadow Wildlife Sanctuary, a reserve run by the Audubon Society of Massachusetts. Our eyes riveted to our telescopes, we attempt to sketch the aerial acrobatics of an Eastern Phoebe, this small

flycatcher for whose return Audubon watched every spring while he was at Mill Grove. Barry confides in me:

To be frank, I wasn't seduced by Audubon's prints when I first became interested in birds. They were too stiff, too dated for my taste. Later on, after studying art at university, I came to appreciate the graphic design of his compositions, and I am still very impressed by his observational capabilities at a time when optical instruments of today's quality did not exist.

A male American Redstart sings a couple of yards away, opening wide his beak while emitting his characteristic trills. Barry is one of the few American animal illustrators and painters who, like me, works essentially in nature without

Northern Gannet, Bonaventure Island and Percé Rock National Park, Quebec, Canada, June 29, 2003.
PENCIL, 4.72 × 8.66 IN (12 × 22 CM).

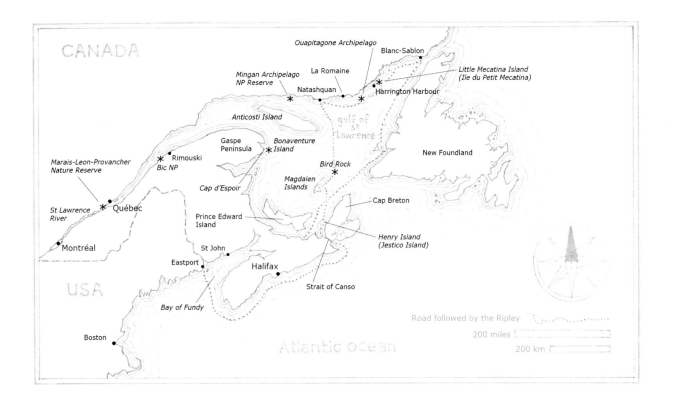

resorting to photography. We talk technique, and I ask him what he finds most important when he wants to sketch a bird like this one quickly.

With this type of small, active species I first try to capture the general form and the characteristic postures. I note how the various parts of the bird relate to another—the angles formed by the tail, wings, legs, and bill, in relation to the body and head. I call this the "geometry" of the bird. Once I establish these important relationships, I can focus on refining the shapes, capturing the facial expression and adding other details of plumage, et cetera.

After arriving in Cambridge, Massachusetts, I stroll along the winding paths of the rustic Mount Auburn Cemetery before setting up to paint some Wild Columbines. Soon, a Carolina

Wren approaches, maybe intrigued by my stillness; overhead, a noisy Chipping Sparrow and a Red-eyed Vireo sing continuously in the still-tender leaves.

Numerous white tombstones stand out here and there in the sun whereas others align themselves more discretely in the shade of the trees. Winslow Homer, one of my favorite American watercolor painters, was buried here in 1910. The gravestone of Josiah Quincy is also found in the cemetery; this man was president of Harvard University and mayor of Boston. He invited Audubon into his house in March 1833. From the top of Washington Tower on the highest point of the cemetery I can see to the east the buildings of the prestigious university where over one hundred works from Audubon's youth are stored among the collections of the Houghton Library. Further south, Boston extends behind the trees that border the Charles River.

The Audubon family, newly reunited following the Florida expedition, arrived in this city on August 1, 1832, after a stay in New York shortened by a cholera epidemic. The very dynamic city of Boston was the fourth largest in the United States at that time, with 61,000 inhabitants. Audubon was introduced into high society there thanks to prominent public figures who helped him to sign up rapidly seven new subscriptions to *The Birds of America*, followed by six more in the coming months. He was now forty-six years old. Over 150 prints were already published, but there were vast lands left for him to explore. Hesitating

between California and Quebec, he wrote his friend Reverend Bachman, whose advice probably incited him to choose the latter:

The only reasons why a visit to the coast of Labrador might be advisable, is, that you may be able to complete your dissertations on the habits of the Ducks, Gulls, etc. This would certainly enable you to say more with regard to the habits of our water birds, than has ever been written before. ... If your visit to Labrador is indispensable, you had better go in the Spring.[1]

After an initial summer visit with his family to the coast of Maine and New England, Audubon's oldest son, Victor, left in October for London to supervise the publishing of the prints. Then his father focused with determination on his work until the following spring, comfortably set up in a boardinghouse situated on Pearl Street. Most often he sketched and painted the birds that people brought him, sometimes alive but more often dead. Among the watercolors painted over the course of this winter are those of the King Eider, the Greater Prairie-Chickens, the Boat-tailed Grackle, and the Golden Eagle. One day his friend, James Curtiss, sent him from Eastport some carefully prepared birds, including a Thick-billed Murre. Audubon wrote later about this:

The specimen from which my figure was made was sent to me in ice, along with several other rare birds, from Eastport in Maine. I received it quite fresh and in excellent plumage, on the 18th of February 1833.[2]

A few days later, the 16 of March, a frightening event interrupted this period of work: Audubon found himself paralyzed by a stroke, possibly the consequence of fatigue accumulated since the fall. Luckily, the incident lasted only a couple of hours, but he saw in this traumatic episode the harbinger of old age and another reason to pursue his work without delay. He also needed to satisfy the expectations of his subscribers and avoid being overshadowed by other artists, such as the Englishman John Gould in Europe. Preparation for his Labrador trip and bad weather, however, delayed his departure until midspring 1833.

Audubon finally left Boston aboard the *Edward Preble* on the evening of May 4 with his younger son, John Woodhouse. Three days later they reached Eastport, in northern Maine, and were welcomed by the family of a judge, the Lincolns. Snow and ice lingered here and there, but Audubon recorded that Barn Swallows and Cliff Swallows had already arrived. Flights of Surf Scoters migrated northward, crossing Passamaquoddy Bay. He stayed for a month in Eastport, during which time he explored neighboring islands. Poor weather gave him the opportunity to sketch some additional species such as the Black Guillemot, Black-capped Chickadee, Harlequin Duck, and Wilson's Phalarope.

Five young men accompanied Audubon during his voyage to Labrador. In addition to his own son, he was joined by George C. Shattuck, William Ingalls, Joseph A. Coolidge, and Thomas Lincoln, the judge's middle son. These vigorous

Yellow-bellied Sapsucker, Wachusett Meadow Wildlife Sanctuary, Princeton, Massachusetts, May, 22, 2006.

PENCIL AND WATERCOLOR, 5.51 × 3.15 IN (14 × 8 CM).

Sapsuckers make rows of shallow holes in tree bark, then they return to drink sap and eat insects that are attracted to the sap.

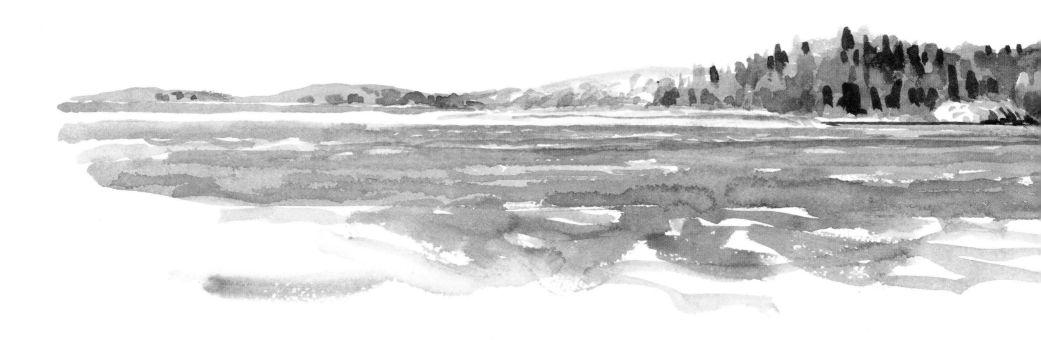

**Near the Kennebec River mouth,
coast of Maine, September 25, 2007.**

PENCIL AND WATERCOLOR,
5.51 × 24.41 IN (14 × 62 CM).

and enthusiastic companions were capable of exploring for entire days despite bad weather and difficult terrain. Audubon had clothing made for each of them and himself specially adapted for the cold and the rain. On June 1, the schooner chartered for the expedition, the *Ripley*, arrived in Eastport. She was commanded by a young twenty-four-year-old captain, Henry T. Emery. It took several days to load the boat with food and ballast. A large table was specially fitted for the

needs of the artist, as well as for meals and for preparing the skins of collected birds. This last operation required the use of arsenic, and one can imagine what precautions this required. Audubon wrote one last letter to Lucy to reassure her about the state of his health. The *Ripley* cast off on June 6, saluted by eight cannon shots and numerous inhabitants assembled along the wharf. The real expedition to Labrador could finally start.

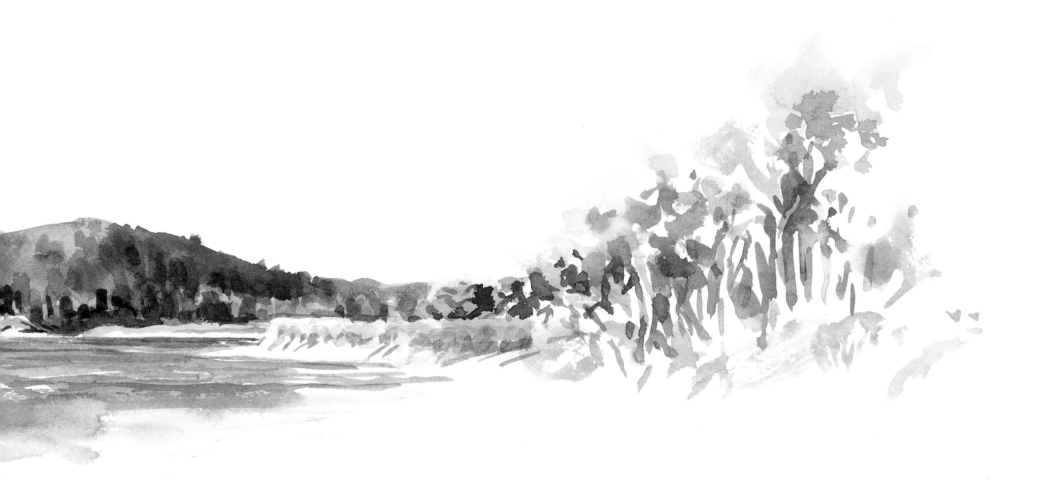

The schooner crossed the Bay of Fundy and sailed around Nova Scotia, Canada, in bad weather. Four days later it reached the entry of the Strait of Canso north of Halifax and crossed this natural channel, which separates Cape Breton from the continent, on June 11. She entered the Gulf of Saint Lawrence and dropped anchor near the small island of Jestico,[3] but the visit was cut short by the threat of a gale that forced the captain to move the ship away from

the coast. When Audubon woke the next morning, he had just enough time to glimpse the thin outline of the Îles-de-la-Madeleine before a thick fog engulfed the ship.

July 3, 2003. Boarded the CTMA ferry, at Souris, Prince Edward Island. After four hours of crossing, I make out the outline of the archipelago still far away. We slowly approach the port of Cap-aux-Meules, then the enormous bow of the ferry makes fast to the dock. All around us

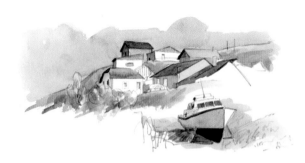

Cap aux Meules, Magdalen Islands, Quebec, July 6, 2003 (detail).

PENCIL AND WATERCOLOR,
10.63 × 16.14 IN (27 × 41 CM).

dozens of small, multicolored houses seem posed like toys on the hillside. I have a meeting with Donna Gail, an enthusiastic birder, who will be my guide during this visit.

It was a few miles south of here, in Pleasant Bay, that the Ripley moored. It was very cold when Audubon and his team landed. On the trail leading to the village they encountered a young woman carrying a small infant, but Audubon couldn't exchange a single word with her because her old French patois was incomprehensible to him. In search of information about the birds present on the island, he questioned other inhabitants, which finally provoked his young, impatient companions to survey by themselves. Numerous small birds were clustered in the bushes and the rare wooded areas: Robins, Hermit Thrushes, Winter Wrens, Goldfinches, Fox Sparrows, and warblers. They loaded their guns with mustard seed to kill the birds with as little damage as possible to their plumage. Along the shore, the team collected Common Terns and a few Arctic Terns, a species that Audubon observed for the first time.

Donna suggests a stop near Havre-aux-Maisons, where I set up my telescope to observe a small colony of Common Terns in full courtship displays on Île Paquet. Males offer fish, and couplings follow. We make out among them an Arctic Tern and, a little way off, a Roseate Tern. The fog suddenly engulfs the landscape, and on our left Île Rouge is only a strange floating garnet vessel in the middle of the lagoon. Thousands of

raucous cries resound from it. Double-crested Cormorants are there by the hundreds. Even though they are invisible, for the moment I feel the colony's energy. I imagine their beaks open and their necks extended, a continual mixture of greetings and disputes.

Donna drives me next to the beach of La Pointe where she coordinates the protection of a Piping Plover colony. Planted in the sand near orange nets marking the nesting zone, signboards ask the public to respect these small wading birds for a few weeks. But the growth of outdoor recreational activities, more and more numerous dogs, predation by foxes, and more frequent storms hamper the success of this operation each spring. Currently rain is falling. With their sandy-colored plumage, these small shorebirds are difficult to distinguish when they are still. I detect a slight movement between two tufts of vegetation: a chick moved! A few steps to the right, to the left, then he returns to take shelter and disappears under the fluffy breast of the adult; I can make out only his feet. Their plaintive cries moved Audubon, who took only two females and a male among them.

The next day we stop between Pointe-aux-Loups and Grosse Île on a narrow band of land; to the west a Common Loon majestically swims and dives in a bay sheltered from the wind, while to the east only a few small dunes covered by low vegetation separate us from the ocean. Numerous Sarracenia Pitcher Plants flower there in the peaty hollows. While I sketch these strange

carnivorous plants, Donna tells me about her life on the archipelago: the local dialects that in olden times varied from one island to another; the winters that she considers spending in the southern United States even though the sea hardly ever freezes here anymore, a phenomenon that, along with the rise in sea level, accelerates coastal erosion. Her passion for birds was born during an excursion to the Bird Rock, a large cliff situated offshore about twenty miles from here where a colony of Northern Gannets is located, the very same one that Audubon discovered just after his visit to the Magdalen Islands.

Fishing is still the principal source of revenue here, along with tourism. In the harbor of Grande Entrée, the entire flotilla is docked because lobster season ends today. The fishers are busy unloading and cleaning their traps. I learn that even though cod fishing has been prohibited by Canada since 1995, the cod population in the Saint Lawrence has not revived, given the five centuries of overharvesting that decimated this previously abundant fish.[4]

The day ends on top of a reddish cliff where we admire in silence the mating dance of Black Guillemots. Audubon watched with great attention these birds standing along narrow flats of the rock:

Whilst in Labrador, I was delighted to see with what judgment the Black Guillemot prepares a place for its eggs. Whenever the spot chosen happens to be so situated as to preclude damp, not a pebble does the bird lay there, and its eggs are placed on the bare rock. It is

only in what I call cases of urgency that this trouble is taken. About fifty or sixty pebbles or bits of stone are then used, and the number is increased or diminished according to circumstances.[5]

I shiver a bit thinking of Captain Emery who, wanting to offer a few eggs of this species to Audubon, suspended himself over the cliff at the end of a rope held by the men of his crew.

Leaving Pleasant Bay early in the morning of June 14, 1833, with a good breeze, the Ripley set course for Bird Rock. Around ten o'clock the cliff appeared on the horizon. The boat moved at a good clip, so that an hour later Audubon could make out the summit of the small island:

At eleven I could distinguish its top plainly from the deck, and thought it covered with snow to the depth of several feet; this appearance existed on every portion of the flat, projecting shelves. Godwin[6] *said, with the coolness of a man who had visited this Rock for ten successive seasons, that what we saw was not snow—but Gannets! I rubbed my eyes, took my spy-glass, and in an instant the strangest picture stood before me. They were birds we saw,—a mass of birds of such a size as I never before cast my eyes on. ... The nearer we approached, the greater our surprise at the enormous number of these birds, all calmly seated on their eggs or newly hatched brood, their heads all turned to windward, and towards us.*[7]

To admire these magnificent birds, I visit Bonaventure Island on the Gaspe Peninsula,[8] home to the other large colony of Northern

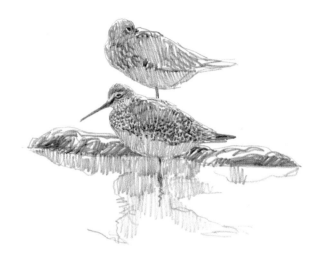

Lesser Yellowlegs, Plum Island, Massachusetts, September 20, 2007.

PENCIL, 7.48 × 9.45 IN (19 × 24 CM).

Black-legged Kittiwake, Cap d'Espoir, Gaspé Peninsula, Quebec, June 28, 2003 (DETAIL).

PENCIL AND WATERCOLOR,
11.42 × 15.75 IN (29 × 40 CM).

Gannets in the Gulf of Saint Lawrence. A well-tended path allows me to observe the adults and their chicks without disturbing them. Below the masses of Northern Gannets, Razorbills come and go with their quick direct flight while seals loll at the base of the cliffs. The numbers of this colony fluctuate from one year to the next—mostly downward—and do not compare with those of thirty or forty years ago. There are numerous causes for this, almost all linked to human activities, because even though the looters no longer exist and the fishers no longer use their meat as bait for cod fishing, marine pollution and climate changes have had multiple consequences on the ocean ecology and the life of marine birds.

After its stop at Bird Rock and two days of sailing, the *Ripley* finally approached the coast of Labrador in the early morning of June 17, 1833. Audubon had gotten up at dawn and tirelessly scanned the horizon. The sky was filled with White-winged Scoters, and many Common Murres and some Puffins and Razorbills crisscrossed the ocean, often in long, single-file lines. But the artist's thoughts were elsewhere, way over there, on the unknown coasts:

I looked on our landing on the coast of Labrador as a matter of great importance. My thoughts were filled, not with airy castles, but with expectations of the new knowledge of birds and quadrupeds which I hope to acquire. ... At five o'clock the cry of land rang in our ears, and my heart bounded with joy; so much for anticipation.[9]

From here I follow Audubon's path on the coaster *Nordik Express*, which is heading due east between Anticosti Island and the North Shore of Quebec. Yesterday I boarded this boat that links Rimouski and Blanc-Sablon each week, making eleven stops, before the return trip to its home port. Tomorrow morning we will reach Natashquan, where *Ripley* dropped anchor exactly 170 years ago during her first stop in Labrador.

But at the moment I am looking far and wide with my binoculars at the Gulf of Saint Lawrence waters, where the movements of the birds create an astonishing choreography: the deep, slow beating of Herring Gull wings contrasts with the graceful pirouettes of some Leach's Storm-Petrels just over the top of the waves. I make out a little farther away the acrobatics of a few Black-legged Kittiwakes pursued by a Pomarine Jaeger intent on stealing their meal. From time to time an Atlantic Puffin crosses the path of the boat and takes off like an arrow toward the Mingan Archipelago.

Jacques Larivée, whom I met a few days ago in Rimouski, told me a lot about the Mingan Archipelago National Park Reserve, which, among other protected sites, allows a few colonies of sea birds to sustain themselves along the north shore. An experienced ornithologist, Jacques is also passionate about the work of Audubon. We talked about the diminution of this region's fauna over several centuries and in particular the decline of bird life. According to him, the populations of quite a few northeastern American bird species had already been greatly

diminished when Audubon arrived in the United States. Since that time, the decline has continued and has now reached alarming proportions among species that live on flying insects and shorebirds.

At each stop of my journey, the crew of the *Nordik Express* and the crane bustle to unload and load a large quantity of goods under the watchful eye of the locals, mostly native Innus. I go off by myself on the rocks or in the Black Spruce woods, just long enough to paint a landscape or to sketch some birds. Natashquan, Kegaska, La Romaine, New Harbor, ... so many stops along this rounded-off coastline, less and less wooded, more and more uniform. The shadows of the clouds cast shapes on the granite formed hundreds of millions of years ago.

In 1833, the *Ripley* could not drop anchor near the mouth of the Natashquan River because the Hudson Bay Company owned a fishery there and prohibited American ships from mooring. So the schooner anchored five miles farther north in a protected bay named American Harbor, where the Nordik Express nowadays docks twice a week. Audubon quickly disembarked, and the first living creature that he saw was a Robin, a far cry from the bears, wolves, and all sorts of other wild creatures that a few hours earlier he had imagined scurrying about. Audubon realized right away how harsh this land was and, in the evening, wrote in his journal: *A poor, rugged, miserable country; the trees like so many mops of wiry composition, and where the soil is not rocky it is boggy up to a man's waist.*[10]

Ripley was moored three weeks at Natashquan, then fifteen days in *Wapitiguan Harbor*,[11] fifty miles further east. On the 19 of June, Audubon noted:

Drawing as much as the disagreeable motion of the vessel would allow me to do; and although at anchor and in a good harbor, I could scarcely steady my pencil, the wind being high from southwest. At three A.M. I had all the young men up, and they left by four for some islands where the Larus marinus breeds.[12]

The entire crew worked relentlessly, sometimes with nice weather but more often facing the rain, wind, cold, and mosquitoes. Audubon stayed on board most of the time, making one study after another as long as sea sickness didn't nail him to his berth. In view of these circumstances, so conducive to clumsiness, I am still astonished by the precision and neatness of his original watercolors.

Audubon used a technique similar to the one he had developed thirty years earlier at Mill Grove that allowed him to create an effect of vivid movement, so characteristic of his work: the birds were fixed in the position of his choice on a board marked with grid lines before being reproduced in their actual size and exact proportions on a sheet of paper, also gridded. Eleven new watercolors were realized in this way over the course of these five weeks.

A little further north, off Harrington Harbour, I experience one of the strongest sensations of

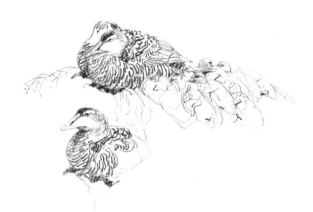

Females and ducklings of Common Eider, Bic National Park, Quebec, Canada, June 27, 2003.

PENCIL, 7.09 × 14.17 IN (18 × 36 CM).

Harrington Harbour, Quebec, July, 12, 2003.
PENCIL AND WATERCOLOR, 2.36 × 3.94 IN (6 × 10 CM).

my long companionship with Audubon. On this
morning of July 11, 2003, the motorboat of the
fisherman Calvin Rainson takes off after having
left me at the bottom of Havre-de-la-Croix, at the
southern end of the Little Mecatina Island. It is
the northernmost point of my trip. The weather
is calm and bright, the air is warm, and the
mosquitoes are amazingly absent. Here I am
alone for a few hours, moved by the thought that
Audubon approached this spot on essentially the
same day of the year and at my age. Bare-chested,
I raise my arms to the sky and cry out: "Audubon,
I'm here!" The landscape is totally wild, apart
from the wooden cabin that I glimpse on the
opposite bank. Here nothing has changed since
the naturalist's visit, contrary to all the other
places that I surveyed in North America. Not a
tree on the hills. Some cries of Common Ravens
resonate along the cliffs; a Rough-legged Hawk
soars then disappears behind a crest where some
granite boulders protrude, deposited by a glacier
18,000 to 20,000 years ago.

I climb to a plateau and sit down not far from
a small peat pond. From time to time from the
sea down below rise the whistles of a minke
whale. A long cry, forceful and plaintive, suddenly
resounds: a Red-throated Loon, followed by
another, slowly moves away from the shore where
there is probably a nest. I execute a series of
sketches, then back away to paint the landscape
and make my presence as unobtrusive as possible.

Calvin comes back for me earlier than planned,
fearing a turn for the worse in the weather.

Seeing me working, he waits, watching the clear
water at the foot of the rocks. He catches a young
lobster and shows it to me before letting it go:
Too young, better to let it grow up.

Before nightfall, we reach Harrington Harbour,
where I stay for two days; I will reembark
tomorrow on the *Nordik Express* and go on to
Rimouski.

Audubon explored diverse sites farther north
before reaching Bras d'Or, near Blanc-Sablon, the
evening of July 25, 1833. This last stop in
Labrador ended in the heart of a Atlantic Puffin
colony with a bizarre hunting party, useless and
murderous, a disturbing climax to this expedition.
The *Ripley* then headed south and dropped off its
passengers at Pictou in Nova Scotia after a brief
stop in southern Newfoundland. Audubon met
Lucy in New York on September 6, after having
passed by Halifax, Eastport, and Boston. Although
the final result of the expedition was not up to
his hopes, he nevertheless brought back twenty-
three completed or nearly complete plates, 173
skins, a large number of new observations …
and five young men in good health.

Audubon had dreamed of a Labrador left
intact by humans and returned very affected by
the damage caused to nature there, whether it be
from looting eggs for sale from nesting bird
colonies, even more destructive that he had seen
in Florida; excessive fishing of salmon and cod; or
even extensive trapping of numerous mammals.
On June 23, he had indeed written one of the
most severe commentaries about this carnage:

The Fur Company may be called the exterminating medium of these wild and almost uninhabitable climes, where cupidity and the love of gold can alone induce man to reside for a while. Where can I go now and visit nature undisturbed?[13]

He also declared that he would never accompany a band of fur traders on an expedition for anything in the world. But by irony of destiny, ten years later by accepting the invitation of Pierre Chouteau, head of the biggest fur trading company in the United States, as a guest aboard one of his boats, Audubon went up the Missouri River in exactly the same conditions that he had denounced.

Yet it was in a calm state of mind that Audubon returned to Canada in September 1842, hoping to find there new clients for his publications. He was warmly welcomed in Quebec City and visited two important private collections of mounted birds in the region. The beauty of the landscapes prompted him to extend his visit before going to Montreal, then returning to New York by train.

In June 2014, around ten years after my voyage along the lower north coast, I myself also return to Canada. There I meet the ornithologist Gérard Cyr at the Marais-Léon-Provancher Nature Reserve, near Quebec City. The morning I am there he is making sound recordings of birds as part of a survey of the Quebec marshes. I observe some small Pied-billed Grebes swimming with some giant frogs, I sight the American Bittern

and discover a Chestnut-sided Warbler while behind us—him again—a Red-eyed Vireo sings continuously in the trees.

1. Bachman, Catherine. *John Bachman.* Charleston, South Carolina: Walker, Evans, and Cogswell, 1888.

2. Audubon, *Ornithological Biography*, vol. 3, 1835.

3. Today called Henry Island.

4. The situation now seems to improve in northern Newfoundland thanks to the cod moratorium but also—paradoxically—from a "positive" effect of climate change on Capelin, a principal food source for cod.

5. Audubon, *The Black Guillemot* in *Ornithological Biography*, vol. 3, 1835.

6. Originally from Nova Scotia, M. Godwin was hired as a pilot on the *Ripley* at the Capelin Îles-de-la-Madeleine.

7. Audubon and Coues, The Labrador Journal in Audubon and His Journals.

8. This island is part of the Bonaventure Island and Percé Rock National Park.

9. Audubon and Coues, *The Labrador Journal.*

10. Audubon and Coues, *The Labrador Journal.*

11. Today called Ouapitagone Archipelago.

12. Great Black-backed Gull. Audubon and Coues, *The Labrador Journal* in *Audubon and His Journals.*

13. Audubon and Coues, *The Labrador Journal.*

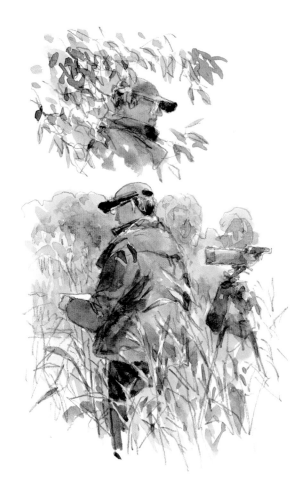

Gérard Cyr, ornithologist, listening at predetermined spots for a survey of the bird life of the marshes of Quebec, Marais-Léon-Provancher Nature Reserve, Neuville, Quebec, June 20, 2014.

PENCIL AND WATERCOLOR,
9.05 × 5.52 IN (23 × 14 CM).

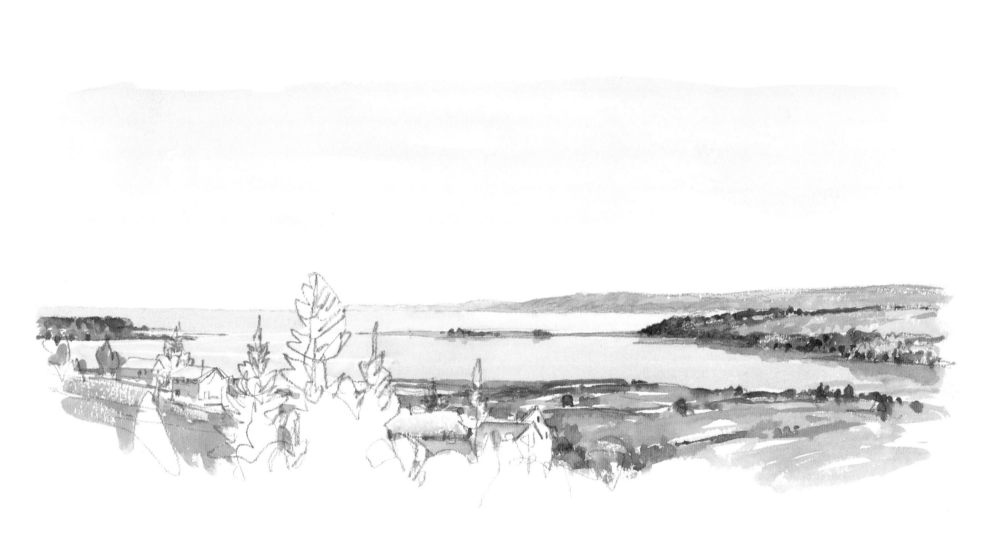

The western entry of the Strait of Canso on the right, Saint George Bay, Nova Scotia, Canada, July, 2, 2003.

PENCIL AND WATERCOLOR, 4.33 × 16.93 IN (11 × 43 CM).

The *Ripley* passed here during the afternoon of June 11, 1833.

Bow wave, sea mist, sailing on the Nordik Express ferry across the Gulf of Saint Lawrence, July 13, 2003.

WATERCOLOR, 11.42 × 15.75 IN (29 × 45 CM).

For almost two hours I observed the very regular movement of the swell, painting very slowly to suggest the dynamism of the wave and the effect of the luminous mist.

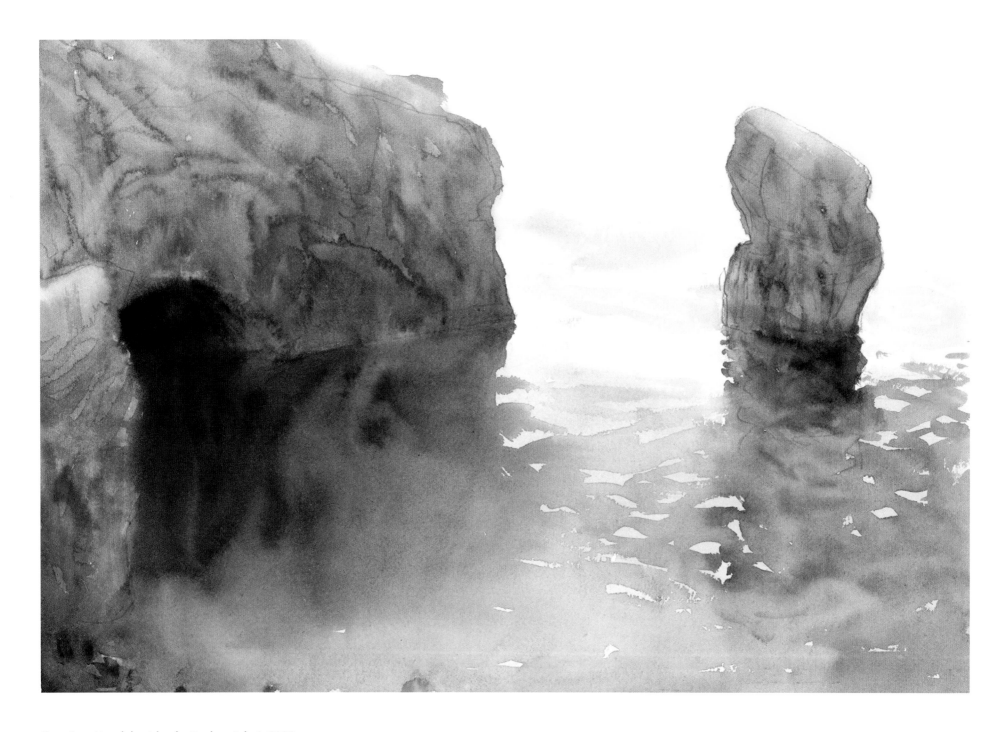

Gros Cap, Magdalen Islands, Quebec, July 6, 2003.

PENCIL AND WATERCOLOR, 11.42 × 16.14 in (29 × 41 cm).

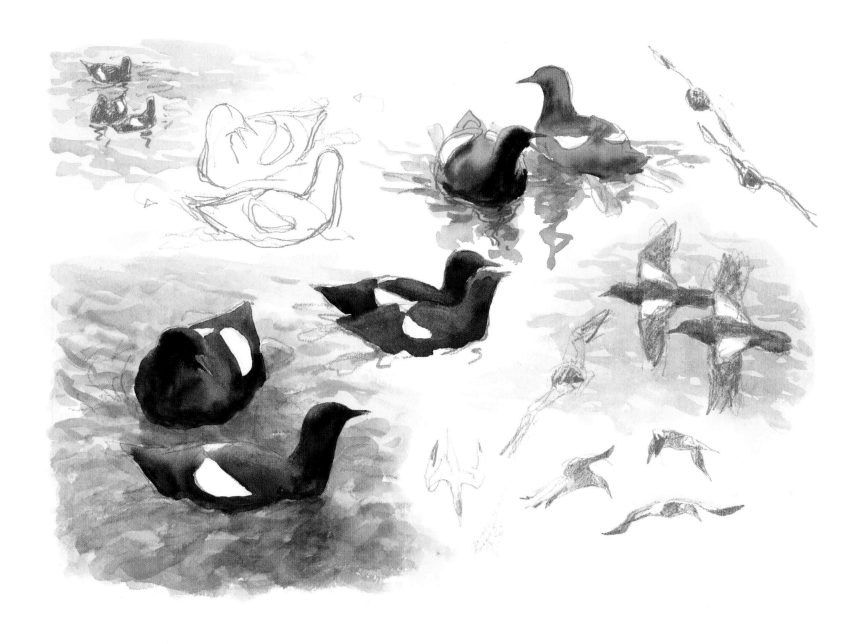

Nuptial display of Black Guillemots, Northern Gannet, Magdalen Islands, Quebec, July 5, 2003.

PENCIL AND WATERCOLOR, 11.42 × 16.53 IN (29 × 42 CM).

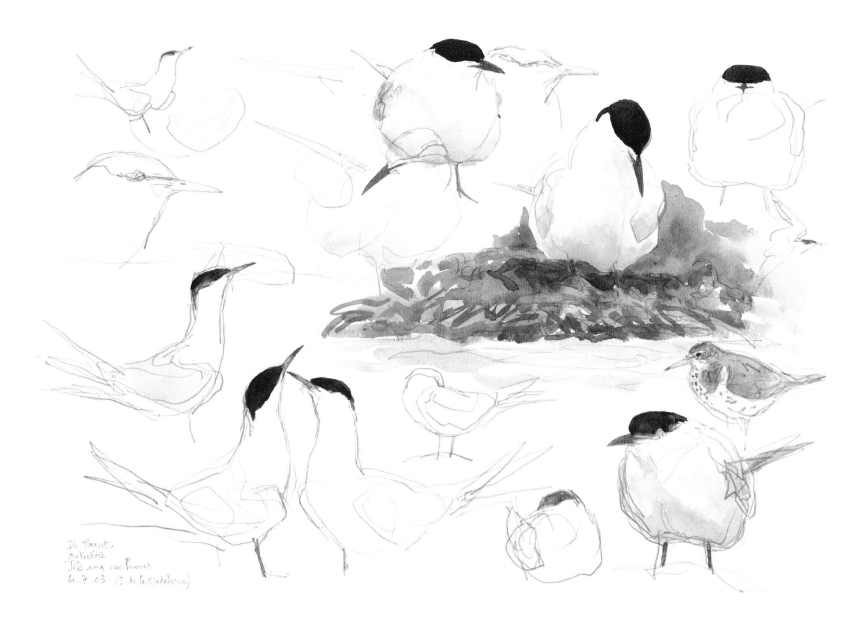

Common Terns, Arctic Tern, and Spotted Sandpiper, Paquet Island, Magdalen Islands, Quebec, July 4, 2003.

PENCIL AND WATERCOLOR, 11.02 × 16.53 IN (28 × 42 CM).

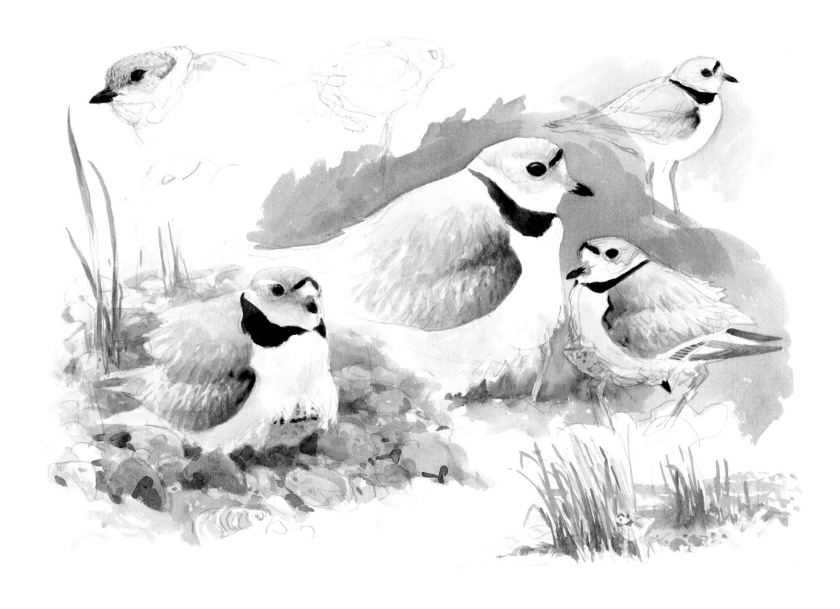

Piping Plover, Plage de la Pointe, Magdalen Islands, Quebec, July 4, 2003.

PENCIL AND WATERCOLOR, 11.42 × 16.93 IN (29 × 43 CM).

The chick is crouching under the adult's belly to get out of the rain.

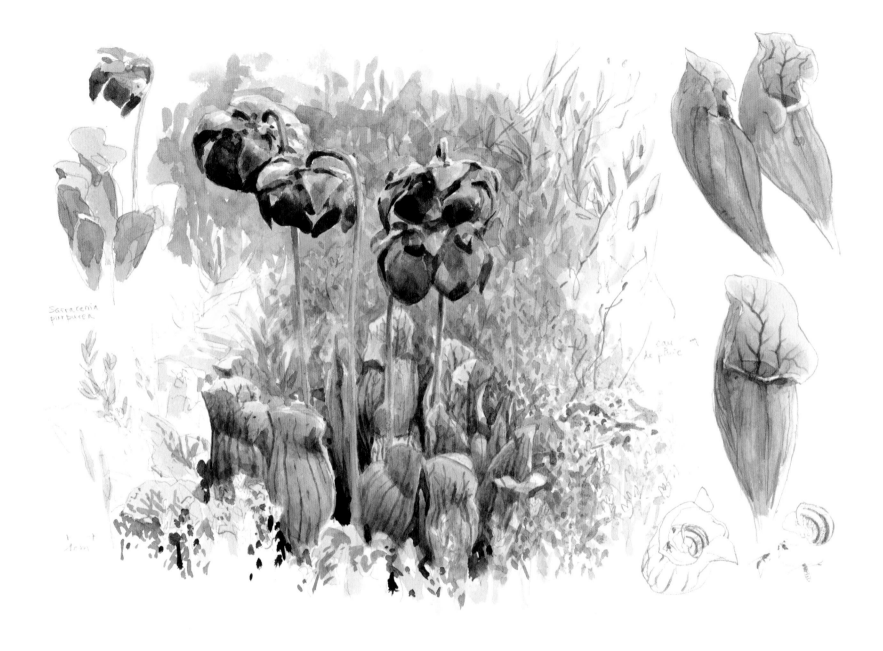

Parrot Pitcher Plant, between Pointe-aux-Loups et Grosse Île, Magdalen Islands, Quebec, July 5, 2003.
PENCIL AND WATERCOLOR, 11.02 × 16.53 IN (28 × 42 CM).

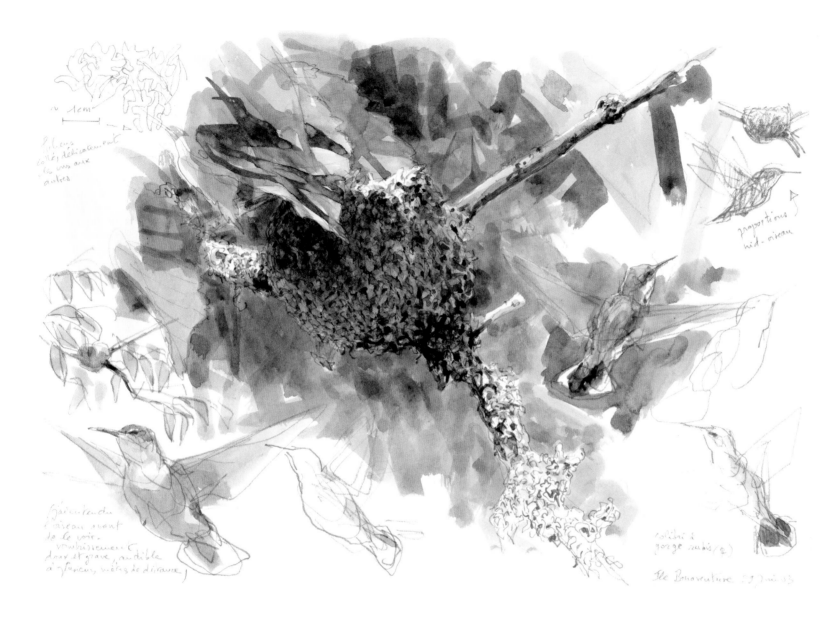

Female and nest of Ruby-throated Hummingbird, Bonaventure Island, Quebec, June 29, 2003.

PENCIL AND WATERCOLOR, 11.02 × 16.14 IN (28 × 41 CM).

I would not have found this tiny nest without precise directions from a national park ranger. Watching this bird, which weights hardly more than three grams (0.1 ounce), I can hardly believe that it goes all the way to Central America every year to spend the winter.

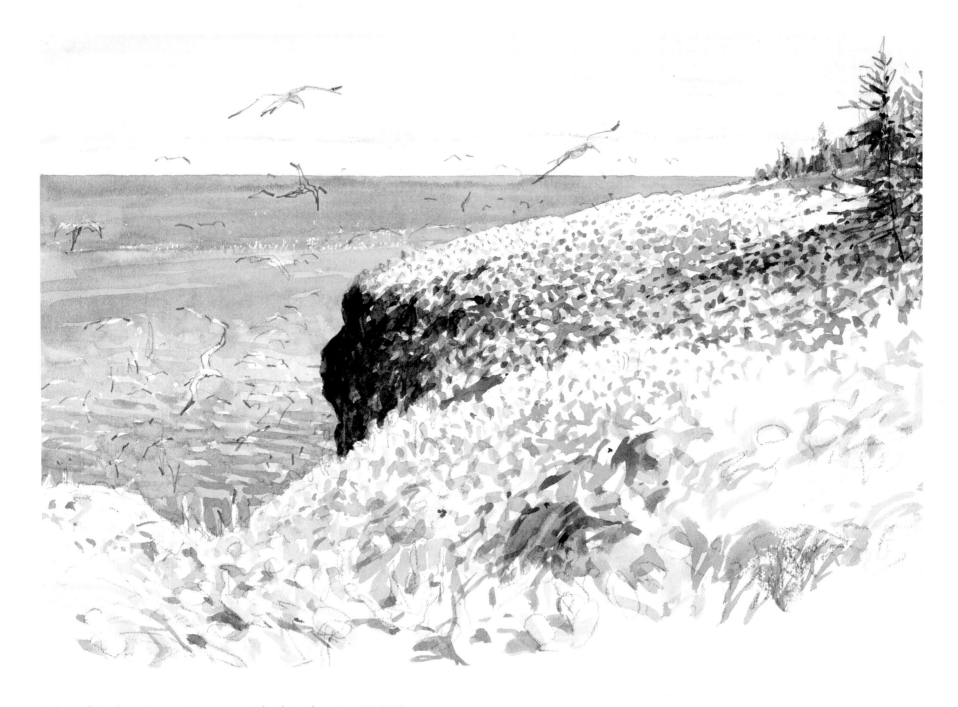

Colony of Northern Gannets, Bonaventure Island, Quebec, June 29, 2003.

PENCIL AND WATERCOLOR, 11.42 × 16.14 IN (29 × 41 CM).

Overwhelmed by the tumult of these thousands of birds, I was unable to paint on the spot. So I made this watercolor from memory a little later, as I waited more calmly for the ferry.

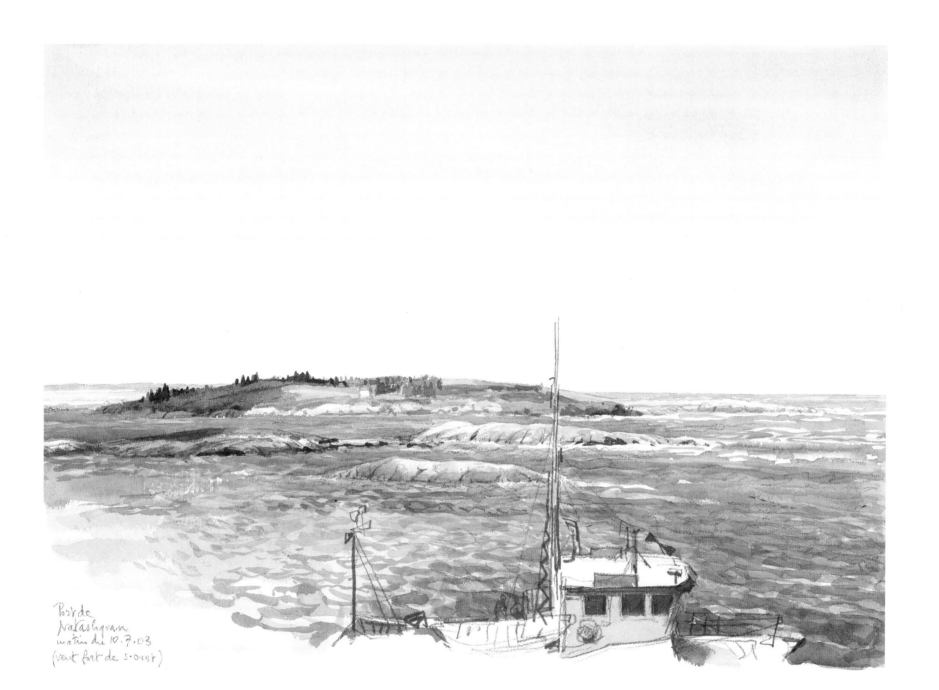

Pory de
Natashquan
matin du 10.7.03
(vent fort de s.ouest)

Natashquan Harbor, Quebec, July 10 2003.

PENCIL AND WATERCOLOR, 11.42 × 16.14 IN (29 × 41 CM).

The *Ripley* dropped anchor not far from here in 1833.

**Between Kegaska and La Romaine,
Quebec, September 10 2003.**

PENCIL AND WATERCOLOR,
5.31 × 16.14 IN (13.5 × 41 CM).

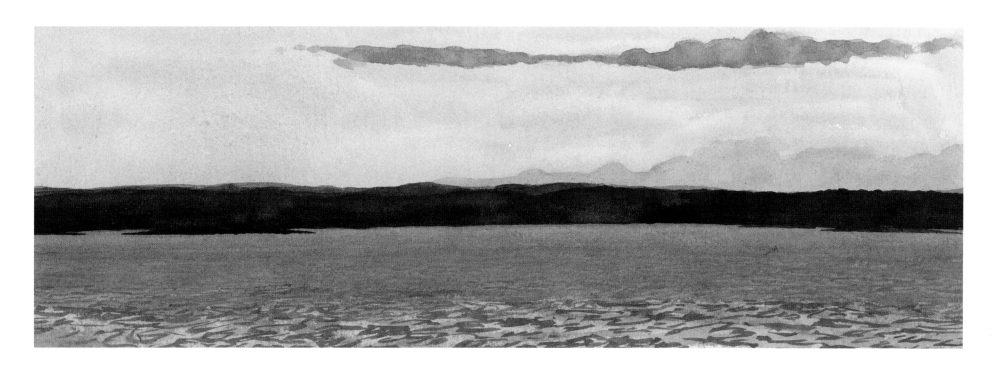

**Between La Romaine and Harrington Harbour,
Quebec, evening of September 10, 2003.**

PENCIL AND WATERCOLOR,
5.31 × 16.14 IN (13,5 × 41 CM).

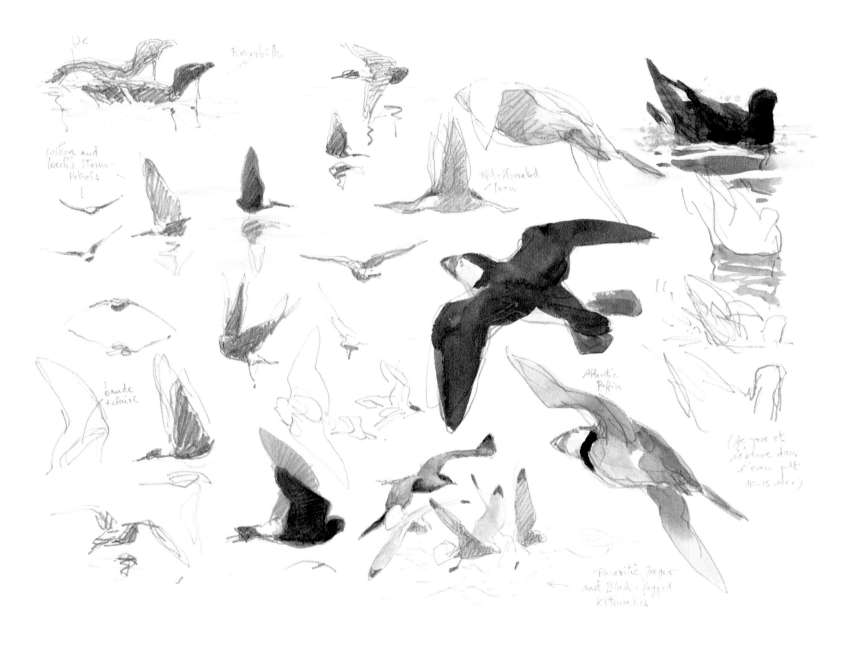

Birds observed at sea: Wilson and Leach's Petrels, Razorbills, Red-throated Loon, Atlantic Puffin, Parasitic Jaeger, and Black-legged Kittiwakes, Gulf of Saint Lawrence, Quebec, September 14, 2003.

PENCIL AND WATERCOLOR, 5.31 × 16.14 IN (13.5 × 41 CM).

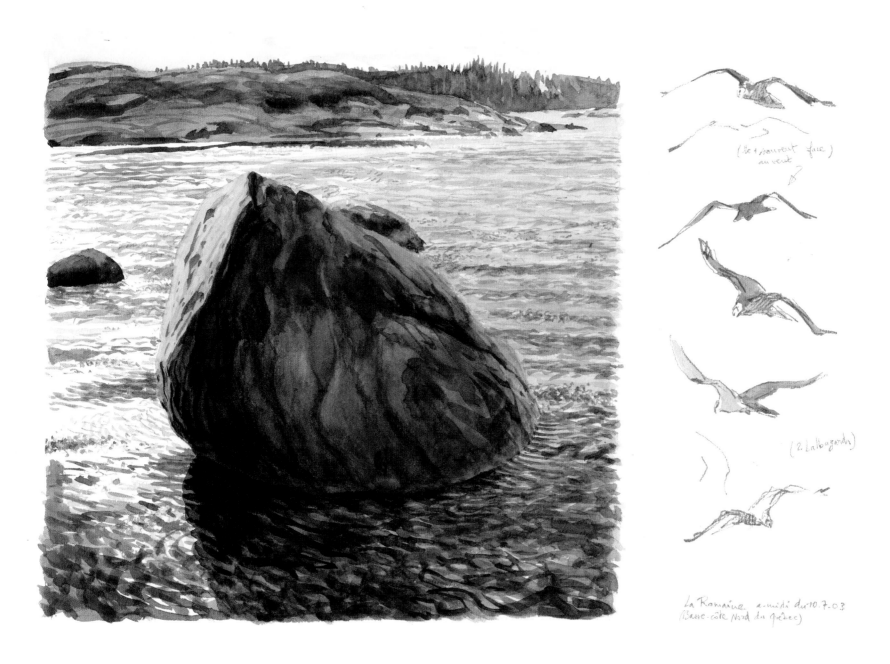

(Île + souvent face au vent)

(2. Lalbugardu)

La Romaine, a-midi du 10.7.03
(Basse-côte Nord du québec)

**Osprey, near La Romaine,
Quebec, September 10, 2003.**

PENCIL AND WATERCOLOR, 11.42 × 16.14 IN (29 × 41 CM).

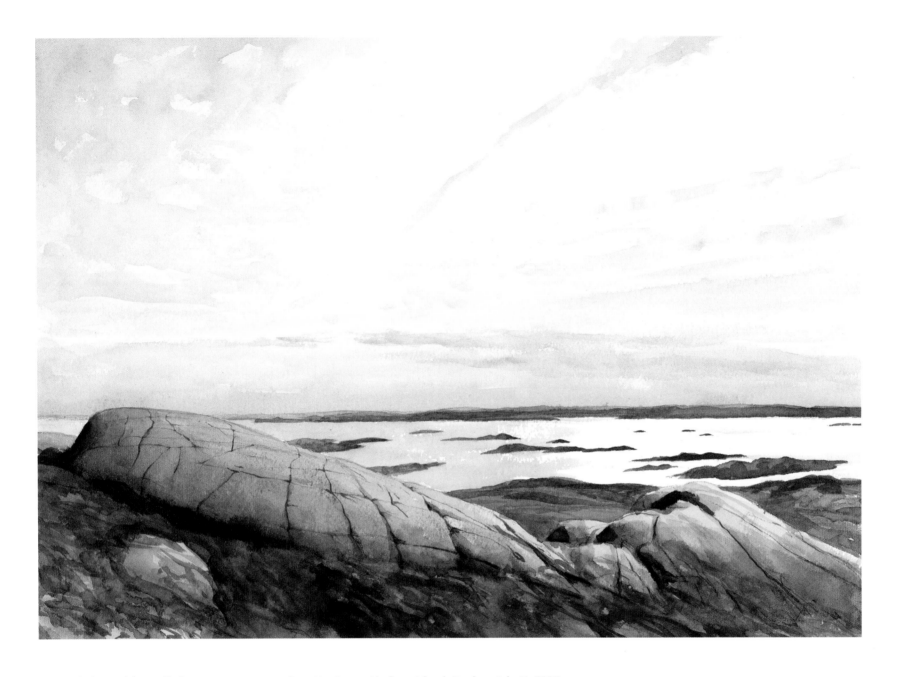

The north shore of the Gulf of Saint Lawrence seen from Harrington Harbour island, Quebec, July 11, 2003.

PENCIL AND WATERCOLOR, 11.42 × 16.14 IN (29 × 41 CM).

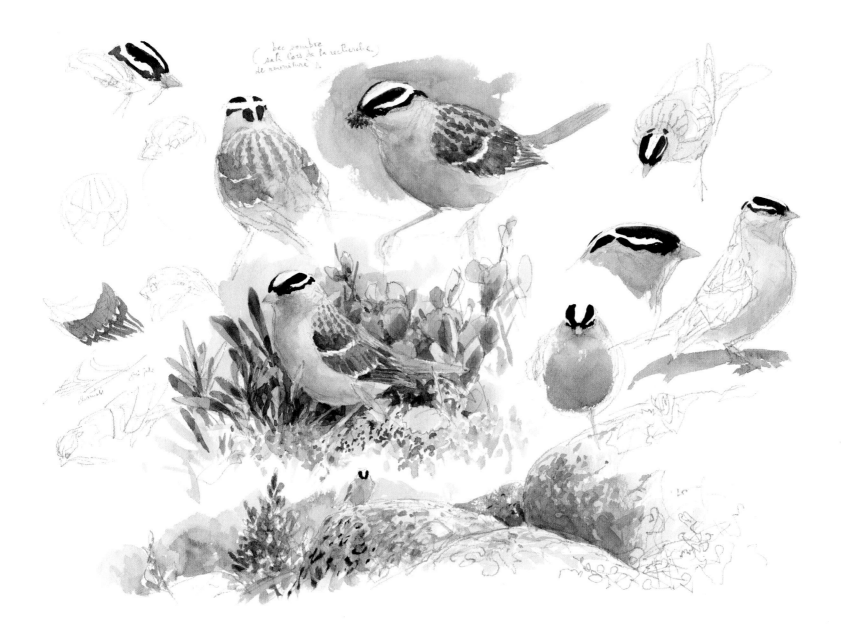

White-crowned Sparrow, Harrington Harbour, Quebec, July 12, 2003.

PENCIL AND WATERCOLOR, 11.02 × 15.75 IN (28 × 40 CM).

John found the nest of a White-crowned Bunting. ... The nest was like the one Lincoln found placed in the moss, under a low bough, and formed of a beautiful moss outwardly, dried, fine grass next inside, and exquisitely lined with fibrous roots of a rich yellow color.

—Audubon and Coues, *The Labrador Journal in Audubon and His Journals.*

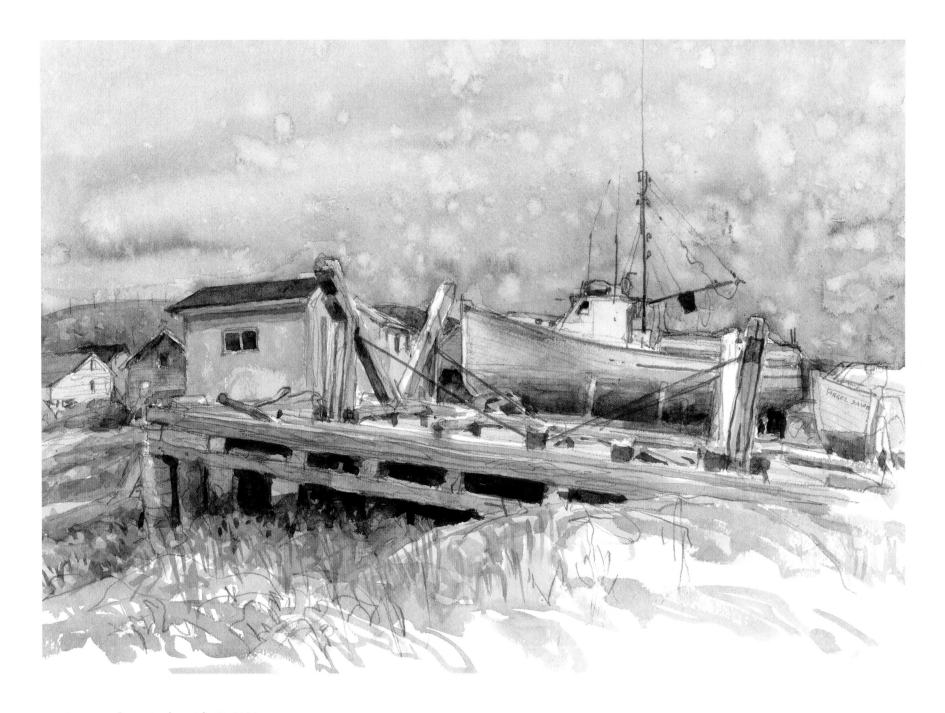

Harrington Harbour, Quebec, July 12, 2003.

PENCIL AND WATERCOLOR, 11.42 × 16.14 IN (29 × 41 CM).

This village was founded in 1871 by Protestant fishermen coming from Newfoundland.

(mer d'huile) Petit rorqual

en approchant de l'île
du Petit Mecatina.
11.7-03

Lesser Rorqual, approaching Little Mecatina Island, Quebec, July 11, 2003.

PENCIL AND WATERCOLOR, 10.24 × 16.53 IN (26 × 42 CM).

Pair of Red-throated Loons, Little Mecatina Island, Quebec, July 11, 2003.

PENCIL AND WATERCOLOR, 11.42 × 16.14 IN (29 × 41 CM).

The weather dubious, wind east. Two boats with the young men moved [off] in different directions. I sat to finishing the ground of my Grouse, and by nine had to shift my quarters, as it rained hard. By ten John and Lincoln had returned; ... They brought a Red-necked Diver and one egg of that bird; the nest was placed on the edge of a very small pond, not more than ten square yards.

—Audubon and Coues, *The Labrador Journal in Audubon and His Journals.* (Written on July 15, 1833, during Audubon's stay at Little Mecatina Island.)

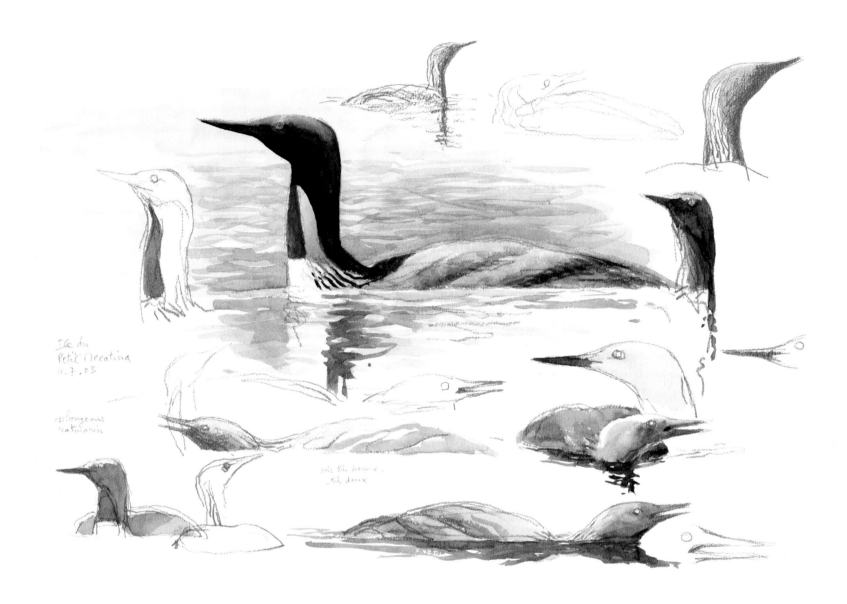

Red-throated Loons, Little Mecatina Island, Quebec, July 11, 2003.

PENCIL AND WATERCOLOR, 11.02 × 15.75 IN (28 × 40 CM).

The birds call softly, a moving sound in this austere landscape.

le St Laurent (marée basse) vue de St Rémi - Baie du Marais, L. Boisvert . 20.06.14

158

Saint Lawrence River,
Marais-Léon-Provancher
Nature Reserve, Quebec,
June 20, 2014.

PENCIL AND WATERCOLOR,
9.84 × 25.19 IN (25 × 64 CM).

159

Flowers, butterflies, and dragonfly, Marais-Léon-Provancher Nature Reserve, Quebec, June 20, 2014.

PENCIL AND WATERCOLOR, 11.02 × 15.75 in (28 × 40 cm).

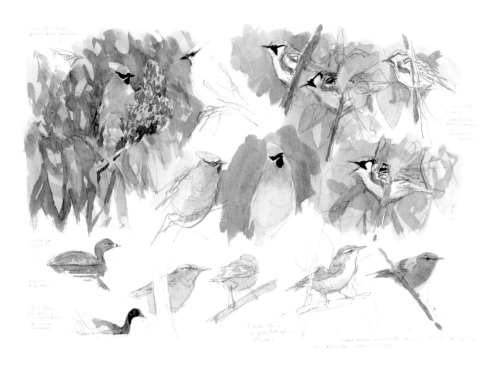

Cedar Waxwing, Chestnut-sided Warbler, Pied-billed Grebe, Common Moorhen, and Red-eyed Vireo, Marais-Léon-Provancher Nature Reserve, Quebec, June 20, 2014.

PENCIL AND WATERCOLOR, 11.02 × 15.75 in (28 × 40 cm).

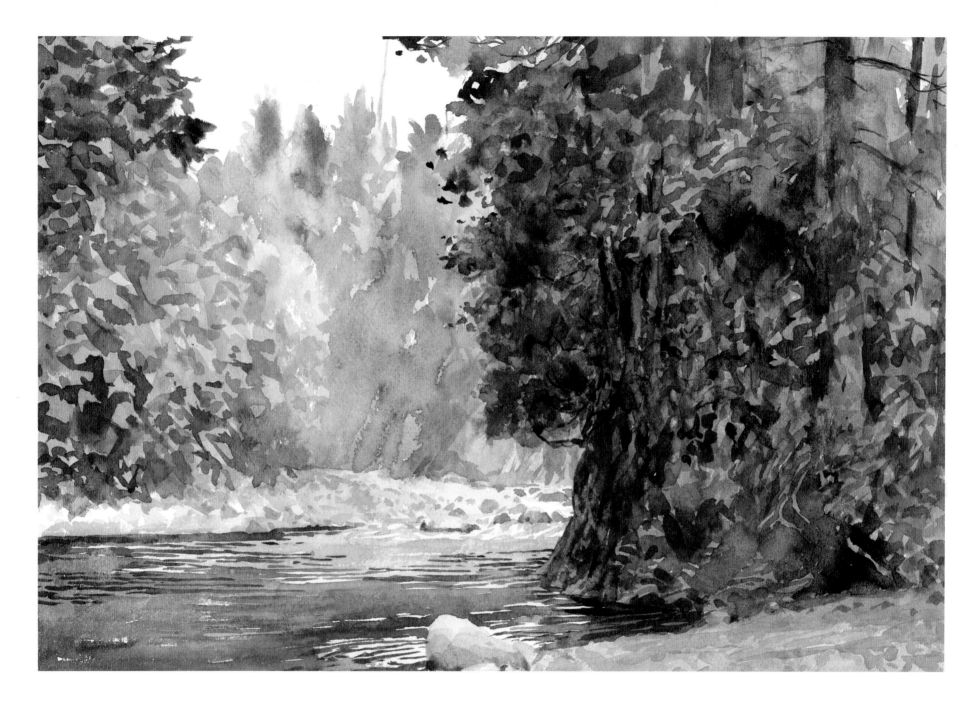

Saint Charles River, near Quebec City, June 25, 2014.

PENCIL AND WATERCOLOR, 10.24 × 14.96 IN (26 × 38 CM).

I imagine Audubon exploring this wild valley when he spent several days around Quebec City in 1842.

Head of a Buffalo calf.

John James Audubon, 1843.

WATERCOLOR ON PAPER,
24 × 28 IN (61 × 71 CM).

PRIVATE COLLECTION

FROM SARAH E. BOEHME, *JOHN JAMES AUDUBON IN THE WEST: THE LAST EXPEDITION: MAMMALS OF NORTH AMERICA.* NEW YORK: HARRY N. ABRAMS, IN ASSOCIATION WITH BUFFALO BILL HISTORICAL CENTER, 2000.

EXPEDITION ALONG THE MISSOURI RIVER

THE LAST ADVENTURE

Buffalo resting, Theodore Roosevelt National Park, North Dakota, September 14, 2003.

BLACK PASTEL, 2.56 × 10.24 IN (6.5 × 26 CM).

My dear Bachman,

I reached my happy home this day week last at 3 o'clock and found all well. The next day Victor handed me your letter of the 1st Instant, to which I will now answer as much as I can do in the absence of my cargo of skins, &c., which I trust will be at home early next week. ... I have no less than 14 new species of birds, perhaps a few more, and I hope that will in great measure defray my terrible heavy expenses. The variety of quadrupeds is small in the country we visited, and I fear that I have no more than 3 or 4 new ones.[1]

In this letter to Reverend Bachman upon his return from Missouri River, during the month of November 1843, Audubon attempted to reassure his friend even while admitting a partial defeat.

Bachman was impatient for discoveries that would enrich their common project on the quadrupeds of America. This respected naturalist had up-to-date knowledge of the mammals, and before Audubon departed, Bachman had given him a list of what needed most urgently to be researched and collected during the expedition. When he was able to analyze the notes and the materials collected, Bachman clearly expressed his disappointment, considering that the hunting parties had clearly taken precedence over true biological surveys.

You did not go far enough. There are in your journal some Buffalo hunts that are first rate—But after all, your expenses were greater than the knowledge was worth.[2]

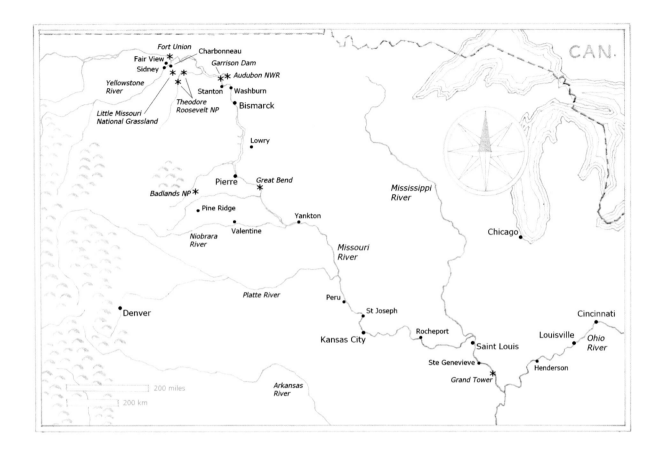

When the artist left New York on March 11 of the same year headed for Saint Louis, Missouri, first by train, then by stagecoach, and finally by boat, ten years had passed since his return from Labrador. In England, he had supervised the publication of the last plates of *The Birds of America*, as well as writing the texts of *Ornithological Biography* with the Scotsman, William MacGillivray.

In America, with his son John, he had worked tirelessly to publish *The Birds of America* in a smaller format and at a more affordable price, while also multiplying his trips to the south—Philadelphia, Washington, Charleston, Houston—and north as far as Quebec, mostly to promote his publications. A new generation of explorers was crisscrossing the regions that he had not been able to explore. Now he needed, while he was still able, to organize an expedition toward the Rockies.

Blocks of ice were still floating down the Missouri River when Audubon arrived in Saint Louis with his team, composed of his friend Edward Harris, the artist Isaac Sprague, the taxidermist John Graham Bell, and Lewis Squires, the son of neighbors in New York. He had to wait a month before embarking on the steamboat *Omega* headed for Fort Union, located at what is now the border between North Dakota and Montana. At Saint Louis, Audubon divided his time among social events, interviews, and surveys of nature around the city. Several times he visited the Chouteau family who owned the important American Fur Company and who had kindly

Audubon's naturalist ambitions were in reality thwarted by the depletion of numerous species due to the fur trade and by a serious incident that happened with the Blackfeet Indians, the unforeseen and suspicious death of a chief, an event that prevented Audubon from reaching more distant lands even richer in animal life.

But what did the pastor's criticisms matter, however justified they were. Audubon, honored and praised since the complete publication of his work on birds but also getting older, was tired from a vigorous life. He returned home in November 1843 after having realized, at least in part, the last of his dreams, a long voyage beyond the Mississippi River into the immense and wild landscapes of the West.

offered to provide the round-trip journey as well as housing at their trading post in Fort Union. The *Omega* sailed April 25 with about one hundred professional trappers and a small group of Iowa Indians aboard. Audubon had just lost one of his last teeth and would soon be fifty-eight years old. Nevertheless, he set forth with enthusiasm on a long journey of seven weeks along a river difficult to navigate in American Indian territories more or less pacified according to the region.

I, too, dreamt for several years of traveling along the Missouri River. This project becomes reality at Rocheport, Missouri, a charming village located to the west of Columbia. On this September 23, 2017, in stifling heat, we launch five canoes, and, like the other members of the group, I do my best not to slip in the mud. Brett Dufur warmly welcomed us a few minutes ago in the center of the village with talkative energy. From spring to the end of the summer, every Saturday, he organizes this river excursion between Rocheport and Huntsdale, about eight miles downstream.

Once the flotilla has regrouped in the middle of the river, we allow ourselves to drift a bit, just long enough for our guide to make his first comments,

Today you are going to feel some unique sensations, but at the risk of disappointing, you should know that the Missouri that you are going to discover is nothing like the one that Lewis and Clark navigated.[3] The river and the surrounding land used to be connected. With each flood the Missouri modified and recreated natural habitats where an incredible number of plants and animals lived. A real Garden of Eden. But the river posed problems to those who wanted to modernize; too unpredictable during nine months of the year, too strewn with obstacles. Beginning in 1881, the Corps of Engineers was charged with cleaning and dredging the Missouri, building levees and consolidating the banks. All this to assure a single navigable channel between Saint Louis and Sioux City.

Halfway through the trip we land at the foot of a large cliff. Brett points out an orange-colored pictogram on the rock, twenty-five feet above our heads: just a point topped by curved line, a design probably inscribed by the Sauk or Fox Indians who lived in this region. A little higher up, a dozen Cliff Swallow nests are aligned under a ledge. We return to the canoes moored to the stones that stabilize the bank. Hearing strange sounds coming from the stones that sound like the chirps of insects, I examine some holes and discover small frogs called Blanchard's Cricket Frog. Like Brett, I take a dip in the coolness and freshness of the Missouri and enjoy this precious moment in contact with this mix of waters coming from the Rockies as well as from a multitude of springs and marshes scattered in the prairies of the Midwest.

Some Monarch Butterflies flutter along the bank, on their way to their tropical winter habitat. A few Turkey Vultures soar elegantly just above the cliff and remind me of those Audubon had seen not far from here:

Scarlet Globemallow, Rock Hills Ranch, Lowry, South Dakota, June 9, 2010.
PENCIL AND WATERCOLOR, 9.45 × 5.12 IN (24 × 13 CM).

Indians often used this plant, either brewed or in a paste obtained by chewing the leaves, to treat burns or eye pain.

*Yesterday we passed under long lines of elevated shore,
surmounted by stupendous rocks of limestone, with many
curious holes in them, where we saw Vultures and Eagles
enter towards dusk.*[4]

At one moment, I think I glimpse a hippopotamus
in the middle of the river, but it is only a large
submerged branch floating just below the surface.
Audubon too had imagined giant elk antlers, only
to discover that innumerable dead trees obstructed
the river because of the continual collapse of the
banks. To these often-invisible obstacles feared by
ship captains were added a quantity of sandbars
and shallow areas that one probed with poles
from light boats, not to mention the crosscurrents
and storms that complicated travel. Audubon
noted on May 4:

*We had constant rain, lightning and thunder last night.
This morning, at the dawn of day, the captain and all
hands were at work, and succeeded in removing the
boat several hundred yards below where she had struck;
but unfortunately we got fast again before we could
reach deep water, and all the exertions to get off were
renewed, and at this moment, almost nine, we have a
line fastened to the shore and expect to be afloat in a
short time.*[5]

Stops to restock wood were frequent, and the water
so muddy that the boilers had to be cleaned every
day.

Audubon and his companions took advantage
of these stops to survey the surrounding areas
and collect specimens. The brevity of these stops,
however, prevented extensive observations of

mammals. Even though the time of year was favorable for bird observation, all the species noted since Saint Louis were already known and illustrated: turkeys, falcons, thrushes, swallows, warblers, parakeets, ducks, waders, and so on. But on the 4 of May, a little before reaching the Black Snake Hills, where today the city of Saint Joseph, Missouri, is located, Audubon mentioned for the first time a species that seemed new to him. After having studied a few more individuals, he wrote:

On examination of the Finch killed by Harris yesterday, I found it to be a new species, and I have taken its measurements across this sheet of paper. It was first seen on the ground, then on low bushes, then on large trees, but never did we hear it make the least sound.[6]

This species, which Audubon named Harris Finch and which we call today Harris's Sparrow, had been, in fact, discovered seven years earlier in this region by Thomas Nuttall. However, a bird that John Bell brought in on May 6 was an unknown species, a little vireo that Audubon named in gratitude Bell's Vireo.

Soon after the trading post at Vermillion River, the *Omega* had to stop for a few days because of a damaged boiler. When the voyage resumed, Audubon noted that the Missouri was in places very wide and shallow. This section of the river has kept its natural aspect even if certain sandbars are the result of recent works projects. I experience a memorable morning there in June 2010 in the company of two officials of the US Army Corps of Engineers. After having put our

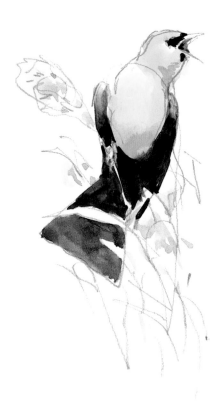

Yellow-headed Blackbird, north of Yankton, South Dakota, June 7, 2010.

PENCIL AND WATERCOLOR, 7.48 × 3.94 IN (19 × 10 CM).

boat in the water a little below Yankton, South Dakota, we go a few miles downstream to join a team of biologists who are studying the reproduction of Piping Plovers. What a curious contrast between these upright human forms, immobile, eyes glued to their binoculars, and the swift, tiny chicks, running here and there, so quickly that one couldn't make out their feet. We then approach another sandbar, greeted by the cries of Least Terns who are nesting among Cottonwood sprouts. During the return trip, for nearly a half mile, we follow a clay cliff riddled with small holes in front of which are fluttering hundreds of Bank Swallows. A few Black Terns are searching for food just above the water.

On the 21st of May, 1843, the *Omega* passed the mouth of the Niobrara River and then reached Fort Pierre on the thirty-first. Bison, wolves, deer, antelopes, and elk were more and more numerous. Audubon often saw dead bison floating by with the current. When these animals crossed the river and reached the other bank, they were hampered by escarpments impossible to climb, so they drowned sometimes in great numbers. As the days went by, Audubon envied his young companions when he saw them leave to go off to hunt and then return the next day exhausted and happy, as he had himself done so many times during his own life. The passage of the famous "Great Bend" presented him the occasion to enjoy one of his last bivouacs in the wilderness. Captain Sire proposed to Audubon to shortcut the narrowest part of the bend on foot.

This escapade of a few miles across the prairie allowed him a wonderful evening and night around the fire:

After a hearty meal we went to sleep, one and all, under the protection of God, and not much afraid of Indians, of whom we have not seen a specimen since we had the pleasure of being fired on by the Santees. We slept very well for a while, till it began to sprinkle rain; but it was only a very slight shower, and I did not even attempt to shelter myself from it. Our fires were tended several times by one or another of the party, and the short night passed on, refreshing us all as only men can be refreshed by sleep under the sky, breathing the purest of air, and happy as only a clear conscience can make one.[7]

At Pierre, the capital of South Dakota, I join Tim Olson who works for the South Dakota Department of Game, Fish, and Parks. A few months ago, when I told him about my interest in grassland restoration programs, Tim suggested that I meet a rancher deeply involved in this project. Thus we leave in the morning to visit Lyle and Garnet Perman, who run a ranch near Lowry, about seventy-five miles to the north. Along Route 83, on both sides of this endless straight line, extend fields of corn and soybeans as far as the eye can see, punctuated here and there by large machines standing in the middle of the fields. Farmhouses appear at lengthy intervals, most of the time sheltered behind a curtain of trees. It is June. Red-winged Blackbirds enliven every available water hole. Yesterday I saw

for the first time some Yellow-headed Blackbirds around a marsh near Marty, the excited males singing while exhibiting their bright colors, perched on reeds moving in the wind.

The landscape changes as we approach Lowry, South Dakota, hillier with more pastures. We go up Swan Creek Valley to a village, then take the road that leads to Rock Hills Ranch. All around us there is only a series of undulating hills continuing to the horizon, like a grass ocean blocked by steep rocky cliffs. The buildings finally appear, grouped in a small valley. The Permans's welcome is very warm. Lyle is impressive: tall, a frank look, a clear voice, as firm as the features of his face, a man of experience and efficiency with little use for small talk. Very quickly he invites me to stay until tomorrow and suggests that we climb into the back of his pickup to go move a herd from one pasture to another. The vehicle brushes the grass as it advances, which reminds me of the Tanzanian savannahs, except that the black forms that appear aren't Wildebeest but Black Angus cows! Garnet and Lyle have lived here since 1976 and will soon turn the management of the ranch over to their son, Luke, and his wife, Naomi, pregnant with their first child. *This will be the sixth generation of Permans!* Lyle proudly tells us, convinced that the most important thing he can do is transfer this land and his experience to the next generation. *We work hard and every day we learn what God made. I try to honor what he has given us.*

I sketch the cows, which are coming together and passing the open gate. Lyle's approach consists of managing the soil and plants not only to make his cattle ranch prosper but also to restore and maintain a healthy prairie.[8] I mention the millions of bison of the past and the phenomenal quantities of grass that they were eating yet without turning the prairies into deserts. *Precisely*, he responds:

By moving my cows to the fields that I let rest for an entire year, the impact of grazing will be a little like that of the bison, and we are even seeing the original plants reappear. But we have to keep track of the herd size compared to the size of the grazing land so that the cows graze evenly. This prevents the invasion of plants that they don't like as much.

Lyle and Tim chat a while along a fence. A little farther away, behind them, two male Bobolinks come and go on the wires, each one no doubt at the border of his territory.

At the end of the afternoon, I set up at the top of a hill to work. The wind requires me to paint close to the ground. It carves uncountable moving wrinkles in the grass, which move downhill then climb along the slopes: a magnificent vision of this landscape trembling like a great body.

Lyle and Garnet indicate a marsh nearby, "*a very nice place*," where I could see and draw some birds before leaving the region. I head there the next morning and am immediately overcome by the show: lost in the middle of nowhere, the marsh that covers the bottom of this valley is a true paradise for birds. An uninterrupted show of

Bracted Spiderwort, Green Needle Grass, Shell-leaf Penstemon, Rock Hills Ranch, Lowry, South Dakota, June 9, 2010.
PENCIL AND WATERCOLOR, 14.96 × 7.87 IN (38 × 20 CM).

The simple geometry and elegant coloring of Spiderwort blossoms inspired Dakota men to salute this plant in love songs.

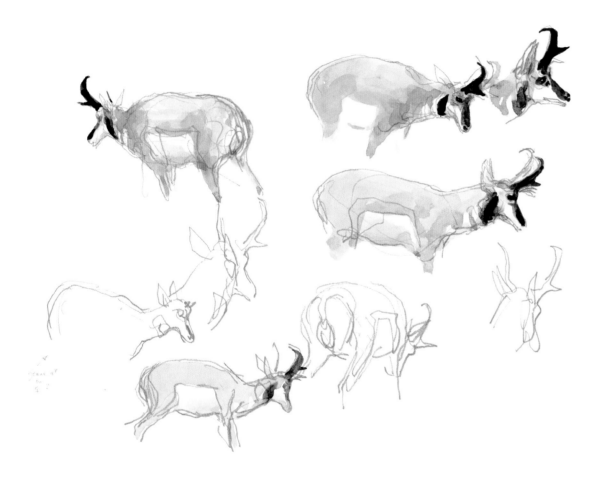

Pronghorn, Badlands National Park, South Dakota, June 5, 2010.

PENCIL AND WATERCOLOR, 10.63 × 14.57 IN (27 × 37 CM).

courtship displays, songs, calls, flights, and dives. I hurriedly sketch Ruddy Ducks, Wilson's Phalaropes, Franklin's Gulls, Marbled Godwits, and White-faced Ibis.

Near Stanton, North Dakota, I stop at the Fort Clark Historic Site situated on a hill overlooking the river. A village of Mandan Indians was there when the Omega landed on June 7, 1843. They were the last survivors of a terrible smallpox epidemic brought by trappers seven years earlier. This stop at the Mandan village struck Audubon profoundly. The people he found there saddened and disgusted him at the same time.

The appearance of these poor, miserable devils, as we approached the shore, was wretched enough. There they stood in the pelting rain and keen wind, covered with Buffalo robes, red blankets, and the like, some partially and most curiously besmeared with mud.[9]

All his life Audubon had an ambivalent relationship with American Indians and feelings about them. At first he was fascinated by these people living so close to nature and, like many Europeans, saw in them a symbol of purity and wisdom still unaffected by civilization. His curiosity and respect toward them were often sincere, and he condemned several times the cruelties to which White people subjected them. But the aging, now famous John James had changed. His journal of the Missouri voyage is dotted with negative and derisive notes about them, an antipathy accentuated by the very

weakened physical state of the American Indians that he encountered on the plains.

After having read the historical markers telling the story of the Mandans, I cross a meadow where two beautiful American Indian ponies are grazing to check out the surrounding hedges. A few Field Sparrows move between the low branches and the grasses; with their candy-colored pink beaks they look like cartoon characters. A little farther, two Northern Flickers peck at the fruit of a Silver Buffaloberry bush. Audubon was one of the first to comment about the variable plumage of this species.

The *Omega* arrived at Fort Union on June 12. Alexander Culbertson, manager of the fort, welcomed Audubon with all the respect due to his fame. Delicious dinners and comfortable beds, the quality of the hospitality was remarkable throughout his stay, as it had been for two other artists—George Catlin and Carl Bodmer—ten and twelve years beforehand. Audubon could not have dreamed of anything better. He was going to spend most of his summer visit avoiding the hunting parties, drawing at the fort, fishing for long hours alone, and finally growing more and more impatient to rejoin his family. As in Louisiana, he paid some hunters in the hope of gathering interesting specimens.

His reluctance to organize excursions far from the fort limited his biological discoveries in a region already explored and intensively hunted for more than twenty years. Nevertheless, Bell prepared eighty-five mammal skins over the

course of the stay at Fort Union and twenty-seven others elsewhere during the expedition. But none of these species was unknown.

Bison were still abundant, and Audubon's companions went hunting almost daily. His friend Harris often shot wolves that passed near the fort and, sometimes, even entered to devour the pigs. After a few weeks, Audubon felt more and more bothered by these hunts, to the point of being seriously afraid that the American Bison would disappear. Their massacre was only starting, however, and would reach its peak thirty years later during the land rush in the western United States.

Wishing to go back down the Missouri before cold weather arrived, Audubon left Fort Union in mid-September aboard a boat specially constructed for the return and reached Saint Louis in five weeks. He finally arrived home in New York on November 6, 1843.

Tuberous roots of Breadroot Scurfpea, also called Prairie Turnip, Indian Breadroot, White Apple, and Timpsula in Lakota language, Pine Ridge Reservation, South Dakota, June 12, 2010.

PENCIL AND WATERCOLOR, 8,66 × 3,54 in (22 × 9 cm).

May 22, Monday. ... We found here an abundance of what is called the White Apple, but which is anything else but an apple. ... This plant is collected in great quantities by the Indians at this season and during the whole summer, and put to dry, which renders it as hard as wood; it is then pounded fine, and makes an excellent kind of mush, upon which the Indians feed greedily. I will take some home.

—Audubon and Coues, *The Missouri River Journals* in *Audubon and His Journals.*

Lazuli Bunting, specimens collected by Audubon near Fort Union. Collection of the Academy of Natural Sciences, Philadelphia, Pennsylvania, March 7, 2007.

PENCIL AND WATERCOLOR, 3.35 × 7.68 IN (8.5 × 19.5 CM).

At the end of a September afternoon, I reach the junction of the Missouri and Yellowstone Rivers a little before Fort Union, North Dakota, just in time to paint before nightfall. Faced with the vast scale of the landscape I attempt a large format. It will have to be quick, with large brushes, not too well thought out because the high clay cliffs that border the Yellowstone to the southeast are already tinted pink.

That morning I saw about twenty White Pelicans grooming their plumage along the river bank, near Garrison Dam, signaling that migration has already started. Then, without stopping, I crossed open spaces dotted by myriad ponds, some tiny but whose existence is vital for the North American duck population.

I finish the watercolor and stop to greet two employees of the Missouri–Yellowstone Confluence Interpretative Center who are thrilled to welcome a visitor from so far away. They talk to me proudly about this region, of the pleasure of living here far from large cities. We talk about Audubon, but more of Lewis and Clark who, with their men on the evening of April 26, 1805, camped on the point formed by the junction of these two rivers.

Contrasting with a magnificent blue sky, the white-painted walls of the Fort Union Trading Post rise up from a terrace less than two hundred yards from the Missouri. The fort is a replica of the original one constructed between 1828 and 1829, then destroyed forty years later after the Civil War. The central building where Culbertson and his Native American wife lived now contains offices, a museum area, and a book store. The side buildings where Audubon and his companions stayed have not been reconstructed. I have a strange feeling of visiting a deserted film stage between two takes. The north gate opens onto a prairie that, beyond the road, extends far to the first hills. Not a bird in sight. I walk around a couple of teepees erected there, lifeless, to remind the tourists of the constant presence of American Indians when the trading post was active.

I miss the wolves so often mentioned by Audubon. I would really like to see one, just long enough, to draw a sketch. I make the grasshoppers jump while walking in the grass and bend down

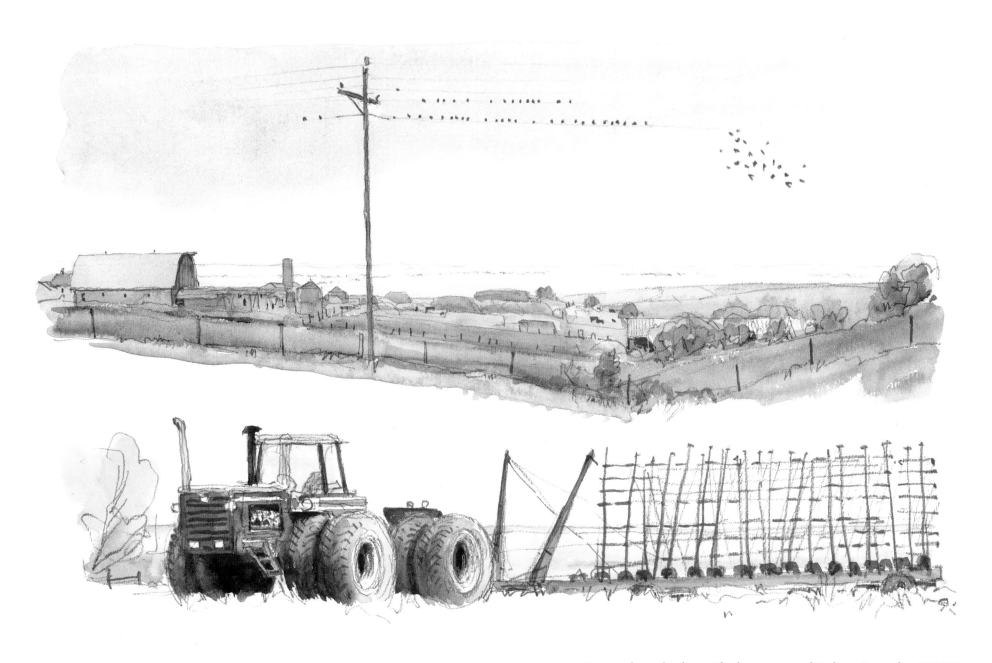

Farm and grassland near Charbonneau, North Dakota, September 17, 2003.

PENCIL AND WATERCOLOR, 9.84 × 16.14 in (25 × 41 cm).

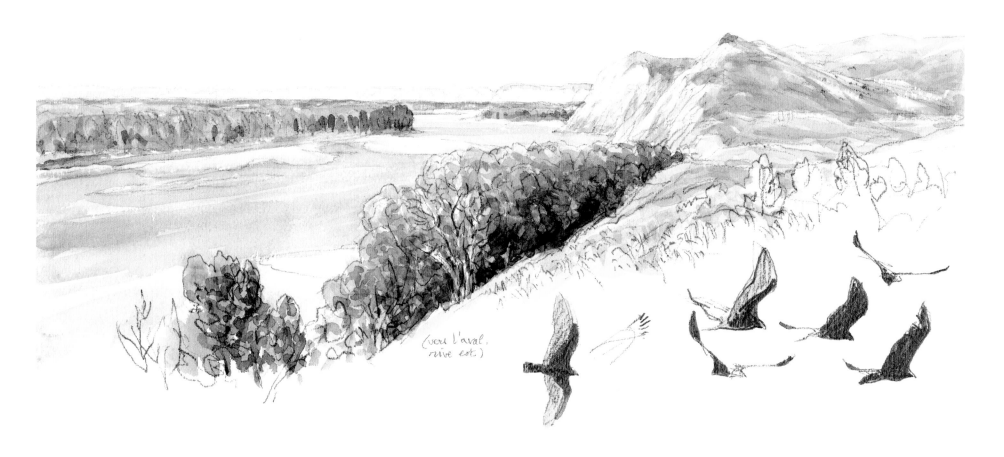

(vers l'aval.
rive est.)

The Yellowstone River, between Sidney and its junction with the Missouri River, and Turkey Vultures, Montana, September 16, 2003.

PENCIL AND WATERCOLOR,
6.30 × 16.14 IN (16 × 41 CM).

to examine more closely one of them being eating by a cricket.

Continuing my route, near Sidney, Montana, I see some Northern Harriers hunting over cultivated fields west of the Yellowstone while, on the other side, prairie dogs bustle about in the grass on the eroded slopes of the Badlands. Barely visible among the yellowed grasses, these little

animals frolic near their burrows, stand up, always on guard. I enjoy seeing them turn into little balls when they sit on their behinds to nibble something.

Along a trail that climbs past an oil well and winds among the hills,[10] I stop in an isolated spot. The dry grasses rustle lightly with each breeze. A Sharp-tailed Grouse extends his neck among

the grasses fifty feet away and looks at me just before disappearing like a ghost.

I search, without success, for some Pronghorn Antelopes. I am going to see them later in the parks of South Dakota. But here I am obsessed by the bison. They are the highlight of my trip. So I go to the Theodore Roosevelt National Park. The first bison that I see are very far away, small black points under an immense sky. I spend the whole day near a herd to better sense the rhythm of their life. Between grazing and moving around, the troop stops, and most of the animals rest to ruminate, often on small circles of bare soil. From time to time, an animal rolls on his side to scratch his back, his four legs in the air in the middle of a dust cloud. The prairie dogs circulate heedlessly among these giants. Each time that a bison starts to run, the fluidity and

speed of his gallop surprises me. The stocky neck of the calves is strange, very different than that of young domesticated cattle. Seeing them, I think of those that Charles Jesse Jones caught with his lasso and brought to his ranch in 1886. This hunter and friend of Theodore Roosevelt, nicknamed Buffalo Jones, contributed in this way to saving the American Bison at the last minute from extinction. A little after leaving the park in the twilight, a Coyote honors me with an appearance.

A few days later, I stop near the bridge of Washburn, North Dakota, to paint one last time the Missouri River. During the night an icy north wind has swept away yesterday's warmth as if, in this region, winter could follow summer, ignoring fall altogether. A few flocks of Sandhill Cranes stretch out in the sky, hurrying toward the South.

Coyote, Theodore Roosevelt National Park, North Dakota, September 14, 2003.

PENCIL, 5.31 × 2.56 IN (13.5 × 6.5 CM).

1. Rhodes, *The Audubon Reader.* Reproduced by permission of Everyman's Library, an imprint of Alfred A. Knopf.

2. John Bachman to John James Audubon, March 6, 1846, Bachman Papers, Charleston Museum, South Carolina.

3. A little after the Louisiana Purchase, President Thomas Jefferson ordered an exploratory expedition to the Pacific coast, which he entrusted to Meriwether Lewis and William Clark. They left Saint Louis on May 14, 1804, and returned at the end of September 1806 after a voyage of two years, four months, and ten days.

4. Audubon and Coues, *The Missouri River Journal* in *Audubon and His Journals.*

5. Audubon and Coues, *The Missouri River Journal.*

6. Audubon and Coues, *The Missouri River Journal.*

7. Audubon and Coues, *The Missouri River Journal.*

8. In 2014, Rock Hills Ranch was awarded the Environmental Stewardship Award and the Leopold Conservation Award.

9. Audubon and Coues, *The Missouri River Journal.*

10. Under this region lie enormous reserves of gas and petroleum. The exploitation of this reserve, called Bakken Shale, has developed dramatically since 2008 because of hydraulic fracturing. The companies, having not constructed extra pipelines in time, allowed enormous quantities of gas to be burned in gas flares, a practice that contributed to greenhouse gas emissions as well as being a huge waste of energy.

Sandhill Cranes migrating, near the Audubon National Wildlife Refuge, Coleharbor, North Dakota, September 17, 2003.

PENCIL, 3.94 × 7.09 IN (10 × 18 CM).

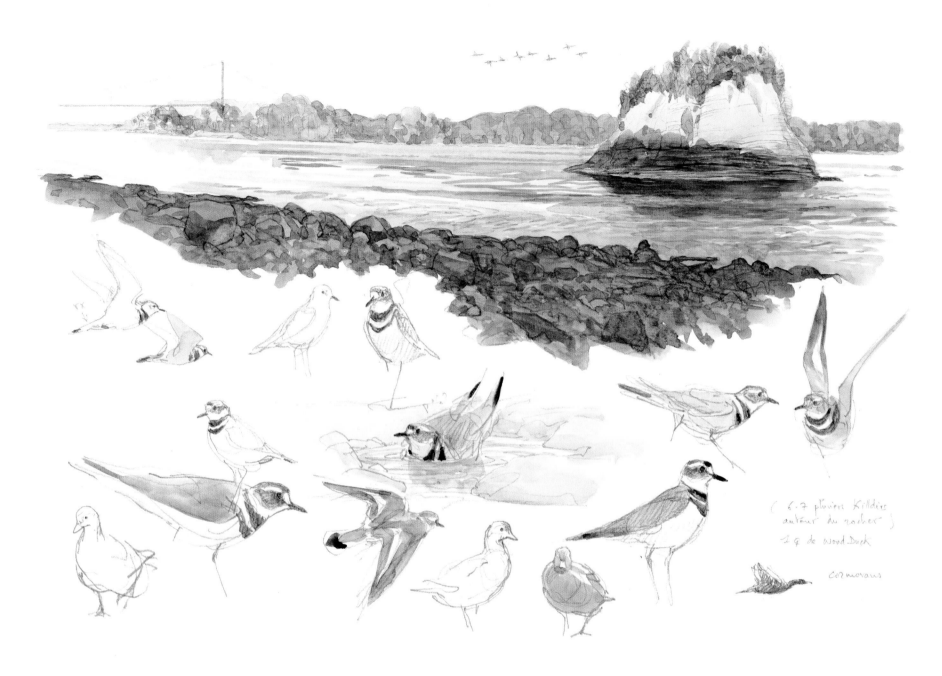

Handwritten notes on image:
(6.7 plumes Killders
autour du rocher)
1 ♀ de Wood Duck

Cormorans

The Grand Tower and the Mississippi River; Killdeers, Wood Duck, and Double-crested Cormorants, Brazeau, Missouri, evening of September 22, 2017.

PENCIL AND WATERCOLOR, 10.63 × 15.75 IN (27 × 40 CM).

Audubon passed near this geological curiosity when he went up the Mississippi to Saint Louis, the starting point of his expedition up the Missouri.

After the Civil War the US Army Corp of Engineers proposed clearing rocks from the river to eliminate obstacles to navigation. Upon a recommendation of the secretary of interior, then-president Ulysses Grant issued an executive order that spared the Grand Tower from blasting.

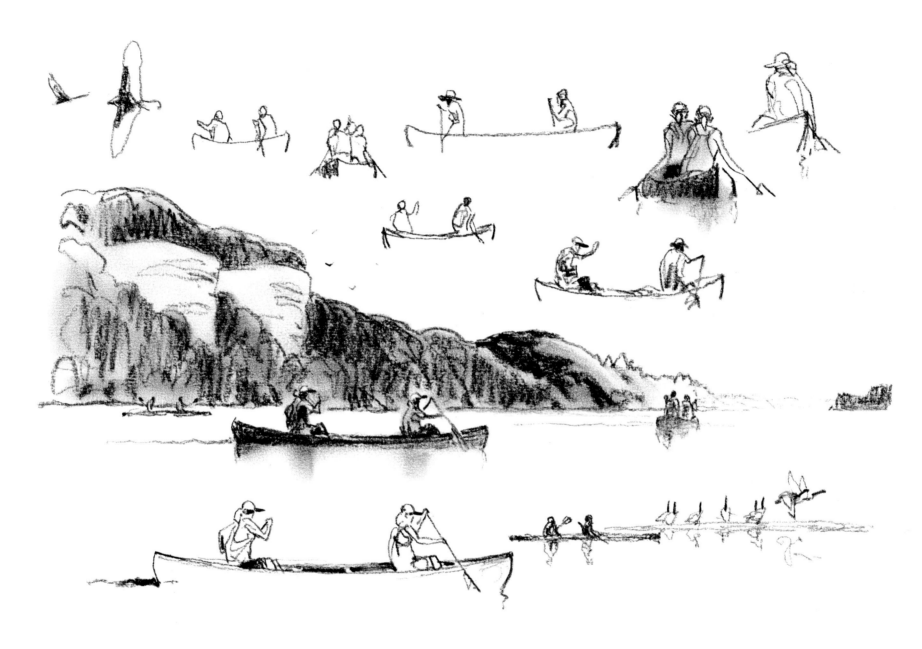

Canoeing on the Missouri River along Rocheport cliffs; Turkey Vulture
and Canada Geese, Rocheport, Missouri, September 23, 2017.

CHARCOAL, 9.84 × 14.96 IN (25 × 38 CM).

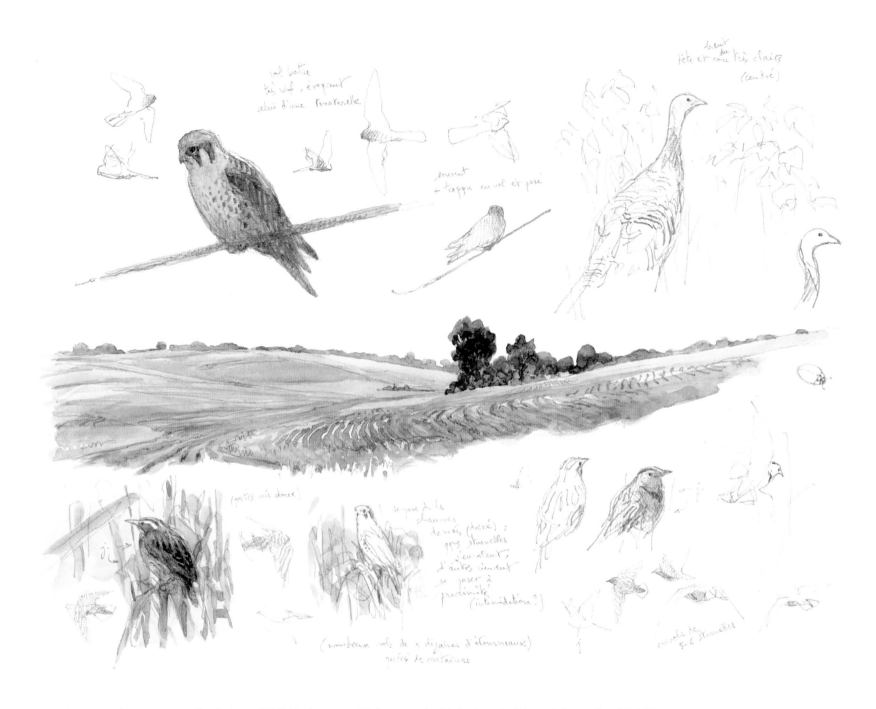

American Kestrel, Western Meadowlarks, and Wild Turkey, near Wallace, south of Saint Joseph, Missouri, September 26, 2017.

PENCIL AND WATERCOLOR, 11.42 × 15.75 IN (29 × 40 CM).

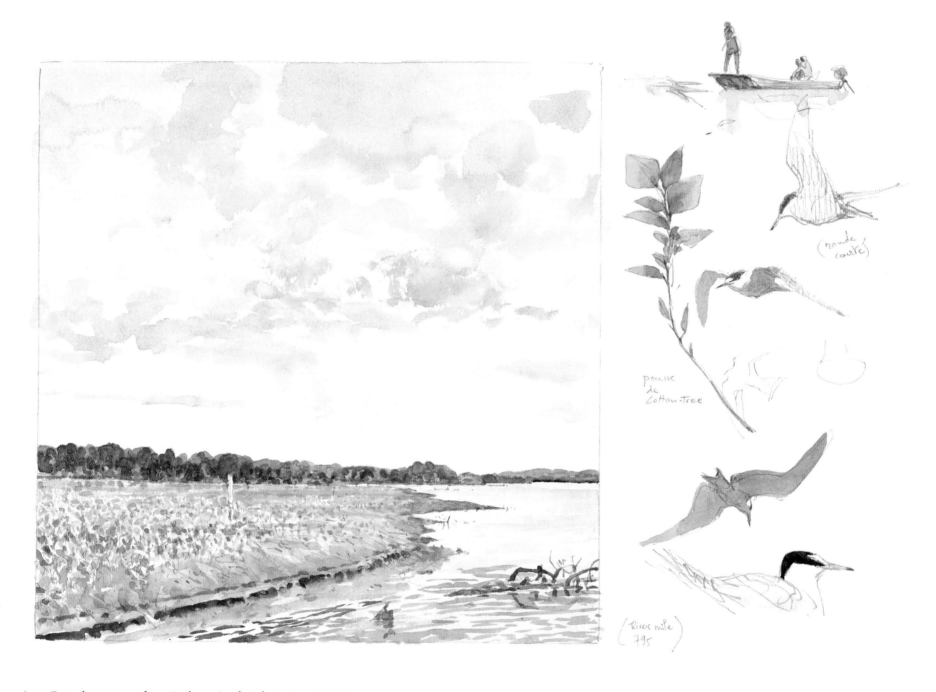

Least Tern, downstream from Yankton, South Dakota, June 7, 2010.

PENCIL AND WATERCOLOR, 11.42 × 15.75 IN (29 × 40 CM).

Several pairs of Least Terns and Piping Plovers nest on islets reconstructed by the US Army Corps of Engineers along this portion of the Missouri River.

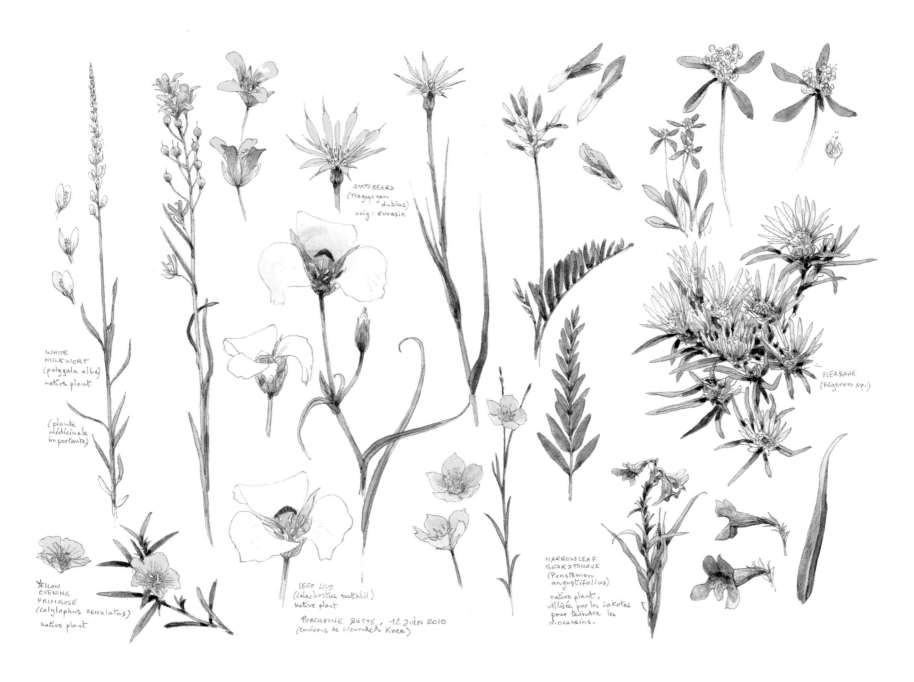

WHITE
MILKWORT
(Polygala alba)
native plant

(plante
médicinale
importante)

GOATSBEARD
(Tragopogon
dubias)
orig : Eurasie

YELLOW
EVENING
PRIMROSE
(Calylophus serrulatus)

native plant

SEGO LILY
(Calochortus nuttallii)
native plant

PORCUPINE BUTTE, 12 JUIN 2010
(environs de Wounded Knee)

FLEABANE
(Erigeron sp.)

NARROWLEAF
BEARDTONGUE
(Penstemon
angustifolius)

native plant,
utilisée par les Lakotas
pour teindre les
mocassins.

Studies of native and introduced plants: White Milkwort, Yellow Evening Primrose, Goatsbeard, Sego Lily, Narrowleaf Beardtongue, and Fleabane, Porcupine Butte, near Wounded Knee, Pine Ridge Reservation, South Dakota, June 12, 2010.

PENCIL AND WATERCOLORS, 11.81 × 16.53 IN (30 × 42 CM).

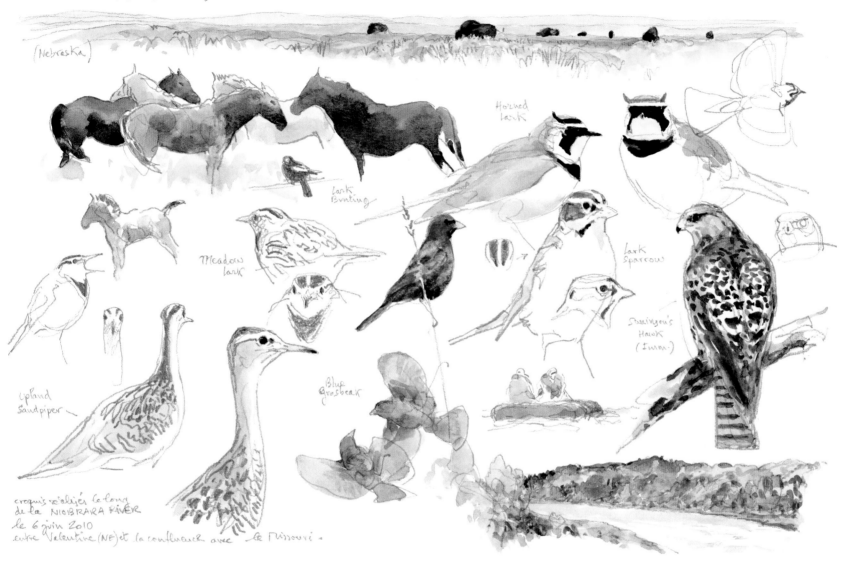

Buffalos, ponies, Western Meadowlark, Blue Grosbeak, Lark Bunting, Horned Lark, Lark Sparrow, Upland Sandpiper, and Swainson's Hawk, along the Niobrara River, from Valentine to Niobrara River mouth, Nebraska, June 6, 2010.

PENCIL AND WATERCOLOR, 11.02 × 15.75 IN (28 × 40 CM).

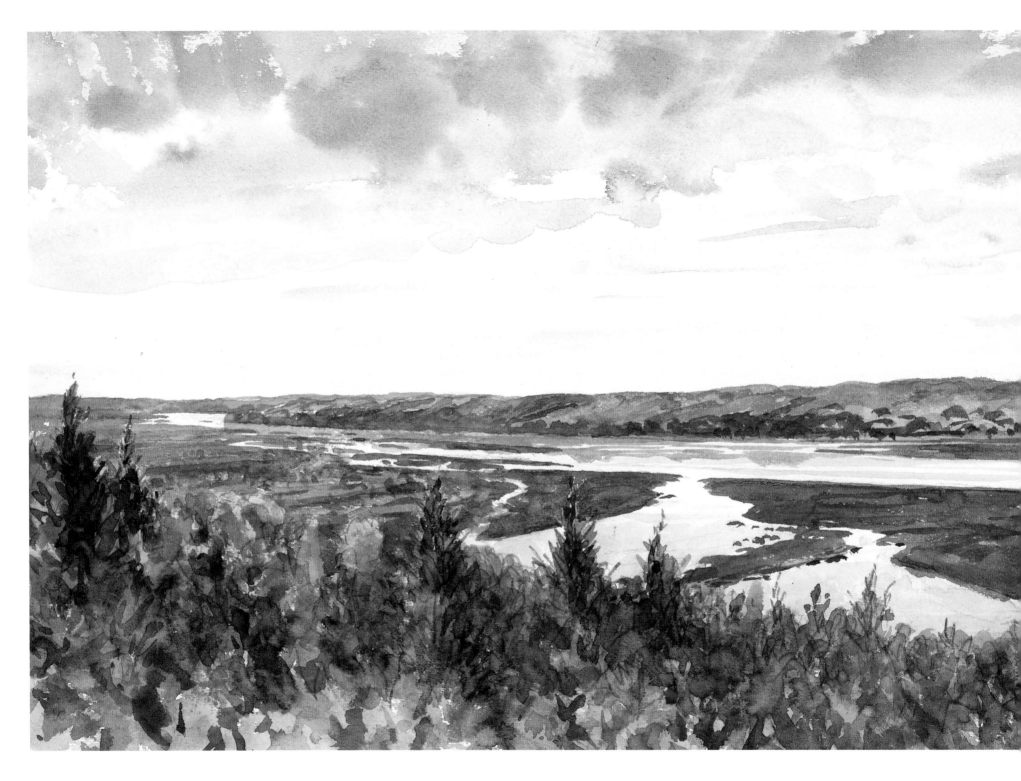

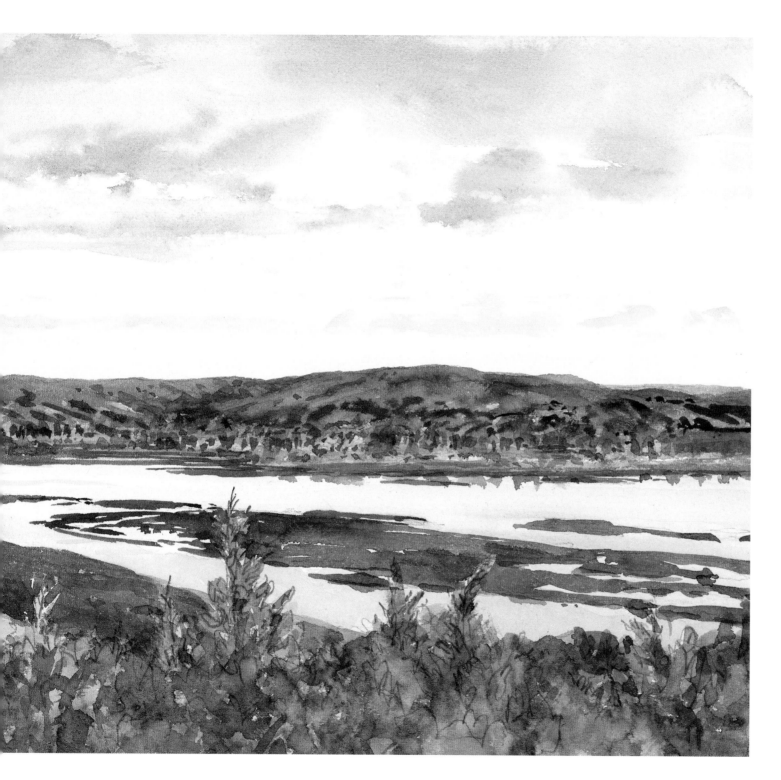

The junction of Niobrara and Missouri Rivers, Niobrara State Park, Nebraska, evening of June 6, 2010.

PENCIL AND WATERCOLOR, 9.84 × 25.19 IN (25 × 64 CM).

Audubon passed this spot on May 21, 1843, before stopping a bit farther upstream at Ponca Island. He noted that day in his diary:

We have seen this day about fifty Buffaloes; two which we saw had taken to the river, with intent to swim across it, but on the approach of our thundering, noisy vessel, turned about and after struggling for a few minutes, did make out to reach the top of the bank, after which they travelled at a moderate gait for some hundreds of yards; then, perhaps smelling or seeing the steamboat, they went off at a good though not very fast gallop, on the prairie by our side, and were soon somewhat ahead of us.

—Audubon and Coues, *The Missouri River Journals* in *Audubon and His Journals.*

183

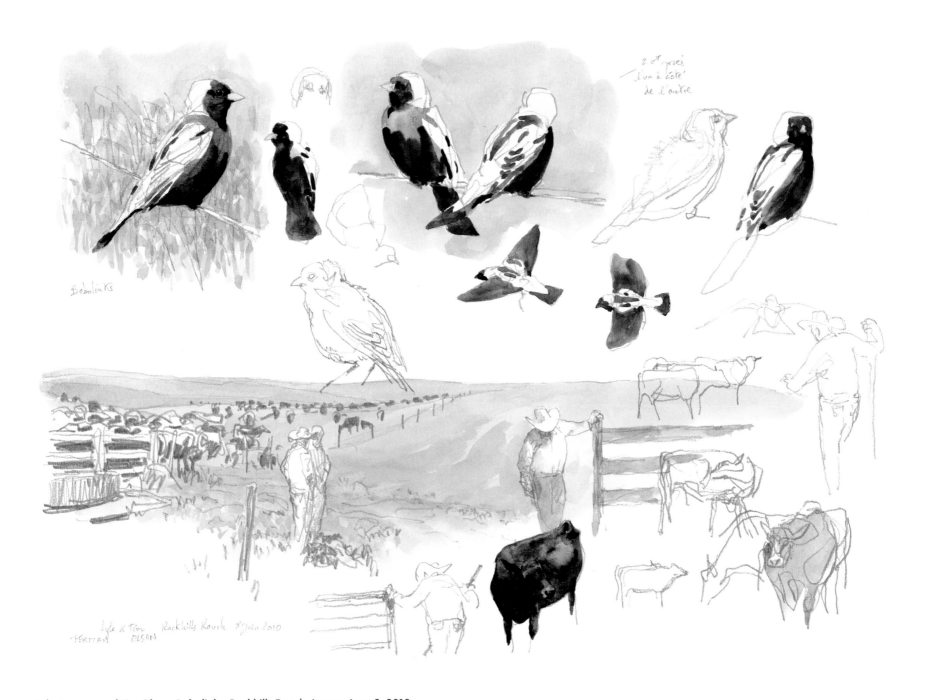

Lyle Perman and Tim Olson, Bobolinks, Rockhills Ranch, Lowry, June 8, 2010.

PENCIL AND WATERCOLOR, 11.42 × 16.14 in (29 × 41 cm).

184

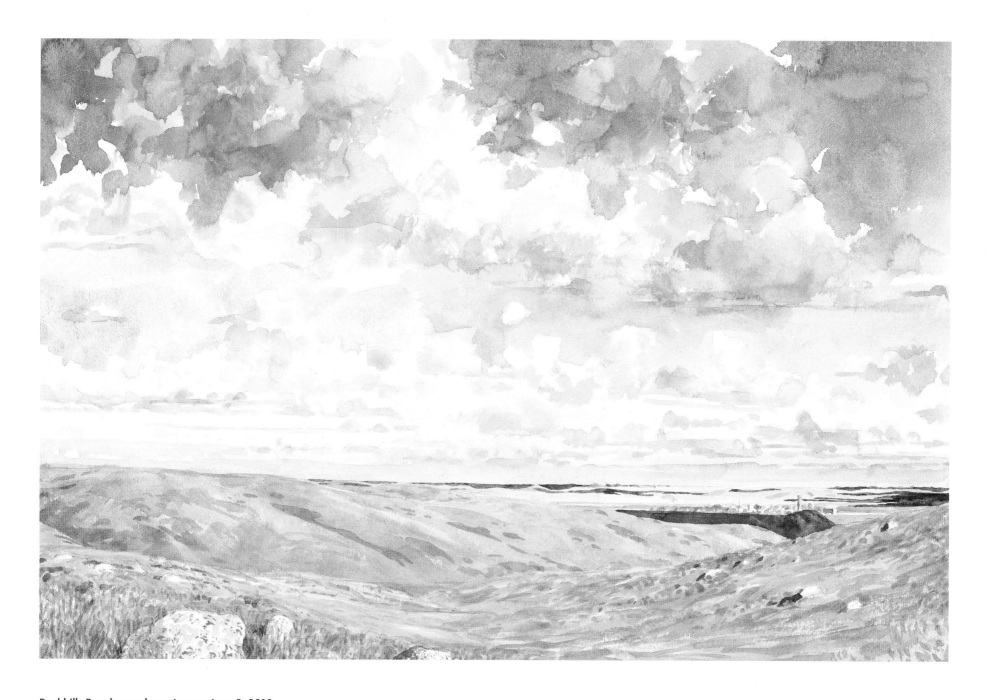

Rockhills Ranch meadows, Lowry, June 8, 2010.

PENCIL AND WATERCOLOR, 10.24 × 15.35 IN (26 × 39 CM).

The tallgrass prairie that covered the easternmost belt of the Great Plains has been already converted to farmland.
Lyle Perman told me he was worried that here, too, grain cultivation is spreading at the expense of grassland.

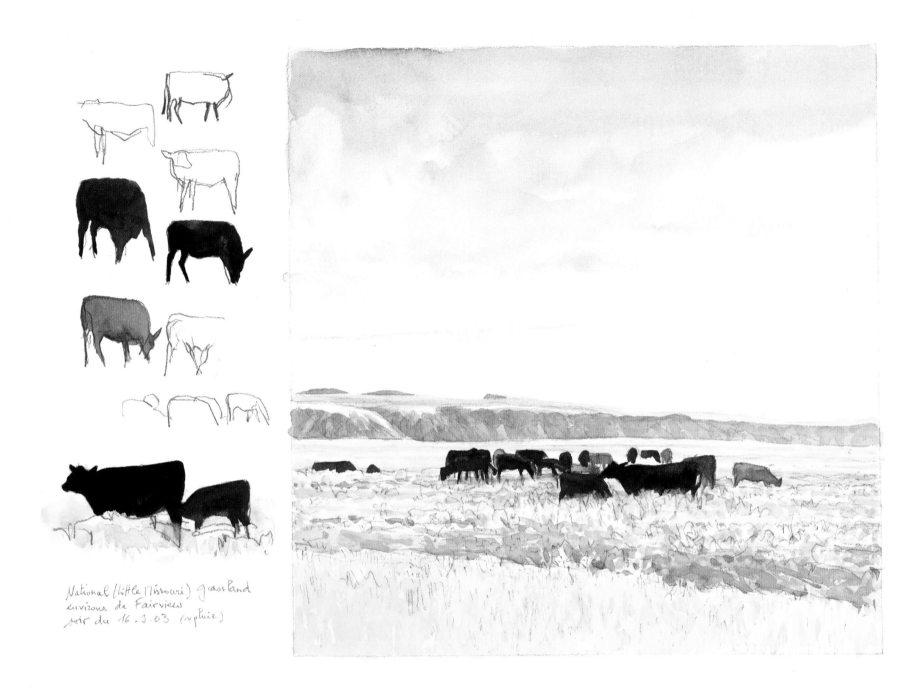

National (Little Missouri) grassland
environs de Fairview
soir du 16.9.03 (rpluie)

**National Little Missouri Grassland, near
Fairview, Montana, September 16, 2003.**

PENCIL AND WATERCOLOR, 11.42 × 16.14 IN (29 × 41 CM).

Together, shortgrass, mixed-grass, and tallgrass prairies cover about one-fifth of North America.

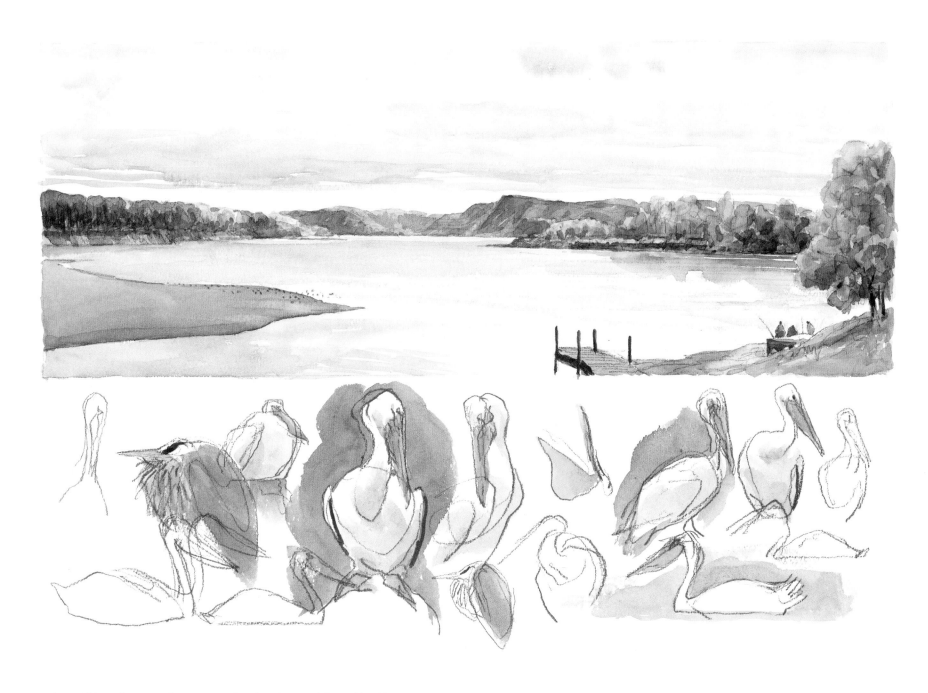

American White Pelicans resting, a pause in migration, and Great Blue Herons,
downstream from Garrison Dam, North Dakota, September 17, 2003.

PENCIL AND WATERCOLOR, 10.63 × 16.14 IN (27 × 41 CM).

Sharp-tailed Grouse, Badlands near Sidney, Montana, September 15, 2003.

PENCIL, 11.02 × 14.17 IN (28 ×36 CM).

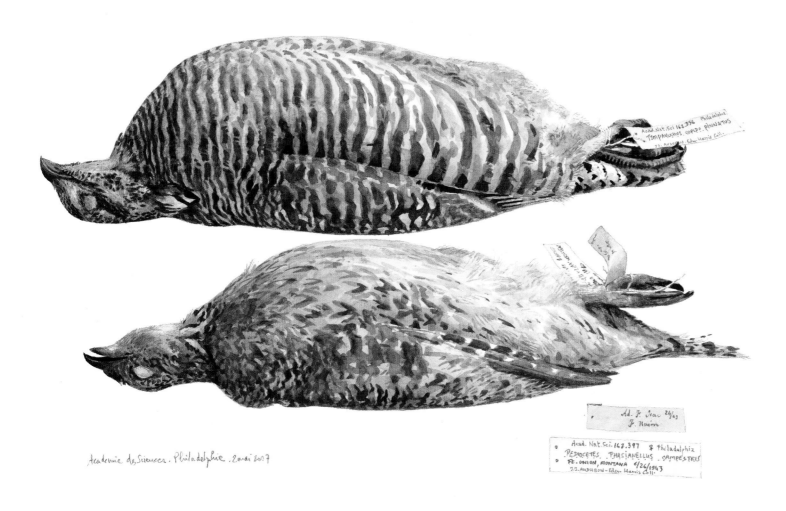

Academie des Sciences . Philadelphie . 2 mai 2007

Acad. Nat. Sci 162.356 Philadelphie
TYMPANUCHUS CUPIDO . PINNATUS
J.J. Audubon, Edw. Harris Coll.

Ad. F. Jean 24/43
Ft. Union

Acad. Nat. Sci. 162.397 & Philadelphia
PEDIOCETES . PHASIANELLUS . CAMPESTRIS
Ft. Union, Montana 6/26/1943
J.J. Audubon - Edw. Harris Coll.

Study of Greater Prairie-Chicken and Sharp-tailed Grouse.
Collection of the Academy of Natural Sciences of Philadelphia, May 2, 2007.

PENCIL AND WATERCOLOR, 8.66 × 14.17 IN (22 × 36 CM).

These birds were collected by Audubon during the expedition along the Missouri River.

189

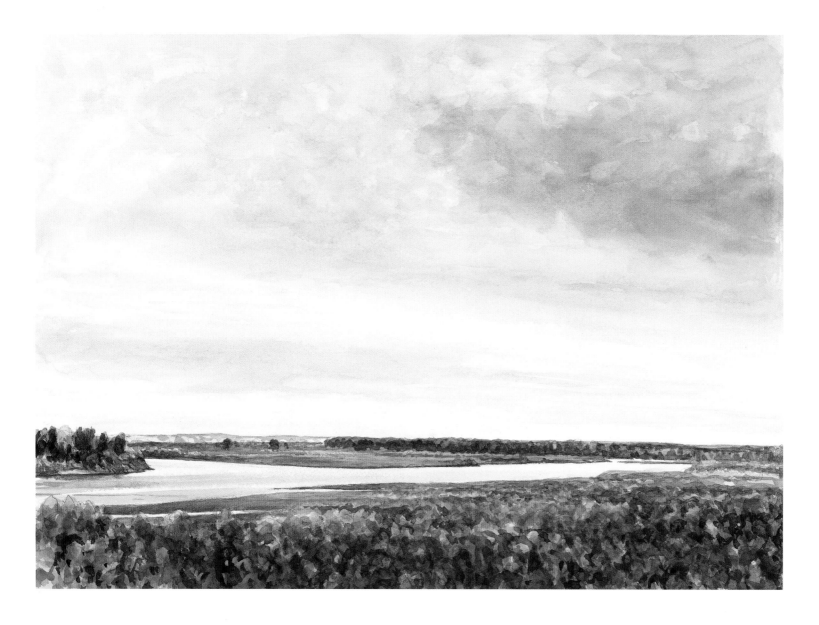

The confluence of the Yellowstone River with the Missouri River, Missouri–Yellowstone Confluence Interpretive Center, Williston, North Dakota, September 15, 2003.

PENCIL AND WATERCOLOR, 16.14 × 22.44 IN (41 × 57 CM).

The Missouri River flows from right (west) toward left (east). The Yellowstone enters at the left of the center coming from the south.

June 12, Monday. We had a cloudy and showery day, and a high wind besides. We saw many Wild Geese and Ducks with their young. We took in wood at two places, but shot nothing. I saw a Wolf giving chase, or driving away four Ravens from a sand-bar; but the finest sight of all took place shortly before we came to the mouth of the Yellowstone, and that was not less than twenty-two Mountain Rams and Ewes mixed, and amid them one young one only. We came in sight of the fort at five o'clock, and reached it at seven.

—Audubon and Coues, *The Missouri River Journals* in *Audubon and His Journals.*

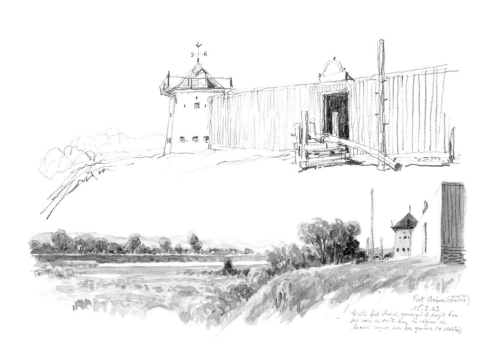

Fort Union (partially reconstructed), Williston, North Dakota, September 15, 2003.

PENCIL AND WATERCOLOR,
10.63 × 16.14 IN (27 × 41 CM).

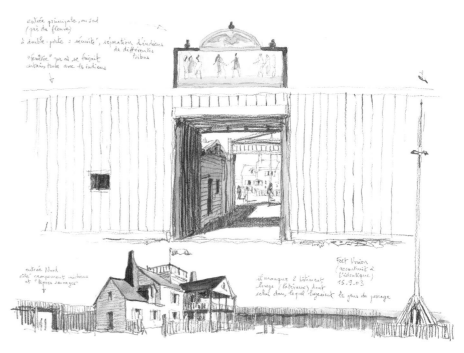

Fort Union, Williston, September 15, 2003.

PENCIL AND WATERCOLOR, 11.02 × 16.14 IN (28 × 41 CM).

The room which we are to occupy during our stay at this place is rather small and low, with only one window, on the west side. However, we shall manage well enough, I dare say, for the few weeks we are to be here.

—Audubon and Coues, *The Missouri River Journals* in *Audubon and His Journals.*

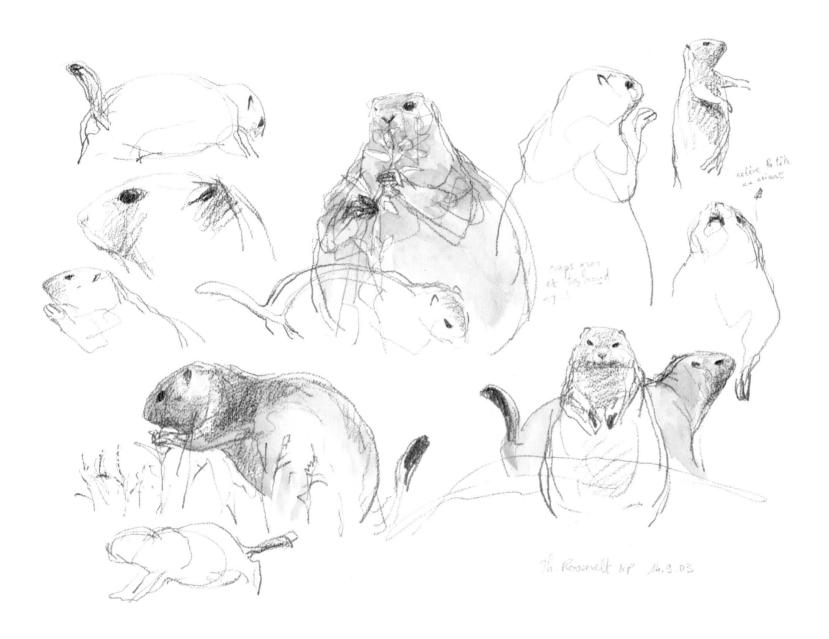

Black-tailed Prairie Dogs, Theodore Roosevelt National Park, North Dakota, September 14, 2003.

PENCIL AND WATERCOLOR, 10.24 × 14.96 IN (26 × 38 CM).

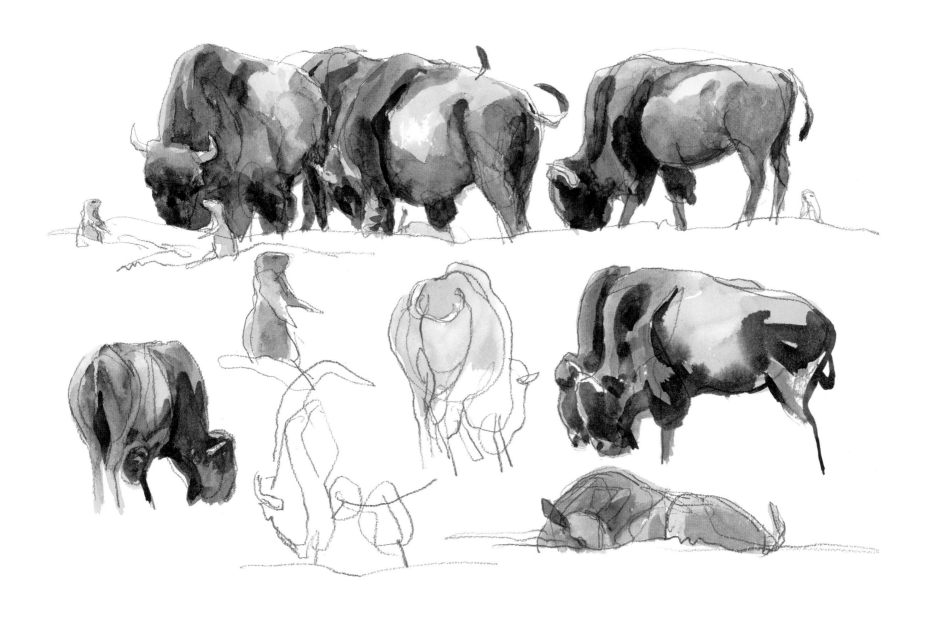

Buffalos (females) and Black-tailed Prairie Dogs, Theodore Roosevelt National Park, September 14, 2003.

PENCIL AND WATERCOLOR, 9.45 × 14.57 IN (24 × 37 CM).

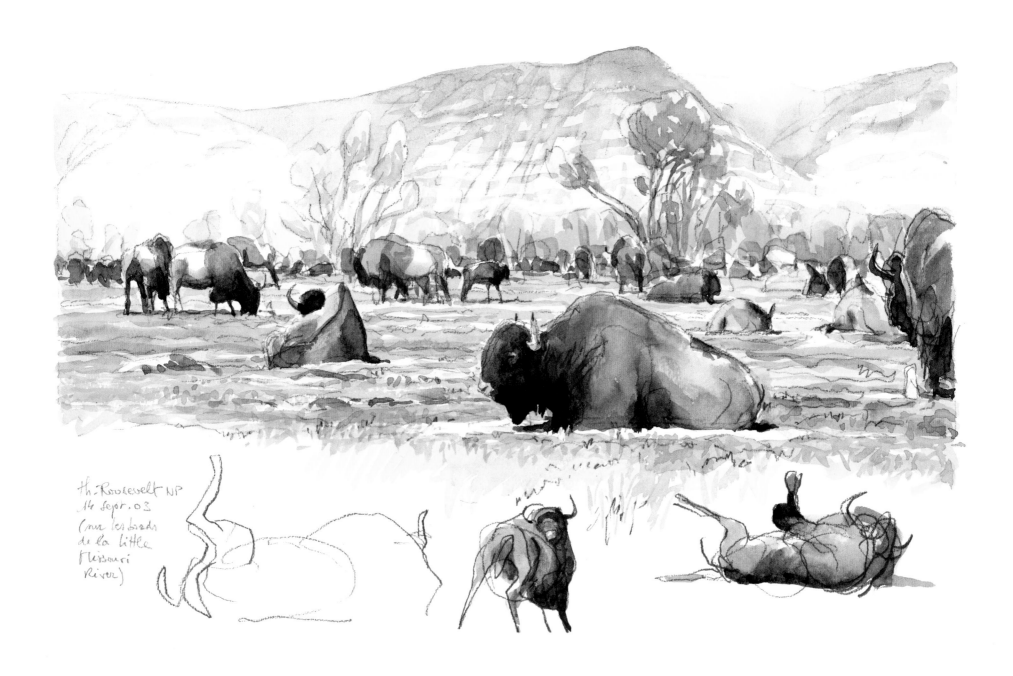

th. Roosevelt NP
14 Sept. 03
(sur les bords
de la Little
Missouri
River)

Herd of buffalos resting along the Little Missouri River,
Theodore Roosevelt National Park, September 14, 2003.

PENCIL AND WATERCOLOR, 10.24 × 16.14 in (26 × 41 cm).

OPPOSITE PAGE: Buffalos in the Badlands, Theodore
Roosevelt National Park, September 14, 2003.

PENCIL AND WATERCOLOR, 16.14 × 22.05 in (41 × 56 cm).

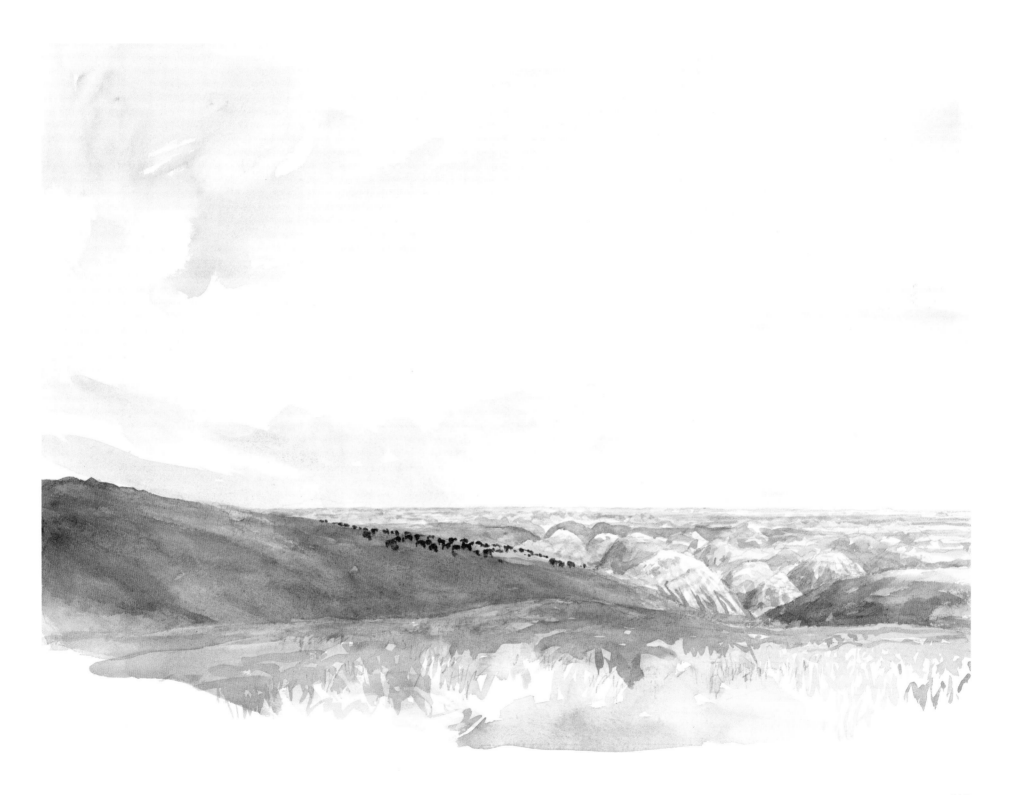

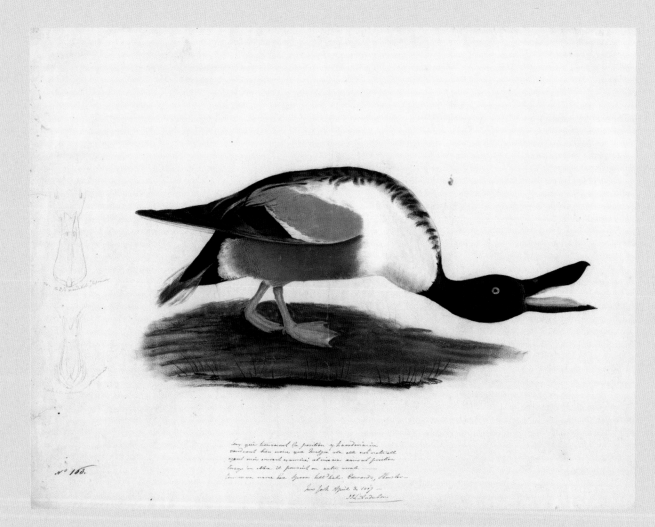

"Spoon Billed Teal. Edwards, Shoveler"
(Northern Shoveler).

John James Audubon,
New York, April 3, 1807.

PASTEL, GRAPHITE AND INK ON PAPER,
18.90 × 26.77 IN (48 × 68 CM).

MS AM 21 (69), BOX 13, HOUGHTON
LIBRARY, HARVARD UNIVERSITY.

This drawing is annotated as follows (the original in French):

Those who will find this posture extraordinary should know that it is in fact natural. I have often myself seen this bird in this position when it angrily pursues another male.

NEW YORK CITY
AT THE CROSSROADS

Pair of Northern Shovelers, Central Park, New York City, January 15, 2017.
PENCIL AND WATERCOLOR, 2.75 × 6.69 IN (7 × 17 CM).

JOHN JAMES AUDUBON first set foot on American soil in New York City one fine day in August 1803. Located at the southern end of Manhattan Island, the city had become American around twenty years earlier after the War of Independence and already counted more than 80,000 inhabitants.

The young Audubon had left France a month and a half earlier to establish himself at his father's property in Mill Grove. He never imagined that this trip would be followed by many others, nor that many years later New York would become his junction between America and Europe. Indeed, this city will become the focal point of the relationships that he will weave on both sides of the Atlantic, and he will live there his last twelve years, surrounded by his children and grandchildren.

But that day in 1803, the exceptional beauty of New York Bay was not enough to dispel his melancholy: *My affections were with those I had left behind and the world seemed to me a great wilderness.*[1] And to make matters worse, he caught a bad fever as soon as he arrived:

On landing at New York I caught the yellow fever by walking to the bank at Greenwich to get the money to which my father's letter of credit entitled me. The kind man who commanded the ship that brought me from France, whose name was a common one, John Smith, took particular charge of me, removed me to Morristown, NJ, and placed me under the care of two Quaker ladies who kept a boarding-house.[2]

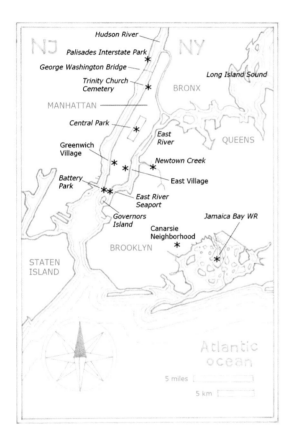

Like Audubon, I discover the United States for the first time during the summer and in New York City. It is September 1991. The halls of John Fitzgerald Kennedy International Airport don't have the charm of a wooden wharf swept by a marine breeze, but this doesn't stop me from examining the sky through the bay windows in order to see "my" first American gulls. Before continuing my trip to Wausau, Wisconsin, where every year the Leigh Yawkey Woodson Art Museum holds its *Birds in Art* exhibition, I stop in New York to present my project of travels "in the steps" of John James Audubon to a publisher. I take advantage of my time in New York City to leave Manhattan and visit Jamaica Bay, an immense lagoon dotted with small islands located at the edge of the city.

This day I am lucky enough to witness the strange choreography of Black Skimmers fishing in flight, their beaks open just at water level. This astonishing place, where birds fly about with skyscrapers in the background, is an essential stopping point for thousands of migratory birds between the Arctic tundra, Florida, the Caribbean Islands, and South America; it is one of the best urban sites in the United States for ornithologists.

Until the start of the nineteenth century, Jamaica Bay had phenomenal ecological richness. Oysters collected there were famous all the way to Europe. However, the rapid development of the city nearly destroyed this natural paradise by industrial pollution, the accumulation of trash, and the filling of marshes. The bay owes its survival only to strong citizen activism in the 1970s, in particular opposition to the enlargement of neighboring Kennedy Airport. But despite being protected as a nature reserve, the health of the lagoon continued to deteriorate. Diverse community groups and nonprofit organizations, such as Jamaica Bay Ecowatchers, reunited again to alert the authorities once again about the consequences of water quality decline: invasion by algae, problems of public health, the decrease of fish populations necessary as a food source for the poor populations living around the bay. Finally, the City of New York decided to invest hundreds of millions of dollars to modernize the four water treatment plants situated around the bay, and volunteer groups cleaned the areas of all kinds of trash. An Osprey passes just above me with a big fish in its strong claws. This predatory bird now nests on more than a dozen artificial eyries, constructed for the most part from driftwood.

Audubon lived a little more than a year at Mill Grove before returning to New York for a couple of weeks during March 1805. He was hosted by the family of Lucy Bakewell, his future wife, then briefly initiated into business practices by her uncle Benjamin, who managed an international trading company. He also took advantage of this trip to discover the city, attend some lectures on natural history, and sketch in his free time before embarking for France where he needed to discuss the management of Mill Grove with his father. Even more importantly, he wanted to ask his permission to marry Lucy.

Audubon returned to America on the 28 of May 1806 on board Polly in the company of Ferdinand Rozier, son of a Nantes businessman associated with his father. After a brief visit to the Bakewells, the Frenchmen went to Pennsylvania. Then the young men settled in Manhattan a few months later, not far from the warehouses of Uncle Benjamin located at 175 Pearl Street. For almost a year Audubon benefited from his hospitality and learned at his side the import–export business, but not without difficulties. *The mercantile business did not suit me. The very first venture which I undertook was in indigo; it cost me several hundred pounds, the whole of which was lost.*[3] These serious occupations didn't at all diminish his curiosity about natural history, and it didn't take him long to get out of the city and find himself in nature because Manhattan Island was still mostly covered by marshes, woods, and fields. Even with all these activities, Audubon didn't forget about France. To Dr. Charles Marie d'Orbigny he regularly sent all sorts of things collected in the vicinity or found in the marshes—seeds, shells, bird specimens, reptiles preserved in bottles. He even shipped live birds in cages and turtles to his father.

In New York, Audubon was introduced to a friend of the Bakewells, Samuel Latham Mitchill, doctor and naturalist like d'Orbigny, who later went on to found the Lyceum of Natural History in New York.[4] Mitchill proposed to the young enthusiast a position as taxidermist to prepare

2 White Street, New York City, June 3, 2006.
PENCIL AND WATERCOLOR, 11.02 × 15.75 IN (28 × 40 CM).
This old house was built in 1809. Thirty years later, back from a last stay in Europe, the Audubon family moved to 86 White Street, near here.

bird and mammal skins. Audubon sketched more and more. His technique improved. He took care to compose his works better, and his portfolio grew thicker as the months passed. During that winter he made several studies of ducks observed in the wild or collected during walks, among them the Black Scoter, the Long-tailed Duck, the Northern Shoveler, and the Common Goldeneye.

I observe another species of duck, called Bufflehead, for the first time in the Jacqueline Kennedy Onassis Reservoir at Central Park on a cold and gray January day: a female and, parading around her, two males whose breasts reflect magnificent tones of green, blue, and purple. Indifferent to the people walking by, they dive one after the other a few yards from the bank, among the Canada Geese and Mallards. With their pink legs well visible under the water they look like small mechanical toys. I sketch them from different angles, often incompletely because they move a lot. With each new sketch I capture more accurately the proportions of the head and the body, and I better connect the form of the head with that of the beak. While watercoloring the sketches that seem to me the most accurate and the most dynamic, I imagine Audubon not far from here a little less than two hundred years ago, hidden behind some bushes at the edge of a pond, also discovering among some water birds a species he didn't know yet. The construction of Central Park was to start a few years after Audubon's death, and one of his friends, the writer Washington Irving, was to be among those who promoted the establishment of a vast green space for the people of the city.

This is a very special place for bird observation, particularly in spring and fall. Over the past fifteen years, I have met Roger Pasquier there several times. He walks the park trails early each morning when he isn't in Latin America. He works there with nonprofit organizations to help create natural reserves in order to preserve a few additional areas of tropical forest, which in winter shelters an important part of North American bird life. Together we have observed many common species, but I have also discovered some more unusual birds with him.

One morning in June 2006, along one of the trails of "the Ramble," Roger suddenly murmurs, *Oh, look, something interesting*! It is a male Mourning Warbler, which is discretely rummaging in the bushes. Roger is the author of several books on birds and wildlife art. After working for prestigious museums, the World Wildlife Fund, and the National Audubon Society, he has chosen to challenge large corporations directly. *Recycling plastic bags, that's good*, he says, *but that doesn't have enough impact. We must change the scale, and for that we need to work with governmental agencies and large companies to obtain changes at a higher level.*

Audubon spent a few more days in Manhattan during the summer of 1824, upset by the response he had received from the Philadelphia Academy of Sciences. During a walk along the sea front, not far from West Battery, now the

Roger Pasquier, Central Park, New York City, June 4, 2006.

PENCIL, 14.17 × 9.84 IN (36 × 25 CM).

Battery, he met Charles-Lucien Bonaparte, whose acquaintance he had recently made. Son of Lucien Bonaparte, second brother of Napoleon, Charles-Lucien was passionate about ornithology. Already an expert on American birds, he had begun writing a book designed to bring the work of Alexander Wilson up to date.

Audubon also went to see Samuel Latham Mitchill who, since they had last seen each other, had been elected senator and had become a respected scientist. Impressed by Audubon's recent watercolors made in Louisiana, Mitchill sent a letter to the Lyceum supporting Audubon's candidature and proposing that his work be shown there. Contact with these scientists made Audubon aware of his deficiencies and his lack of formal education. As in Philadelphia, in New York he found neither an engraver nor a publisher interested in his work. This diminished his hopes of seeing his sketches published in America and depressed him all the more: *In a few days I shall be in the woods, and quite forgotten.*[5]

Indifferent to General Lafayette's triumphal tour organized that summer for the fiftieth anniversary of the end of the War of Independence, he left the city to go to Albany, New York, then traveled to Niagara Falls, New York, before settling again in Louisiana.

Audubon didn't return to New York again until the spring of 1829, following a first three-year stay in Europe, principally in England and Scotland. He had recently turned forty. A

portfolio that he brought back in his baggage contained the first fifty watercolored engravings of *The Birds of America*, which he showed to the members of the Lyceum of Natural History. Things were finally starting to happen. A few lines of praise were published in the *American Journal of Science and Arts* pronouncing this display the "most magnificent work of its kind ever executed in any country."

Less than a year later, after having been received at the White House by President Andrew Jackson, Audubon again crossed the Atlantic, this time with Lucy. In the meantime, he had been able to sketch enough new species to make his ambitious project credible. Thanks to his perseverance, his talent was beginning to be recognized in America. With the support of some friends, he was elected a member of the American Philosophical Society in Philadelphia, an institution that, like the famous Academy of Sciences of Philadelphia, subsequently added its name to the list of subscribers to *The Birds of America*.

Returning from England in September 1831, Audubon was delighted to see the local press praising his emerging work. He went to Washington, then to Philadelphia. From there he went to discover the birds of Florida. New York had become by then the largest city in the United States, with nearly 250,000 inhabitants. It was growing northward, and businessmen and the newly wealthy were constructing mansions along paved and well-lit streets. However, the city lacked clean water, and the poor were cramped in

Cardinal, Central Park, New York City, June 4, 2006.

PENCIL AND WATERCOLOR, 8.26 × 4.72 IN (21 × 12 CM).

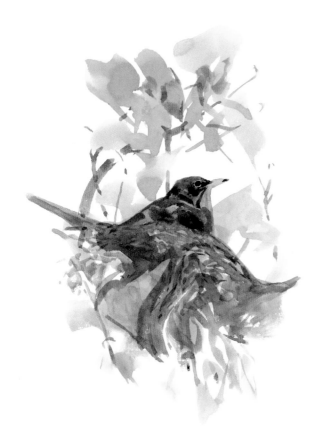

American Robin brooding, Central Park, New York City, June 2, 2010.

WATERCOLOR, 10.24 × 7.09 IN (26 × 18 CM).

unsanitary neighborhoods. At the southwest end of Long Island, the population of the old Dutch village of Breukelen, renamed Brooklyn by the English, was rapidly growing after the start of a steamboat ferry service. Shipyards constructed along the East River continued their steady activity.

In June 2010, I visit one of these still very industrialized neighborhoods of Brooklyn, invited on the boat of the Hudson Riverkeepers. We sail slowly up Newtown Creek, which winds between fuel storage tanks and shipping wharves. In this treeless universe, a few cranes work on mountains of cardboard and piles of waste metal. I have the strange impression of discovering the hidden side of the city, of passing behind the screen. What a contrast to the shiny towers of Manhattan! The other passengers are political representatives of the Borough of Brooklyn, to whom the Riverkeepers association want to show some disturbing sources of pollution. Gliding through the dark water, our boat enters an even narrower channel to a place where a strange oily swirl betrays the outflow of a suspicious liquid.

Audubon stayed in New York just before his departure for Labrador. Proof of his growing celebrity, Philip Hone, the mayor of the city, received him, and he dined in the company of prominent people. Following this evening Hone wrote of Audubon:

He is an interesting man of about 55 years of age, modest in his deportment, possessing general intelligence, an acute mind, and great enthusiasm. His work on the birds of North America, in which he is now engaged, is probably the most splendid book ever published.[6]

Audubon also showed his work to the president of Columbia College, who organized a public showing at the college library. The weather was magnificent, the migratory birds were already en route, and Audubon perceived high in the sky flocks of Purple Martins heading north, toward regions that he was getting ready to explore.

Seven years later, in September 1839, the Audubons set down their bags yet again in Manhattan at 86 White Street after yet another trip to England. Audubon had just finished drafting the text of his *Ornithological Biography* with the Scotsman MacGillivray. The London engraver Havell had printed and colored the very last engraving for *Birds of America*, the American Dipper. The material that Audubon used to finish his work had been substantially enriched by his voyages to Florida and Labrador and also by specimens collected in 1834 by John Kirk Townsend and Thomas Nuttall during their expedition to the Rockies and the Pacific coast.

For Audubon, the following period was marked by great joy and deep sorrow. His sons, John and Victor, were married one after the other to the daughters of Reverend Bachman. Unfortunately, the two women died of tuberculosis within eight months of one another. John's two children were, however, alive and well, and the family needed to create a new project. The house on White Street now seemed to carry bad memories, and the

absence of nature became unbearable in the rapidly burgeoning city. The Audubons decided to acquire some unspoiled land at the north end of Manhattan along the Hudson River and to build a house there. It was an enchanting place, crossed by a stream and populated by birds. Wooded hillsides descended slowly toward the Hudson River across from the majestic Palisades cliffs of New Jersey. Audubon quickly started construction of a house, encouraged by the first sales of the smaller-format edition of *Birds of America*, to which his son John, a very good artist himself, had greatly contributed. The family moved into their new house at the beginning of spring 1842, and because John and Victor were in the habit of calling their mother "Minnie," the Audubons named their property "Minnie's Land." Audubon and his sons created a vegetable garden, planted numerous fruit trees, enclosed a farmyard to welcome chickens, some pigs, and even a few cows. These happy days were also marked by the second marriages of both John and Victor. Audubon left his loved ones once again just after the second marriage to explore the Missouri River.

On a beautiful day in May I cross the Hudson to go see these famous Palisades. From there I can just make out in the distance the trees of the Trinity Cemetery in Manhattan, which replaced those that had shaded Minnie's Land. The house no longer exists. Surrounded by boulevards and apartment buildings at the beginning of the twentieth century, then sold to a real estate developer, it was destroyed at the end of the

1930s. The George Washington Bridge extends its overlapping decks between the two banks. It is so large that I barely make out the tractor-trailer trucks crossing it. Farther south, skyscrapers mark the horizon with their gradations of pale blues. A small group of Canada Geese wade a few yards away while two male Baltimore Orioles confront one another in a nearby tree, exhibiting their shiny colors. A few gulls glide just above the high basalt cliffs of this surprising geological formation that extends upstream for nearly twenty miles. Classified as a national natural landmark, it owes its preservation to the involvement of the New Jersey Federation of Women's Clubs, which since the end of the nineteenth century fought for the creation of the Palisades Interstate Park Commission. Around the same time, other women were mobilizing in Boston against the killing of birds for the feather trade, precursors of the first Audubon Society in the United States.

Whether one looks to the north or the south, the site is grandiose. At the end of this slightly hazy afternoon, under a gray sky tinted in places with rose, the dark rocks give the landscape a dramatic dimension, and I understand how such lighting effects had the ability to inspire artists who starting after the 1820s, following Thomas Cole, traveled the banks of the Hudson and the surrounding mountains.[7] Audubon himself often marveled at the grandeur of the American wilderness but, except for a few sketches, never felt tempted by landscape painting.

Along the High Line, Manhattan, September 9, 2017.

PENCIL AND WATERCOLOR, 9.84 × 4.72 IN (25 × 12 CM).

Audubon returned from the Great Plains in November 1843, after an absence of eight months, looking forward to seeing his family and tired from this long voyage. *He painted little after his return from the Yellowstone River,* wrote Georgianna later, one of his daughters-in-law, but as he looked at his son John's animals, he said: *"Ah, Johnny, no need for the old man to paint any*

more when you can do work like that."[8] Audubon progressively lost his sight starting in the summer of 1845. Two years later the signs of dementia started to appear and rapidly worsened. Walled up in silence, the man who for more than forty years put so much energy into representing life with his pencils and brushes passed away among his loved ones on February 27, 1851.

IF HE WERE ALIVE TODAY, John James Audubon would certainly be appalled by the environmental degradation since his time and by its impact on natural resources, ecosystems, and biodiversity. He would hardly believe that humans, becoming so numerous, have managed to perturb irreversibly the climatic mechanisms of the entire planet. He would be swift to denounce this damage, as he did several times during the course of his life, and I am certain that he would strongly support many initiatives intended to better understand and respect nature, whether it be scientific research, organic farming, artistic creation, or educational initiatives.

I return to New York in June 2018 to conclude my adventures "in the steps" of this exceptional man. I plan to meet schoolchildren, teachers, volunteers, scientists, and students involved in two projects that seem to me to illustrate well the ecological awareness now necessary on a worldwide scale.

First of all, I return to Jamaica Bay. It is very hot, the sky is immense, and the sunlight blinding. I make my way across the Jamaica Bay Wildlife Refuge. Both sides of the path are bordered by Northern Bayberry and Eastern Red Cedar. Expanses of beach grass carry one's gaze to the sea. Stationary behind their telescopes, some visitors observe Osprey pairs perched on their artificial platforms while young volunteers patrol the reserve. Their assignment is to locate Diamondback Terrapins in the process of laying eggs so that these eggs can be saved from the raccoons.

I sketch a Gray Catbird scolding a small squirrel attracted by the red berries of a bush and take advantage of the moment to ask Dave Taft, unit manager of the preserve, what this plant is. *It's an Oriental Bittersweet, one of the nonnative introduced species that gives us the most problems,* he tells me, before mentioning the tens of thousands of trees and bushes planted at the reserve several years ago by volunteers. *This*

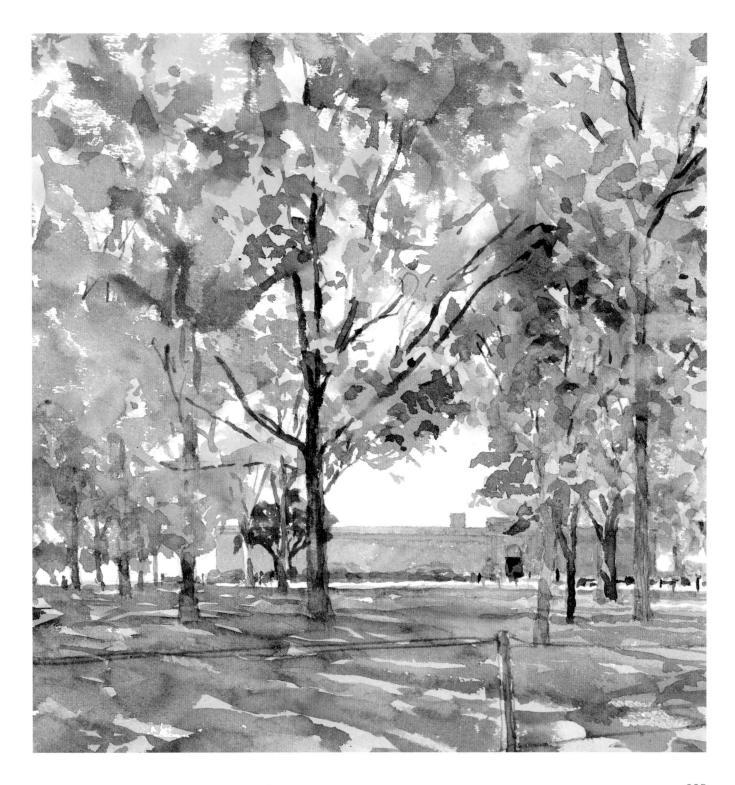

Battery Park, south of Manhattan,
New York City, June 13, 2018.

PENCIL AND WATERCOLOR,
9.84 × 9.64 in (25 × 24.5 cm).

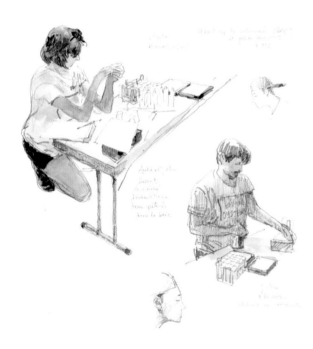

Student volunteers analyze water samples from the bay, Urban Assembly New York Harbor School Center, Governors Island, New York City, June 13, 2018.

PENCIL AND WATERCOLOR,
10.63 × 9.45 IN (27 × 24 CM).

National Park Service initiative is supported by the Nature Conservancy, he adds. *We are preparing for the future by encouraging the installation of vegetation more resistant to sea immersion and salinity. This would promote an ecosystem more adapted to the effects of climate change.*

Now off to Governors Island. I take the first ferry of the morning reserved for the people who work on this island situated a few minutes from Manhattan because I have a meeting at the Urban Assembly New York Harbor School. This establishment prepares students for college and maritime careers. Some of them take on leadership roles in the exciting Billion Oyster Project that aims to restore oyster reefs to New York Harbor.

I am welcomed by Peter Malinowski, a tall red-bearded fellow. Educator, son of oyster farmers, Peter is, with his colleague Murray Fisher, at the origin of the Billion Oyster Project that unites various groups not often accustomed to working together: scientists, teachers, students, volunteers, city services, private businesses, and residents living around the bay. *Billion Oyster is inspired by a successful project coming from the Chesapeake Bay*, explains Peter. *We estimate that in the past the oyster reefs covered close to 200,000 acres in the estuary of the Hudson. These organisms filtered enormous quantities of water, and the reefs which they formed sheltered a multitude of other marine life. But the oysters finally disappeared due to filling of the bay, overfishing and pollution.*

Next I meet with Jeremy Esposito, the laboratory manager who is responsible for raising the young oysters. In a few minutes, he will welcome a visiting middle school class, and I sketch him working amidst the basins, aquariums, and pipes of all sizes. Already the program has made thousands of children aware of the importance of preserving water quality and the ecology of the bay. Many of them help fill sacks with oyster shells recovered from dozens of restaurants. Once immersed in areas chosen by the scientists, oyster larvae attach themselves to these small artificial reefs and grow.

Now my trip ends. During the few hours remaining before my return flight to Europe, I attend the inauguration of an oyster reef near the Canarsie neighborhood in south Brooklyn. The Billion Oyster team will oversee the project's development, but the schools and local organizations will be in charge of the regular inspection and educational activities. The official speeches and the traditional photos take place. Then, once the waders and life vests are put on, the artificial reef is installed in a relaxed and friendly atmosphere.

Later, before leaving this place now returned to calm, I take in a few moments of the beautiful late afternoon light. The tide is rising and covering the shore little by little. A Yellow-crowned Night-Heron silently lands, then straightens up and freezes, attentive to the slightest underwater movement, a splendid conclusion to fifteen years of adventure in the steps of John James Audubon.

Oyster reef reconstituted in an aquarium; Killifishes, Tautog Blackfish, and Skilletfish, Urban Assembly New York Harbor School Center, Governors Island, June 13, 2018.

PENCIL AND WATERCOLOR, 10.63 × 15.35 IN (27 × 39 CM).

1. Audubon, *Ornithological Biography*, vol. 2, 1834.

2. Audubon and Coues, *Myself* in *Audubon and His Journals*.

3. Audubon and Coues, *Myself*.

4. Founded in 1817, this later became the New York Academy of Sciences.

5. Audubon, Lucy Bakewell. *The Life of John James Audubon, the Naturalist*. New York: G.P. Putnam, 1869.

6. Tuckerman, Bayard, ed. *The Diary of Philip Hone: 1828–1851*. New York: Dodd, Mead, 1889.

7. This art movement was later called the Hudson River School.

8. Audubon and Coues, *Audubon and His Journals*.

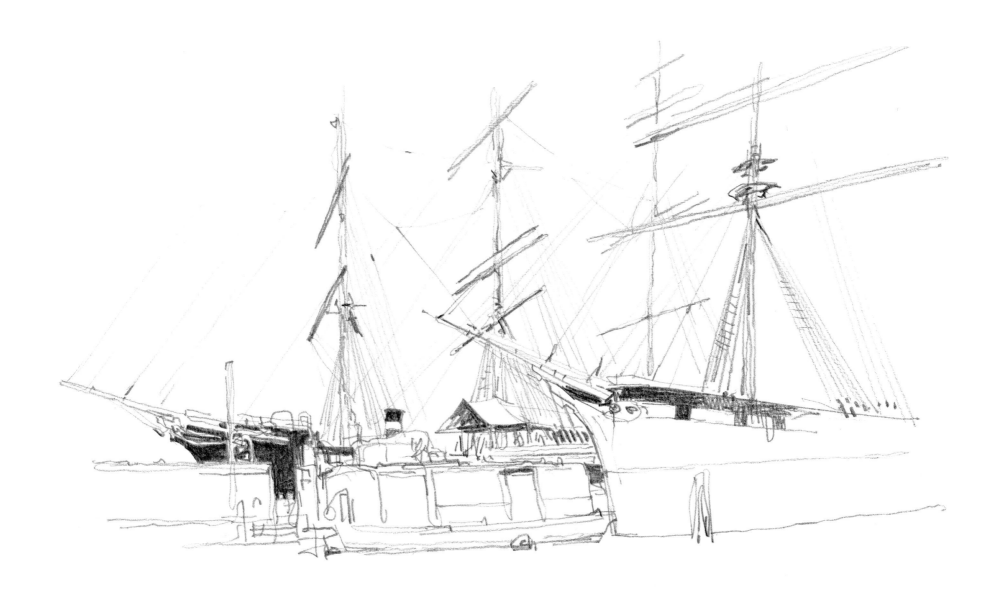

East River Seaport, Manhattan, June 4, 2006.

PENCIL, 8.26 × 15.35 IN (21 × 39 CM).

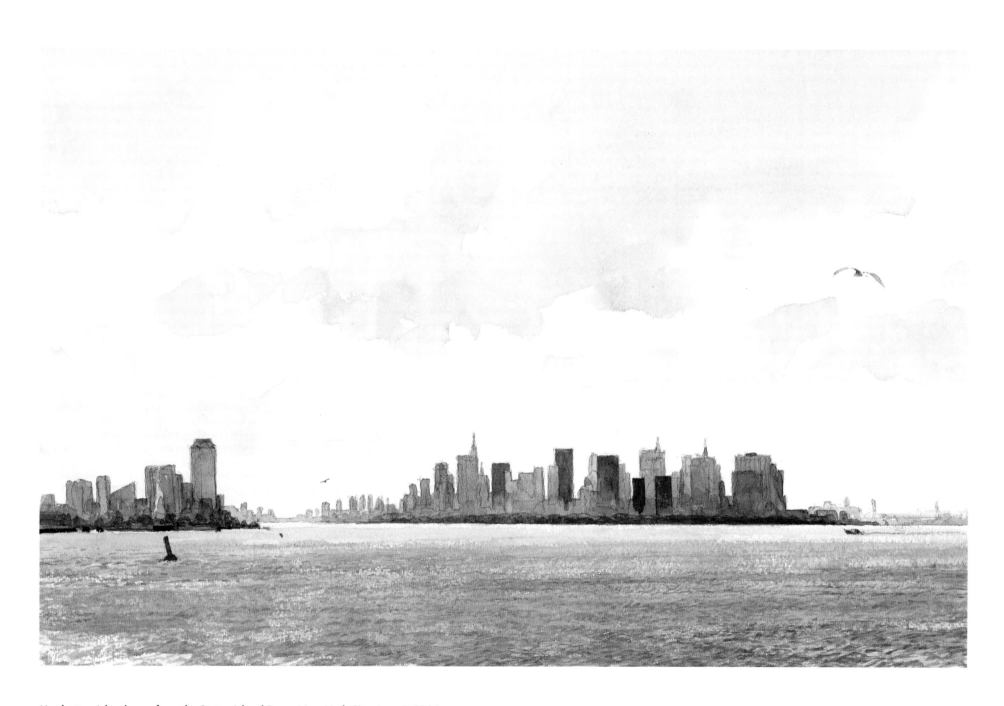

Manhattan Island seen from the Staten Island Ferry, New York City, June 3, 2006.

PENCIL AND WATERCOLOR, 10.43 × 16.14 IN (26.5 × 41 CM).

"La Casita," a Puerto Rican community garden, East Village, Manhattan, September 21, 2017.

PENCIL AND WATERCOLOR, 11.02 × 15.75 IN (28 × 40 CM).

I drew this place thinking of the Audubon's family decision in 1842 to leave the south of Manhattan, now so far from nature, and settle at Minnie's Land, surrounded by trees, wildlife, and domestic animals.

A hundred and thirty years later, during the financial crisis of the 1970s, the inhabitants of New York wanted to recreate nature in their city. They received permission to transform abandoned lots into vegetable gardens and green spaces.

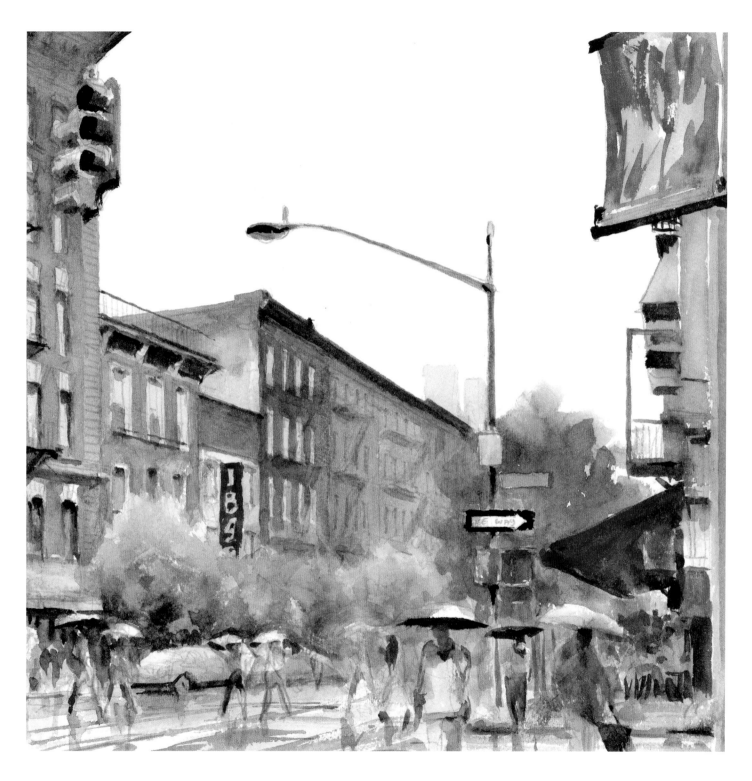

Rainy day, Greenwich Village, June 3, 2006.

PENCIL AND WATERCOLOR,
10.24 × 10.24 IN (26 × 26 CM).

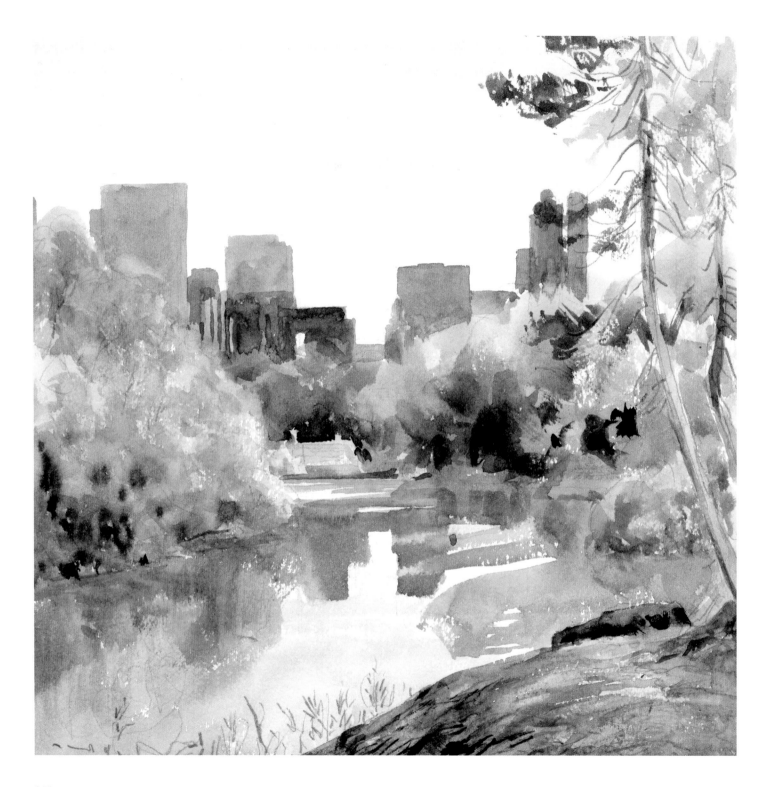

Central Park, June 4, 2006.

PENCIL AND WATERCOLOR,
10.24 × 10.24 in (26 × 26 cm).

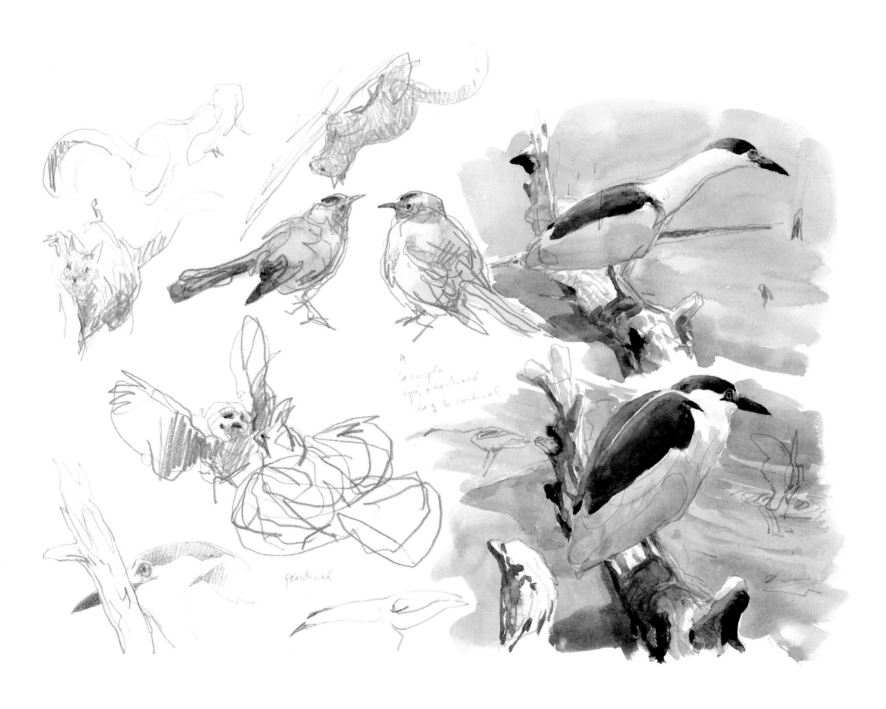

Eastern Gray Squirrel, Catbirds, Cardinal, and Black-crowned Night Heron, Central Park, June 4, 2006.

PENCIL AND WATERCOLOR, 11.42 × 15.75 IN (29 × 40 CM).

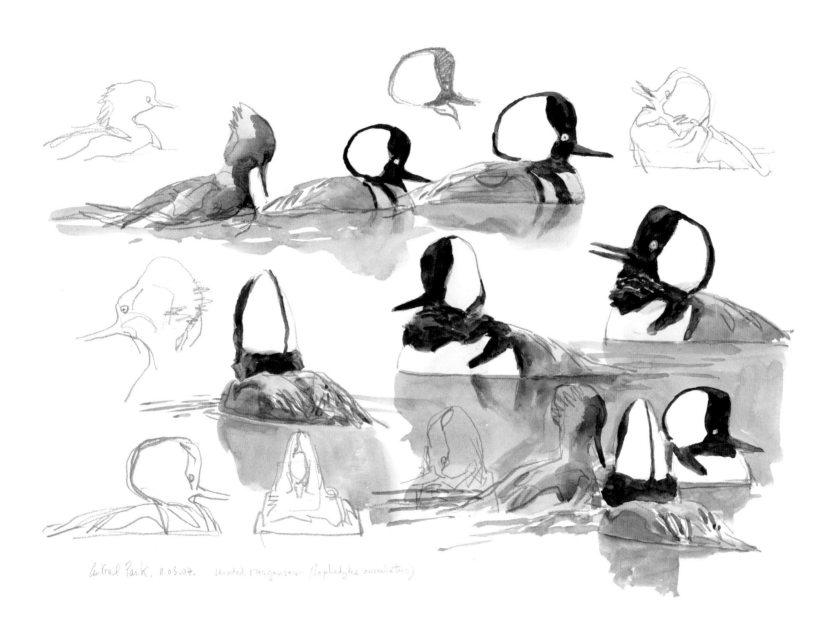

Hooded Mergansers, Central Park, March 11, 2007.

PENCIL AND WATERCOLOR, 10.24 × 15.75 IN (26 × 40 CM).

Mourning Warbler, Central Park, June 4, 2006.

PENCIL AND WATERCOLOR,
10.24 × 15.75 IN (26 × 40 CM).

This uncommon warbler breeds in dense stands of shrubbery, at the edges of bogs and ponds created by beavers, and where forests have been burned or cut over. Alexander Wilson, who discovered this bird, saw it only once; Audubon saw very few.

— Roger Pasquier

The "Clearwater" sailing on the Hudson River near the place where
Audubon's property was located, north end of Manhattan, June 5, 2006.

PENCIL AND WATERCOLOR, 10.24 × 15.75 IN (26 × 40 CM).

This wooden vessel, launched in 1969, is operated by the Hudson River Sloop Clearwater Corporation.
Created in 1966 by the folksinger Pete Seeger and his wife, Toshi Seeger, this nonprofit organization seeks
to protect the Hudson River and surroundings wetlands through environmental activism and public education.

216

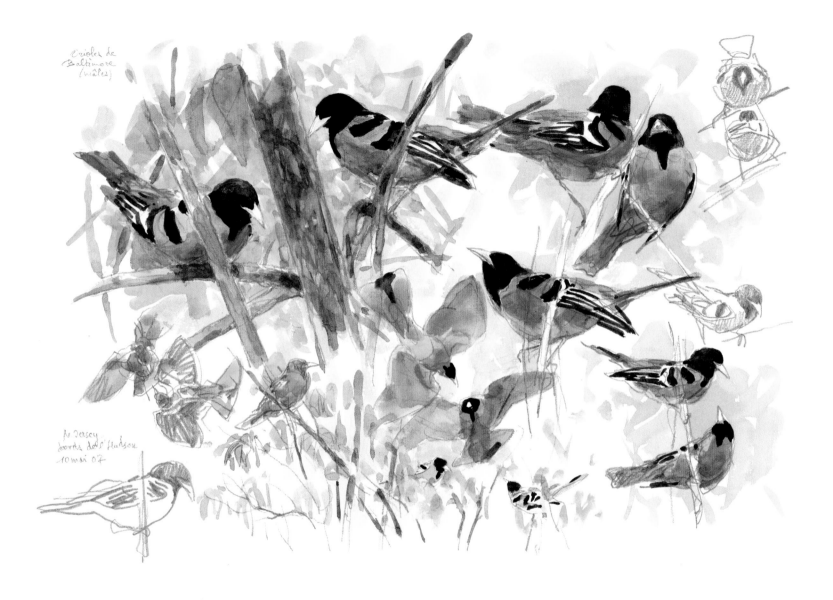

Two male Baltimore Orioles, Palisades Interstate Park, New Jersey, May 10, 2007.

PENCIL AND WATERCOLOR, 10.63 × 16.14 IN (27 × 41 CM).

The Baltimore Oriole, although found throughout the Union, is so partial to particular sections or districts that of two places not twenty miles distant from each other, while none are to be seen in the one, a dozen pairs or more may be in the neighborhood of the other.

—Audubon, *The Baltimore Oriole in Ornithological Biography*, vol. 1.

The George Washington Bridge, Palisades Interstate Park, September 22, 2003.

PENCIL AND WATERCOLOR, 11.42 × 11.42 IN (29 × 29 CM).

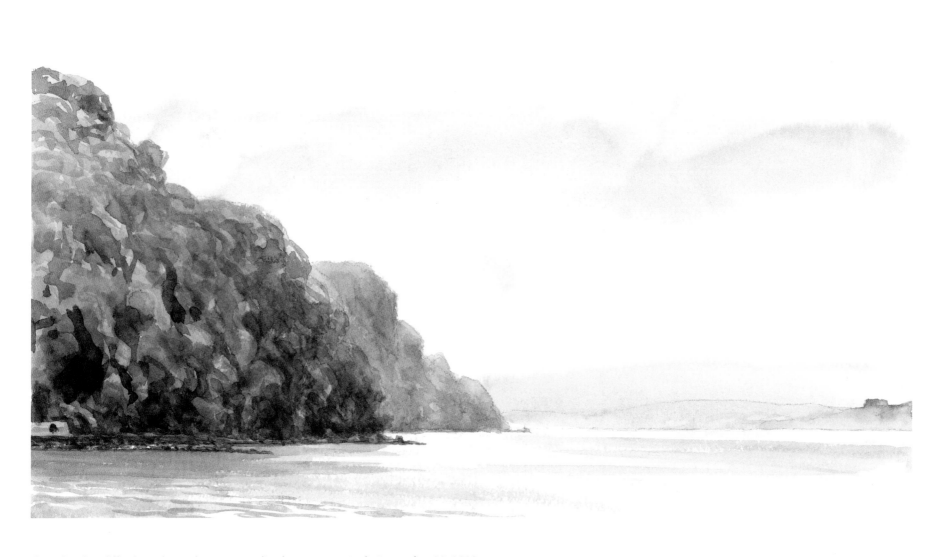

The Palisades Cliffs along the Hudson River, Palisades Interstate Park, September 22, 2003.

PENCIL AND WATERCOLOR, 11.42 × 16.14 IN (29 × 41 CM).

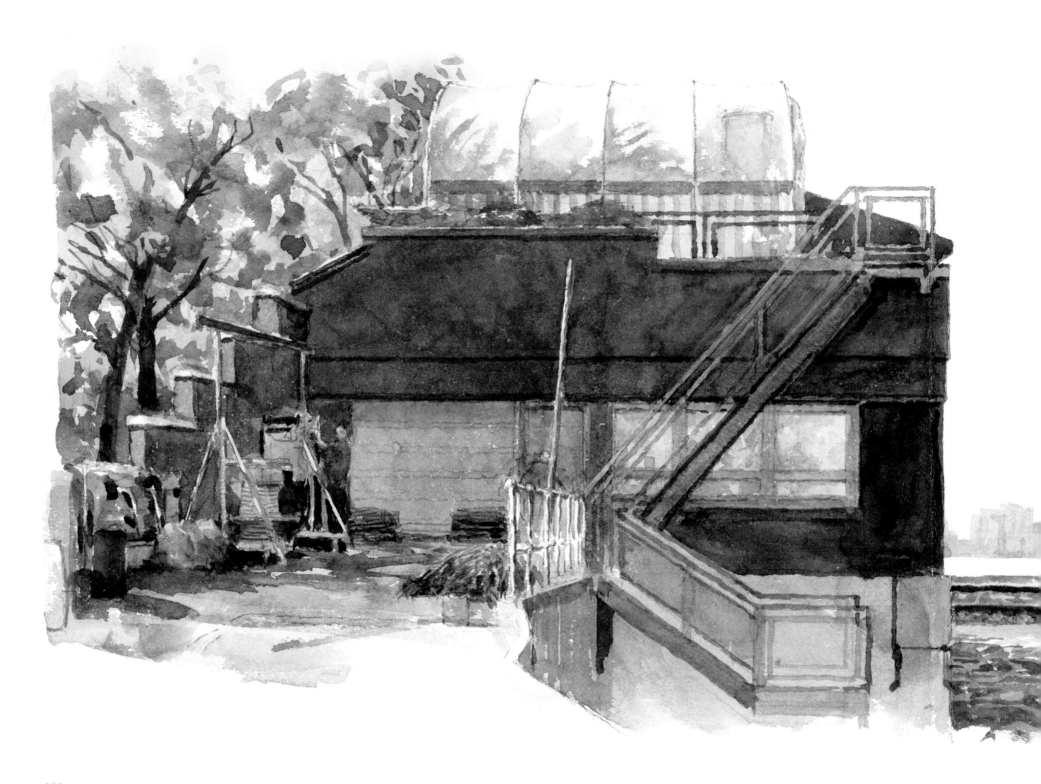

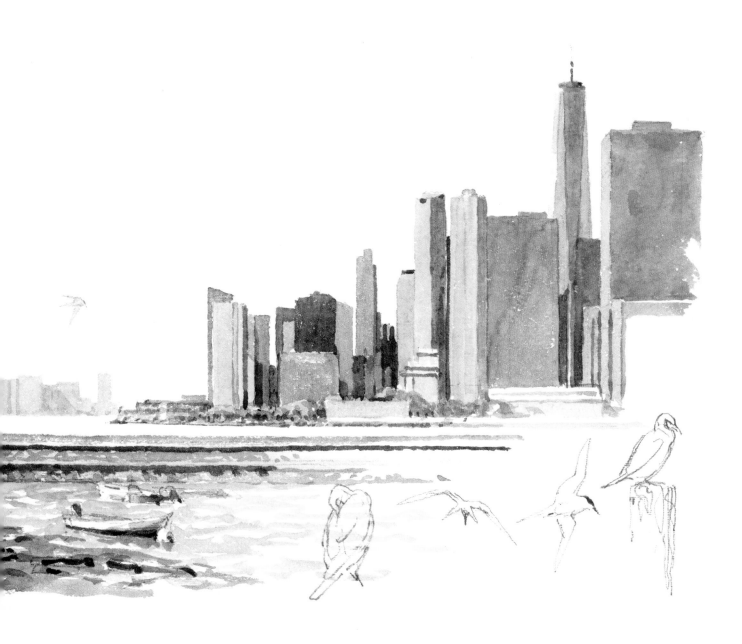

The Urban Assembly New York
Harbor School Center; Common
Tern and Double-crested Cormorant,
Governors Island, June 12, 2018.

PENCIL AND WATERCOLOR,
9.05 × 24.41 IN (23 × 62 CM).

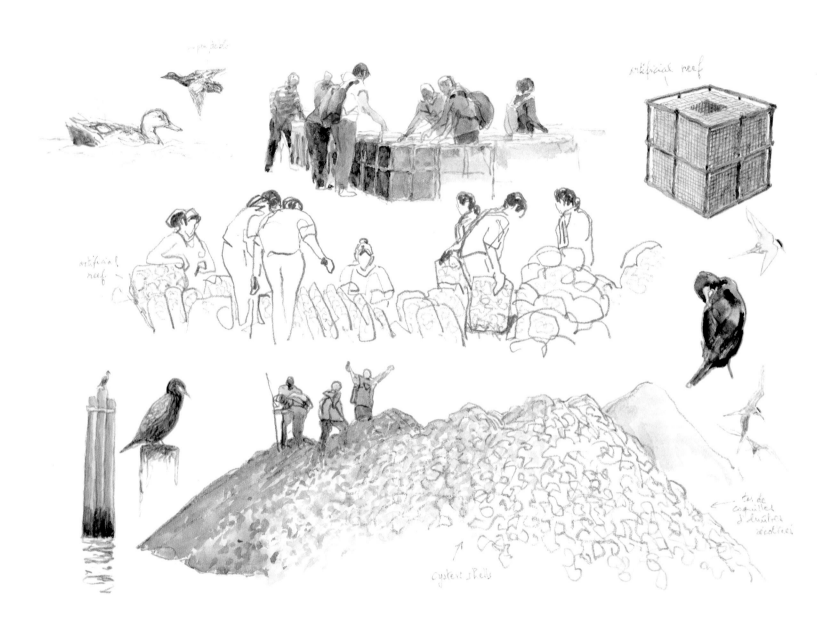

Schoolchildren construct artificial reefs from oyster shells gathered in New York City restaurants. Blue-winged Teal, Common Tern, and Double-crested Cormorant, Urban Assembly New York Harbor School Center, Governors Island, June 16, 2018.

PENCIL AND WATERCOLOR, 11.02 × 15.75 IN (28 × 40 CM).

These artificial reefs will be submerged and will permit oyster larvae to attach and grow.

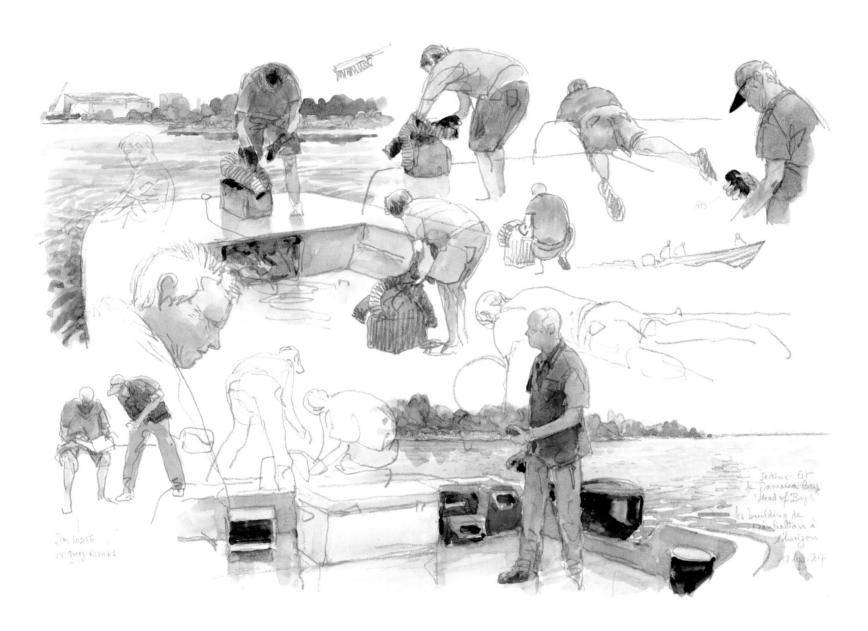

Greg Rivara, aquaculture specialist (Cornell University Cooperative Extension of Suffolk County) and Jim Lodge, senior scientist (Hudson River Foundation), looking at spat collectors for newly set oysters, Jamaica Bay, September 18, 2017.

PENCIL AND WATERCOLOR, 11.02 × 15.75 IN (28 × 40 CM).

**Glossy Ibis, Osprey, Jamaica Bay Wildlife
Refuge, New York City, May 9, 2007.**

PENCIL AND WATERCOLOR, 11.42 × 15.35 IN (29 × 39 CM).

Red-winged Blackbird, Osprey, Willet, Tree Swallow, Laughing Gull, and Glossy Ibis, Jamaica Bay Wildlife Refuge, June 14, 2018.

PENCIL AND WATERCOLOR, 11.42 × 15.35 IN (29 × 39 CM).

The Trinity Church Cemetery, along Riverside Drive, northern Manhattan, evening of January 16, 2017.

PENCIL AND WATERCOLOR, 7.48 × 12.20 IN (19 × 31 CM).

Audubon's house stood at the site of the apartment buildings on the right. The "Minnie's Land" property extended to the left all the way to the Hudson River. His daughter-in-law Georgianna described in this way the happy days that Audubon spent here:

He was most affectionate in his disposition, very fond of his grandchildren, and it was a pleasant sight to see him sit with one on his knee, and others about him, singing French songs in his lively way. It was sweet too, to see him with his wife; he was always her lover, and invariably used the pronouns thee and thou in his speech to her.

—Audubon and Coues, The Missouri River Journals in Audubon and His Journals.

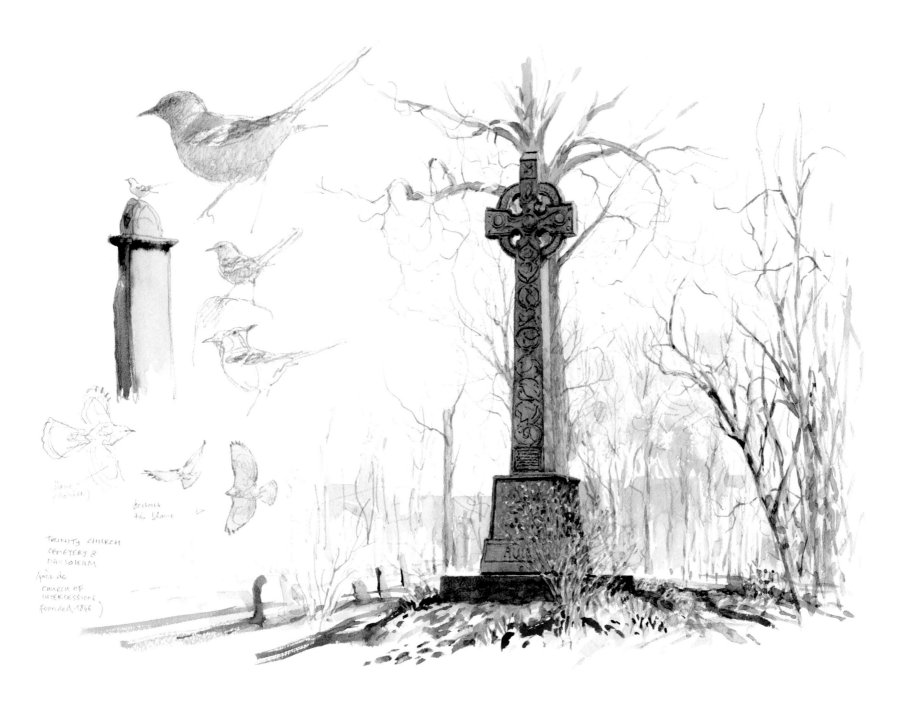

John James Audubon's grave, Northern Mockingbird, young Red-tailed Hawk, Trinity Church Cemetery, January 16, 2017.

PENCIL AND WATERCOLOR, 11.42 × 15.35 IN (29 × 39 CM).

I was moved to see a Mockingbird, one of Audubon's favorite species, at this spot.

"Missouri Meadow Lark Male"
(Western Meadowlark)

John James Audubon, 1844.

PENCIL, 5.5 × 5 IN (14 × 12.7 CM).

MISSOURI MEADOW LARK DRAWING, BOX 2,
FOLDER 13, JOHN JAMES AUDUBON DRAWINGS
AND PROOFS, MSS.5160, E. A. McILHENNY
NATURAL HISTORY COLLECTION, LOUISIANA
STATE UNIVERSITY LIBRARIES, BATON ROUGE.

CHRONOLOGY

1785
April 26: Audubon born Jean Rabine, illegitimately, to ship's captain and sugar planter, Jean Audubon, and French chambermaid, Jeanne Rabin, at Les Cayes, Santo Domingo (Haiti).

1787
Rose, Audubon's half sister, born illegitimately to Catherine Bouffard at Les Cayes.

1788
Audubon, three years old, arrives in Nantes, France. Jean Audubon's wife, Anne Moynet, welcomes him.

1789
Slaves on the verge of rebellion in Santo Domingo. Jean Audubon sells plantation and buys Mill Grove property near Philadelphia.
Beginning of French Revolution.

1791
Rose arrives in Nantes.

1794
Jean Audubon and his wife formally adopt the two children.
Slavery is abolished in all French Republic territories. Napoléon Bonaparte will restore slavery in 1802.

1794–1803
Audubon's childhood spent in Nantes and Couëron.
In 1800, Jean Rabin baptized and renamed Jean-Jacques Fougère Audubon.

1803
John James Audubon, eighteen, arrives for the first time in America, settles at Mill Grove.
France sells Louisiana to the United States.

1804
Audubon and Lucy Bakewell meet at Fatland Ford, Pennsylvania.
Lewis and Clark Expedition departs for the West.
Napoleon Bonaparte crowned emperor of France.

1805
Audubon sails to France to seek permission to marry Lucy Bakewell. He carries some 120 drawings of French and American birds, which he gives to his mentor, Charles d'Orbigny.

1806
Audubon returns to America with business partner Ferdinand Rozier.
Audubon begins business training in New York City under Lucy's uncle, Benjamin Bakewell.
Lewis and Clark Expedition returns from the West.

1808
Audubon and Lucy Bakewell marry and emigrate to Louisville, Kentucky, to operate a general store.
Beethoven completes the sixth symphony, "Pastoral."

1809
Victor Gifford Audubon born in Louisville.

1810
Audubon's family moves to Henderson, Kentucky.
Audubon meets Alexander Wilson for first time.

1811
The *New Orleans* is the first steamboat placed in service between Pittsburgh and New Orleans.

1812
The United States declares war on England.
Audubon becomes an American citizen.

Audubon has second meeting with Alexander Wilson, in Philadelphia.
At least two hundred drawings destroyed by rats.
John Woodhouse Audubon born in Henderson.

1815
Lucy Audubon, born in Henderson; hydrocephalic, she will live less than two years.
Treaty of Ghent ends war.

1816
Audubon and brother-in-law Thomas Bakewell form partnership to build steam-powered mill at Henderson.

1818
Audubon's father dies at Nantes.

1819
Audubon's business fails; family possessions sold at auction; jailed for debt, declares bankruptcy.
Audubon decides to live as a professional artist drawing portraits; continues drawing birds.
Birth and death at Louisville of a second daughter, named Rose.

1820
Audubon joins Western Museum, Cincinnati, where he is employed during a few months as artist and taxidermist.
Audubon departs Cincinnati by flatboat with assistant Joseph Mason, bound for New Orleans.

1821
Audubon arrives in New Orleans, where he draws portraits and birds. He takes up residence during five months at Oakley Plantation as teacher.

1822

Audubon's style has reached maturity. He decides to redraw all his earlier drawings.

Audubon moves to Natchez, where Lucy and their two sons join him.

1823

Lucy opens school at Beechwood Plantation near Saint Francisville, Louisiana. She will spend four years there.

1824

Audubon moves to Philadelphia to find publisher and patrons.

Audubon travels to Albany and Niagara Falls, New York, then returns to Louisiana.

1826

Audubon sails for Liverpool and Edinburgh where William Home Lizars agrees to undertake engraving *The Birds of America*.

1827

Audubon moves to London, transfers engraving of Birds to establishment of Robert Havell.

1828

Audubon spends a few months in Paris, looking for French subscribers. Cuvier welcomes him and praises his work.

1829

Audubon returns to America and works during a few months in New Jersey. In November, he reunites with Lucy in Louisiana.

Andrew Jackson inaugurated as President.

1830

Audubon sails for England with Lucy. Begins writing *Ornithological Biography*. First volume of *Birds* completed in December.

1831

Audubon and Lucy spend one month in Paris, then return to United States.

Audubon explores South Carolina and northeast Florida.

First volume of *Ornithological Biography* published.

HMS *Beagle* sails for South America with Charles Darwin.

1832

Audubon explores South Florida, winters in Boston.

Eugène Delacroix travels to Morocco and Algeria.

Edouard Manet born in Paris.

Oregon Trail opens.

1833

Audubon explores Gulf of Saint Lawrence with his son John.

1834

Audubon moves to England; he stays in Edinburgh with Lucy and John.

Abolition of slavery in most British colonies takes effect in August.

Second volume of *The Birds of America* finished.

1835

Audubon finishes drawings for fourth volume of *The Birds of America*.

Third volume of *Ornithological Biography* published.

Fire in New York City destroys Audubon's pre-1821 journals.

1836

Audubon and his son John return to the United States. Audubon works from Nuttall–Townsend Expedition skins. He dines at White House with President Andrew Jackson.

1837

Audubon travels along the Gulf of Mexico to Galveston Bay, Texas; he returns to England.

John Constable dies in London.

1838

The Birds of America finished.

1839

Last volume of *Ornithological Biography* finished.

Audubon and Lucy return to America.

Audubon begins work on lithograph Octavo (smaller) edition of *The Birds of America*, plans *Quadrupeds* with his friend Reverend Bachman.

1840–1841

Audubon's daughters-in-law die of tuberculosis.

Claude Monet born in Paris.

1842

Audubons acquire Minnie's Land on Hudson River at 155th Street, Manhattan.

Audubon travels to Canada and visits Quebec City

1843

Audubon explores upper Missouri River.

1845

Viviparous Quadrupeds of North America begins publication (1845–1854).

1847

Audubon disabled by dementia.

1848

California gold rush starts.

Second and definitive abolition of slavery in French colonies.

1851

January 27: Audubon, 65, dies at Minnie's Land.

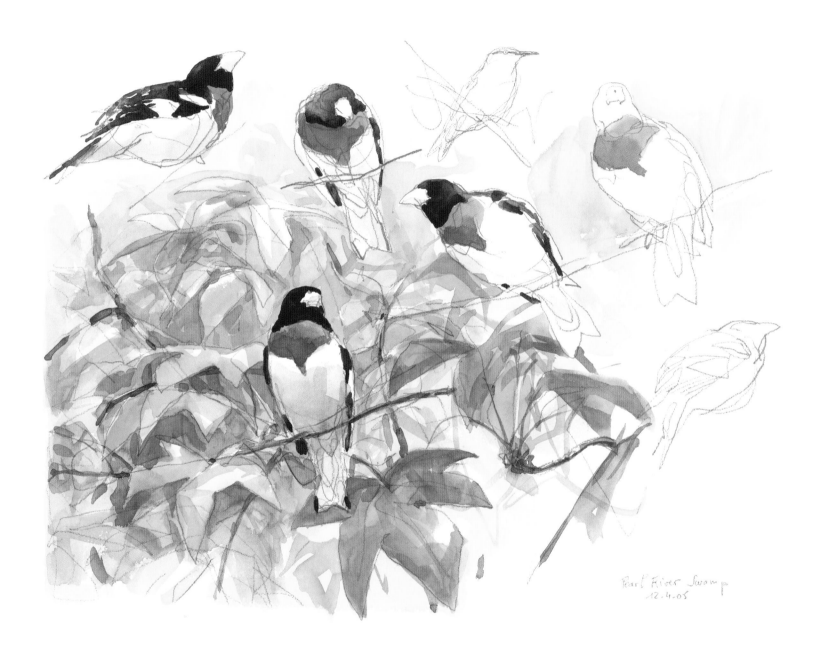

Rose-breasted Grosbeak, Pearl River Swamp, Mississippi, April 17, 2005.

PENCIL AND WATERCOLOR, 11.42 × 15.75 IN (29 × 40 CM).

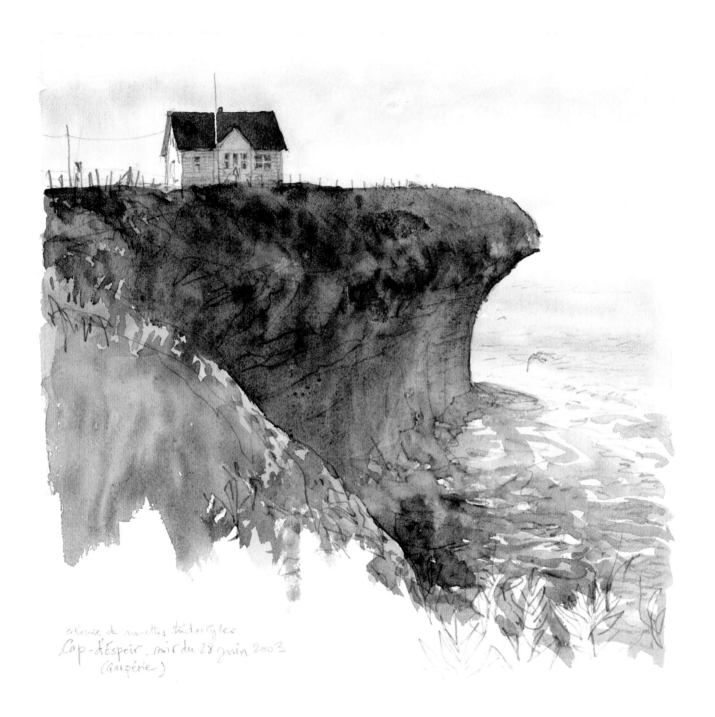

colonie de mouettes tridactyles
Cap-d'Espoir, soir du 28 juin 2003
(Gaspésie)

Cap d'Espoir, Gaspé Peninsula, Quebec, June 28,
2003 (detail).

PENCIL AND WATERCOLOR,
11.42 × 15.75 IN (29 × 40 CM).

ACKNOWLEDGMENTS

THIS BOOK OWES much to four people in particular. First of all, Thérèse Evette, life and travel companion, literary advisor, and enduring support in my digital adventures.

Next, Sarah Plimpton and Robert Paxton, friends and ornithologists. Their encouragement and interest in the project from day one were invaluable. By the accuracy of his precisions, always warm, Robert contributed a lot to the final quality of this book. Finally, Sherrie York, friend and wildlife artist, who was the source of many beautiful encounters, so important during my travels.

For their confidence, their advice, and their unfailing support, I would also like to thank Yvon Chatelin, author in France of a biography of Audubon, and Jacques Larivée, a Quebec ornithologist who is also passionate about the illustrious character.

From our first meeting, David Sibley encouraged me with his gentle voice to bring this project to fruition. Not only did his precious bird guide accompany me on all my travels, but David has given me the pleasure and honor to preface this book.

Thanks to Martha Le Cars, Franco-American friend, who greatly contributed to the success of the project by translating the text into English with the wise assistance of her husband, Yves.

The quality and harmony of the watercolors that illustrate this book owe much to the eye and skills of Jean-Louis Véronique, in charge of digital image capture.

I am pleased to thank the New York Historical Society, the Société des Sciences Naturelles de Charente Maritime, the Houghton Library of Harvard University, the E. A. McIlhenny Natural History Collection and Louisiana State University Libraries, Baton Rouge, for allowing me to reproduce the original pastels, drawings, and watercolors that John James Audubon made during his travels, as well as the Museum d'Histoire Naturelle de Nantes, France, and the Leigh Yawkey Woodson Art Museum, Wausau, Wisconsin, who have given me the pleasure of acquiring some of the watercolors reproduced in this book.

I also want to thank the University of Nantes, the City of Nantes, the Hudson River Keepers, the US Army Corp of Engineers in Yankton, South Dakota, the Fullen Dock and Warehouse Company, the Club of Odd, Boston, the Everyman's Library, London, and the Buffalo Bill Historical Center, Cody, Wyoming.

For lack of space, I cannot mention in detail the contributions of the many people named below. By welcoming me, by sharing their passions, by offering me new encounters, by guiding me through unknown landscapes, thanks to their support and advice, they have all enriched this long adventure. I would like to express my gratitude and appreciation to all of them.

Larry W. Agee, Robin Arnold, Fredrick Baumgarten, Jean Bochnowski, Don Boarman, Julia and Eny's Cajun Country B&B, Lanny Chalk, Gilles Chapdelaine, Susan and Emmanuel Coudel, Jennifer and Tom Coulson, Gérard Cyr, Pierre Desrochers, Barbara and Jack Dundon, Brett Dufur, Corinne Faure-Geors, John Flicker, Iris Fried, Donna Gail Gaudet, Alan Gehret, Edie and David Griffiths, Philippe Guillet, Jill Hamilton, Peter Jacobs, Brynne Langan_Mulrooney, Jean-Louis Lavigne, Duck Locasio, Jerry Lorenz, Rick Lowe, Peter Malinowski, Alex Matthiessen, James McCarville, Amy Montague, Brennan Mulrooney, Jay Nanquin, Richard Nanquin, Marceline Nanquin (1925–2019), Glynda and Cliff Newton, Cary Nicholas, Shelley, Abbie, and Eric Nilson, Antonia Nocero, Roberta Olson, Tim Olson, Herb Packer (1951–2021), Roger Pasquier, Elise Patole-Edoumba, Ruth Patrick (1907–2013), Robert McCracken Peck, Lyle and Garnet Perman, Ellen and Phillip Petersen, Pierre Poulin, Nancy Powell, Calvin Rainson, Sean Quinn, Kenny Ribbeck, Karen and Gregg Rivara, Jacques Soignon, Robin D'Arcy Shillcock, Dave Taft, James Thorpe, Barry Van Dusen, Pierre Vattelet, and Mary Whittam.

Many thanks to Regina Ryan, my agent in New York. Her enthusiastic welcome of this project and her plentiful advice were so precious to me.

I am honored to have this book published by such a prestigious publishing house as Princeton University Press. Thanks to Robert Kirk and his collaborators for their expertise and for the wonderful work they did.

Finally, special thanks to Léa Clavreul, Delphine Clavreul, and Laure Schalchli, who each in their own way helped at different stages of the project.

American White Pelicans, near Flamingo Visitor Center, Everglades National Park, February 5, 2003.

PENCIL AND WATERCOLOR, 5.12 × 7.09 IN (13 × 18 CM).

BIBLIOGRAPHY

Audubon, John James. *Journaux et récits.* 2 vols. Nantes: L'Atalante et la bibliothèque municipale de Nantes, 1992.

Audubon, John James. *Ornithological Biography, or An Account of the Habits of the Birds of the United States of America.* 5 vols. Edinburgh: Adam Black, 1831; Edinburgh: Adam and Charles Black, 1834, 1835, 1838, 1839.

Audubon, Maria R., and Elliot Coues, eds. *Audubon and His Journals.* 2 vols. New York: Charles Scribner's Sons, 1897.

Bartram, William. *The Alligators in Travels through North & South Carolina, Georgia, East & West Florida, the Cherokee Country, the Extensive Territories of the Muscogulges, or Creek Confederacy, and the Country of the Chactaws.* Philadelphia: James and Johnson, 1791.

Blaugrund, Annette, and Theodore E. Stebbins Jr., eds. *John James Audubon: The Watercolors for The Birds of America.* New York: Villard Books, 1993.

Boehme, Sarah E. *John James Audubon in the West: The Last Expedition: Mammals of North America.* New York: Harry N. Abrams, in association with Buffalo Bill Historical Center, 2000.

Chalmers, John. *Audubon in Edinburgh and His Scottish Associates.* Edinburgh: NMS Enterprises Limited, 2003.

Chatelin, Yvon. *Audubon, peintre, naturaliste, aventurier.* Paris: Editions France-Empire, 2001.

Chatelin, Yvon. *Promenades dans une Amérique naissante. Sur les pas d'Audubon le naturaliste.* Paris: L'Harmattan, 2013.

Clavreul, Denis. *Jean-Jacques Audubon et l'écologie.* In *Jean-Jacques Audubon 1785–1851, Dessins de jeunesse, catalogue raisonné*, edited by Lucille Bourroux. Saintes: Le Croît Vif, Muséum de la Rochelle, 2017.

Corning, Howard, ed. *Journal of John James Audubon Made during His Trip to New Orleans in 1820–1821.* Boston: Club of Odd Volumes, 1929. Reprint, New York: Library of America, 1999.

Corning, Howard, ed. *Letters of John James Audubon, 1826–1840.* 2 vols. Boston: Club of Odd Volumes, 1930. Reprint, New York: Klaus Reprint, 1969.

DeLatte, Carolyn E. *Lucy Audubon, A Biography.* Baton Rouge: Louisiana University Press, 1982. 2nd ed., 2008.

Durant, Mary, and Harwood Michael. *On the Road with John James Audubon.* New York: Dodd, Mead, 1980.

Ford, Alice. *John James Audubon.* Norman: University of Oklahoma Press, 1964.

Ford, Alice. *John James Audubon. A Biography.* New York: Abbeville Press, 1988.

Gourdin, Henry. *Jean-Jacques Audubon (1785–1851).* Arles: Acte Sud, 2002.

Herrick, Francis Hobart. *Audubon the Naturalist: A History of His Life and Times.* 2 vols. New York: D. Appleton, 1917. 2nd ed., New York: D. Appleton, 1938; 3rd ed., New York: Dover, 1968.

Irmscher, Christoph. *John James Audubon, Writings & Drawings.* New York: Library of America, 1999.

Logan, Peter B. *Audubon, America's Greatest Naturalist and His Voyages of Discovery to Labrador.* San Francisco: Ashbryn Press, 2016.

Nobles, Gregory. *John James Audubon: The Nature of the American Woodsman.* Philadelphia: University of Pennsylvania Press, 2017.

Olson, Roberta J. M. *Audubon's Aviary.* New York: Skira Rizzoli, with New York Historical Society, 2012.

Pasquier, Roger F. *Birds in Winter: Surviving the Most Challenging Season.* Princeton, New Jersey: Princeton University Press, 2019.

Pasquier, Roger F., and John Farrand Jr. *Masterpieces of Bird Art, 700 Years of Ornithological Illustration.* New York: Abbeville Press, 1991.

Peterson, Roger Tory, and Virginia Marie Peterson. *Audubon's Birds of America.* New York: Abbeville Press, 1981.

Proby, Kathryn Hall. *Audubon in Florida.* Miami, Florida: University of Miami Press, 1974.

Rhodes, Richard. *John James Audubon: The Audubon Reader.* New York: Everyman's Library, 2006.

Rhodes, Richard. *John James Audubon: The Making of an American.* New York: Alfred A. Knopf, 2004.

Rhodes, Richard, and Scott V. Edwards. *Audubon, Early Drawings.* Cambridge, Massachusetts: Belknap Press of Harvard University Press, 2008.

Sibley, David Allen. *The Sibley Field Guide of Western Birds of North America.* New York: Alfred A. Knopf, 2003. 2nd ed., 2016.

Sibley, David Allen. *The Sibley Field Guide to Birds of Eastern North America.* New York: Alfred A. Knopf, 2003. 2nd ed., 2016.

Sibley, David Allen. *What It's Like to Be a Bird.* New York: Alfred A. Knopf, 2020.

Villerbu, Soazig. *Le jeune Audubon dans l'histoire du commerce et des révolutions atlantiques. In Jean-Jacques Audubon 1785–1851, Dessins de jeunesse, catalogue raisonné*, edited by Lucille Bourroux. Saintes: Le Croît Vif, Muséum de la Rochelle, 2017.

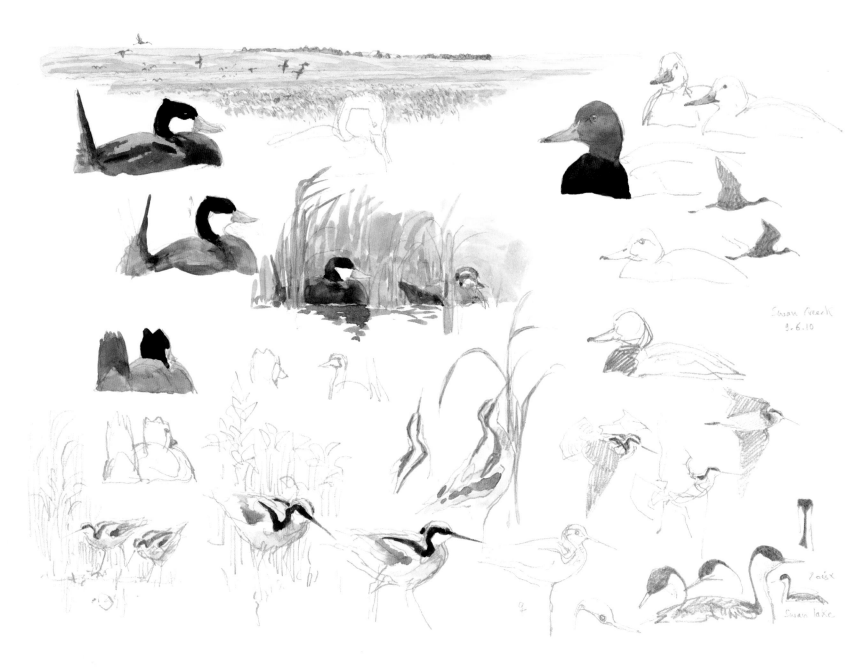

Ruddy Ducks, Canvasbacks, White-faced Ibis, Wilson's Phalaropes, and Western
Grebe, Swan Creek, Swan Lake near Lowry, South Dakota, June 9, 2010.

PENCIL AND WATERCOLOR, 11.02 × 15.75 IN (28 × 40 CM).

INDEX OF BIRD SPECIES ILLUSTRATED

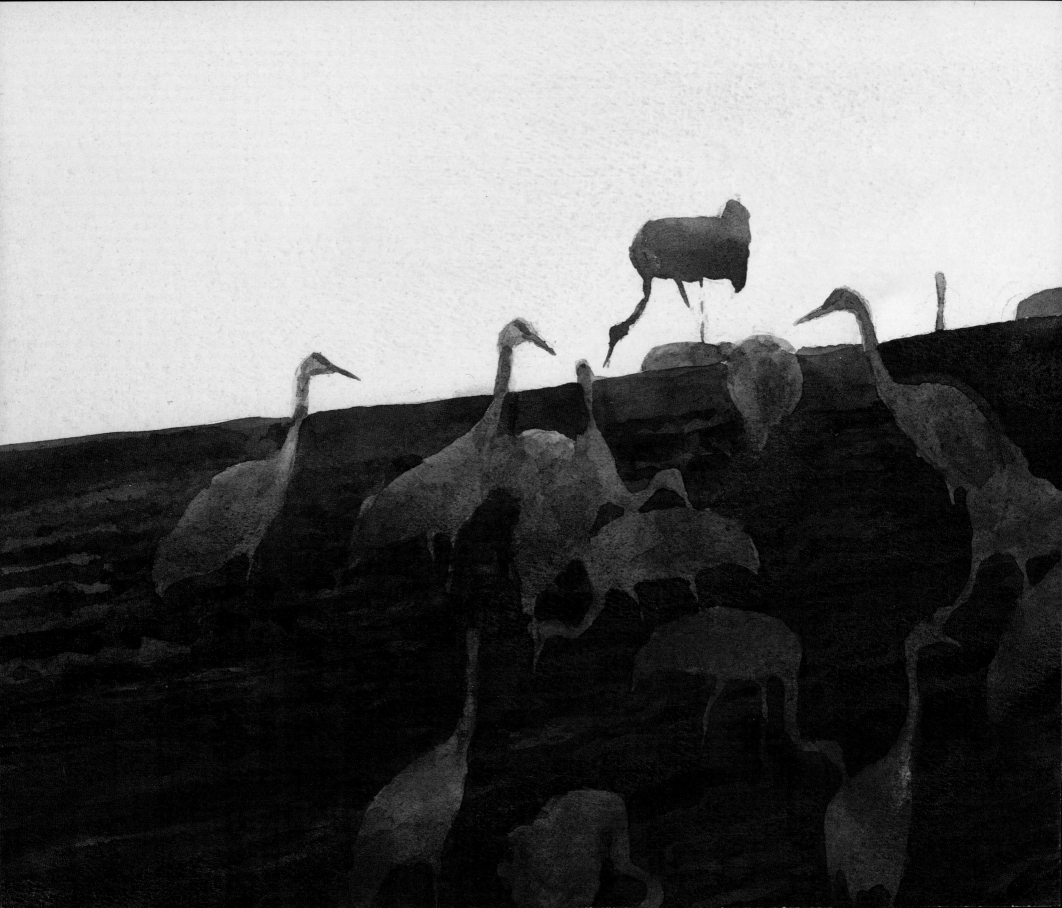

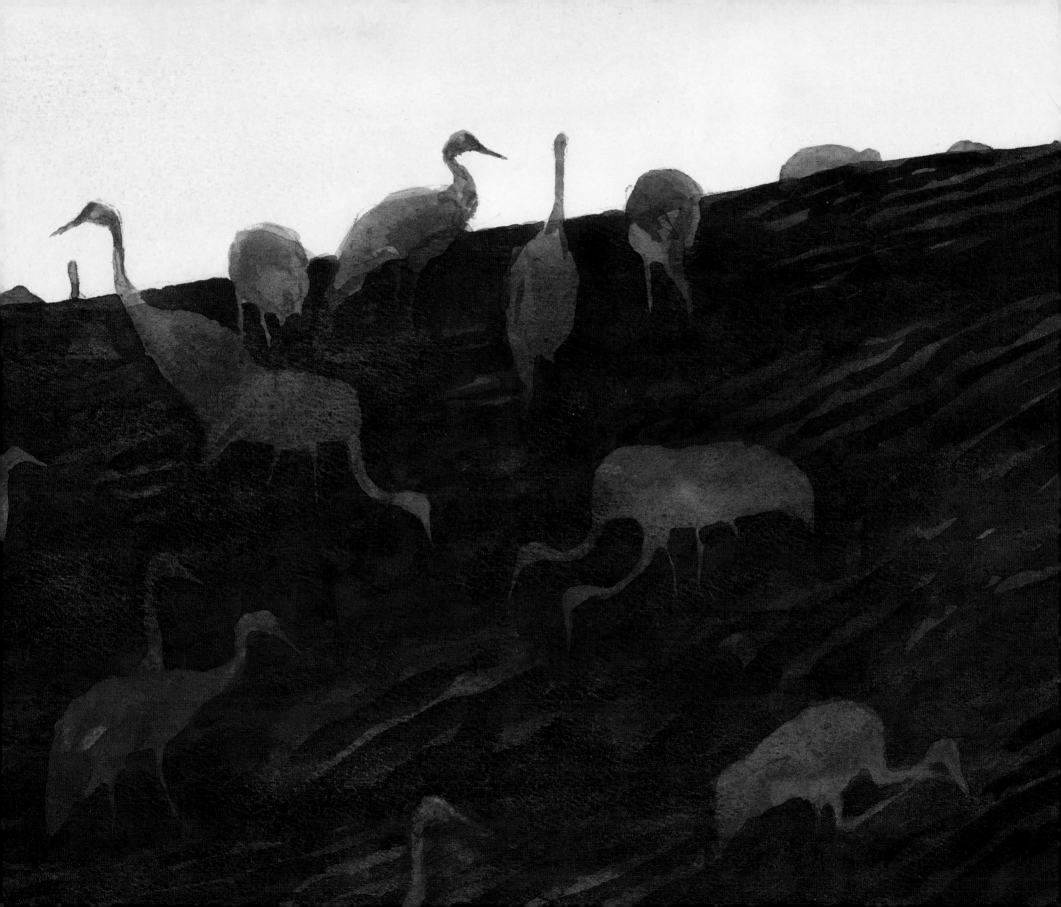

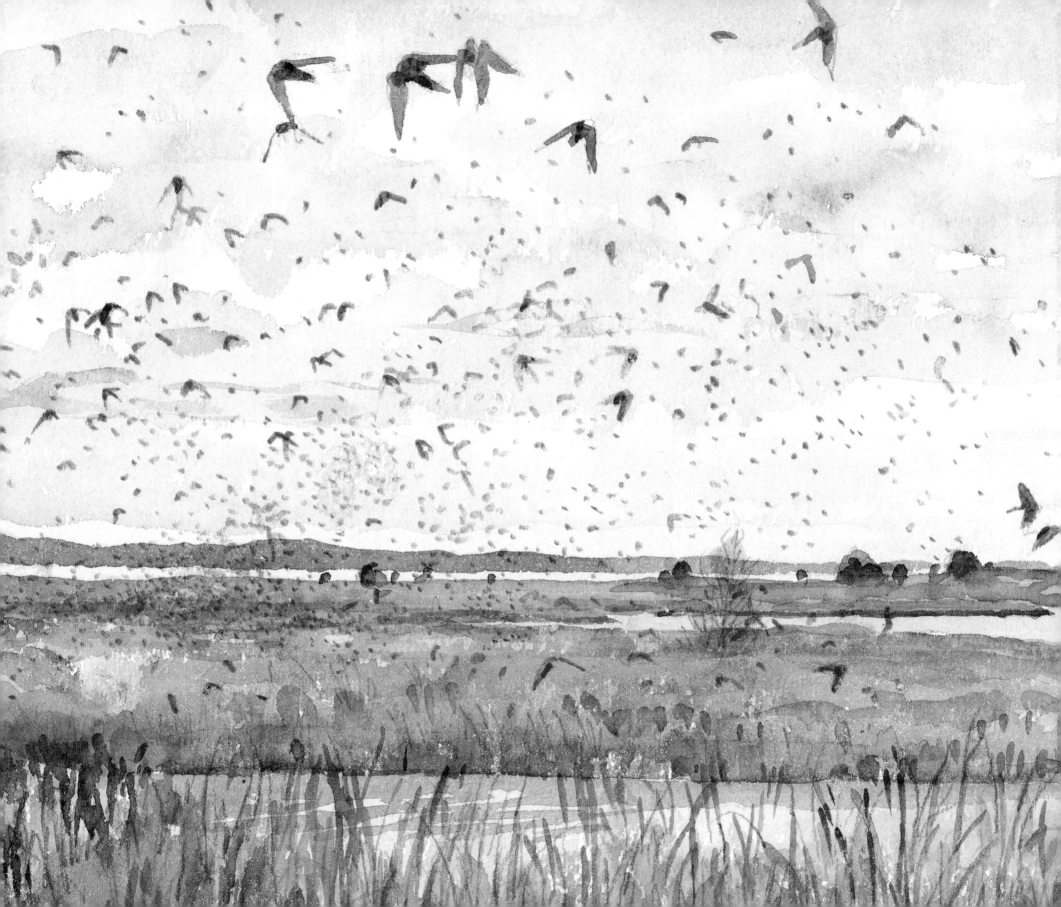

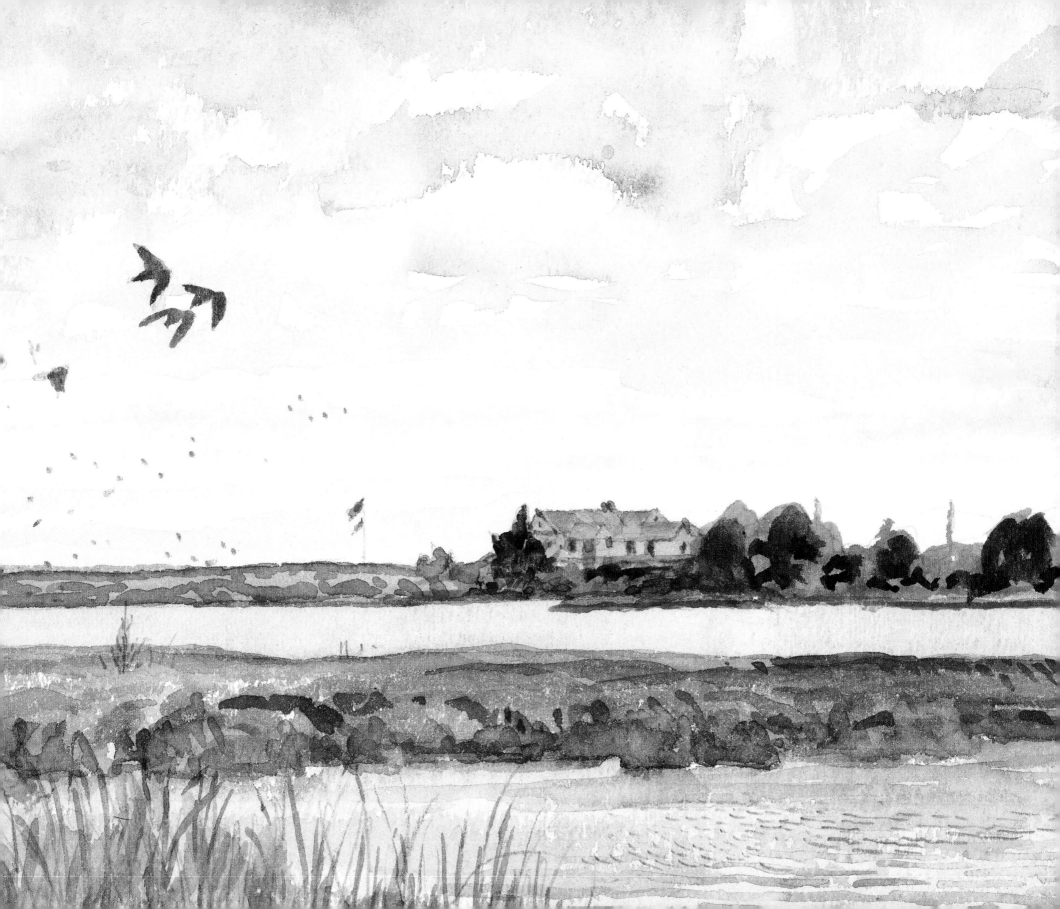